The Concise
Focal Encyclopedia
of Photography

The Concise Focal Encyclopedia of Photography

From the First Photo on Paper to the Digital Revolution

MICHAEL R. PERES, MARK OSTERMAN, GRANT B. ROMER, NANCY M. STUART, Ph.D., J. TOMAS LOPEZ

ELSEVIER

AMSTERDAM • BOSTON • HEIDELBERG • LONDON
NEW YORK • OXFORD • PARIS • SAN DIEGO
SAN FRANCISCO • SINGAPORE • SYDNEY • TOKYO

Focal Press is an imprint of Elsevier

Focal Press

Acquisitions Editor: Diane Heppner
Publishing Services Manager: George Morrison
Senior Project Manager: Brandy Lilly
Associate Acquisitions Editor: Valerie Geary
Assistant Editor: Doug Shults
Marketing Manager: Christine Degon Veroulis
Cover Design: Alisa Andreola
Interior Design: Alisa Andreola

Focal Press is an imprint of Elsevier
30 Corporate Drive, Suite 400, Burlington, MA 01803, USA
Linacre House, Jordan Hill, Oxford OX2 8DP, UK

 Recognizing the importance of preserving what has been written, Elsevier prints its
books on acid-free paper whenever possible.

Library of Congress Cataloging-in-Publication Data
Application submitted

British Library Cataloguing-in-Publication Data
A catalogue record for this book is available from the British Library.

ISBN: 978-0-240-80998-4

For information on all Focal Press publications
visit our website at www.books.elsevier.com

07 08 09 10 11 5 4 3 2 1

Printed in China

Contents

Contributors

Lynne Bentley-Kemp, Ph.D.
Head of Photography
Florida Keys Community College
Key West, Florida, USA

David Brittain
AHRC Research Fellow
Manchester Metropolitan University
Manchester, London, United Kingdom

Daniel Burge
Research Scientist
Image Permanence Institute
Rochester Institute of Technology
Rochester, New York, USA

Christopher Burnett
Director
Visual Studies Workshop
Rochester, New York, USA
http://vsw.org

Bruce Checefsky
Director
Reinberger Galleries
The Cleveland Institute of Art
Cleveland, Ohio, USA

A. D. Coleman
Independent Photography Critic, Historian,
 and Curator
Staten Island, New York, USA
http://photocritic.com

Margaret P. Evans
Associate Professor
Communication/Journalism Department
Shippensburg University
Shippensburg, Pennsylvania, USA

John (Craig) Freeman
Associate Professor
Emerson College
Boston, Massachusetts, USA

Gretchen Garner
Photographic Author and Scholar
Columbus, Ohio, USA

David C. Hart, Ph.D.
Assistant Professor
Cleveland Institute of Art
Cleveland, Ohio, USA

Barry Haynes
Photographic Author
Gibsons, British Columbia, Canada
www.barryhaynes.com

Robert Hirsch
Light Research
Buffalo, New York USA
www.lightresearch.net

Daile Kaplan
Vice-President and Director of Photographs
Swann Galleries, Inc.
New York, New York, USA

John Kaplan
Professor
College of Journalism and Communications
University of Florida
Gainesville, Florida, USA
www.johnkaplan.com

J. Tomas Lopez
Professor
Art and Art History
University of Miami
Coral Gables, Florida, USA

David Malin
Astronomer/Photographic Scientist
Anglo-Australian Observatory
Sydney, New South Wales, Australia
Adjunct Professor of Scientific Photography
RMIT University
Melbourne, Victoria, Australia

Doug Manchee
Associate Professor
School of Photographic Arts and Sciences
Rochester Institute of Technology
Rochester, New York, USA

Photographers and Image Contributors

Berenice Abbott
Miriam and Ira D. Wallach Division of Arts
New York Pubic Library
New York, New York, USA

Ansel Adams
Ansel Adams Publishing Rights Trust
Mill Valley, California, USA

Robert Adams
George Eastman House Collection
Rochester, New York, USA

Raymond K. Albright
George Eastman House Collection
Rochester, New York, USA

Thomas Annan
George Eastman House Collection
Rochester, New York, USA

Frederick Scott Archer
George Eastman House Collection
Rochester, New York, USA

Eugéne Atget
George Eastman House Collection
Rochester, New York, USA

Anna Atkins
Spencer Collection
New York Pubic Library
New York, New York, USA

Édouard Baldus
George Eastman House Collection
Rochester, New York, USA

Thomas Barrow
George Eastman House Collection
Rochester, New York, USA

A. Bartlett
George Eastman House Collection
Rochester, New York, USA

Samuel A. Bemis
George Eastman House Collection
Rochester, New York, USA

Abraham Bogardus
George Eastman House Collection
Rochester, New York, USA

Mathew Brady
George Eastman House Collection
Rochester, New York, USA

Adolphe Braun
George Eastman House Collection
Rochester, New York, USA

Anne W. Brigman
George Eastman House Collection
Rochester, New York, USA

Gordon P. Brown
Imaging Consultant
Rochester, New York, USA

Nancy Burson
George Eastman House Collection
Rochester, New York, USA

Julia Margaret Cameron
George Eastman House Collection
Rochester, New York, USA

Lewis Carroll
George Eastman House Collection
Rochester, New York, USA

Charles Chevalier
George Eastman House Collection
Rochester, New York, USA

Carl Chiarenza
George Eastman House Collection
Rochester, New York, USA

Antoine-Francois Jean Claudet
George Eastman House Collection
Rochester, New York, USA

Chuck Close
George Eastman House Collection
Rochester, New York, USA

Commerce Graphics, Ltd, Inc.
New York, New York, USA

Robert Cornelius
George Eastman House Collection
Rochester, New York, USA

Cromer's Amateur Daguerreotypist
George Eastman House Collection
Rochester, New York, USA

Louis-Jacques-Mandé-Daguerre
George Eastman House Collection
Rochester, New York, USA

Andrew Davidhazy
Professor
School of Photographic Arts and Sciences
Rochester Institute of Technology
Rochester, New York, USA

Bruce Davidson
Magnum Photos
George Eastman House Collection
Rochester, New York, USA

George Davison
George Eastman House Collection
Rochester, New York, USA

F. Holland Day
George Eastman House Collection
Rochester, New York, USA

André-Adolphe-Eugène Disdéri
George Eastman House Collection
Rochester, New York, USA

Maxime du Camp
George Eastman House Collection
Rochester, New York, USA

Louis Ducos Du Hauron
George Eastman House Collection
Rochester, New York, USA

P. Dujardin and Léonard Berger
George Eastman House Collection
Rochester, New York, USA

George Eastman House
George Eastman House International
 Museum of Photography and Film
Rochester, New York, USA

Peter Henry Emerson
George Eastman House Collection
Rochester, New York, USA

Elliot Erwitt
George Eastman House Collection
Rochester, New York, USA

Frederick H. Evans
George Eastman House Collection
Rochester, New York, USA

Walker Evans
George Eastman House Collection
Rochester, New York, USA

Eye of Science
Oliver Meckes and Nicole Ottawa
Reutlingen Germany
www.eyeofscience.com

Amy Faber
Student
Shippensburg University
West Chester, Pennsylvania, USA

Roger Fenton
George Eastman House Collection
Rochester, New York, USA

Robert Fichter
George Eastman House Collection
Rochester, New York, USA

Jacob Forsell
Photographer
Stockholm, Sweden

Samuel M. Fox
George Eastman House Collection
Rochester, New York, USA

Abe Frajndlich
Visual Studies Workshop
Rochester, New York, USA

Felice Frankel
Massachusetts Institute of Technology
Cambridge, Massachusetts, USA

Lee Friedlander
George Eastman House Collection
Rochester, New York, USA

Francis Frith
George Eastman House Collection
Rochester, New York, USA

Adam Fuss
George Eastman House Collection
Rochester, New York, USA

Alexander Gardner
George Eastman House Collection
Rochester, New York, USA

GM Media Archive
General Motors
Detroit, Michigan, USA

Gernsheim Collection
Harry Ransom Humanities Research Center
The University of Texas at Austin
Austin, Texas, USA

Elias Goldensky
George Eastman House Collection
Rochester, New York, USA

Emmet Gowin
George Eastman House Collection
Rochester, New York, USA

Baron Jean-Baptiste-Louis Gros
George Eastman House Collection
Rochester, New York, USA

Ernst Haas
George Eastman House Collection
Rochester, New York, USA

Philippe Halsman
George Eastman House Collection
Rochester, New York, USA

Franz Hanfstaengl
George Eastman House Collection
Rochester, New York, USA

Barry Haynes
Independent Author and Photographer
Gibsons, British Columbia, Canada
www.barryhaynes.com

Robert Heinecken
George Eastman House Collection
Rochester, New York, USA

Alexander Hesler
Illinois State Historical Society
Chicago, Illinois, USA

David Octavius Hill and Robert Adamson
George Eastman House Collection
Rochester, New York, USA

Lewis W. Hine
George Eastman House Collection
Rochester, New York, USA

Graciela Iturbide
George Eastman House Collection
Rochester, New York, USA

Frederic Ives
George Eastman House Collection
Rochester, New York, USA

William Henry Jackson
George Eastman House Collection
Rochester, New York, USA

Laura Adelaide Johnson
George Eastman House Collection
Rochester, New York, USA

J. Murray Jordan
George Eastman House Collection
Rochester, New York, USA

Kenneth Josephson
George Eastman House Collection
Rochester, New York, USA

John Kaplan
Professor
College of Journalism and Communications
University of Florida
Gainesville, Florida, USA
www.johnkaplan.com

Gertrude Käsebier
George Eastman House Collection
Rochester, New York, USA

Mark Klett
George Eastman House Collection
Rochester, New York, USA

Eastman Kodak Company
Rochester, New York, USA
www.kodak.com

Les Krims
George Eastman House Collection
Rochester, New York, USA

Barbara Kruger and the Mary Boone Gallery
New York City, New York, USA

Dorthea Lange
Farm Security Administration
Office of War Information Photograph
 Collection

Library of Congress Prints and Photographs
 Division
Washington D.C., USA

W. and F. Langenheim
George Eastman House Collection
Rochester, New York, USA

Gustave Le Gray
George Eastman House Collection
Rochester, New York, USA

Henri Le Sec
George Eastman House Collection
Rochester, New York, USA

Life Magazine
New York, New York, USA

Gabriel Lippmann
George Eastman House Collection
Rochester, New York, USA

J. Tomas Lopez
Professor
Art and Art History
University of Miami
Coral Gables, Florida, USA

Danny Lyon
Edwynn Houk Gallery
George Eastman House Collection
Rochester, New York, USA

Joan Lyons
George Eastman House Collection
Rochester, New York, USA

Nathan Lyons
George Eastman House Collection
Rochester, New York, USA

David Malin
Astronomer/Photographic Scientist
Anglo-Australian Telescope
Sydney, New South Wales, Australia
RMIT University
Melbourne, Victoria, Australia

Mary Ellen Mark
George Eastman House Collection
Rochester, New York, USA

Thomas L. McCartney
West Palm Beach, Florida, USA

Susan Meisalas
Magnum Photos
George Eastman House Collection
Rochester, New York, USA

Joel Meyerowitz
George Eastman House Collection
Rochester, New York, USA

Richard Misrach
George Eastman House Collection
Rochester, New York, USA

Laszlo Moholy-Nagy
George Eastman House Collection
Rochester, New York, USA

Museum of Contemporary Photography
Columbia College Chicago
Chicago, Illinois, USA

Eadweard J. Muybridge
George Eastman House Collection
Rochester, New York, USA

Rebecca Myers
Student
Shippensburg University
Shippensburg, Pennsylvania, USA

Nadar
George Eastman House Collection
Rochester, New York, USA

Joseph Nicéphore Niépce
Gernsheim Collection
Harry Ransom Humanities Research Center
The University of Texas at Austin
Austin, Texas, USA

Willie Osterman
Professor
School of Photographic Arts and Sciences
Rochester Institute of Technology
Rochester, New York, USA

Timothy H. O'Sullivan
George Eastman House Collection
Rochester, New York, USA

Pach Brothers
George Eastman House Collection
Rochester, New York, USA

Olivia Parker
George Eastman House Collection
Rochester, New York, USA

Gordon Parks
Farm Security Administration
Office of War Information Photograph
* Collection*
Library of Congress Prints and Photographs
* Division*
Washington, D.C., USA

Martin Parr
Magnum Photos
George Eastman House Collection
Rochester, New York, USA

Joe Petrella
Daily News L.P.
New York, New York, USA
www.dailynewspix.com

Michael Profitt
Shippensburg University Student
Kirkland, Washington, USA

Stephanie Prokop
Student
Shippensburg University
Hamilton Square, New Jersey, USA

Jill Rakowicz
Student
Shippensburg University
Gettysburg, Pennsylvania, USA

Oscar Rejlander
George Eastman House Collection
Rochester, New York, USA

Richter & Company
George Eastman House Collection
Rochester, New York, USA

James Robertson
George Eastman House Collection
Rochester, New York, USA

Henry Peach Robinson
George Eastman House Collection
Rochester, New York, USA

RIT Archives and Special
Collections
Wallace Memorial Library

Rochester Institute of Technology
Rochester, New York, USA

Arthur Rothstein
Farm Security Administration
Office of War Information Photograph
* Collection*
Library of Congress Prints and Photographs
* Division*
Washington, D.C., USA

Jean Baptiste Sabatier-Blot
George Eastman House Collection
Rochester, New York, USA

Erich Salomon
George Eastman House Collection
Rochester, New York, USA

Lucas Samaras
Pace/MacGill Gallery
New York City, New York, USA

Scully and Osterman Archives
Rochester, New York, USA

Sonia Landy Sheridan
George Eastman House Collection
Rochester, New York, USA

Cindy Sherman
Metro Picture Gallery
New York, New York, USA

John Shaw Smith
George Eastman House Collection
Rochester, New York, USA

Frederick Sommer
George Eastman House Collection
Rochester, New York, USA

Frederick and Francis Sommer
Foundation
Prescott, Arizona, USA

Southworth & Hawes
George Eastman House Collection
Rochester, New York, USA

Paul Strand
George Eastman House Collection
Rochester, New York, USA

J.C. Strauss
George Eastman House Collection
Rochester, New York, USA

Nancy M. Stuart, Ph.D.
Executive Vice President and Provost
The Cleveland Institute of Art
Cleveland, Ohio, USA

William Henry Fox Talbot
George Eastman House Collection
Rochester, New York, USA

David Teplica, M.D., MFA
Fine Artist, Plastic and Reconstructive
* Surgeon*
Chicago, Illinois, USA

John Thomson
George Eastman House Collection
Rochester, New York, USA

Adrien Tournachon
George Eastman House Collection
Rochester, New York, USA

Jerry Uelsmann
George Eastman House Collection
Rochester, New York, USA

Doris Ulmann
George Eastman House Collection
Rochester, New York, USA

Visual Studies Workshop
VSW Archive
Rochester, New York, USA

Weegee
International Center of Photography/
* Getty Images*
George Eastman House Collection
Rochester, New York, USA

Clarence H. White
George Eastman House Collection
Rochester, New York, USA

Joel Peter Witkin
George Eastman House Collection
Rochester, New York, USA

Zeiss MicroImaging
Thornwood, New York, USA

About the Editors

Michael Peres is the Chairman of the Biomedical Photographic Communications department at the Rochester Institute of Technology where he is also a Professor in the School of Photographic Arts and Sciences. Professor Peres teaches and specializes in photomicrography as well as biomedical photography. He began teaching at RIT in 1986 and has authored numerous publications, delivered more than 100 oral papers, and conducted more than 35 imaging-related workshops all over the United States as well as in Sweden, Tanzania, the Netherlands, Germany, and Australia. He has been a member of Bio-Communications Association since 1978 and is currently a member of the Ophthalmic Photographer's Society. Peres serves as the Chair of the Lennart Nilsson Award Nominating Committee, is one of the coordinators of the annual R.I.T Big Shot (www.rit.edu/bigshot) project and the R.I.T Images from Science project (http://images.rit.edu). In 2003, Peres was awarded RIT's Eisenhart award given annually for outstanding teaching. Michael holds a Master's Degree in Instructional Technology and Bachelors degrees in Biology and Biomedical Photographic Communications.

Mark Osterman is process historian for the Advanced Residency Program in Photograph Conservation at the George Eastman House International Museum of Photography and Film. Mark is a recognized expert in the technical evolution of photography and leads a series of demonstrations and workshops in his area of expertise worldwide. Osterman frequently demonstrates the pre-photographic techniques, the earliest photosensitive methods of Niépce and Daguerre through gelatin emulsion for papers and plates.

A graduate from the Kansas City Art Institute, Osterman has taught studio and darkroom photography for 20 years at the George School in Bucks County, Pennsylvania prior to coming to the George Eastman House.

With his wife France Scully Osterman, Scully and Osterman are widely recognized as the foremost experts in the collodion process in all its variants. Through their research, writings, workshops and exhibitions the Ostermans have been the single most important influence in the current revival of collodion in fine art photography.

Grant B. Romer is currently the Director of the Advanced Residency Program in Photograph Conservation at the George Eastman House International Museum of Photography and Film. He has been active as an educator and advocate for the conservation of photographs and a specialist in the history and practice of the nineteenth century photography, particularly the daguerreotype. He has lectured extensively world-wide as well as having held numerous fellowships and visiting professorships.

A graduate of the Pratt Institute and the Rochester Institute of Technology, Romer joined the staff of the International Museum of Photography and Film at George Eastman House in 1978 when he became its Conservator. He has also served as curator of numerous exhibitions, most notably the permanent historical survey gallery of the museum, and recently, "Young America—The Daguerreotypes of Southworth and Hawes."

Romer is recognized, internationally, for his broad understanding of photography and unique perspectives on the importance and nature of the medium.

Nancy M. Stuart is the Executive Vice President and Provost of The Cleveland Institute of Art. From 1984–2002 she held various faculty and administrative positions including Associate Professor of Photography, Associate and Acting Director of the School of Photographic Arts and Sciences, as well as the Associate Dean of the College of Imaging Arts and Sciences at

Rochester Institute of Technology. She also served as Applied Photography Department Chair. She began teaching photography in 1975 at Lansing Community College.

As an artist, she has addressed various social issues through her work. Her most recent published project, *DES Stories: Faces and Voices of People Exposed to Diethylstibestrol* (VSW Press, 2001) explores the impact of accidental chemical exposure on the lives of forty individuals. One portrait from the book was chosen for the John Kobal Portrait Award Exhibit at the National Portrait Gallery in London.

Nancy completed her Ph.D. at the State University of New York at Buffalo in the Graduate School of Education. She lives with her husband David and two children, Sarah and Stuart, in Chagrin Falls, Ohio.

J. Tomas Lopez is a Professor of Art and Art History as well as the Director of Photography/Digital Imaging at the University of Miami. Professor Lopez is nationally and internationally known for his large-scale digital prints ranging from underwater photography to politically charged flags. He has been showcased in over 100 group exhibitions and 25 solo exhibitions. His work is included in many permanent collections: The Smithsonian Institution, National Gallery of American Art, La Biblioteque Nation-ale de France (Paris), The International Museum of Photography, and many museums, public, and private collections. He has been with the University of Miami since 1994 where he lives and works with his wife Carol. Professor Lopez has been a recipient of the Florida Individual Artist Grants program, the Cintas Foundation Fellowship, and the NEA Award in the Visual Arts.

Acknowledgments

As I reach the conclusion of this project, I am reminded of the more than 1500 email files in my archive, the countless word and image files as well as the **GIGABYTES** of data that were required to produce the *Fourth Edition*. This book—a representative portion of the *Fourth Edition*—represents the work of a world wide photographic community and because of the method in which the original revision was undertaken, it has been suggested that the *Fourth Edition* wrote and illustrated itself.

From the beginning of this process, it was my objective to achieve the quality and successes of the first three editions, but to do so in a new and different way. This book is the work of many talented people and it includes the cumulative knowledge and experience of many dedicated professionals, many whom I do not know. Although I have never worked on a project this complicated, the journey was one of great discovery, adventure and challenges. My heart felt thanks to all the authors and photographers for sharing their expertise and in the end, creating the wonderful and diverse content for both the fourth and concise editions.

I had much help and support during the time it took to produce this and the *Fourth Edition*. Words alone cannot begin to express my appreciation to Diane Heppner, the book's acquisition editor who started this journey for me by supporting my application for the editor-in-chief position. I am grateful for that support but more importantly, I am sincerely grateful for her advice, which she shared freely during the various phases of creating, producing and publishing the *Fourth Edition*. The creation of the *Concise Edition*, which was built from content produced for the *Fourth Edition* was supervised by Valerie Geary and Brandy Lilly, who did a wonderful job given the short time this edition was provided. I am also grateful for the support of Dr. Zakia and Dr. Stroebel, the editors for the *Third Edition* who were supportive of my selection as editor-in-chief. I was also fortunate to have the unanimous support of Professors Andrew Davidhazy and Bill DuBois, the administrative chairs in the School of Photographic Arts & Sciences who endorsed my involvement in this project from the beginning. The School of Photographic Arts and Sciences is a very special place where my students and colleagues are a source of inspiration, knowledge and creativity, which is shared daily through their work and passion for photography.

The first step in revising the *Fourth Edition* was proposing a revision strategy and getting the proposal approved. With the approval in hand, identifying and persuading section editors to join the team was the next challenge I faced. Finding the right people was very slow and difficult, but once the editors were committed to the project, the results they produced were well worth the struggle. The expertise and networking accomplished by Professor Tom Lopez, Nancy Stuart Ph.D., and Mark Osterman and Grant Romer was truly remarkable. Their wealth of personal knowledge and their invitations to authors reached deep into communities that only experts in their fields could access. This book represents what is possible when a group of dedicated and brilliant editors, authors, and photographers who are passionately involved with photography commit to a project.

Early on during the conceptual phase of this revision, I reached out to Mr. Tony Bannon, the Director of the George Eastman House about a possible collaboration with the Museum and its collections. The idea to explore the collaboration was quickly embraced and became very important to me knowing this revision would include some of the world's important photographs that were held in the Museum's world-renown collections. Once supported, the Museum's associate curator, Sean Corcoran, as well as Todd Gustavson, the curator of the technology collection, selected and delivered excellent suggestions to illustrate so many of the essays.

Many others offered help and encouragement throughout the various stages of this production. Becky Simmons, Kari Horowicz, and Amelia Hugill-Fontanel from the RIT Wallace Memorial Library provided many helpful insights when I was at various stages of producing this book and needed to do more research. The RIT Special Collections at the library also provided a number of important pictures taken during RIT's 100 year history of teaching photography.

There were countless others that offered encouragement during the adventure along the way including my parents, who more than 25 years ago supported my pursuit of a second degree in photography. I wish I had enough pages to list all of my collaborators that helped prepare me for this challenge. In the end though, the love and support of my wife Laurie and my children Jonathan and Leah, made this work possible. Their support and understanding of my passion for new adventures gave me the confidence to take on this challenge for which I am forever grateful. Their love was never more evident when I was in the final stages of finishing on-time when there did not seem to be enough time.

Michael Peres
June 2007

Introduction

The first edition of *The Focal Encyclopedia of Photography* was published in 1956 at a time when innovations in silver halide technology, photographic tools, and practices were growing exponentially. Reading the Introduction to the *First Edition* published by Hungarian author Andor Kraszna-Krausz, the first chairman of the editorial board, provided an interesting chance to compare how much imaging technology has changed since that time while the applications have changed more slowly. In fact some things have actually stayed the same. I might also add that it is an achievement for this, or any, book to be available 50 years after its initial printing.

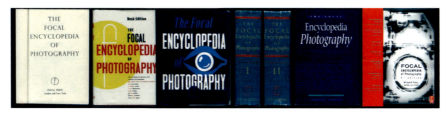

Various covers and title pages from 50 years of editions.

This *Concise Edition* was produced using selected content which was created for the complete revision of the *Fourth Edition*. The content in the *Fourth Edition* was undertaken at a time when great changes are being experienced in all technologies associated with photography. The book's format was created to provide a concise and comprehensive resource sharing the breadth of photography at the time when both film and digital practices co-mingled and users were firmly entrenched in both technologies. The content was written in a narrative style to allow subjects to be explored from both the theoretical and the applications perspectives. It was decided that subjects would be grouped thematically rather than alphabetically. The decision to allow subjects to be explored this way is less traditional for modern encyclopedias, and it was my hope that this would lead to a photographic resource that is uniquely different in this era of electronic resources. The exploratory writing style was selected to enable users to see how a subject is widely defined and then be able to use the ever-increasing resources found on the web in a complementary manner. Additionally, the use of photographs in this edition has created a completeness that prior editions were unable to achieve.

Images were supplied by authors, photographers, organizations, and from the Technology and Image Collections at the George Eastman House International Museum of Photography and Film. The response to the *Fourth Edition* has been excellent thus far and so the *Concise Edition* has been produced to share selected content to a group of readers who might not require the completeness of the *Fourth Edition*.

While photography can be defined as both a subject and a practice, it is also unique in that it uses the same technology when practiced as art or science. No event in the developed world occurs without cameras being present. Cameras are found virtually everywhere in medicine, at birthday parties, in art museums, in cellular telephones and at natural disasters. The power of the image and the consequences photography brings to bear are often overlooked at the time of the picture making during daily events, yet the capturing of such routine events sometimes can be compelling evidence of events long gone. In 1888 when Kodak and George Eastman branded the expression "you push the button and we do the rest" for the Kodak marketing campaign of the time, little could the world have imagined the penetration photography would have into everyday life world-wide in the 21st century.

Producing *The Focal Encyclopedia of Photography* at this moment in history has created many new questions as a consequence of the pace of all the changes the industry and users wrestle with. When I use the digital tools that are re-defining photography today I often wonder, will the majority of my digital pictures made in this era be readable tomorrow by my children or colleagues? Will the images of this era survive the journey of time, when the equipment required to make and see them is changing at rates never before experienced in this medium? Although the complex technical problems surrounding this issue are explored in several essays in the contemporary section of this book, the future is still an unsettled place for photographers who are anxious about these changes and evolution. Therese Mulligan, Ph.D. suggests "that we might consider for a minute that this era in photography must have practical and cultural circumstances that were similar to the era when photography was first practiced in the 1830's. The new is often met with trepidation and this is the nature of change. However, how do digital technologies present opportunities and new possibilities for interpretation, communication and art? Do they co-exist with photography and deepen its significance or is the converse the future?" I am sure you will find this book to be a real treasure and full of surprises.

Michael Peres
Editor-in-Chief
June 2007

HISTORY AND EVOLUTION OF PHOTOGRAPHY

MARK OSTERMAN
George Eastman House International
Museum of Photography and Film

GRANT B. ROMER
George Eastman House International
Museum of Photography and Film

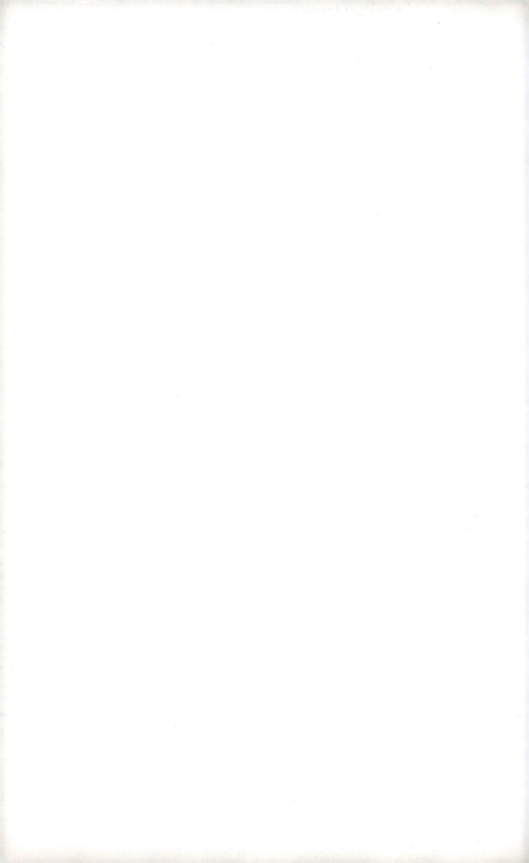

Contemporary Thoughts on the History of Photography

GRANT B. ROMER

George Eastman House and International Museum of Photography and Film

All photographers work today with historical perspective. They know that the technology they use has an origin in the distant past. They know photography has progressed and transformed over time, and they believe the current system of photography must be superior to that of the past. They are sure they will witness further progress in photography. These are the lessons of history understood by all, and none need inquire any further in order to photograph.

Yet photography has a very rich and complex history, which has hidden within it the answers to the fundamentally difficult questions: "What is photography?" and "What is a photograph?" All true photographers should be able to answer these questions for themselves and for others. To do so, they must make deep inquiry into the history of photography.

Recognition of the importance of history to the understanding of photography is evidenced in the title and content of the very first manual of photography published in 1839, *The History and Description of the Process of the Daguerreotype and Diorama.* Most of the early inventors of photographic processes gave account of the origin of their discoveries not just to establish priority but also to assist comprehension of the value and applications of the technology. When the entire world was childlike in understanding the full potential of photography, this was a necessity.

Many histories of photography have since been written for many different reasons. Each historian, according to his or her interest and national bias, placed certain details large in the foreground, diminished others, and represented most by a few slight touches. By 1939, the hundredth anniversary of photography, a much-simplified chronological story had been told, more or less fixed and repeated ever since. In essence it

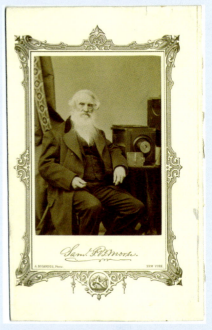

FIG. 1 A representative period portrait of inventor Samuel F. B. Morse, ca. 1890, by Abraham Bogardus. Albumen print. Courtesy of the George Eastman House Collection, Rochester, New York.

goes as follows: Photography emerged in the first quarter of the 19th century in Western Europe out of the exploration of the properties and effects of light, the progress of optics and chemistry, and the desire to make accurate and reproducible pictorial records of visual experience.

The first processes were relatively limited and were rapidly improved by the efforts of many through better lenses, camera design, and chemical innovation. One process yielded commercial dominance to an easier and better one until gelatin emulsion technology brought a new era of photography in the 1880s, which was to continue into the

21st century. The photography industry subsequently grew. More people became enabled to make more photographs. Cameras were freed from the tripod. Color and motion picture photography became possible. The applications of photography steadily multiplied and increasingly benefited society. "Masters" of the medium, in every era, created photographs that transformed how we see and what we know.

The developments of the last decade now make it necessary to deconstruct and reassemble that history of photography to include the origins, progress, and transformation of electronic imaging as well as that of other recording, reproduction, and information technologies. For instance, Becquerel's observation of the photovoltaic effect in 1839 must be placed along with Daguerre and Talbot's discovery of principle of the latent image as a primal moment in the history of photography. Every purchase of a digital camera adds to the historical importance of the discovery of the conversion of light into electricity.

With the convergence of imaging and information technology, it is now quite legitimate to trace the history of photography within many contexts other than that of the progress of optics and chemistry.

Photography is now seen as a part, not the all, of imaging technology. The very definitions of *photography* and *photograph* are in transition along with the technology and industry of photography. Thus the history of photography must also change as silver is replaced by silicon. A new generation of photographers will soon know nothing directly of the thrill and mystery of the development of the latent image, which has long been the initiatory experience and bond among serious photographers. The digital revolution, like all revolutions, is in the process of disrupting and destroying an old order. The history of the chemical era of photography may become less interesting if it is not properly linked to the electronic era by a new inquiry.

History teaches that photography is a mutable and ever-changing technology. How it changes is not as interesting as why it changes. By what criteria is any method of photography judged superior to another at any given time, and who are the significant judges? Who decides what form of photography serves in the present? The future historians of photography would do well to address these questions. Perhaps the most interesting and important question for all is, "What do we want photography to be?" ◑

Part page photograph: Photograph of John Taylor made by W. and F. Langenheim, ca. 1846. Transparency, albumen on glass (Hyalotype). Image courtesy of the George Eastman House Collection, Rochester, New York.

The Technical Evolution of Photography in the 19th Century

MARK OSTERMAN
George Eastman House and International Museum of Photography

Concept and First Attempts

Whereas the observation of numerous light-sensitive substances and the formative evolution of the camera obscura predate 1800, the invention of photography, as we know it, was essentially a 19th-century phenomenon. Who actually invented photography has been disputed from the very beginning, though the task would have been easier had there been a universally accepted definition of *photograph*.

Taken literally, the Greek words *photos* and *graphos* together mean "light drawing." Even today the term *photography* is being manipulated to fit digital imaging, but in its most elegant form, a photograph may best be described as a reasonably stable image made by the effect of light on a chemical substance. Light is energy in the form of the visible spectrum. If light or some other invisible wavelength of energy is not used to make the final picture by chemical means, it cannot, by this definition, be a photograph.

The stability of an image made by light is also important. Without stability, the term *photograph* could apply to the most fragile and fugitive examples of images such as frost shadows of buildings on a sunny November morning. The word *photography* was not the product of just one man. Its introduction was a logical choice by those with knowledge of Greek who contemplated the concept. The term may have been first used by Antoine Hercules Romuald Florence in 1833. Florence was living in Brazil, working in relative isolation, and had no apparent influence on the European scientific community. Sir John Herschel (Figure 7), in England, also used the terms *photography* and *photograph* in 1839, but his contacts were many. Because of this Herschel has traditionally been credited with the use of the terms by those seeking words to describe both the process and product.

Some of the first images to be recorded with light-sensitive materials were made by Thomas Wedgwood, son of Josiah Wedgwood, the well-known potter. His associate, the scientist Sir Humphrey Davy, published the results and observations in the *Journal of the Royal Institution* in 1802. Wedgwood and Davy made images on paper and white leather coated with silver nitrate. They laid leaves and paintings on glass upon the sensitive materials and exposed them to sunlight, which darkened the silver. In an attempt to keep the image, they washed the exposed materials without success. They found that combining the silver solution with sodium chloride produced the more sensitive whitish paste of silver chloride. Even with this improvement, Wedgwood felt the process was too slow to make images in a camera, and though they did make the first photographic enlargements of microscopic specimens by projecting the images using a solar microscope, they had no way to preserve the image once it was formed.

Many of the observations of Wedgwood and Davy were actually ideas already covered years earlier by Johann Heinrich Schulze (1725), Carl Wilhelm Scheele (1777), and Jean Senebier (1782), though without the same sense of purpose. Schulze discovered the sensitivity of silver nitrate to light rather than to heat. Scheele, in addition, observed and published that ammonia would dissolve unexposed silver chloride, the means to permanently fix silver chloride images. It is still difficult to understand why Scheele's published observation escaped Davy. The experiments of Wedgwood and Davy are important because their work combined photochemical technology with the sole intent to make images with light. Few doubt that success would have come to Wedgwood had he applied ammonia to his images, but he died a few years after publishing his findings. Davy did not continue the research.

Joseph Nicephore Niépce

Several years later Joseph Nicephore Niépce (Figure 15), living in the village of Saint-Loup-de-Varennes near the town Chalon-sur-Saône in France, began his own experiments using paper

sensitized with silver chloride. Some time around 1816, Niépce made printed-out negative images on paper by using a camera obscura and partially fixed them with nitric acid. Not satisfied with the process, he moved on to another light-sensitive material, asphaltum.

Niépce had been involved with etching and lithography and was looking for a means to make etched plates without having to depend on skilled handwork. It is probable that he and others would have noticed that the asphalt etching ground was harder to remove with solvents when printing plates were exposed to the sun. He coated lithographic stones and plates of copper, pewter, zinc, and glass with asphaltum dissolved in oil of lavender. When the asphalt dried, the plates were covered with an object and exposed to light. The unexposed areas were then dissolved with a solvent such as Dippel's oil, lavender oil, or turpentine while the hardened exposed areas remained intact, creating a negative image. Why Niépce did not use his asphalt images on glass as negatives to make positive prints on silver chloride paper remains a mystery to photographic historians and scholars.

Niépce eventually placed waxed engravings in contact with these sensitive plates. After the unexposed areas were removed with a solvent, the plate negative image of the engraving was visible. The plate was then etched with acid and subsequently used as a conventional etching plate for printing in a press. Niépce called these plates heliographs, from the Greek words *helios* and *graphos*, meaning "sun drawing." The process eventually became the conceptual cornerstone of the photo-engraving industry.

Of all the heliographic plates made by Niépce, the only known surviving example made in a camera has become an icon of photographic history. In 1826 Niépce prepared a heliograph with a thinner asphalt coating upon polished pewter. This plate was exposed in a camera facing out the window of his estate, known as Le Gras (Figures 15–17). The "View from the Window at Le Gras," now in the Gernsheim collection at the Harry Ransom Center in Austin, Texas, probably took two days of exposure to record the outline of the horizon and the most primitive architectural elements of several buildings outside and below the window. Niépce's image is both negative and positive depending on how it is illuminated, and it is permanent.

Louis Jacques Mandé Daguerre

It was 1826 when Louis Jacques Mandé Daguerre contacted Niépce though the firm of Vincent and Charles Chevalier (Figure 3), opticians in Paris from whom they were both purchasing lenses for their experiments. Daguerre, inventor of the popular Diorama in Paris, was also seeking a means to secure images by light in a camera. At the time of their meeting, Niépce was discouraged because of an unsuccessful trip to London where he had tried to generate interest in his heliograph process. Daguerre had nothing more to offer than some experiments with phosphorescent powder and a technique called *dessin fumee*—drawings made with smoke (Figure 18). Nevertheless, Niépce entered into partnership with Daguerre in 1829 for the purpose of working toward a common goal. It is assumed that he felt that Daguerre's energy and popular success would be of some benefit.

By the early 1830s, both Daguerre and Niépce observed that light would darken polished silver that had been previously exposed to iodine fumes. Niépce used that same technique to darken the exposed portions of heliographs made on polished silver plates. Niépce and Daguerre had also developed the physautotype, a variant of the heliograph that used rosin instead of asphalt on silver plates. The process was equally slow, but the images were superior to the heliograph, looking more like the daguerreotype that was soon to be invented. It is assumed that around this time Daguerre came upon the process that would make him famous. His experiments began by exposing silver plates fumed with iodine in the back of a camera obscura. Given sufficient exposure, a fully formed violet-colored negative image against a yellow ground was made on the plate within the camera. These images were beautiful, capable of infinite detail, but not permanent.

Daguerreotype

In 1833 Niépce died, leaving his heliograph process unpublished and his son Isadore to assume partnership with Daguerre. Two years after Niépce's death, Daguerre discovered that the

silver iodide plate required only a fraction of the exposure time and that an invisible, or latent, image that could be revealed by exposing the plate to mercury fumes. Instead of requiring an exposure of hours, the new process required only minutes, and the image could be stabilized by treating it in a bath of sodium chloride.

The resulting image, called a daguerreotype, was both positive and negative depending on the lighting and angle in which it was viewed. The image was established by a delicate, frosty white color in the highlights and black in the polished silver shadows, provided the plate was tilted toward a darkened room. By the time he demonstrated the daguerreotype process to Francois Arago, the director of the Paris Observatory, Daguerre had a completely practical photographic system that included fixing the image permanently with sodium thiosulfate, a process that was discovered by Sir John Herschel in 1819. Sodium thiosulfate was known at this time as hyposulfite of soda or as hypo. In 1839 the French government awarded Daguerre and Isidore Niépce a pension for the technology of the daguerreotype and offered the discovery to the world.

Every daguerreotype was unique. The final image was the very same plate that was in the camera during exposure. The latent image and use of silver combined with iodine (silver iodide) that were introduced by Daguerre became the basis of every major camera process of the 19th century until the introduction of gelatin bromide emulsions used in the manufacture of dry plates and developing-out papers.

Photography on Paper

William Henry Fox Talbot (Figure 13), an English scholar in the area of hieroglyphics, began his own experiments with silver chloride in 1834. Talbot, however, came to understand how the percentages of silver nitrate to sodium chloride affected sensitivity. Nevertheless, images made in the camera could take hours. Why he did not use hypo to fix his images remains a mystery since he was in communication with Herschel. Hypo was an expensive chemical, and it is possible that Talbot sought another compound for the sake of economy.

His observations, however, led him to discover a way of making the unexposed areas of his images less sensitive. Talbot treated his images in a strong solution of sodium chloride and a dilute potassium iodide or potassium bromide, which resulted in the colors brown, orange, yellow, red, green, and lilac, depending on the chemical and degree of exposure. This process did not actually remove the unexposed silver chloride, so these images were simply considered "stabilized." Provided the image was not exposed to strong light, it could be preserved for years or even used to make a positive image by contact printing in the sun on a second piece of sensitized paper.

The process for both the stabilized negative and the subsequent positive print was called photogenic drawing. Like all silver chloride papers, the exposures required for a fully formed print were minutes for a contact image of a leaf printed in the sun and up to several hours for a negative made within a camera, depending on the size of the negative. Typically the procedure of using the original negative to make a positive print often darkened the former so much that it was useless for printing a second time. By 1839 Talbot's positive photogenic drawings were colorful, soft in focus, and still relatively sensitive. Compared to the speed, permanence, and infinitesimal resolution attainable by the daguerreotype, the photogenic drawing was very primitive, very slow, and impossible to exhibit in daylight without a visible change. Sir John Herschel is said to have remarked to Arago after seeing a daguerreotype in May of 1839, "This is a miracle. Talbot's [photogenic] drawings are childish compared with these."

1839—The Race for Acknowledgment

Talbot was caught off guard when Daguerre's work was announced by Arago to the Academy of Sciences in Paris on January 7, 1839. Aware but not knowing the details of Daguerre's technique, Talbot rushed to publish his own photogenic drawing process in a report titled, "Some Account of the Art of Photogenic Drawing." The report was read to the Royal Society on January 31 and subsequently published in the English journal *The Athenaeum* on February 9. Talbot's account made a strong point of the utility of his process but contained no specific formulas or details of the actual technique of making photogenic drawings.

Daguerre and Isidore Niépce had accepted a government pension in exchange for the details of both the daguerreotype and heliograph processes. On August 19, 1839, Arago explained the daguerreotype process in detail to a joint meeting of the Academy of Science and the Academy of Fine Arts at the Palace of the Institute in Paris. A daguerreotype camera and complete set of processing equipment was manufactured by Giroux, Daguerre's brother-in-law, and offered for sale at this time. Daguerre also produced a manual, which was the first of its kind and remains one of the most comprehensive photographic treatises ever written. Within its pages are historical accounts, complete formulas, descriptions of Niépce's heliograph process with variations, and Daguerre's latent image process, and line illustrations of all the equipment needed to make a daguerreotype.

Bayard, Ponton, and Herschel

Hippolyte Bayard, an official at the Ministry of Finance in Paris, invented a direct positive process on paper in 1839. His process was based on the light bleaching of exposed silver chloride paper with a solution of potassium iodide. The prints were then permanently fixed with hypo. Bayard sought the attention of the French government to claim the invention of photography. His direct positive process was permanent but very slow and was rejected in favor of Daguerre's. In 1840 Bayard submitted his process a second time and was rejected again. In response he produced a self-portrait as a drowned man and sent it to the Academy accompanied with prose expressing his disappointment. Had this image been of a leaf or piece of lace, like so many of Talbot's photogenic drawings, Bayard and his process would probably never have been remembered with such pathos. In comparison, Bayard's direct positive self-portrait was technically superior to what Talbot was making at the same time.

In 1839 Mungo Ponton, in Scotland, observed that paper soaked in a saturated solution of potassium bichromate was sensitive to light. The delicate printed-out image was washed in water and had reasonable permanence. The process was not strong enough for a positive print and not fast enough for camera images, but Ponton's work led Talbot to discover the hardening effects of gelatin treated with chromium compounds. This characteristic of dichromated colloids became the basis of both carbon and gum printing and several photomechanical printing processes.

In the same year, Sir John Herschel made hypo-fixed silver carbonate negatives on paper. He also produced the first silver halide image on glass by precipitating silver chloride onto the surface of a plate and printing out a visible image within a camera. The process was similar and as slow as the photogenic drawing, however in this case the image was permanently fixed with hypo. When this glass negative was backed with dark cloth, it could be seen as a positive image. Herschel, who could have invented photography, seems to have been satisfied with helping others to do so. He held back on publicizing his processes as a courtesy to Talbot.

Improvements to Daguerre's and Talbot's Processes
The improved daguerreotype

Daguerre's original process of 1839 was too slow to be used comfortably for portraiture. Exposures were typically no less than 20 minutes. Because of the slow lens and optics of the time, the early daguerreotype process was limited to still-life and landscape imagery. Two improvements that were to change all this were the introduction of bromine fumes in the sensitizing step of the process and the formulation of a faster lens.

In 1840 several experimenters working independently discovered that different combinations of chlorine, bromine, and iodine fumes could be used to produce daguerreotype plates that were many times more sensitive than plates that were simply iodized. Because of these experimenters' research, daguerreotypists eventually settled on fuming their plates with iodine, then bromine, and once again with iodine. The bromine fuming procedure eventually became standard practice throughout the daguerreotype era, allowing daguerreotypists to make exposures measured in seconds.

The design of a faster lens, formulated in 1840 by Max Petzval, also allowed for shorter exposures. In combination with the more sensitive plate, this faster lens ushered in the first

practical application of the daguerreotype process for portraiture. The Petzval lens was designed specifically for portraiture and became the basis for all portrait and projection lenses for the next 70 years. By the early 1840s, commercial daguerreotype portraits were being made in studios under a skylight (Figure 22).

Another important improvement in 1840 was gold toning, introduced by Hippolyte Fizeau. A solution of *sel d'or*, made by adding gold chloride to hypo, was applied to the fixed plate. The process became known as gilding. Gilding extended the range of tones and made the fragile image highlight less susceptible to abrasion.

The calotype

Talbot's photogenic drawing process, as introduced, was also impractical for portraiture even when improved lenses became available. In 1841, however, Talbot changed his formula to use silver iodide, which was more sensitive than silver chloride. It was the very same silver halide as used by Daguerre, though applied to paper. The iodized paper was sensitized with a solution of silver nitrate, acetic acid, and a small amount of gallic acid.

This new paper was exposed damp and required only a fraction of the time needed to print a visible image with the photogenic drawing process. It bore either a feeble or no visible image when removed from the camera. The latent image was developed to its final form in a solution of gallic acid and then stabilized in potassium bromide or permanently fixed in sodium thiosulfate. The new process was called the calotype, from the Greek *kalos*, meaning "beautiful." Despite the use of silver iodide, the calotype process usually required at least a minute of exposure in full sunlight using a portrait lens.

Calotype negatives could be retouched with graphite or inks to prevent transmission of light or could be made translucent locally with wax or oil. Talbot made positive prints from these as he did with photogenic drawings, by printing them in the sun onto plain silver chloride paper. Even after Talbot adopted the use of hypo for fixing his negatives, he occasionally stabilized these prints in salt or iodide solutions, presumably because he preferred the final image colors. Eventually Talbot and other calotypists chose to permanently fix their positive images in hypo, resulting in an image of colors ranging from deep orange to cool brown. These were called salt (or salted) paper prints (Figures 28 and 29). Another improvement was made by not adding the gallic acid in the sensitizing step of the process.

Those wishing to use the patented calotype process were required to pay Talbot for the privilege. This license was expensive, and the commercial potential of the calotype process was not particularly attractive to the average working person. The calotype seemed to appeal to the educated upper classes that had an appreciation for the arts, scientific curiosity, and plenty of leisure time. Variants of preparing calotype paper began to emerge as more people used the process. An early improvement to the process omitted the gallic acid in the sensitizer, allowing the paper to be used hours after preparation without browning spontaneously.

In 1844 Talbot published the first installment of a book titled *Pencil of Nature*, which was illustrated with salt prints from calotype negatives. The publication was sold by subscription, and subsequent issues were sent to the subscriber as they were produced. Because of technical difficulties, *Part II* was not sent until seven months after the first. *Part VI* was not available until 1846. The venture was not successful, but it offered a vision of what might be possible in the future. If there was ever a commercial use for the calotype, it was to be for the illustration of written material and particularly for documentation of architecture. Although not technically conducive to portraiture, particularly in a studio, the calotype process was used on occasion for this purpose.

The most ambitious and celebrated uses of the calotype process for portraits were made by the team of David Octavius Hill and Robert Adamson (Figure 27) as reference images for a painting that Hill was planning of the General Assembly of the Free Church of Scotland. The portraits for this project give a fair idea of the quantity of light required for an exposure. In many examples the subjects face sunlight as if it were a strong wind. Hill and Adamson produced several bodies of work from 1843 to 1847, including genre portraits and architectural views. Their work stands alone as the most comprehensive use of calotypy for portraiture.

Although the calotype process was licensed by Talbot to Frederick and William Langenheim of Philadelphia, the calotype would never become popular in the United States. Shortly after the process was perfected by the Langenheims, the daguerreotype was well established and not to be toppled until the invention of collodion photography in 1851.

Calotypes were made by a small number of photographers in the 1840s and early 1850s (Figures 35 and 37), the most famous examples being documentary images of architecture by French and English photographers. In 1851 Maxime du Camp produced major albums of views from Egypt, Palestine, and Syria, which were documented by the calotype process in 1849 (Figure 39). Documentary work by Edouard Baldus and Henri le Secq (Figure 36) were also made with an improved variant of the calotype called the waxed-paper process, introduced by Gustave Le Gray in 1851.

The waxed-paper process evolved because French papers were not ideally suited for calotype as they were sized with starch rather than gelatin. Le Gray saturated the paper with hot beeswax prior to treating with iodine and sensitizing with silver. The development was identical to the calotype. Waxing the paper prior to iodizing resulted in better resolution, and the process could be done with the paper completely dry, making it perfect for the traveler.

The Business of Photography

By the late 1840s, the daguerreotype process was being used commercially in every industrialized nation of the world. Although the total number of calotypes made in the 19th century might be counted in the thousands, this was still less than the yearly production of daguerreotypes in most major cities in the United States in the 1850s. The business of the daguerreotype was profitable for many daguerreotypists, the plate manufacturers, and the frame and case makers.

The American daguerreotypists in particular produced superior portraits (Figure 46). A technique perfected in America called galvanizing involved giving the silver plate an additional coating of electroplated silver. Galvanizing contributed to greater sensitivity, which was important for portraits, and it provided a better polish, resulting in a wider range of tonality. The works of Thomas Easterly and of the celebrated team of Albert Southworth and Josiah Hawes (Figure 33) remain as both technical and artistic masterworks. The daguerreotype was well established in the early 1850s as a commercial and artistic success, though it also had drawbacks. The images were generally small, laterally reversed direct positives that required copying or a second sitting if an additional image was desired.

Although not impossible, landscape work was a technical commitment and not commercially profitable considering the effort required to make a single plate. When properly illuminated, daguerreotypes were (and still are) awe inspiring; however, they were seldom viewed at the best advantage. This failure resulted in a confusion of negative and positive images juxtaposed with the reflection of the viewer.

Negatives on Glass

In 1847 a new negative process, producing the niépceotype, was published in France by Abel Niépce de Saint Victor (Figure 10). After initial experiments with starch, Niépce de Saint Victor came upon the use of egg albumen as a binder for silver iodide on glass plates. Variants of the same albumen process were simultaneously invented by John Whipple, in Boston, and the Langenheim brothers, in Philadelphia. Development of these dry plates was identical to the calotype, but they required much more time. Exposures too were much longer than those required for the calotype, but the results were worth the effort. Even by today's standards, the resolution of these plates was nearly grainless. The Langenheims took advantage of this characteristic and in 1848 invented the hyalotype (Figures 30 and 31). This was a positive transparency on glass that was contact-printed from albumen negatives.

The Niépceotype process was never to be used for studio portraiture, but for landscape and architectural subjects it was technically without equal even after the collodion process was invented. It was, however, still a tedious process, and after 1851 the only reasonable applications of the albumen process were for when a dry process was advantageous or for the production of lantern slides and stereo transparencies where resolution was important.

A major essay made during the latter part of the Crimean War in the mid-1850s was documented with large albumen plates by James Robertson (Figure 48), and Felice Beato. After the war Robertson and Beato made images in the Middle East, continuing a series started before the war, and in war-torn India. The pictures of the Siege of Lucknow and the Kashmir Gate at Delhi feature the first true glimpses of the horrors of war.

The Wet Plate Process

In 1848 Frederick Scott Archer (Figures 2 and 34), an English sculptor and amateur calotypist, experimented with collodion as a binder for silver halides as a means to improve the calotype. The term *collodion,* from the Greek word meaning "to stick," was used to describe a colorless fluid made by dissolving nitrated cotton in ether and alcohol. When poured onto glass, collodion dried to a thin, clear plastic film. In their calotype manuals of 1850, both Robert Bingham, in England, and Gustave Le Gray (Figure 44), in France, published the possible benefits of using collodion, but the first complete working formula of the wet collodion process was published by Archer in 1851 in *The Chemist.*

Archer's formula began with coating a glass plate with iodized collodion. The collodion film was then sensitized, while still wet, by placing the plate in a solution of silver nitrate. After exposure in a camera, the latent image was developed with either gallic or pyrogallic acid. The image was then fixed with hypo and washed. The fragile collodion film retained the alcohol and ether solvents throughout sensitizing, exposure, and processing, which is why it was known as the wet plate process.

Contested unsuccessfully by Talbot as an infringement on his calotype process, Archer's wet plate technique came at a time when the calotype, the waxed-paper, the daguerreotype, and the albumen processes were all being used. Originally the process was conceived by Archer to include coating the fixed image with a rubber solution and stripping the film from the glass plate. The thin rubber-coated collodion film was then to be transferred onto a secondary paper support for printing. The stripping and transfer method was quickly abandoned as unnecessary, though it eventually became an important technique used in the graphic arts industry until the 1960s.

Exposure times were reduced by half with the wet plate technique, making portraiture in the studio possible when ferrous sulfate was used for development. Although more sensitive than the calotype, the wet collodion negative process as generally practiced in the studio was not faster than the daguerreotype of the 1850s.

Collodion negatives were used to make salted paper prints, originally called crystalotypes by Whipple (Figure 40), but were perfectly matched to the albumen printing process introduced by Louis Deserie Blanquart-Evrard in 1850. The synergy of the collodion negative (Figure 68) and albumen print was to become the basis of the most commercially successful and universally practiced photographic process in the 19th century until it was eventually replaced by the gelatin emulsion plate in the 1880s.

By 1855 the collodion process had eclipsed the daguerreotype for commercial portraiture and was quickly being adopted by the amateur as well. The great photographic journals such as the *Photographic News, The British Journal of Photography, La Lumiere, Humphrey's Journal,* and the *Photographic and Fine Art Journal* were all introduced in the early 1850s. Such publications fueled the steady advancement of photography and were the "chat rooms" of the era, featuring well-documented research by chemists, empirical discoveries by the working class, and petty arguments between strong personalities.

The Art of Photography

From the 1860s onward, the photographic journals occasionally touched on the subject of art and photography, though like many art forms, there was little consensus. Photographic societies and photo-exchange clubs were formed in many cities, and exhibitions based on the salon style were held and judged. It is customary to mention in histories of photography the celebrated artists of the wet plate process such as Julia Margaret Cameron (Figures 7 and 61), Oscar Gustave Rejlander (Figure 57), and Gaspar Felix Tournachon, also known as Nadar.

At the time, however, much of their work was not generally recognized by the public or the greater photographic community. Critics also failed to take photography seriously as an art form, an attitude that continued for many years to come.

Cameron's genius was not recognized until late in the century when the pictorialists were deconstructing the convention of photography. Nadar on the other hand came to own a very successful Parisian Photo Gallery. His operators posed the subjects, processed the plates, and delivered the prints, producing commercial portraiture that was technically enviable though generally without the soul of his own early work.

The great landscapes documented with collodion such as those of Gustave Le Gray (Figure 44), Francis Frith (Figure 52), Leopoldo and Giuseppe Alinari, and John Thomson (Figure 67) were pictorial achievements by any standards and were made under very difficult conditions. The wet plate process was challenging enough in a studio, but to pour plates within a portable darkroom was an enormous task made more taxing when the plates were large. In Western America, Carleton Watkins, Eadweard Muybridge, William Henry Jackson (Figure 71), and Timothy O'Sullivan (Figure 65) also produced work under equally difficult conditions. In most cases the works of these landscape photographers were the first recorded images of a region. The final product, however, was most often seen by the general public not as an albumen print but as a wood engraving from the print.

Heavily retouched solar enlargements printed on salted and albumen paper were offered by progressive photographers in larger towns and cities throughout the 1860s and 1870s, but at great expense. The process of enlarging did not become commonplace until the acceptance of silver bromide developing papers, beginning in the late 1880s.

The most common connection of the public with photography in the 1860s was the commercial albumen print in the form of the small *carte de visite* (Figure 55) (calling card) portrait or a stereograph — two albumen prints on a card designed to be seen in three dimensions with a special viewer. By the late 1860s, the larger cabinet card photograph was also introduced. Cabinet cards (Figure 73) and *cartes de visite* ushered in an industry of mounts and album manufacturing. Larger framed prints were available at the portrait studios, but the two smaller portrait formats were the bread and butter of the working photographer until the end of the century. Stereographs remained popular until after the turn of the century and were usually a specialty item made by landscape photographers and sold by subscription or in stores.

Collodion Variants and the Positive Processes

The mid-1850s proved to be a fertile era for both new processes and variants of the collodion process. Soon after its introduction, collodion was used for stereo transparencies, microphotographic transparencies, and lantern slides. Direct collodion positives, called alabasterines by Archer, were originally made by bleaching an underexposed plate with bichloride of mercury. When ferrous sulfate was adopted as the developer and cyanide as the fixer for collodion positives, the plates were more sensitive and the positive images did not require bleaching. Exposures of these plates in the studio were faster than exposures for the daguerreotype. The plates were also a cheaper and easier-to-view alternative. These plates were generally known as collodion positives, verreotypes, daguerreotypes without reflection, or daguerreotypes on glass. Though the actual image-making technique was usually the same, there were many variants, and those who introduced them were quick to apply a new name to each type.

A patent was awarded to James Anson Cutting in 1854 for a method of sealing these positive images on glass with balsam, using the same technique as that used for covering a microscope slide. Cutting called his variant of the collodion positive process *ambrotype*, from the Greek word meaning "imperishable." Cutting eventually changed his middle name to Ambrose to commemorate the process. Though the name *ambrotype* was specific to Cutting's patented sealing technique, the word quickly evolved to be the generic term for all such images (Figure 47).

Direct positive collodion images on japanned iron plates were invented simultaneously by photographers working in England, France, and the United States. In 1853 Adolphe Alexandre Martin first published the process in France. Hamilton Smith, in the United States, and William Kloen, in England, both patented the process in 1856. Smith, who called his plates melainotypes,

sold the rights to Peter Neff, who manufactured them. Victor Griswold, a competitor, also manufactured japanned plates, calling them ferrotypes, a name that would eventually be adopted by the general public along with the less-formal "tintype" (Figures 76 and 80).

It is important to understand that those who made commercial ambrotype or ferrotype images were not considered photographers. Although the term *photography* is often applied indiscriminately to any photosensitive process used in the mid-19th century, it is technically specific to the making of negatives used to produce prints. Those whose work cannot be strictly classified as photography were known as daguerreotypists, ambrotypists, and ferrotypists or tintypists.

Positive collodion transfers onto patent leather (Figure 45), oilcloth, and painted paper were called pannotypes and were also born in this era, along with the milk-glass positive (Figure 63), printed from a negative onto a sheet of white glass. But neither of these would approach the popularity of the tintype, which eventually replaced the ambrotype in the 1860s and continued to be made in various sizes throughout the 19th century.

Collodion Variants and the Negative Processes

In an attempt to make the collodion process possible without erecting a darkroom on location, some amateurs began experimenting with making preserved or dry collodion plates in the 1850s. Humectant-based processes relying on oxymel, a medical compound of honey and acetic acid, and various syrups to keep the sensitive plate damp were very successful. These plates, however, were up to five times slower than the conventional wet plate. The dry tannin and Taupenot plates were also very slow. These techniques, although an interesting footnote in the evolution of the collodion process, were never sensitive enough to be useful for anything but landscape work and were seldom used. Most landscape photographers preferred to see the plate develop on site should they need to make a second exposure.

In the late 1870s, collodion emulsions were being used by curious amateurs. Based on the technique that used initial silver chloride emulsions for collodion printing-out papers, collodion emulsions were made by mixing halide and silver together in the collodion rather than sensitizing an iodized plate in a separate silver bath. Although the collodion emulsion process for negatives did not come into general use, it was the basis for the gelatin emulsion process and the production of collodion chloride printing-out papers used well into the next century.

Concerns of Permanency

The correct processing of paper prints from collodion negatives was not fully understood during the 1840s and early 1850s, and the consequence of fading prompted committees in both England and France to investigate the problem and search for alternatives. Despite the gold-toning procedure applied to all albumen prints, most of these prints were prone to fading. This was usually caused by incomplete fixing or washing.

From this climate of questioning came the carbon printing process introduced by Alphonse Louis Poitevin and the developed-out salt printing processes of Thomas Sutton and Louis Deserie Blanquart-Evrard. The cool tones of developed-out salt prints were not embraced by photographers or the public, though the process was much more stable than any other printed-out technique. The process eventually found its niche with the technique of solar enlarging, which was introduced in the late 1850s. The typical printed-out solar enlargement from a collodion negative required more than an hour of exposure. Exposures on developed-out salted papers were counted in minutes.

The carbon process, based on the light sensitivity of pigmented gelatin treated with potassium bichromate, did not achieve its technical potential until the single-transfer variant patented by Sir Joseph Wilson Swan was universally adopted in 1864. Despite the superiority of the carbon process to albumen prints in both tonality and permanence, they were tedious to make, particularly for a single print. Carbon prints were better suited to making large runs of a single image but not for the typical studio portrait (Figure 66). Photographers preferred to make albumen prints over carbon prints until albumen printing was replaced with the collodio-chloride

and gelatin-chloride aristotype printing-out papers late in the century. Carbon and gum prints based on the same principle continued to be available but in very limited numbers.

In 1873 one of the most beautiful printing processes of the 19th century was patented by William Willis (Figure 74), of London. Although platinum had been used on occasion for toning prints, Willis's process, perfected by 1879, was based on a faint image, formed with iron compounds, that was developed to completion into a pure platinum deposit. The Platinotype Company, established in 1879, produced sensitized platinum papers that were favored by a growing movement of artists using photography. The matte finish and neutral tones of the platinum print were ideally suited to the soft masses of tonality favored by the pictorialist and fashionable portrait galleries late in the century.

The cyanotype, a process invented by Herschel in 1841, was reasonably permanent, but the image was blue and not particularly suited to most imagery. With the exception of documenting botanical samples by contact and occasional printing from calotype or collodion negatives, the cyanotype process was not popular until the end of the century (Figure 83), when amateurs used it as an easy and economical way to proof their gelatin negatives.

Gelatin Emulsions and the Modern Era

It may seem out of place to call the last quarter of the 19th century the modern era of photography. However, the introduction and eventual acceptance of gelatin emulsion plates, papers, and flexible films in this period became a technology that was not challenged until digital imaging appeared at the end of the 20th century. Looking back from a 21st-century perspective, we might more appropriately call the late 1900s the last era of photography.

The complicated evolution of research, development, and manufacturing of silver gelatin photographic materials in the latter quarter of the 19th century is filled with simultaneous invention, lawsuits, and countersuits. Chronicling the history is beyond the scope of this essay, but what follows presents the essential progression.

The invention of emulsion plates was primarily English and began with collodion emulsions of the 1850s. In 1865 G. Wharton Simpson made printed images on paper coated with a collodion chloride emulsion. Soon after this, leptographic paper coated with a collodion chloride emulsion was manufactured by Laurent and Jose Martinez-Sanchez in Madrid. An innovation introduced specifically for collodion emulsions was the use of a baryta coating applied to the paper support as a smooth, white barrier layer. Leptographic paper was made until 1870 with limited success, but baryta papers reappeared several years later and were eventually used throughout the 20th century for all photographic papers.

In England W. B. Bolton and B. J. Sayce introduced a collodion emulsion for negative plates in 1864 that was based on bromides rather than iodides. These were nearly as sensitive as wet collodion plates and were processed with an alkaline developer. The use of bromides and of alkaline development was to become the key to making fast plates with gelatin emulsions. Collodion emulsion plates remained the territory of advanced amateurs for the next 20 years.

Based on the earlier experimental work of W. H. Harrison, Dr. Richard Leach Maddox added silver nitrate to a warm gelatin solution bearing some cadmium bromide and then coated some glass plates with the emulsion. After exposing the plates in the camera, Maddox developed them with pyrogallic acid and some silver. The process used with these plates was slower than the wet collodion process but was the first serious attempt at making a gelatin emulsion. Maddox's silver bromide gelatin emulsion process was published in the *British Journal of Photography* in 1871.

Additional experiments in the early 1870s were continued by John Burgess, who used pyro developer in an alkaline state. The problem with the Burgess emulsion was that although it contained the necessary silver bromide, it was also affected adversely with potassium nitrate, a by-product of the technique. Removing the unwanted compound was first accomplished by J. Johnson, who allowed his gelatin emulsion to dry into thin sheets called pellicles. He then cut them into small pieces and washed them in cool water. After washing, the sensitive gelatin was dried in darkness and packaged. These pellicles could be stored and rehydrated for coating at a later time. Richard Kennett patented a similar product of washed sensitive pellicles in 1873 and was selling both the pellicle and the precoated gelatin plates by 1876. The English market

for gelatin plates was growing steadily but did not fully topple collodion technology until the mid-1880s.

Gelatin emulsion plates were a hard sell to professional photographers who were used to getting excellent results with the wet collodion process. The early gelatin plates were met with limited interest and limited commercial success. The discovery that changed everything was observed when the gelatin pellicle was rehydrated and the emulsion was melted. The longer the emulsion was heated, the more sensitive it became. The cause, called ripening, was first identified by Sir Joseph Wilson Swan in 1877 and was a trade secret until revealed in 1878 by Charles Bennett, who also observed the phenomenon. Bennett continued his experiments by keeping the emulsion hot for days.

A year later George Mansfield suggested ripening the emulsion at a higher temperature over a period of minutes, a method generally adopted by all those who continued research in this area. By 1879 gelatin emulsions were ripened by heat and then allowed to set to a firm jelly. The emulsion was squeezed through a mesh to produce noodles that were washed in cool water to remove the unwanted nitrate. The washed noodles were then drained and remelted with some additional gelatin and applied, while hot, onto glass plates by hand under dim, red light. Coated plates were then placed on marble leveling tables until the gelatin set to a stiff jelly, at which point they were taken to a dark drying room and packed in boxes. This was the way all commercial plates were made until the development of automated equipment in the mid-1880s.

Gelatin plates, also called dry plates, were being manufactured by hand on a much larger scale by 1880. Interest and acceptance by both amateur and professional was much slower in the United States than in England and the rest of Europe. The English photographic journals at this time were beginning to include more articles on the gelatin process than collodion, and these, in turn, were being reprinted in the American journals. Some American professionals began using the new plates with mixed results, and they published their findings.

In 1880 the Photographers Association of America appointed a committee to investigate the new technology of gelatin plates. The quality of commercial plates varied considerably, but the plates had great potential in skilled hands. Many of the problems photographers had with these plates were due to increased sensitivity. Fogging, more often than not, was caused by overexposure in the camera or poor darkroom conditions that had little effect on the slower collodion plates.

As interest grew, more plate manufacturers appeared on the American horizon, and more professionals began taking the risk of changing their systems from wet to dry. The prices of plates were decreasing, and interest was growing. At the same time, all of the manufacturers of cameras and associated equipment were targeting a new generation of amateurs who could make images at any time without the skills that were previously necessary.

Gelatin plates could be relied upon at any time and developed later at a more convenient location. When plate-coating machines became a reality, the price of plates was reduced enough for the commercial photographer to adopt plates for their work as well. It can be assumed that most commercial photographers in America were using gelatin plates for both exterior and studio portraiture by 1885.

The popular developers for these early plates were alkaline solutions of pyrogallic acid or ferrous oxalate. Within a few years, hydroquinone was also used, followed by metol and a combination of the two chemicals, commonly called MQ developer. Developing powders were available in boxes of premeasured glass tubes.

Flexible Films

The concept of flexible film dates back to the calotype and Archer's initial idea of stripping collodion film from glass plates. Attempts to market paper roll film and sheets of celluloid-based film on a large scale did not succeed until the products were introduced by the Eastman Dry Plate Company in the mid-1880s. This stripping film was made by applying a standard silver bromide gelatin emulsion on a paper support previously coated with a thin layer of soluble gelatin. The machine that produced stripping film was also used to manufacture silver bromide developing-out paper for printing. Marketed as American Film, rolls of paper-support

stripping film were designed to be used in a special holder that could be fitted to the back of any size of camera. The film, the machine that was used to coat the paper, and the system to transport the film in the camera were all patented at the same time.

The exposed film was cut into separate sheets in the darkroom with the aid of indexing notches and was processed as usual. The washed film was then squeegeed onto a sheet of glass coated with a wet collodion film and was allowed to set for about 15 minutes. The plate was then placed in hot water that softened the soluble layer of gelatin, which allowed the paper support to be removed. The plate could then be dried and used like any other gelatin glass negative, or the film could be stripped from the glass by applying a second layer of clear gelatin, followed by a second layer of collodion, and then cut from the plate with a sharp knife.

American Film was supplied in the first Kodak introduced in 1888. The Kodak was a small detective camera that spawned several generations of hand-held box cameras used by millions of amateur photographers. While not a commercial success, American Film bought enough time for the Eastman Dry Plate and Film Company to introduce Eastman Transparent Film in rolls and sheets of clear, flexible nitrocellulose in 1889.

Sensitometry

The concept of measuring the actinic effect of light or the sensitivity of photosensitive materials dates to the earliest days of photography, but the first reliable sensitometer was invented by Russian-born Leon Warnerke in 1880. With this tool a reliable rating number could be applied to an emulsion calculated against the average sensitivity of a collodion plate. Some companies in the 1880s used the Warnerke rating system while others simply addressed the matter by stating that a specific plate was fast, slow, or extra quick.

A unified standard for emulsion speeds did not come until much later, and even then there were different scales requiring conversion tables. Two major innovations that came from sensitometry were the evolution of the instantaneous lens shutter and an attempt to set a numerical standard to the apertures placed in lenses. Two systems of aperture standards evolved during the dry plate period: the f-numbering system and the US (Uniform System) introduced by the Royal Photographic Society. The US featured the numbers 1, 2, 4, 8, 16, 32, 64, and 128. The f-system as introduced used 4, 5.6, 8, 11.3, 16, 22.6, 32, and 45.2. The only rating that was common to both systems was 16.

Glimpses of Color

Throughout the 1880s gelatin-emulsion makers were engaged with increasing the sensitivity of their product. Though the speed of gelatin emulsions was gradually increased, the emulsions were still mostly sensitive only to the ultraviolet, violet, and blue wavelengths, a defect they shared with all of the previous photographic processes of the 19th century.

Increasing the spectral sensitivity of photographic materials was important for many reasons but essential to the evolution of color photography. Color daguerreotypes — invented by Levi Hill in the 1850s — and a similar product, the heliochrome, first exhibited in 1877 by Niépce de St. Victor, stood alone and were not influential in the evolution of modern color photography. However, in 1861 James Clerk-Maxwell made a celebrated demonstration of additive color synthesis, generating interest in finding a way to extend sensitivity of collodion plates for full-color photography. Thomas Sutton made three negatives of a colorful ribbon through red, blue, and green filters for Maxwell's demonstration. These separation negatives were used to make lantern slides that were projected from three magic lanterns through the same filters. The virtual image on the screen was convincing enough for the era.

In 1869 Ducos Du Hauron patented a procedure in France that relied on red, blue, and green additive dots applied to a sensitized plate. However, this type of additive screen process was not a reality until John Joly introduced the first commercially successful additive ruled plates in the mid-1890s. Du Hauron did, however, suggest the subtractive-color process with which he made assembly prints from yellow, cyan, and magenta carbon tissues exposed from additive color-separation negatives as early as 1877 (Figure 70). The subtractive-assembly concept evolved to be the basis for how all color photographs are made.

Adolph Braun, Hermann Wilhelm Vogel, and Frederic Ives (Figure 81) conducted promising experiments in the 1870s using dye-sensitizing emulsions with eosin and chlorophyll. Braun, Vogel, and Ives were sensitizing collodion bromide emulsions at the time. These so-called orthochromatic emulsions were still highly sensitive to the blue areas of the spectrum but also to green and some yellow.

By the 1890s other dye sensitizers helped to extend the range of gelatin emulsions to deep orange. Such plates were known as isochromatic. True panchromatic plates that were sensitive to the entire visible spectrum were not available until 1906, and even after they became available, few photographers embraced the technology. The fact was that panchromatic plates were seen as a disadvantage by photographers accustomed to developing negatives by inspection under safe light. The important experiments with isochromatic emulsions, however, were a great help to those in the printing industry and individuals interested in making color-assembly prints from separation negatives or experimental additive color plates.

Floodgate to the 20th Century

By the end of the century, more individuals, both amateur and professional, owned cameras than in the daguerreotype and wet plate eras combined. There was no need to go to a professional studio photographer anymore, even though studios could generally achieve better results. The photofinishing business was evolving to accommodate the amateur market, and manufacturers were introducing photographic equipment and materials at a dizzying rate. Enlargements on silver-bromide paper were being made by projection, using gas or electrically illuminated magic lanterns.

The photographic image, itself a copy of nature, was being reproduced in magazines and books by several different ink processes, making anything that was originally the product of a camera known as "a picture." In the 1890s photographs were common and available in a wide range of sizes on a variety of photographic papers, including platinum-toned collodio-chloride and gelatin-chloride printing-out papers, developed-out silver-bromide paper, silver chloride gaslight papers, cyanotypes, carbon and gum prints, and, if money was no object, pure platinum prints.

The influence of the impressionists, members of an artistic movement who rethought the role of painting in a world of photography, in turn released a 50-year grip on photographic convention. This allowed the pictorialist movement to redefine what a photograph needed to be. Photography, long appreciated for how it could copy nature in infinite resolution, was being used in a way that was, in a word, antiphotographic. The romantic photographic departures of P. H. Emerson in the 1880s had paved the way for the likes of Clarence White, Gertrude Kasebier, and F. Holland Day in the next decade. As a result, the pictorialists' soft imagery and romantic approach to photography influenced a new direction in commercial portraiture that remained popular for 30 years after the turn of the century. ◎

Introduction to the Biographies of Selected Innovators of Photographic Technology

GRANT B. ROMER
George Eastman House International Museum of Photography and Film

The marvelous nature of the tools, technology, and imagery of photography drives us to wonder after the individuals responsible for their creation. Something in photography appeals to the individualist. Every photographer is, in a way, a pioneer. Whatever initial instruction they receive, some aspects of photography can only be learned through highly personal and private experimentation. All photographers have certain primal experiences of discovery that provoke a sense of real contact with the pioneers of photography and give an understanding of the impetus for invention and innovation in photography.

The photographic technology of our day is the composite achievement of thousands of individuals working in many different disciplines over centuries. However, single individuals made contributions that had profound impact upon all of photography. It is easiest to discern such "heroes" of photography in its earlier history. Many historians have attempted to select the most important names from the host of amateurs and professionals who contributed significantly to photography in its first hundred years. All attempts have failed to be fair to every interest.

An interesting exercise for anyone deeply involved in photography would be to arbitrarily fix a number, say fifty, and make a list of the important contributors to photography. By what criteria can a balanced selection be made from the host of scientists, inventors, designers, mechanics, manufacturers, industrialists, photographers, historians, curators, collectors, critics, and publishers who have shaped photography? Within each category, fifty names could be listed without exhausting the possibilities for inclusion.

A perusal and comparison of the index of any history of photography will reveal the common occurrence of the names of Niépce, Daguerre, and Talbot. Much energy has been misdirected in the past to establishing which individual was the inventor of photography. There can be no common agreement on that issue. But everyone agrees that knowing the lives and works of these three pioneers is an indispensable part of understanding the history of photography. Beyond these three, however, much less agreement can be found. The selection that has been made for this edition is based upon what agreement is found in the most influential histories of photography in English. It excludes photographers who made purely pictorial achievements in favor of individuals that made important technical contributions that influenced the progress of photography in its formative era, since this publication primarily serves technical inquiry.

Josef Maria Eder's *History of Photography* is the best source to consult for basic biographical information on photography's great innovators. Eder's history, first published in English in 1945 and, regrettably, now out of print, is unparalleled in scope and scholarship. Those more concerned with aesthetics and socio-cultural contributions will find in the classic histories of photography by Taft, Gernsheim, and Newhall, the biographies of the great "masters" of the art. Monographs for each of these individuals abound. Any number of valid histories could be written using an entirely different set of names than is found in all of the above works; so rich is the story and population of photography. The biographies included in this publication can only represent how individual achievements have contributed to the great technology that truly changed the culture of the world.

Biographies of Selected Innovators of Photographic Technology from the 19th Century

Editor's Note: The following entries were originally published in the *Focal Encyclopedia of Photography*, Revised Desk Edition, 1969 or the 3rd Edition, 1993. The biographies were written by: Mary Street Alinder; Arthur Chevalier; R. Colson; H. Harting; J. C. Gregory; C. H. Oakden; M. von Rohr; and M. E. and K. R. Swan.

Abney, Sir William (1843–1920)

Sir William Abney was an English chemist, writer, and educator. He discovered hydroquinone as a developing agent (1880). Invented gelatin chloride printing-out paper (POP) in 1882. Developed infrared-sensitive emulsion to help chart the solar spectrum. Served as president of the Royal Photographic Society of Great Britain for five years, the first photographic authority to assume that position.

Archer, Frederick Scott (1813–1857)

Frederick Scott Archer was an English inventor and sculptor. Archer published the first working formula of the wet collodion process. He presented his discovery as a free gift to the world (March 1851). Archer's collodion wet plate process superseded both the daguerreotype and calotype and was the primary process used by photographers for 30 years. He authored the *Manual of the Collodion Photographic Process* (1852), and invented the collodion positive on glass, and also introduced the stripping of collodion films, later used in much photomechanical

work. However, since Archer had not patented the collodion process, he died unheralded and impoverished.

Bayard, Hippolyte (1801–1887)

Hippolyte Bayard was a French photographer and inventor. In early 1839, spurred on by reports of Daguerre's achievement of positive images, but with little additional information, Bayard produced the first positive images directly in the camera. His independent discovery, almost simultaneous to the very dissimilar processes of Daguerre and Talbot, yielded unique paper photographs. Bayard intentionally created his photographs as art, often expressive in content. Thirty of his prints were the first publicly exhibited photographs on June 24, 1839, in Paris, hung amid work by Rembrandt and Canaletto. Bayard did not reveal the directions for his process until 1840 only to find a public already infatuated with the daguerreotype which was made public in August 1839. Bayard's discovery was ignored. He was a founding member of the Société Héliographique (1851), and from 1866 to 1881 was the Honorary Secretary of the Société Franç Laise de Photographie.

FIG. 2 Frederick Scott Archer, ca. 1849, albumen print from original negative printed later. (Courtesy of the George Eastman House Collection, Rochester, New York.)

FURTHER READING

Jammes, A. and Janis, E. P. (1983). *The Art of the French Calotype.* Princeton: Princeton University Press.

Becquerel, Alexandre-Edmond (1820–1891)

Alexandre-Edmond Becquerel was a French physicist who discovered in 1839 the photogalvanic effect, upon which a century later the first photoelectric light meters were based. He demonstrated in 1840 that an underexposed daguerreotype plate could be intensified by diffused supplementary exposure under red glass (the Becquerel effect). Becquerel was acknowledged as a founding father of color photography. He achieved natural color images on daguerreotype plates in 1848, although after years of experimentation he was never able to make them permanent.

Bennett, Charles Harper (1840–1927)

Charles Bennett was an English amateur photographer. In 1878 he published his method for increasing the photographic sensitivity of gelatin emulsions by prolonged heating at a temperature of 90°F.

Bertsch, Adolph (Dates Unknown)

Adolph Bertsch was a French microscopist and photograher. He introduced in 1860, the chamber noire automatique, a 4-inch-square metal box with frame viewfinder, spirit level, and fixed focus (automatic) lens of 3-inch focal length. The 2-1/4 inch square negative could be enlarged 10× in diameter with Bertsch's megascope or solar enlarger. This was the forerunner of the modern system of a small camera producing negatives for enlargement at a period when enlarging was seldom practiced.

Dancer, John Benjamin (1812–1887)

John Benjamin Dancer was an English optician and microscopist in Liverpool and later in Manchester. He made the first photomicrograph in England by the daguerreotype process in 1840 and was the first to make micrographs (by the collodion process) on microscopic slides. Dancer made the prototype of the binocular camera proposed by Sir David Brewster, which did not go into production until 1856.

Davy, Sir Humphry (1778–1829)

Sir Humphry Davy was an English chemist. Around 1802 his experimentations with Thomas Wedgewood led to the production of silhouettes and contact copies of leaves, etc., on white paper or leather moistened with silver nitrate and chloride solution, and under the microscope, but could not fix them. He discovered the electric arc light in 1813.

Draper, John William (1811–1882)

John William Draper was an American professor of chemistry and a great investigator in the field of scientific photography. He was a pioneer daguerreotypist associated with Samuel F. B. Morse. Draper discovered of the law of photochemical absorption, since known as the Draper-Grotthuss Law. He was probably also the first observer of the retrogression of the latent image in daguerreotypes. In 1840, he published the first paper on portrait photography and probably took the first successful ones. He produced the first daguerreotype photographs of the moon and of the spectrum (1840).

FURTHER READING

Scientific Memoirs (1878).

Driffield, Vero Charles (1847–1915)

Vero Charles Driffield was an English chemist who, with Ferdinand Hurter, originated the study of sensitometry. In 1890 they charted the H&D curve that traces the relationship between exposure and photographic density, determining the speed, or sensitivity, of the emulsion and enabling the computation of correct exposure times.

Ducos Du Hauron, Louis (1837–1920)

Louis Ducos Du Hauron was a French scientist and pioneer of color photography. In *Les Couleurs en Photographie* (1869) he described a three-color photographic process and formulated the principles of the additive and most of the subtractive methods of color reproduction. His research provided much of the foundation of color theory.

FIG. 5 Self-Portrait deformation, ca. 1888. Photography by Louis Ducos Du Hauron albumen print. (Courtesy of the George Eastman House Collection, Rochester, New York.)

Eastman, George (1854–1932)

George Eastman was an American photographic inventor and manufacturer. His first products were gelatin dry plates for which he introduced machine coating in 1879. He invented the first roll film in 1884 using paper negatives and, in 1888, roll film on a transparent base, which is still the universal standard until the end of the 20th century. Eastman introduced the "Kodak" in 1888 along with the first roll-film camera. The incredibly popular Kodak box camera encouraged millions of hobbyists worldwide to become photographers. The camera's advertising slogan, "You press the button, we do the rest," proved true to great success. As a direct consequence, the Eastman Kodak Company in Rochester, New York, provided a dramatic, almost fantastic example of growth and development in industry, and it has founded and supported a unique chain of

research laboratories. Eastman's commercial manufacture of roll film provided the basic material for cinematography. Eastman introduced 16mm reversal film for amateur filmmaking (and the necessary camera and projector) in 1923 and developed various color photography processes to commercial application. Eastman died by his own hand—"My work is done—why wait?"

FURTHER READING
Collins, D. (1990). *The Story of Kodak*. New York: Abrams.

Eder, Josef Maria (1855–1944)
Josef Maria Eder was an Austrian photochemist, teacher, and photographic historian. He made outstanding contributions to photography, photographic chemistry, and photomechanical work so numerous that only a few highlights can be listed. In 1879 his thesis on *The Chemical Action of Colored Light* was published. In 1880 Eder became professor of chemistry at the Royal Technical School in Vienna. With Pizzighelli, he introduced gelatin-silver chloride paper in 1881. In 1884 he produced his encyclopedic *Handbook of Photography* on the science and technique of photography, which remained in print through many editions for 50 years. He was appointed direc-

FIG. 6 George Eastman, 1890. Photograph by French photographer Nadar (1820–1910), albumen print. (Courtesy of the George Eastman House Collection, Rochester, New York.)

tor of Vienna's highly regarded Graphic Arts Institute in 1889, a position he held for 34 years. Finally, among other books, there is his respected *History of Photography*, the last edition (German) of which appeared in 1932.

Fizeau, Hippolyte Louis (1819–1896)
Hippolyte Louis Fizeau was the French physicist who invented gold toning of daguerreotypes in 1840. He also invented a very successful process of etching daguerreotypes for mechanical printing in 1841. With Foucault in 1844 Fizeau studied the action of various light sources and of the spectrum on daguerreotype plates and found reciprocity law failures. He took the first pictures of the sun on daguerreotype (1845) with Foucault.

Foucault, Jean Bernard Léon (1819–1868)
Jean Bernard Léon Foucault was a French physicist who was one of the foremost photographic scientists in the first quarter century of photography. With Donne he constructed (1844) a projection microscope, and in 1849 (with Duboscq) an electric arc lamp. With Fizeau in 1844 he studied the effect of light on daguerreotype plates, and produced the first daguerreotype photograph of the sun in 1845. His collected works were edited by Gabriel and Bertrand (Paris 1878).

Fraunhofer, Joseph Von (1787–1826)
Joseph Von Fraunhofer was a German optician who, after an early struggle, became an assistant and later partner in important optical works. In 1814 he discovered a method of calculating a spherically and chromatically corrected objective. He also invented a machine for polishing large and mathematically accurate spherical surfaces. Between 1814 and 1817 he

determined accurately the dark lines in the solar spectrum, since known by his name. He was the first to study diffraction with a grating and was responsible for producing high-quality optical glass.

Gaudin, Marc Antoine Augustine (1804–1880)

Marc Antoine Augustine Gaudin was a French photographer, optician, and scientist. He improved the daguerreotype process, and achieved the first instantaneous exposure in 1841. He also investigated the Becquerel effect (1841) and studied nitrated cellulose (1847) and silver halide collodion emulsions (1853, 1861). In 1853 Gaudin proposed potassium cyanide as fixing agent and gelatin and other substances as image binders. He described a collodion emulsion for negatives in 1861.

Goddard, John Frederick (1795–1866)

John Frederick Goddard was a Science Lecturer in London, England. He was employed by Beard and Wolcott to speed up the daguerreotype process by chemical means. Goddard published his successful application of bromine as an accelerating sensitizer on December 12, 1840. This shortened the exposure from about 15 minutes to approximately 2 minutes, thus constituting a major improvement in the daguerreotype process.

Herschel, Sir John Frederick William (1792–1871)

Sir John Frederick William Herschel was an English astronomer and pioneer photographic chemist. In 1819 he discovered thiosulfates and that their properties included the ability to completely dissolve silver salts. Upon learning in 1839 that both Talbot and Daguerre claimed to have discovered photography, he independently invented a silver chloride negative process on glass (1839). Herschel generously suggested to both men, and others, that they use sodium thiosulfate or "hypo," as a photographic fixing agent. This proved to be important, since hypo more effectively eliminated unexposed silver salts than the common table salt then used. Though widely credited with coining the word *photography*, that was actually done by the Frenchman Hercules Florence in Brazil in 1834. He introduced the terms *negative* and *positive* as well as *emulsion* and *snapshot*. Herschel investigated the photochemical action of the solar spectrum, and discovered the different spectral sensitivities of the silver halides, chloride and bromide, and silver nitrate. He also described the light sensitivity of the citrates and tartrates of iron and of the

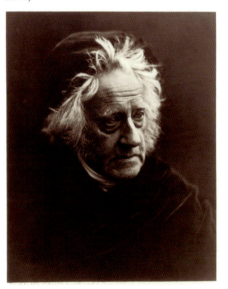

FIG. 7 Sir J. F. W. Herschel (Bart), 1867. Photography by Julia Margaret Cameron, albumen print. (Courtesy of the George Eastman House Collection, Rochester, New York.)

double iron-ammonium citrates. He discovered the Herschel effect, the name given to the fading caused by infrared radiation falling on an exposed image, which has been the starting point for much modern research on the nature of the photographic latent image. Herschel invented the cyanotype, the first blueprint in 1842 and suggested microfilm documentation.

FURTHER READING

Newhall, B. (1967). *Latent Image*. (*Letters 1842–1879*). New York: Doubleday.
Hunt, Robert 1807–1887.

Hurter, Ferdinand (1844–1898)

Ferdinand Hurter was a Swiss chemist who worked in an English chemical factory and was a colleague of V. C. Driffield. These two scientists and amateur photographers established the first reliable approach to accurate sensitometry, including the H&D curve, now known as the D-log H-curve. They published a full description of their apparatus and methods in 1890, and they were granted the Progress Medal by the Royal Photographic Society in 1898.

Ives, Frederic Eugene (1856–1937)

Frederic Eugene Ives was an American photographic inventor. Among his 70 U.S. patents are many concerning improvements in the halftone printing process, the most important was the cross-line screen introduced in 1886. Also a pioneer in color photography, he invented a series of cameras, beginning in 1892, that produced a color image via three transparencies viewed all together with the assistance of a special viewer or projector. He performed basic research in the field of subtractive color during the 1920s that was essential to the development of Kodachrome film in 1935.

Lippmann, Gabriel (1845–1921)

Gabriel Lippmann was a French physicist and professor at the Sorbonne. In 1891 he originated the interference method of direct color photography that produced the first excellent and fixable color photographs, but the process was difficult to carry out and is now only practiced as a technical curiosity.

FIG. 8 Portrait of Frederic E. Ives, ca. 1915. Photograph by Elias Goldensky, gelatin silver print. (Courtesy of the George Eastman House Collection, Rochester, New York.)

Lippmann received the Nobel Prize in physics in 1908 for this invention. In 1908 he suggested lenticular film should be used for additive color photography and for the production of stereoscopic images.

Lumiére, Auguste (1862–1954) **and Lumiére, Louis** (1864–1948)

Auguste and Louis Lumiére were French scientists, filmmakers, and photographic manufacturers. Their father, Antoine, founded a photographic dry plate factory in Lyon in 1882. The two brothers continued the manufacture of dry plates and expanded to the production of roll films and printing papers in 1887. Together and separately, they carried out and published important scientific and technical work on a variety of photographic subjects. In 1904 they invented the first widely used color process, the autochrome. In 1895 they publicly demonstrated their cinematographe motion picture camera and projector, which used perforated, celluloid 35 mm film; the design continues to be used in nearly all modern filmmaking apparatus. They were acknowledged in that same year for making the first movie to be publicly exhibited.

FURTHER READING

Rosenblum, N. (1984). *A World History of Photography*. New York: Abbeville Press.

Maddox, Richard Leach (1816–1902)

Richard Leach Maddox was an English physician, inventor, and photographer. In 1871 he described the first workable dry plate process that unshackled photographers from their darkrooms. Maddox coated silver-bromide gelatin emulsion on glass plates that, with improvements by others such as the replacement of glass by celluloid in 1883, laid the foundation of

the future film industry. He made his ideas public "to point the way," without patenting this revolutionary process and spent his last years in straitened circumstances.

Maxwell, James Clerk (1831–1879)

James Clerk Maxwell was a Scottish physicist who established that light was an electromagnetic wave. He was the author of valuable investigations on color perception. In 1855 Maxwell began making some of the earliest color photographs. He formally demonstrated the fundamental basis of projected additive three-color photography in 1861.

Monckhoven, Desire Charles Emanuel Van (1834–1882)

Desire Charles Emanuel Van Monckhoven was a Belgian chemist and photographer who became one of the foremost photographic scientists of the 19th century. Working in Vienna from 1867 to 1870 he built a famous studio for the photographer Rabending where life-size solar enlargements were made. In 1878, he perfected the preparation of silver bromide gelatin emulsion in the presence of ammonia. In 1879, he improved the manufacture of dry plates and sold emulsion to dry plate factories. Later, in Belgium, he established a factory for pigment papers. He also worked on spectral analysis and astronomy and improved the solar enlarger to which he added artificial illumination. He wrote papers on photographic chemistry and optics.

Muybridge, Eadweard James (1830–1904)

Eadweard James Muybridge was an English photographer who journeyed to the United States in early 1850s. He gained fame with spectacular photographs of Yosemite from his trips in 1867 and in 1872, when he used 20 × 24 inch collodion mammoth glass plates to great effect. He was hired in 1872 by Leland Stanford to prove with photographs that at some time a galloping horse has all four feet off the ground. Muybridge successfully captured this circumstance in 1877 by assembling a string of cameras that made consecutive exposures at regular intervals. In 1879, he synthesized motion with his Zoogyroscope, using drawings from serial photographs, producing the first animated movie. He published eleven volumes in 1887 containing 780 plates of the first serial photographs of humans and animals in motion. His work greatly influenced painters and stimulated other investigators in photographic analysis, synthesis of motion, and early cinematography.

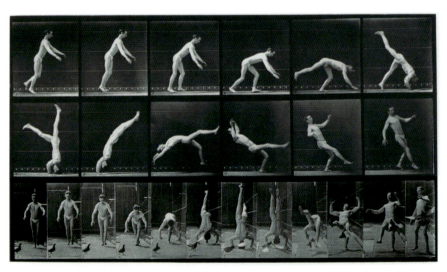

FIG. 9 Head-spring, a flying pigeon interfering. Animal Locomotion, Philadelphia, 1887. Photograph by Eadweard J. Muybridge, collotype print. (Courtesy of the George Eastman House Collection, Rochester, New York.)

FURTHER READING

Mosely, A. V. (ed.) (1972). *Eadweard Muybridge—The Stanford Years, 1872–1882.* Stanford: Stanford University Press.

Naef, W. J. and Wood, J. N. (1975). *Era of Exploration.* Buffalo and New York: Albright-Knox Art Gallery and Metropolitan Museum of Art.

Niépce de St. Victor, Claude Felix Abel (1805–1870)

Niépce St. Victor was a French cavalry officer who invented the albumen-on-glass process in 1847. He modified the heliograph (bitumen process) of his uncle Nicéphore Niépce into a heliogravure photomechanical printing process on bitumen-coated steel plates, which gave good halftone prints (1855). Following Edmond Becquerel's ideas, Niépce de St. Victor succeeded by in taking natural light color photographs (called heliochromy) on silver plates by the interference method (about 1860), but the colors were not stable.

Niépce, Joseph Nicéphore (1765–1833)

Niépce, Joseph Nicéphore (1765–1833) French inventor of photography, which he called *heliography.* In 1816, using a camera obscura, obtained negatives by the action of light on paper sensitized with silver chloride, but could not fix them. By 1822, he succeeded in making permanent images by coating glass, stone, or metal plates with asphaltum. After exposing it for many hours by direct contact with oiled engravings, they were washed with solvents to reveal the shadow portions that had not been hardened by light thus obtaining the first permanent photographic image. The earliest surviving photograph from nature, taken in a camera, dates probably from 1826 and is now in the Gernsheim Collection at the University of Texas, Austin. Niépce was the first to use an iris diaphragm and bellows in his cameras. In 1829, substituting silvered metal plates for pewter, he found he could darken shadows (bare silver) by iodine fumes. He described that in detail in his supplement to the partnership agreement that he

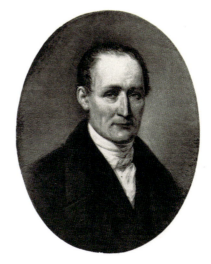

FIG. 10 Portrait of Claude-Felix-Abel Niépce de St. Victor (left) and unidentified man, possibly Alexandre-Edmond Becquerel, ca. 1855. Unidentified French photographer salted print. (Courtesy of the George Eastman House Collection, Rochester, New York.)

FIG. 11 Joseph Nicéphore Niépce ca. 1840. P. Dujardin and Léonard Berger, photogravure. (Courtesy of the George Eastman House Collection, Rochester, New York.)

concluded with Daguerre in 1829, and doubtless contributed to Daguerre's discovery of the light sensitivity of iodized silver plates in 1831. Niépce died in 1833, leaving the completion of his work to Daguerre.

FURTHER READING

Buerger, Janet E. (1989). *French Daguerreotypes*. Chicago and London: University of Chicago Press.

Gernsheim, Helmut (1982). *The Origins of Photography*. London and New York: Thames & Hudson.

Jay, Paul (1988). *Niépce, Genesis of an Invention*. Chalon-sur-Saone, France: Society des Amis du Musee Nicephore Niépce.

Newhall, Beaumont (1967). *Latent Image*. New York: Doubleday.

Marignier, J. L. (1999). *Niépce, L'invention De La Photography*, Paris, Editions Berlin.

Obernetter, Johann Baptist (1840–1887)

Johann Baptist Obernetter was a German photographer and photographic manufacturer. In 1868 he introduced commercially the collodion silver chloride of G. W. Simpson under the name of Aristotypie. He also invented (ca. 1886) a photogravure process on copper plates called Lichtkupferdruck. Obernetter introduced (ca. 1870) a collotype process similar to Josef Albert. In the 1880s his firm made good orthochromatic dry plates.

Ostwald, Wilhelm (1853–1932)

Wilhelm Ostwald was a German professor of physical chemistry at Leipzig University for 20 years and established his independent laboratory nearby in 1907. He received the Nobel Prize for chemistry in 1909. Between 1892 and 1900, Ostwald proposed theories on the chemical development of the latent image and on the ripening and growth of the grains in an emulsion.

In 1914, he introduced a new theory of color and published his *Color Atlas.* In this publication he described the Ostwald System of color tabulation that added varying proportions of black and white to pure hues.

Petzval, Josef Max (1807–1891)

Josef Max Petzval was a Hungarian mathematician who, in 1840, invented the first purposely designed photographic lens, which reduced exposure time by 90 percent. This allowed the rapid development of the daguerreotype's use for portraiture. Manufactured by Voigtländer and later copied by others, the Petzval lens marked a great advance from previous lenses and was widely used for half a century.

Poitevin, Alphonse Louis (1819–1882)

Alphonse Louis Poitevin was a French engineer, chemist, and photographic inventor. He investigated galvanography (1847), engraving of daguerreotype, photography with iron salts, photolithography, photo-ceramics, and the reaction of chromates with organic substances (e.g., glue). In 1855 he laid the foundations of both collotype and pigment printing (carbon and gum printing) and

FIG. 12 Portrait of Alphonse Louis Poitevin ca. 1865. Photographer unknown. Carbon Print. (Courtesy of the George Eastman House Collection, Rochester, New York.)

also produced direct photolithographs in halftone on grained stone coated with bichromated albumen.

Ponton, Mungo (1801–1880)
Mungo Ponton was a Scottish photographic inventor and the secretary of the National Bank of Scotland. In 1839, while experimenting with making photogenic drawings with silver chromates, he discovered that paper impregnated with potassium bichromate was sensitive to light. This was of fundamental importance for most photomechanical processes. Ponton used this photographic paper to record thermometer readings in 1845.

Reade, Rev. Joseph Bancroft (1810–1870)
Joseph Bancroft Reade was an English clergyman, microscopist, astronomer, and pioneer in photography. Early in 1839 he made photomicrographs in the solar microscope on silver chloride paper, which was moistened with an infusion of gall nuts (e.g., gallic acid) thereby using tannin as an accelerator. He was the first to use hypo as a fixing salt for photography (1839). He made camera photographs in 1839.

Regnault, Henry Victor (1810–1878)
Henry Victor Regnault was a French scientist and professor at the Collège de France. He was the President of the Socièté Francaise de Photographie from 1855 to 1868. He proposed (simultaneously with Liebig) pyrogallic acid as a developer in 1851. He also worked on the carbon process and described in 1856 an actinometer using silver chloride paper.

Sabattier, Aramand (1834–1910)
Aramand Sabattier was a French doctor and scientist. In 1862 he described the "pseudo-solarization reversal," a negative image on a wet collodion plate changed to a positive when daylight fell on the plate during development. This Sabattier effect was exploited for making a positive of a reversal, a second exposure, and development after the first exposure and developing.

Scheele, Carl Wilhelm (1742–1786)
Carl Wilhelm Scheele was a Swedish chemist who built on Johann Schultze's discovery of the light sensitivity of silver compounds. In 1777 Scheele determined that the silver in silver chloride would turn black when exposed to light and that the unexposed silver chloride could be washed away with ammonia. He also found that silver chloride blackened more quickly in the violet end of the spectrum than in other colors and deduced the existence of the unseen radiation band that we call ultraviolet rays. Among his many other significant discoveries, he is credited with first identifying elemental oxygen, before Joseph Priestly.

Schulze, Johann Heinrich (1687–1744)
Johann Heinrich Schulze was a German chemist who, in 1725, made the landmark discovery that light darkens silver nitrate, which proved that heat did not have this effect. Photography was eventually built upon Schulze's discovery.

Seebeck, Johann Thomas (1770–1831)
Johann Thomas Seebeck was a German physicist who, in 1810, investigated the photochromy of silver chloride; when this was exposed to white light and then to the spectrum colors, the spectrum reproduced itself on the silver chloride in its own natural colors. This interference process was one of the few direct processes of photography in natural color, but it took 80 years and the work of many inventors before a practical process of giving a permanent image was evolved by Gabriel Lippmann.

Simpson, George Warton (1825–1880)
George Warton Simpson was a English photographer and editor of the *Photographic News* and the *Year Book of Photography* (1860–1880). He did valuable work on development (1861);

collodion silver emulsions for printing-out papers (1864–1865), which formed the basis for the manufacture of Celloidin paper by Obernetter (1868); on the "photochromy" of collodion silver chloride papers (1866); and on Swan's pigment print (carbon) process.

Steinheil, Carl August Von (1801–1870) and Steinheil, Hugo Adolph (1832–1893)

Carl August Von Steinheil was a German astronomer and professor of physics and mathematics at Munich University. Shortly after learning of Talbot's calotype process in early 1839, then Daguerre's process in August 1839, he produced the first calotypes and daguerreotypes in Germany by using cameras he designed. In December 1839, he made the first miniature camera, which produced pictures that had to be viewed through a magnifying glass. In 1855 Steinheil founded the Munich optical company that still bears his name and that was purchased by his son, Hugo, in 1866. The younger Steinheil was a noted designer and manufacturer of fine photographic lenses.

Sutton, Thomas (1819–1875)

Thomas Sutton was an English photographer, inventor, editor, and publisher. Encouraged by Prince Albert and partnered by Blanquart-Evrard, he established a photographic printing works in Jersey (1855). He founded and edited the periodical, *Photographic Notes* (1856–1867). He invented a fluid globe lens in 1859, which he used in his panoramic camera in 1861. Sutton patented the first reflex camera in 1861 and published the first *Dictionary of Photography* in English in 1858.

Swan, Sir Joseph Wilson (1828–1914)

Sir Joseph Wilson Swan was an English inventor, chemist, and photographic manufacturer. He perfected the carbon process for printing photographs in permanent pigment in 1864 (introduced in 1866) and applied it to a mechanical form of carbon printing from an electrotyped copper mold-photomezzotint in 1865. He discovered the ripening process by heat in gelatin emulsion in 1887 when his firm, Mawson & Swan in Newcastle, began producing commercial gelatin plates. He patented the first automatic plate coating machine in Britain in 1879. At the same time, he started the manufacturing of gelatin bromide paper. He greatly advanced halftone printing with lined screen turned halfway through the exposure in 1879. Swan took out over 60 patents; his best known invention was the carbon filament electric light bulb in 1881.

FIG. 13 Portrait of Talbot, 1948 (from 1865 original). Photograph by William Henry Fox Talbot, carbon print. (Courtesy of the George Eastman House Collection, Rochester, New York.)

Talbot, William Henry Fox (1800–1877)

William Henry Fox Talbot was an English inventor of photography. He originated the negative-positive process that enabled the production of multiple prints from one negative, which continues to be the basis for photography as it is practiced today. Frustrated while drawing with the aid of the camera with silver halide photography lucida, in 1834 he experimented with the fixing of images by chemical means. He investigated the action of light on paper treated with silver salts, making successful photograms, which he called photogenic drawings, of such subjects as lace and leaves. In 1835, using a small, homemade camera, he produced a 1-inch square negative image of a latticed window in his home, Lacock Abbey, but did not make a positive print from a negative until 1839.

A scholar of many pursuits, Talbot left his experiments in photography, only to return when told of Daguerre's invention in January 1939. Disturbed that he would not receive due credit, Talbot's process was described to the Royal Society in London on January 31, 1839.

He greatly increased the stability of his prints in 1839 by using Herschel's suggested fixer, sodium thiosulfate. Exposure times for Talbot's photogenic drawings were extremely long, but were dramatically shortened with his improved calotype process (also called Talbotype) in 1840, which he patented in 1841. The calotype relied on paper treated with silver iodide and washed with gallic acid and silver nitrate. When exposed in a camera, the paper produced an unseen, latent image that could then be successfully developed in the same solution of gallic acid and silver nitrate outside the camera.

Talbot began the first printing company for the mass production of photographs in 1843, and published his own book *The Pencil of Nature* in 1844, the first book illustrated with photographs. In 1852, he patented a photoengraving process, and in 1858 he patented an improved process that produced fairly good halftone reproductions.

FURTHER READING

Jammes, A. (1973). *William H. Fox Talbot—Inventor of the Negative-Positive Process*. New York: Collier.
Newhall, B. (1967). *Latent Image—The Discovery of Photography*. Garden City, NY: Doubleday.
Talbot, W. H. F. (1969, 1989). *The Pencil of Nature*. Facsimiles, New York: Da Capa Press and New York: H. P. Kraus.

Vogel, Hermann Wilhelm (1834–1898)

Hermann Wilhelm Vogel was a German chemist and teacher who became the first professor of photography at the Institute of Technology, Berlin, in 1864. He founded several photographic societies and an important periodical, *Photographische Mitteilungen* also in 1864. His *Handbook of Photography*, first published in 1867, was one of the most important textbooks of the late 19th century. In 1837 Vogel discovered that the selective addition of dyes to collodion plates increased their sensitivity to include the green portion of the spectrum. Along with Johann Obernetter he invented the orthochromatic gelatin silver dry plate in 1884, which was sensitive to all colors except deep orange and red. An influential teacher, his students included Alfred Stieglitz in 1881.

Voigtländer, Peter Wilhelm Friedrich (1812–1878)

Peter Voigtländer was an Austrian optical manufacturer who, in 1849, established a new branch of the family firm originally founded in 1756 in Vienna at Brusnwick. From 1841 his firm manufactured the famous portrait and landscape lens calculated by Petzval in 1840. Also in 1841, he produced the first metal daguerreotype camera.

Warnerke, Leon (Vladislav Malakhovskii) (1837–1900)

Leon Warnerke was a Russian civil engineer. In 1870 he established a private photographic laboratory in London. He lived in both London and St. Petersburg and established a photographic factory in Russia. He invented the Warnerke sensitometer, which was the first serviceable device for measuring speed (1880). He used this device during investigations on the silver bromide collodion stripping paper. He manufactured silver chloride gelatin papers starting in 1889. He was awarded the Progress Medal of the Royal Photographic Society in 1882.

Wedgwood, Thomas (1771–1805)

Thomas Wedgwood was an English scientist. Son of the famous potter, Josiah Wedgwood, he produced images made by the direct action of light (photograms, e.g., silhouettes and botanical specimens) on paper or leather moistened with silver nitrate solution and silver chloride. In 1802 he published, with Sir Humphry Davy, an account of a method for copying paintings upon glass and of making profiles by the agency of light upon nitrate of silver. But he and Davy were not able to fix their images, which could only be viewed for a few minutes by candlelight.

FURTHER READING
Gernsheim, H. (1982). *The Origins of Photography*. New York:Thames & Hudson.

Wheatstone, Sir Charles (1802–1875)

Sir Charles Wheatstone was an English scientist who invented the stereoscope. He experimented with this device from 1832 to 1838, publishing his results in 1838. Wheatstone invented the concertina (1829).

Willis, William (1841–1923)

William Willis was an English engineer, bank employee, and photographer. He patented the Platinotype process in 1873 and founded the Platinotype Company, which manufactured platinum development papers from 1878 onward. He later worked out the Satista (silver-platinum) and the Pallidiotype papers. He was awarded the Progress Medal of the Royal Photographic Society in 1881.

Wolcott, Alexander (1804–1844)

Alexander Wolcott was an American instrument maker and daguerreotypist. He designed and patented a camera without a lens in which the light entered to be reflected by a concave mirror onto the plate (that was turned away from the subject). On October 7, 1839, he probably took the first successful portrait ever made. In March 1840 he opened the world's first portrait studio in New York.

Woodbury, Walter Bentley (1834–1885)

Walter Woodbury was an English professional photographer. In 1864 he invented the Woodbury process for printing with pigmented gelatin from lead molds obtained from chromated gelatin reliefs. The process was widely used as it produced prints with halftones and high definition and without any grain or screen. It was superseded in the late 1880s by the collotype process and other processes whose prints did not need trimming and mounting. He invented the stannotype in 1879. Woodbury also worked on balloon photography, on rotary printing, and on stereo projection. He received the Progress Medal of the Royal Photographic Society in 1883 for his stannotype process, a simplified variant of the Woodburytype.

Wratten, Frederick Charles Luther (1840–1926)

Frederick Wratten was an English inventor and manufacturer. In 1878 he founded one of the earliest photographic supply businesses, Wratten and Wainwright, which produced and sold collodion glass plates and gelatin dry plates. He invented, in 1878, the "noodling" of silver-bromide gelatin emulsions before washing. With the assistance of Mees, he produced the first panchromatic plates in England in 1906 and became a famous manufacturer of photographic filters. Eastman Kodak purchased the company in 1912 as a condition of hiring Mees.

FURTHER READING
Mees, E. C. K. (1961). *From Dry Plates to Ektachrome Film*. New York: Ziff-Davis.

Zeiss, Carl (1816–1888)

Carl Zeiss was a German lens manufacturer who founded the Zeiss optical firm in 1846.

FIG. 14 Portrait of Carl Zeiss, ca. mid-1800s. (Courtesy of Carl Zeiss MicroImaging, Thornwood, New York.)

With collaborators Ernst Abbe and Otto Schott, he devised the manufacture of Jena glass, the finest optical quality glass. Zeiss became famous for its excellently designed microscopes, binoculars, optical instruments, and cameras. Zeiss photographic lenses became the standard in the field. Chief lens designer, Paul Rudolph, produced the first anastigmat (1890) and the still-popular Tessar (1902).

Selected Photographs from the 19th Century

MARK OSTERMAN
George Eastman House and International Museum of Photography and Film

Joseph Nicéphore Niépce has been credited with creating the first photograph, titled "View from the Window at Le Gras." It was taken in 1826 in Saint-Loup-de-Varennes, France. This picture, a heliograph on pewter, was made using a camera obscura. After an exposure of at least 8 hours, the camera obscura created a single, one-of-a-kind image. Reproduced here are three versions of that image. The first version was made at the Kodak Research Laboratory in Harrow, England. The rephotographing process produced a gelatin silver print in March 1952. The second version was created by Helmut Gernsheim and the Kodak Research Laboratory in Harrow, England. The second version, a gelatin silver print with applied watercolor reproduction was created March 20–21, 1952. It is interesting to note that Gernsheim, a well-know photographic collector, historian, and author had written several essays and consulted this encyclopedia's first edition before creating the print. The most recent version of Niépce's piece, produced in June 2002, was completed by the Harry Ransom Center and J. Paul Getty Museum.

The images on the following pages were selected by the editor to represent the pictorial evolution of the photograph and to include pictures that have not been published before. They have been arranged chronologically, starting at 1830 and concluding at the turn of the century. All images, except where noted, are courtesy of the Image Collection at the George Eastman House International Museum of Photography and Film in Rochester, New York.

The photography collection at the George Eastman House International Museum includes more than 400,000 photographs and negatives dating from the invention of photography to the present day. The collection embraces numerous landmark processes, rare objects, and monuments of art history that trace the evolution of photography as a technology, as a means of scientific and historical documentation, and as one of the most potent and accessible means of personal expression in the modern era. More than 14,000 photographers are represented in the collection, including virtually all the major figures in the history of the medium. The collection includes original vintage works produced by nearly every process and printing medium employed. (For more information, go to http://www.eastmanhouse.org.)

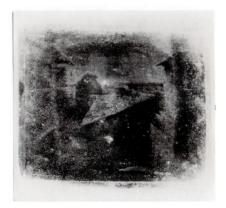

FIG. 15 First version of "View from the Window at Le Gras," made at the Kodak Research Laboratory in Harrow, England, 1952. Gelatin silver print, 20.3 × 25.4cm. (Reproduced with permission of the Gernsheim Collection, Harry Ransom Humanities Research Center, University of Texas at Austin.)

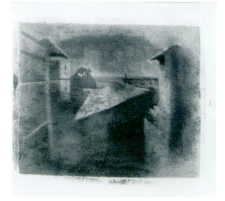

FIG. 16 Second version of "View from the Window at Le Gras," made by Helmut Gernsheim at the Kodak Research Laboratory in Harrow, England. March 20–21, 1952. Gelatin silver print and watercolor, 20.3 × 25.4 cm. (Reproduced with permission of the Gernsheim Collection, Harry Ransom Humanities Research Center, University of Texas at Austin.)

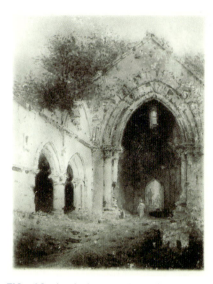

FIG. 18 Louis-Jacques-Mandé-Daguerre, French (1787–1851). "Gothic Ruins," ca. 1830. Dessin fumée, 7.7 × 6 cm. Gift of Eastman Kodak Company, Gabriel Cromer collection.

FIG. 17 Digital print reproduction of "View from the Window at Le Gras," made by Harry Ransom Center and J. Paul Getty Museum, June 2002. Color digital print reproduction, 20.3 × 25.4 cm. (Reproduced with permission of the Gernsheim Collection, Harry Ransom Humanities Research Center, University of Texas at Austin.)

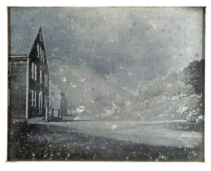

FIG. 19 Samuel A. Bemis, American (ca. 1793–1881). "Abel Crawford's Inn at the Notch of the White Hills, White Mountains, New Hampshire," ca. 1840. Daguerreotype, 16.5 × 21.6 cm, full plate. Gift of Eastman Kodak Company.

FIG. 20 Antoine-Francois Jean Claudet, English (1797–1867). "Portrait of Claudet Family," ca. 1855. Stereo daguerreotype with applied color. Gift by exchange of Mrs. Norman Gilchrist.

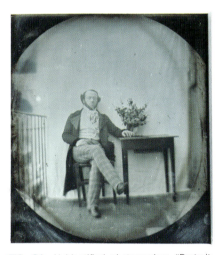

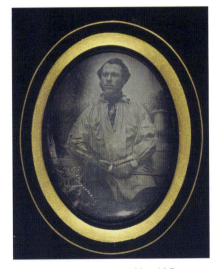

FIG. 21 Unidentified photographer. "Portrait of a Man at a Table," taken with a gaudin camera, 1840. Daguerreotype, 8.2 × 7.4 cm (1/6 plate). Gift of Eastman Kodak Company, Gabriel Cromer collection.

FIG. 22 Louis-Jacques-Mandé-Daguerre, French (1787–1851). "Portrait of an Artist," ca. 1843. Daguerreotype, quarter plate, 9.1 × 6.9 cm (visible) on 15.6 × 13.0 cm plate. Gift of Eastman Kodak Company, Gabriel Cromer collection.

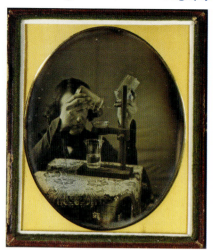

FIG. 23 Robert Cornelius. "Self-Portrait with Laboratory Instruments," 1843. Daguerreotype. Gift of 3M Company, ex-collection Louis Walton Sipley.

FIG. 25 Cromer's Amateur, French. "Still Life, Bouquet of Flowers," ca. 1845. Daguerreotype, 8.2 × 7.0 cm, 1/6 plate. Gift of Eastman Kodak Company, Gabriel Cromer collection.

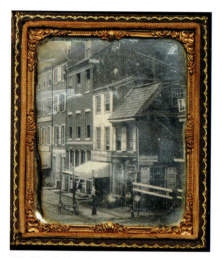

FIG. 24 Unidentified photographer. "Chestnut Street, Philadelphia," ca. 1844. Daguerreotype, 8.2 × 7.0 cm, 1/6 plate.

FIG. 26 Hill and Adamson, Scottish. "The Gowan," ca. 1845. Portrait of Mary and Margaret McCandlish. Salted paper print, 15.3 × 20.4 cm.

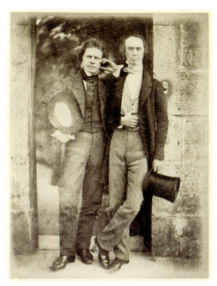

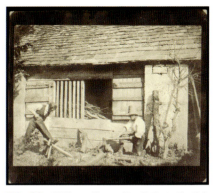

FIG. 29 William Henry Fox Talbot, English (1800–1877). "The Woodcutters," ca. 1845. Salted paper print, 15.2 × 21.2 cm. Gift of Alden Scott Boyer.

FIG. 27 Hill and Adamson, Scottish. "D. O. Hill and W. B. Johnstone," ca. 1845. Salted paper print, 18.8 × 14.5 cm. Gift of Alden Scott Boyer.

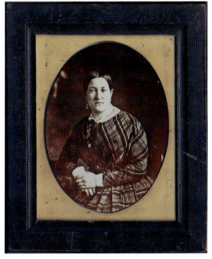

FIG. 28 William Henry Fox Talbot, English (1800–1877). "Lace," ca. 1845. Salted paper print, 23.0 × 18.8 cm (irregular). Gift of Dr. Walter Clark.

FIG. 30 W. and F. Langenheim, American. "Anna Langenheim Voightlander," 1848. Hyalotype transparency from albumen negative; image: 13.3 × 10 cm; frame: 17.6 × 14.5 cm. Gift of 3M Company, ex-collection Louis Walton Sipley.

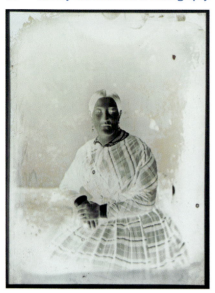

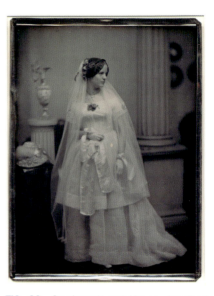

FIG. 31 W. and F. Langenheim, American. "Portrait of Anna Langenheim Voightlander," 1848. Albumen negative, 18.9 × 14.4 cm. Gift of 3M Company, ex-collection Louis Walton Sipley.

FIG. 33 Southworth and Hawes, American (active ca. 1845–1861). "Unidentified Bride," ca. 1850. Daguerreotype, whole plate, 21.5 × 16.5 cm. Gift of Alden Scott Boyer.

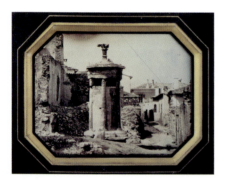

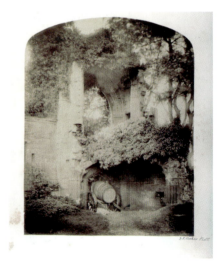

FIG. 32 Baron Jean-Baptiste Louis Gros, French (1793–1870). "Monument de Lysicrates, Vulgairement Appelé Lanterne de Demosthenes; Athenes," May, 1850. Daguerreotype, half plate, 10.8 × 14.7 cm (visible). Gift of Eastman Kodak Company, Gabriel Cromer collection.

FIG. 34 Frederick Scott Archer, "Kenilworth Castle," 1851. *Sel d'or*–toned albumen print from whole-plate wet collodion negative. Scully & Osterman Archive, Rochester, New York.

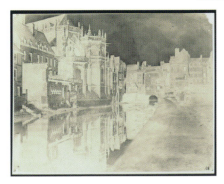

FIG. 35 Unidentified photographer. "Chevet de l'Eglise de Saint-Pierre de Caen," ca. 1850–1855. Calotype negative, 20.5 × 26.8 cm. Gift of Eastman Kodak Company, Vincennes, via the French Society of Photography, ex-collection Henri Fontan.

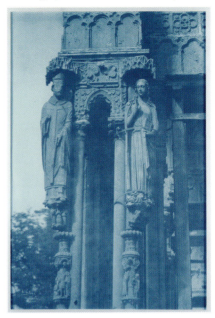

FIG. 36 Henri Le Sec, Chartes. "Portal with Wood Supports," 1851. Cyanotype from paper negative, 32.2 × 21.5 cm.

A

B

FIG. 37 John Shaw Smith, Irish (1811–1873). (A) "Tomb and Mosque of Sultan Eshraf," November 1851. Calotype negative, 16.8 × 22.0 cm (irregular). (B) Reverse, showing selective waxing on lower areas. Gift of Alden Scott Boyer.

FIG. 38 Adolphe Braun, French (1812–1877). "Still Life of Flowers," ca. 1854–1856. Albumen print, 43.8 × 46.5 cm. Gift of Eastman Kodak Company, Gabriel Cromer collection.

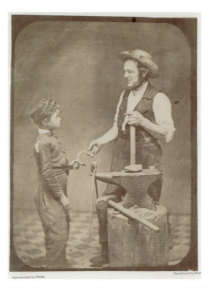

FIG. 40 Hesler. "Driving a Bargin," 1854. Crystalotype print by John A. Whipple from original daguerreotype. Reproduced from *Photographic and Fine Art Journal.*

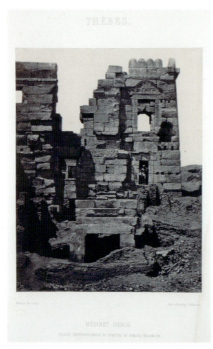

FIG. 39 Maxime du Camp. "Façade Septentrionale du Gynecee de Ramses Meiamoun," 1854. Developed-out salted paper print from a paper negative from *Egypt and Syrie.*

FIG. 41 Édouard Baldus, French (1813–1889). "Pavillon de Rohan, Louvre, Paris," ca. 1855. Salted paper print, 44 × 34.5 cm. Gift of Eastman Kodak Company, Gabriel Cromer collection.

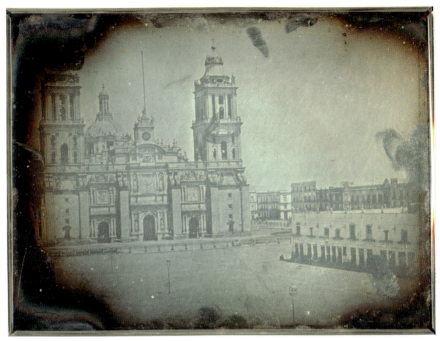

FIG. 42 Unidentified photographer. "Facade of Mexico City Cathedral and 'El Parian,'" ca. 1840. (The two-story structure to the right was the enclosed marketplace known as the Parian. It was torn down on June 24, 1843.) Daguerreotype, 16.4 × 21.5cm, full plate. Gift of Eastman Kodak Company, Gabriel Cromer collection.

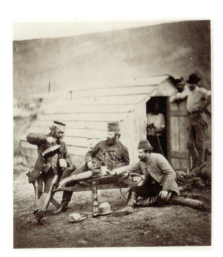

FIG. 43 Roger Fenton, English (1819– 1869). "Hardships in the Camp," 1855. Salted paper print, 18.3 × 16.6cm. Gift of Alden Scott Boyer.

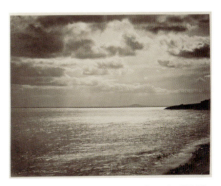

FIG. 44 Gustave Le Gray, French (1820– 1884). "Mediterranean Sea with Mount Agde," ca. 1855. Albumen print from collo- dion negative, 31.9 × 40.7cm. Gift of Eastman Kodak Company, Gabriel Cromer collection.

FIG. 45 Unidentified photographer. "Unidentified Woman, Head and Shoulders Portrait," ca. 1855. Pannotype (collodion on leather), image: 6.5 × 5.5 cm. Gift of Reverend H. Hathaway.

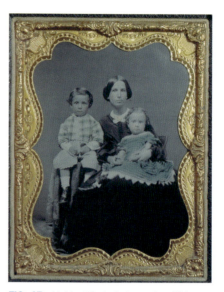

FIG. 47 Unidentified photographer. "Woman Seated, Holding Young Girl on Lap; Young Boy Seated on Posing Table beside Them," ca. 1855. Ambrotype; image: 10.5 × 13.9 cm, 1/2 plate. Gift of Eastman Kodak Company.

FIG. 46 Unidentified photographer. "Two Men Eating Watermelon," ca. 1855. Daguerreotype with applied color, 5.8 × 4.5 cm., 1/9 plate. Museum purchase, ex-collection Zelda P. Mackay.

FIG. 48 James Robertson, British (1813–1888). "The Barracks Battery," 1855. Salted paper print, 23.8 × 30.2 cm. Gift of Eastman Kodak Company, Gabriel Cromer collection.

FIG. 49 Adrien Tournachon, French (1825–1903). "Ratter-Filly," ca. 1855. Salted paper print; image: 16.8 × 23 cm; mount: 31 × 47 cm. Gift of Eastman Kodak Company, Gabriel Cromer collection.

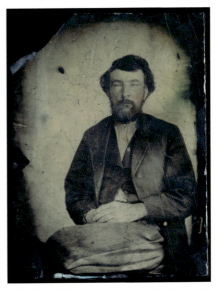

FIG. 51 Unidentified photographer. "Seated Man," ca. 1855. Collodion positive on slate, 10.5 × 8 cm.

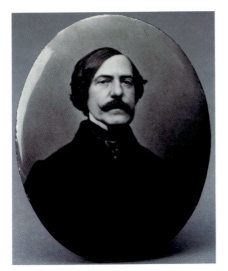

FIG. 50 Nadar et Cie. "The Marquis du lau D'Allemans," ca. 1855. Vitrified photograph on enamel, 9 × 7.3 cm.

FIG. 52 Francis Frith, English (1822–1898). "The Great Pillars and Smaller Temple," ca. 1863. Albumen print, 23.4 × 16.3 cm. Gift of Alden Scott Boyer.

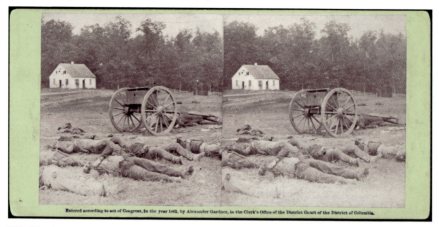

FIG. 59 Alexander Gardner, Scottish (1821–1882). "Completely Silenced! (Dead Confederate Soldiers at Antietam)," 1862. Albumen print stereograph, 7.6 × 15.0 cm, ensemble. Gift of 3M Company, ex-collection Louis Walton Sipley.

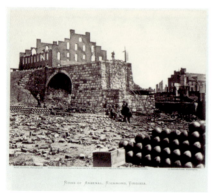

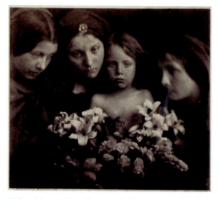

FIG. 60 Alexander Gardner, Scottish (1821–1882). "Ruins of Arsenal, Richmond, Virginia." April, 1863. Albumen print, 17.4 × 22.5 cm. Gift of Alden Scott Boyer.

FIG. 61 Julia Margaret Cameron, English (1815–1879). "Wist Ye Not That Your Father and I Sought Thee Sorrowing?" 1865. Albumen print, 25.2 × 28.8 cm. Gift of Eastman Kodak Company, Gabriel Cromer collection.

A B

FIG. 62 Unidentified photographer, American. (A) "Unidentified Man, Seated"; (B) "Unidentified Man, Seated, Wearing Coat, Vest, Hat; Holding Chain of Pocket Watch," ca. 1865. Tintype, 8.5 × 7.5 cm (each image), 1/6 plate. Gift of Donald Weber.

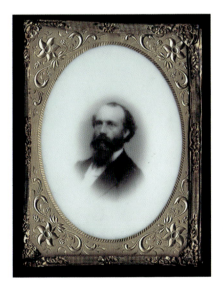

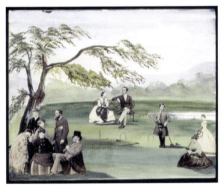

FIG. 64 Unidentified photographer. "Mr. Sutherland, Mr. W. Cochrane, Mr. Balfour, Mr. Machonachie, Mrs. B. Cochrane, Mr. W. Machonachie, Lady M. Hervey, Mr. Powlett, Mr. J. Cochrane, Lady Dunlo, Miss H. Farqhuarson," 1867. Albumen print photomontage with watercolor embellishment, 28.9 × 23.1 cm. Constance Sackville West album, London.

FIG. 63 Unidentified photographer. "Unidentified Man," ca. 1860. Albumen positive on white glass plate, 11 × 8.4 cm.

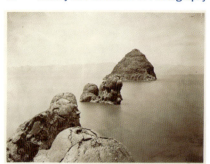

FIG. 65 Timothy H. O'Sullivan, American (1840–1882). "Pyramid Lake, Nevada," April, 1868. Albumen print, 19.8 × 27.0 cm. Gift of Harvard University.

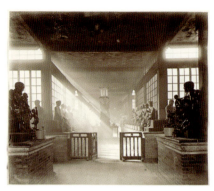

FIG. 67 John Thomson, Scottish (1837–1921). "Wah Lum Chu, Canton," ca. 1868. Albumen print, 23.0 × 27.9 cm. Gift of Alden Scott Boyer.

5. Close. No. 148 High Street.

FIG. 66 Thomas Annan, Scottish (1829–1887). "Close, No. 148, High Street," 1868–1877. Carbon print, 27.3 × 23 cm.

FIG. 68 Unknown photographer. "Studio Portrait of Woman," ca. 1870. Quarter-plate wet collodion negative. Scully & Osterman Archive, Rochester, New York.

FIG. 69 Eadweard J. Muybridge, English (1830–1904). "Loya—Valley of the Yosemite. (The Sentinel, 3,043 Feet High)," ca. 1868. Albumen print, 42.3 × 53 cm. Gift of Virginia Adams.

FIG. 71 William Henry Jackson, American (1843–1942). "Hot Spring," 1871–1872. Albumen print, 10.4 × 18.4 cm.

FIG. 70 Louis Ducos du Hauron, French (1837–1920). "Still Life with Rooster," ca. 1869–1879. Transparency, three-color carbon, 20.5 × 22.2 cm.

FIG. 72 Lewis Carroll (Rev. Charles Ludwidge Dogson), English (1832–1898). "Xie Kitchin as 'a Chinaman,'" 1873. Gum platinum print. Print ca. 1915, by Alvin Langdon Coburn. Gift of Alvin Langdon Coburn.

FIG. 75 Samuel M. Fox. "An Old Saw Mill," ca. 1880. Albumen print from (dry) collodion emulsion negative, 16.5 × 21 cm. From a Philadelphia Exchange Club album, ca. 1880.

FIG. 73 Richter and Company. "Unidentified Child at Fence," ca. 1880. Albumen print, cabinet card; image: 14.6 × 10.1 cm; mount: 16.2 × 10.5 cm.

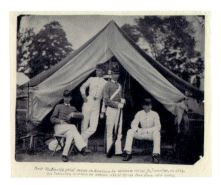

FIG. 74 Pach Bros./William Willis, Jr. "Group of Four Military Cadets Under a Tent Opening," ca. 1865. First platinum print made in America (1877) by William Willis, Jr. From ca. 1865 negative, made by Pach Bros. Studio. Image 18.1 × 23.7 cm., mount 20.4 × 25.5 cm.

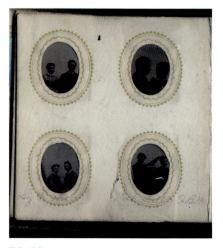

FIG. 76 Unknown photographer, page from a gem album with ferrotypes; each image is 2 × 1.5 cm; each page is 8.5 × 8.1 cm. Personal album.

FIG. 77 Peter Henry Emerson, English (1856–1936). "The Clay-Mill," ca. 1886, Photogravure print (ca. 1888), 20.1 × 29 cm. Gift of Alden Scott Boyer.

FIG. 78 Raymond K. Albright, American (d. 1954). "Ascending Vesuvius, Naples," ca. 1888. Albumen print, 6.8 cm (diameter). Gift of Mrs. Raymond Albright.

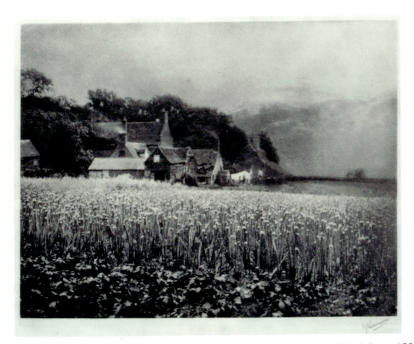

FIG. 79 George Davison, English (1854–1930). "The Homestead in the Marsh," ca. 1890. Platinum print, 22.5 × 18.0 cm. Gift of 3M Company, ex-collection, Louis Walton Sipley.

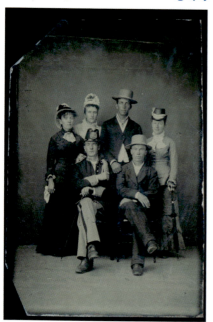

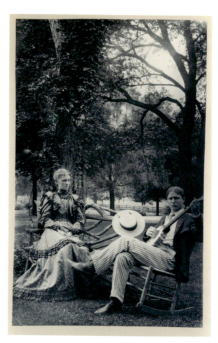

FIG. 80 Unknown photographer. "Group of Three Men and Three Women," ca. 1890. Tintype, 9.3 × 6.3 cm.

FIG. 82 Laura Adelaide Johnson. "Man Playing Banjo for a Woman," ca. 1892. Platinum print, 19 × 12.1 cm. Family album.

FIG. 81 Frederic Ives. Transparency set for additive color projection, ca. 1890. Silver bromide gelatin emulsion plates, each image is 5.5 cm in diameter; object is 7.5 × 23 cm.

FIG. 83 Unidentified photographer. "Varnishing Day, Wassonier Salon," 1892. Cyanotype, 11.5 × 19 cm.

FIG. 84 Unidentified photographer, "Collection of Stuffed and Mounted Birds," ca. 1895. Color plate screen, Joly (natural color) process, 10.2 × 8.2 cm.

FIG. 85 Gertrude Käsebier, American (1852–1934). "Adoration," ca. 1897. Brown platinum print. Gift of Hermine Turner.

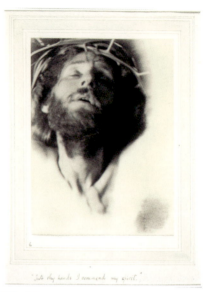

FIG. 87 F. Holland Day, American (1864–1933). "Into Thy Hands I Commend My Spirit," from *The Seven Last Words,* 1898. Platinum print, 20.2 × 15.1 cm.

FIG. 86 Clarence H. White, American (1871–1925). "The Readers," 1897. Platinum print, 19.4 × 10.7 cm.

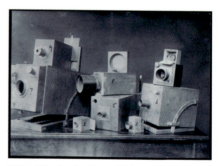

FIG. 88 Dr. J. Murray Jordan. "Mar Saba," from *Travel Views of the Holy Land, etc.,* ca. 1900. Platinum print, 13.5 × 18.5 cm. Personal album.

FIG. 89 A. Bartlett. "Display of Talbot's Cameras," ca. 1900–1907. Gelatin silver print, 10.3 × 14.6 cm. Gift of the Eastman Kodak Patent Museum.

FIG. 90 Gabriel Lippmann, French (1845–1921). "Garden at Versailles," 1900. Direct color (interference process); Lippmann plate. Gift of Eastman Kodak Company.

MAJOR THEMES AND PHOTOGRAPHERS OF THE 20TH CENTURY

NANCY M. STUART, PH.D., EDITOR
The Cleveland Institute of Art

Photography in the 20th Century

NANCY M. STUART PH.D.

The Cleveland Institute of Art

Photography by its very definition is a physical and chemical process that requires the fixing of radiant energy using a photosensitive surface typically with a mechanical or electronic camera. Much can and has been written about the science and technology of this process, but it is the impact of its images on our society that has visually defined our culture and forever changed the way people have communicated following its invention.

Few disciplines other than photography would have the distinction of functioning as a commercial product, an applied science, and a studio art. The complexity of editing this volume is further exacerbated by the possible approaches to organizing a volume on this particular century: a chronological historical survey, an alphabetical compendium of significant practitioners, or an analysis of popular theoretical and critical themes. The outline that was selected grew almost organically out of the author invitation process and their individual interests or areas of scholarship. I chose to review the trends that differentiated this century from the 19th and, likely from the one we are currently living in. Additionally, it was necessary, due to space limitations, to focus primarily on the factors in North America while recognizing that this view is limited because photography itself is a universal practice, if not language.

This volume is categorized by photography's practice (art, society, and commerce), programs (museums, education, and associations), publishing (magazines, books, and theories), and practitioners (image-makers) that have all operated in significant ways during the 20th century.

The first section has been organized to take a broad view of photography's influence on culture. The critic Saul Ostrow writes about photography as a creative medium and its impact on art practice. Independent scholar and author Gretchen Garner took on the effect that photography has had on amateur picture making, advertising, and journalism. Bruce Checefsky, artist and gallery director, began with an investigation of fashion photography that naturally grew into the photography's common objective of "desire" in pornography and fashion genres.

The second section evaluates related programs that grew out of photography's practice. Educator and artist Dr. Lynne Bentley Kemp studied the act of collecting on the discipline of photography through the museums, galleries, and corporate and individual collections that expanded during this era. Chris Burnett, Director of the Visual Studies Workshop, assessed the educational practice of photographic workshops while I reviewed the emergence of photographic programs at the college level and the resulting professionalization of the discipline through the formation of professional associations and journals.

The third section explores the publishing activities in relation to photography. British author David Brittain's essay explores the photographer's press during the influential decade of the 60s. Dr. Gary Sampson reviews the cultural discourse evidenced through photography's published histories, theories, and criticism.

Section four is prefaced by Dr. David Hart's essay on African American photographers and their involvement in the medium since its inception. The chapter then provides an alphabetical listing of over 250 short biographies of some of last century's most influential practitioners by authors and photographers Robert Hirsch, Ken White, and Garie Waltzer. The selection concentrates on image-makers rather than related influential individuals such as authors, curators, editors, educators, or inventors. Determining which photographers were included was left up to the discretion of each author with the guideline of selecting those key individuals who in effect represent a larger group of practice or ideas. The biographies indicate

what a given photographer accomplished and why it is considered of importance. Additionally, at least one significant publication from each photographer was listed for further reading. The decision to include such a minor inclusion of people's work was influenced by the limitations of the book's size.

Each author worked independently and each essay stands on its own merit. Naturally, each topic had the potential of overlapping another, but rather than reading as redundant it reflects the reality of interwoven influences and the richness of a practice that is intertwined throughout 20th century society. ◉

Part page caption: "Young Photographers, Greece 1987," © Professor Willie Osterman.

Photography, Fine Art Photography, and the Visual Arts: 1900–2001

SAUL OSTROW
The Cleveland Institute of Art

Photography, Fine Art Photography, and the Visual Arts: 1900–2001

This essay represents the relationships between photography, fine art photography, and the visual arts as they developed in the United States between 1900 and 2001. Though photography had come to be acknowledged as a legitimate form of artistic pursuit by the early part of the 20th century, it was considered a minor one. This was regardless of the fact that photography's introduction had had a significant impact on our perception and our visual culture. Instead, this evaluation was premised on the fact that photography as a medium had no historical precedent, and if any parallel was to be drawn it would be with that of printmaking, whose conventions of editioning it would eventually adopt. From the point of view of the "Academy," "art" was fixed in concept and form, because it reflected values that were eternal. While this position allowed for the emergence of new styles, which were historically contingent on one another, it did not readily allow for new forms and media. Consequently, abstract art or the material experimentation of the early avant-garde would become integrated into art's history after much critical debate and adjustment. By contrast, for most of the 20th century, photography would exist in a world of parallel institutions, circumscribed by their own history.

In relation to art, photography did not gain a significant position until the 1960s when conceptual artists such as Mel Bochner, Robert Morris, Hans Haacke, Doug Huebler, Dan Graham, Bruce Nauman, Dennis Oppenhiem, Robert Smithson, Gordon Matta-Clark, Michael Asher, et al., were developing non-media-specific, post-studio practices appropriated photography. The effect of this conceptual turn resulted in an end to the hierarchy so cherished by traditionalists, which set photography and film into a category of its own. Today art rather than being media specific constitutes a definitive economy of concepts given representation by those media that best serve them.

During the first half of the 20th century, photography's lack of an historical connection with traditional art making gave rise to a constellation of issues that informed the debate concerning its status. Therefore, while artists and photographers could equally represent their work as the products of their personal struggle to express their individual (subjective) vision, photography during the late 19th and early 20th centuries also represented a challenge to the conventions underpinning the traditional Western arts. This stemmed from the fact that photography was the product of a chemical process that captured and fixed the light reflected off an object into an image of that object, and seemingly required only minimal skills. Photography, consequently, was judged to be no more than a means to mechanically reproduce appearances and as such was most suitable for scientific and documentary (evidentiary) use rather than creative ends.

During this period as photographers explored the mechanics of their new media to determine its capabilities beyond mere transcription, painters were grappling with its effects on their own practices. Since the middle of the 19th century, painters used photography as an optical aid the way previous generations had used the camera obscura and other such devices. While photography's very ability to reproduce appearances more accurately, more realistically, and more objectively served the artist, these qualities also threatened painting's supremacy in the same manner that digital imaging does today. To counter photography's effect and to sustain painting's relevancy in the modern world, painters set about extricating themselves from the limitation imposed upon them by traditional approaches to representation. They did this by initially accentuating color and abandoning perspective to emphasize the literal flatness of the canvas and painterly process. These were all qualities that were beyond the photographic process, which produced mostly black and white images of the external world.

The emerging influence of photography can be found in Edouard Manet's use of a shallow, layered space and flattened color, while his mixture of paint handling and differing degrees of finish announces photography's limitations. Meanwhile, painters such as Claude Monet, and later George Seurat, applied the latest knowledge of optics and light to painting to challenge photography's claim on science by placing dabs or dots of primary and complementary colors in close proximity to one another so that they would blend in the eye of the viewer. In this manner, they could claim painting to be more scientific and superior to photography. The effect of photography can also be found in the manner that Edgar Degas uses the framing edge to cut through a figure. This notion of the picture as a fragment of a continuum that extended beyond the framing edge challenged the classical conception of the painting as a self-contained whole has its origins in photography.

Subsequently, post-impressionist painters such as Utrillo abandoned direct observation altogether and painted his views of Paris' suburbs, from photographs, which offered him ready-made views and compositions that he executed with heavy strokes. Yet, the effect of new medium on the visual arts actually was more profound then as a source of new imagery, optical effects, or even as a means of reproduction. Photography is a contributing factor in the causal chain of cultural, political, and technological events that resulted in emergence of an avant-garde that in the name of "modernity" rejected not only traditional representations, but also the very conventions of art.

The successive schools of impressionism, post-impressionism, cubism, futurism, etc., incrementally moved art to seek new models in the primitive and the industrial. This resulted in artists committed to pictorial issues, as well as focusing materially on the industrial and scientific perspectives that were altering "everyday life." This questioning of the traditional forms of artistic production not only made it possible to stylistically give expression to the iconography of modern life, but it also led to the inclusion of actual bits and pieces of the real world.

Cutting up bits of colored paper and magazines, photographs, old prints, wallpaper, and other materials; lining teacups with fur; or having sculptures and paintings industrially fabricated obviously does not require the same types of technical skills that a naturalistic rendering of an apple glistening with condensation does. This move toward using the real as a means of expression became the foundation for the most important innovation of 20th-century art—the development of collage by Max Ernst, Pablo Picasso, and George Braque. Collage led to the development of photomontages by the Dadaists, Russian Constructivists, and the Bauhaus, which was informed by an ideological vision of an art that could be integrated into and transform everyday life as common things, rather than specialized forms. In this manner, photography significantly contributes to the modernist conception of art in terms of how and what can be represented, by challenging its historical means.

Against the backdrop of modernism's emergent practices, the photographer, gallerist, and progressive thinker, Alfred Stieglitz became a tireless advocate for photography as an aesthetic medium. Stieglitz was a talented "amateur" at a time when the world of fine art photography was made up of amateur photography societies and clubs. Professional photographers were those who maintained portrait studios, produced landscape, created documentary photographs or sentimental scenes for commercial consumption. Consequently, Stieglitz set about to establish the criteria by which photography could be practiced as an art form. He envisioned photography as a pictorial art, premised on the unadulterated image of what the photographer observed through the camera lens, rather than as something to be subjected to manipulation. As such, he opposed the practice of many fine art photographers who altered the photographic image by hand or chemically to make them painterly. Photography and painting in Stieglitz' view were distinctive art forms and each must follow their own course. Due to the new practices of abstraction, Stieglitz came to predict that photography would not be able to continue to follow painting. Yet, this was not true. While staying true to a purist camera approach, Paul Outerbridge, Jr., Edward Weston, Charles Scheeler, Edward Steichen, Imogen Cunningham, and Paul Strand created pictorial strategies that turned real-world things, such as barn siding, the patterns formed by leaves, or the simple geometry of industrial forms into abstract or semi-abstract images.

Just as painters continued to abandon the conventional point of view associated with traditional perspective, photographers began to explore the use of disconcerting viewpoints, taking photographs from above, from below, and at oblique angles to their subject. This produced distortions, deformations, and foreshortening, which called attention both to the optic system of the camera—which is not at all eye-like—and to the photographic image as something potentially unnatural. The sources of many of these effects were aerial photography and scientific studies of motion. The resulting disorientation, along with an emphasis on tonality, pattern, and shape, forestalled the conventional associations with objectivity and narrative, which had become photography's mainstay. It was by these means that photographers liberated themselves from the idea that the photograph was an unbiased image of the objective world. Photographers who had grown bored with conventional photographs used these means to create new visual experiences by creating unexpected visual effects.

As early as 1913 Alvin Langdon Coburn, a member of the Photo-Secession, used a pinhole camera to produce nearly abstract images. Exploiting photography's divided nature, these images presented the world from unexpected perspectives and orientations. Their downward views and distorted perspectives turned streets, squares, and buildings into abstract patterns, which he likened to cubist painting. These photographs took advantage of the fact that when a camera is not held level the building seems to be falling over because the parallelogram of the façade becomes a trapezoid. Although this effect is quite accurate in terms of academic perspective, photography manuals advised amateurs that if the world was to be accurately photographed it was to be photographed head on. Nevertheless, by the 1920s, this new perspective of angled shots and extreme close-ups had become synonymous with modernism and expressionism, which offered the photographer a vast array of compositional possibilities.

Extreme composition, light patterns, and obtuse perspectives and viewpoints were used by the Russian Constructivists and Bauhaus photographers as a way to reinvigorate documentary photography. These effects, all of which could be done in the camera, were used to create an image world that celebrated engineering, mass production, commerce, and fashion. Antithetical to the residual naturalism of these photographers were photographers who, in the first half of the 20th century, scorned the world of appearances by producing images whose artificiality and strangeness were apparent. From the perspective of those who were engaged in such experimentation, both the darkroom and the optical effects produced a truthfulness that was equal if not superior to that of the unadulterated photographic image. In this, they sought to be true to their medium.

Alvin Langdon Coburn also produced a portfolio of abstract photographs in 1917. He called these Vortographs and they were produced by constructing a kaleidoscope-like device consisting of three mirrors clamped together, through which he photographed still-life-like arrangements of crystal and wood. These produced prismatic images without any recognizable reference to the objects photographed. Coburn eventually abandoned this line of inquiry, though other photographers would take up various other approaches to making abstract images. By 1918 Christian Schad, a member of the Zurich Dadaist group, was making camera-less photographs using a technique borrowed from the founder of photography, H. Fox Talbot. By these means Schad produced images that closely resembled cubist collages by laying cut out pieces of paper and flat objects onto light-sensitive paper.

By 1921, painters Man Ray and Maholy-Nagy were exploring similar territory to that of Schad. The main difference between their work and his was that these artists/photographers made their camera-less photographs by placing three-dimensional objects, rather than cut up paper on light-sensitive paper. These objects produced complex images, which consisted of cast shadows and textures in the case of transparent or translucent objects. Although their processes were similar, their goals and imagery were significantly different. The Maholy-Nagy aesthetic was related to that of the Russian Constructivists. He considered his works an exercise in "light modulation" and was concerned with producing architectonic compositions rather than images of the objects he employed. The resulting images he called "photograms," while Man Ray, who was associated with both Dadaists and Surrealists, on the other hand,

chose objects such as a pistol, a spinning gyroscope, and an electric fan because these would cast evocative shadows and provoke associations to produce his "Rayographs."

In the same time period photographers and artists also began to experiment with a number of chemical effects. The best known is solarization or Sabattier in which a photograph that has been developed, but not fixed, is exposed to light and then continues to be developed. The image shows a reversal of tones and wherever there is a sharp edge and its contours are rimmed in black. Photographers also experimented with different ways of developing photographs such as subjecting the prints to rapid temperature changes, which produces an over all web-like texture. Many other effects mimicked X-ray exposures, astronomical photography, and photomicrography.

This process of transforming art into all manners of idiosyncratic things by the avant-garde artists and photographers of the 1910s and 1920s coincides with and is supported by the developing technologies of mass reproduction that were making traditional skills redundant. Walter Benjamin, the German philosopher and critic, in his 1937 essay "Art in the Age of Its Mechanical Reproducibility" describes how the advent of photography and the eventual making of moving pictures revealed how "aura had become a fetter on art's conceptual and political development." For Benjamin the mass production and distribution of images and texts held out the potential of ushering in a progressive political culture that held the promise of producing a democratic culture in which everyone would be a potential producer. Consequently, beyond the development of camera-less photography, the creation of photomontage and collage by artists such as Hannah Hoch, John Heartfield, and Georg Grosz, which is paralleled in the Soviet Union by Alexander Rodchenko and Gustav Klutsis, represents both the influence of cubism and the growing importance that mechanical reproduction played in the circulation of photographic images.

Mass culture supplied both photographers and artists with new sources of imagery as well as new types of visual experiences. Modern life was increasingly fractured along the lines of the public and private as well as the increased tempo of industrial society. Photomontage and photo collage, with their mixing of typography and photographic images, gives expression to these conditions while extending photography beyond what had become fine art photography's limitations and conventions. Though thought of as revolutionary, these innovations were premised on the tricks of the trade of the late 19th century work of commercial photographers, which included double-exposure, timed exposures, and darkroom techniques such as masking, burning, and dodging. The significant difference between the early manipulation of images and those of the 20th century avant-garde photographers and artists is that the latter emphasizes its fracture making it apparent that the photographic image is always a construct.

Coinciding with the formal drive to de-skill and re-orientate art, another vision of art as an expression of irrationality, the libinal and the abject was developing out of Dada's anti-art and anti-aesthetic. Surrealists sought to give representation to the irrationality of our inner world and the power of imagination, unlike the Dadaist who wanted to expose the madness of the world around us. To this end, the surrealist, while embracing all that was new, also sought to subvert art's traditional forms. Consequently, in the case of photography, there is a connection between surrealism and the documentary tradition. For the surrealist, the truth of photography was its ability to create an illusionary image of the unconsciousness that circumscribes our reality. As such, the French photographer Atget bridges the ideal of photography as an objective record of what is seen, and the surrealist fascination with the strangeness of the chance occurrences of everyday life.

Atget pioneered the cleansing of photography of all acts of aesthetization meant to make photography look like art. Today his views of Paris, due to the patina of time, look poetic. They can also be viewed in the context of the ability of the photograph to defamiliarize its object. Atget used the part to represent the whole to reorder the familiar genres of landscape and the candid photograph. His pictures are full of the common things that are forever present and therefore tend to be overlooked or forgotten. By the standards of the day, these pictures would have been considered empty in that they are eerily unpopulated. A similar move toward objectification appears in the work of August Sander who, rather than making portraits, photographed types. This distanced view of the strangeness of chance occurrences of everyday life

and representing people as objects bridges the ideal of the photograph as an objective record of what is seen with that of the psychology of the photographer inversely.

Hans Bellmer used photography in his Poupee Project to create strangely disturbing images that are disquietingly hallucinatory invoking trauma and mutilation. Bellmer sometimes took straight photographs of dolls; at other times he would exploit multiple exposures and super impositions of his poupees posed in familiar space. For these photographs, Bellmer created dolls that consisted of differing combinations of female parts, symmetrical pairs of legs joined at the hips, or at times nothing more than provocative bulges and swells. Other photographers such as Raoul Urbac explored the photographic process itself by submitting the photographic negative to heat to produce what he came to call Brulages. The deformed liquefied image on the negative constituted an attack on form, difference, and identity. Other states of formlessness were the result of the blurring of genres, for instance, when Man Ray photographs a female torso in such a manner as to produce an image in which her arms and chest can be read as a bull's head (Minataur, 1934). Likewise, a photo-work by Salvador Dali executed in collaboration with Brassai also crosses categorical boundaries invoking the found montage of bulletin boards where images of everyday life are juxtaposed, implying a narrative.

While the results of this intense period of experimentation and exploration of the photographic medium with its emphasis on process, phenomena, materiality, and mechanical reproduction became an important part of art's discourse, its most immediate and long-lasting effects were on the experimental films of artists such as Hans Richter, Viking Eggling, and Leopold Souvage who was interested in synathesia. In the 1950s and early 1960s, in the wake of abstract expressionism, Jonas Mekas, Stan Brakhage, Joyce Weiland, and Paul Sharits among others began to again explore film as an expressive medium. Their films construct abstract narratives by means of rhythmic editing, montaging of found footage, hand-drawn animation, and non-traditional processing. With the emergence of video in the 1970s, this analytic manipulation of the medium was employed by such artists as Joan Jonas, Keith Sonnier, and Frank Gillette and continues to be the basis for the video works of artists such as Bill Viola, Stan Douglas, Douglas Gordon, and Tacita Dean. Conversely, photo collage, with its political associations, came to be tamed by graphic designers and continues to play a significant role through the works of painter Robert Rauschenberg. Most notably this tradition within the context of post-modernism is exploited by Barbara Kruger and the Starn Twins who turned the history of experimental photography into a series of devices meant to self-reflexively expose themselves.

As we move into the 21st century, the discourse between critical culture and mass culture, the mechanical and the interpretive, the commercial and the creative continue to circumscribe photography's relation to the visual arts. This continues to be predominantly expressed through its relationship with its other: painting. Photography's influence on both abstract and figurative painting actually intensified during the last decade of the 20th century as both began to be imperiled by digital technologies. During the 1980s and 1990s painters such as Eric Fischl, David Salle, Troy Brauntuch, Jack Goldstien, Elizabeth Peyton, Richard Philips, and Luc Tuymanns made paintings that used photographs as their source, while photographers such as Hanno Otten, Penny Umbrico, and Thomas Shrutte explored photography's relationship to abstract painting. Their work is a critical extension of Pop Art and Photo-Realism, which flourished in the late 1960s and 1970s. Andy Warhol's work is an exemplary model. Unlike Rauschenberg or Rosenquist, Warhol's work explicitly acknowledges the sheer repetitiveness of the image world of photography and reproduction. Warhol's work is not only a depiction of the spectacle of mass culture, but his adaptation of the grid and his hands-off processes wed high art to popular culture by merging abstract painting in the form of ground to the photographic image as figure. The relation between photo silk screen images and its painted ground announces the interdependency of their alterity.

There are also insightful connotations in Warhol's work, as to the nature of photography and its relation to painting. This lies in the most obvious aspect of Warhol's work in that if the order of ground and photographic image were reversed, the painted ground would obliterate the silk-screened image. To paint over the silk screen the way that Rauschenberg does would

unhinge the visual equilibrium that this "natural" ordering makes explicit, which is that the photograph as a picture of something or someone is always already transparent. So we can either see the transparency of "representation" and the opacity of the painting (the ground) or their unity that produces a synthesis in which each element loses part of its identity while acquiring some part of its others. By these means, Warhol establishes the economy of the real (color and process) and the mimetic (image and temporality) by privileging neither. Warhol's use of photo silk screen comes to play a similar role to Picasso's use of collage in the progressive discarding of painting's tradition-laden baggage, while preserving its form.

On the heels of Pop Art, painters used photographs as subject matter to create an inclusive and discursive formalism, one in which issues of composition, opticality, and process would compliment rather than subjugate the image's contents. By these means, they set about recording the changing state of representation as it goes from observation to reproduction to replication. In doing this, these painters absorbed photography's simulacra back into painting. They did this by exploiting the knowledge that within the image world art had already come to exist as something most viewers believed could be known through reproduction. This condition was the central theme of Andrea Malraux's book *Museum Without Walls*. Consequently, the movement referred to alternately as Photo-Realism, or Sharp Focus Realism embraced and subverted the course of reproduction by turning the seamless information of photographs into the fractured information painting. This can be seen in Richard Estes and Ben Shonziet's paintings of urban street scenes and store windows, which when reproduced look as if they were color photographs. Another example of this use of the photographic look in painting would be Chuck Close's large-scale black and white airbrush mug shot-like portraits of friends from the 1970s and 1980s. Though the subject appears casual, Close works from photographs done by a studio photographer.

Another artist who has investigated the relationship between photography and painting, within the context of both Pop Art (as a source of imagery) and post-modernism (focusing on the look of the photographic image) is the German artist Gerhard Richter, who works both in figurative and abstract styles. The reference to photography, in Richter's case is indexed particularly to the idea of the focal plane and the photographic blur. He uses this effect not only in his figural works but also in his abstract paintings. The irony underlying this practice is that unlike photography, painting can never be out of focus, nor is their subject ever in motion, especially when the painting is an abstract one. With such practices painters not only explore how photography orders our perceptions but also our expectations. While many painters continue to work from photographs, others such as Gwen Thomas, Fabian Marcaccio, and Frank Stella either print digital images onto canvas, or incorporate them into their paintings where they are reworked to produce a hybrid form comparable to collage.

While artists in the 20th century were adapting to photography (and motion-picture) influences, photographers who aspired to develop photography into a creative medium used painting as their model. They appropriated art's traditional subjects, photographing tableaux vivants that mimicked neoclassical paintings, pastorals, and picturesque scenes replete with peasants. It is common for new forms during the period of their gestation to imitate (mimic) the traditional forms, which they will either eventually replace or significantly transform. Out of this process, given its tendency to be both commercial and more often then not kitschy, two counter-trends arose that would come to define fine art photography—one was interpretative and expressive, and its predominant aesthetic models were that of impressionism. This tendency is best represented by the works of Mary Devons. The other counter-trend, the documentary tradition, grew out early use of photography to record the world of people places and event. Photographers such as William H. Rau were committed to the idea that though the photograph is authored, it should in the main constitute an unmodified document of what is portrayed.

Given these formative practices and despite the periods of intense experimentation in which the aesthetic, structural, and conceptual concerns of artists and photographers often coincided, fine art photographer's concerns have remained decidedly different than those of the Modern artist. In part, this is because beyond the legitimating debates concerning the role of the photographer's authorial role, the respective truthfulness of the photograph, and

aesthetic issues, photography's broad-based popularity and accessibility had to be addressed both in theory and practice. In the pursuit of freeing themselves from being viewed as mechanical and scientific fine art photographers had to also overcome the fact that social and cultural location diminished its acceptability as an artistic medium. Its novel verity pleased the newly emergent middle classes, which embraced photography both as enthusiasts as well as consumers.

With the development of commercially produced film, processing, and mass produced cameras, amateur photographers came to dominate the field producing souvenir photographs of all types of events and occasions. Amateur photo clubs and societies became the mainstay of photography in the absence of any other institutional support and sprang up everywhere. The middle classes economically secure enough to have cultural aspirations having one's self photographed (from birth to death) first professionally and then as a constant stream of snapshots remains the fashion. The fact that anyone could take photographs without much skill or effort further diminished its acceptability as an art form (at least until the 1970s).

Creating a critical base for fine art photography

The photograph is never unique since (in most cases) it is made from a negative. It is therefore always a copy and always reproducible. Viewing a photograph in reproduction does not degrade it to the degree that a painting is degraded when viewed in reproduction. In other words, "mechanical reproduction had brought an end to the work of art's 'aura'". Yet, in the case of photography its aura has been institutionally established by fetishizing the vintage print (in which it is hoped the photographer had either authored that print or at least supervised its production). For the collector such editioning guarantees that there are a limited number of copies in existence and returns to an anonymous image the aura of authorship. Those photographers who make camera-less photographs or work with the intention of making unique works such as Lucas Samaras, Robert Mapplethorpe, and William Wegman, who had worked extensively with Polaroids, are of course the exception.

Given this complexity of issues, Alfred Stieglitz, at the beginning of the 20th century, worked tirelessly to differentiate the practice of art photography from the mixed bag of amateur and distinctly commercial interests. The photography community of the time viewed Stieglitz' circle as elitists because of the high critical standards and strict views that they held concerning the practice of photography as art. Rather than being interested in capturing a picturesque moment, or creating one in the darkroom, these photographers were committed to expressing a depth of emotion that was dependent on temperament and aesthetics while reinforcing the generally accepted view that veracity was photography's quintessential characteristic. To achieve these goals, Stieglitz asserted that fine art photographers not only needed critical criteria but they also needed to establish their own institutions based upon them.

The struggle to create an institutional base for art photography began with Stieglitz' founding in 1902 of the journal *Camera Works* and launching the organization Photo-Secession. This organization, due to its select membership of influential photographers, became the primary legitimizing institution for fine art photography. In 1905 with the opening of his gallery 291, Stieglitz further advanced photography's claim to being art by exhibiting photographers along with avant-garde American and European artists. Between 1908 and 1911 the photographer, Edward Steichen, and Stieglitz organized exhibitions that included Matisse, Picasso, Cézanne, Rodin, and Brancusi. Yet, despite this impressive record, when it came to the Armory Show of 1917 organized by the Association of American Painters and Sculptures, Stieglitz was little more than a consultant. Yet, the Armory Show permanently changed American culture, unleashing a new vision that wed science, revolution, and new artistic forms (including photography) together.

The triumph of the process of institutionalization and differentiation set into motion by Stieglitz culminated in 1929 when the Museum of Modern Art opened with a photography department that acknowledged both fine art photography as well as vernacular images as an important facet of Modernist practice. Ironically, in the 1960s such photography departments were finding it necessary to discriminate between fine art photographers and artists who were

imposed limitations of the tradition that defined their work as art. Acknowledging the fact that while a photograph is a record of what has been seen, they also refer to what had been excluded in the very process of its making. Others like Robert Cummings tackled the presumption that the photograph represents an isolated a moment in a continuum. Cumming's photographs of studio setups demonstrates how cropping masks the truth of an image by exposing how the photograph is just one frame in an endless sequence of other frames. His pairing of photographs exposes how what the photographer chooses to exclude or include creates a fiction in the guise of truth—each image is no more truthful then the other—and that the photograph creates its own truth.

Robert Frick took our expectations of what may take place before or after a given moment as his subject. He presents repeat images of his subject from differing distances, angles, and lighting in a grid format allowing the viewer to go from detail to whole. The resulting experience (that is both cinematic and minimalist in form) forces upon the viewer an awareness of how the framing of an image is an act of inclusion and exclusion and that our knowledge of a given situation is always a composite of multiple experiences. Other photographers, such as Eve Sonneman and Jan Groover, who straddled the art/photography divide also challenged the belief that a photographer's choice questions the notion of the photograph as representing the most significant or opportune moment within a given continuum by presenting what appeared to be sequential images. For instance, Sonneman would present similar sequences of images in both color and black and white in this way and in doing so she tested the sense of reality that photographs induced.

If photographers were interested in visually exposing how all photographs in one manner or another are fictions, Duane Michals and Frencesca Woodman used anecdote and narrative captions rather than titles to establish context for their images. Michals' work consists of narrative sequences of photographs accompanied by short handwritten text similar to storyboards. Woodman, on the other hand, includes short self-reflective texts. Such approaches extend photography beyond what had become fine art photography's limitations and conventions by suggesting other models of what might constitute the veracity of the image. This conceptual approach addressed the possibility that photography is capable of documenting something more than the external world while also corresponding to the renewed interest of contemporary artists in narrative and anecdote.

Openly using the photograph as an element in the con-struction of narratives has its roots in the history of staged photography, which developed in the days before the advent of moving pictures. This was also reflected in the experimental works of the surrealist photographers. The effect of these traditions is found in the allegorical photography of Clarence John McLaughlin, Ralph Meatyard, and Jerry Uelsmann. These created-for-the-camera or made-in-the darkroom visions form the bridge for the staged tableaux of the photographer Les Krims and the staged, manipulated images of the artist Lucas Samaras in the 1960s that form the segue into what photography critic A. D. Coleman identifies as the directorial mode of the 1980s.

Though often identified with post-modernism, such con-temporary artist/photographers as David Levinthal, Gregory Crewdson, Jeff Wall, Sandy Skoglund, Joel Peter Witkin, Laurie Simmons, and Cindy Sherman, respectively, exploited differing aspects of both photographic and cinematic traditions to naturalize what are obviously staged situations. This work is based on the theory that every photograph is the intersection of two complimentary precepts. These artists and photographers have self-consciously appropriated the conventions of photography's catalog of genres and exploit photography's ability to induce in us a state of suspended disbelief premised on our continued belief that photography in some manner is the shadow of the real. Mary Kelly, Carrie Mae Weems, Felix Gonzalez-Torres, Shimon Attie, and Krzysztof Wodiczko in the form of installations, or site-specific projections consequently, exploit the lack of a clear-cut division between photography as a means of commentary and reportage (the evidentiary) as a document and an artifice.

Also emerging in the mid-1980s, artists such as Sherri Levine, Richard Prince, and Barbara Kruger who were also identified with post-modernism, extended the critical practices of Pop

and Conceptual Art by making explicit the sociopolitical opacity of the photographic medium and its reproduction. Levine does this by photographing reproductions of the work of historically important photographers such as Walker Evans, Rodchenko, and Edward Weston. Upon cursory inspection, the viewer cannot discern her copies from the original. In doing so, she questions the authenticity of the fetishization of the vintage photograph in the sense that her reproductions of reproductions seemingly offer the same pictorial information and aesthetic experience. Likewise, Prince whose early photographic works consist of re-photographing images from advertisements and biker magazines, and Kruger, who works with appropriated photographic images, address how the implicit associations of a photographic image can be made explicit by textually and aesthetically contextualizing it.

The practices ushered in during the late 1980s meant to analyze modernism's essentialist myth of originality, authorship, and purity corresponded not only to the values of mass culture, but also the changing terms and conditions of cultural production and its media. Central to this was the degree to which advertising and mass media had immersed us in a world of simulated representations and reproductions created by new technologies that increasingly could simulate most other media. For the photographers this meant that due to digital imaging technologies the photograph was an aesthetic effect. Seemingly under such conditions, what had driven photography's discourse for more than a century—its capacity to compel (or challenge) us to believe that its referent is real and therefore capable of invoking the past—had come to an end. Yet under these conditions photography and its doppelganger, the photographic effect (of digital imaging), continues to be ordered by the look of photography's historical development and practices, as well as a self-conscious reference to its construct as a simulacrum. The distinction here is that digital imaging, though different in process, is indistinguishable in appearance beyond that of scale and on occasion material choice (paper, canvas, lamination, and inks).

The work of "photographer/artists" Andreas Gursky, Thomas Ruff, and Thomas Struthe is located at the intersection of those discourses concerned with the effect wrought by the technologies of mass production, reproduction, and replication and the historical imagery and practices that inform our conception of what photography is. Within their appropriation of the wide range of photographic genres and their ethos, these artist/photographers investigate the relation between three categories of media image—documentary (objective), aesthetic (expressive), and the collaged (constructed). Given the scale and clarity of digital photography, by extension their work also reopens the question of photography's relation to painting. In this digital imaging has a relationship to chemical photography that is similar to photography's relation to painting in its early days. As such, the evidence of the digital's effect on our consciousness may be observed in the changing relationship between painting, photography, and film as each succumbs to, resists, or is annexed into the experiences and aesthetics engaged by digital's media sphere. Consequently, just as modernism (which was stimulated by the advent of photography and the age of mechanical reproduction) is brought to its end, the differentiation between visual art and photography now exists only as an index of differing perspectives and contexts. ⑥

Photography and Society in the 20th Century

GRETCHEN GARNER
Independent photographic author and scholar

Introduction

It would be hard to imagine a technology that had more impact on 20th century life than photography: the automobile, the airplane, nuclear power, all of these were higher profile than photography, yet in day-to-day terms, photography was truly the most pervasive. Here the

effect that photography has had on 20th century society will be discussed in four distinct areas: amateur photography (making everyone a photographer), advertising photography (creating desire in the public), journalistic/editorial photography (informing and entertaining the public), and documentary photography (recording the lives of real groups of people).

Background

To imagine a social world before photography, we would have to think of a world without picture IDs; without portraits of ordinary people (or schoolchildren); one without pictures as souvenirs of travel; one without celebrity pictures; one without advertising photographs; one without X-rays or views of outer space; a world without views of foreign and exotic peoples; one without pictures of sports, wars, and disasters; and one in which the great masses of people had no way to visually document the important events of their lives.

Such a world is unimaginable to us now, and we have photography to thank for all these things: visual souvenirs, portraits of common folk as well as the famous, advertising pictures that have created desire in the public and educated them about all the products the new consumer culture has on offer, medical diagnostic tools, incredible views of exotic places and even of outer space, pictures of the world's news, and most important, pictures of the events and intimate moments of one's own life.

The technology of photography is part chemical, part optical, and dates from 1839. Soon after its simultaneous invention by William Henry Fox Talbot in England and Louis Jacques Mandé Daguerre in France, photography was used to document foreign places of interest such as India, the Holy Land, and the American West. It was also used for portraits with photographs taken of kings, statesman, and theater or literary personalities.

During the 19th century, however, cameras were mainly in the hands of professionals or self-educated entrepreneurs who tried photography as a trade. Interestingly, photography has never required professional licensing or guild membership (with the exception of Talbot's unsuccessful attempt to sell licenses early after his invention). In the mainstream, any tinker or businessman could buy the equipment, obtain the directions, and proceed. This openness of the medium made photographic practice rather free from the traditions that had grown up around painting or the various printmaking arts.

When pre-coated dry plates were introduced in 1878, the tedious and messy coating of glass plates in the darkroom (or dark tent, for photographers in the field) was eliminated, and when pre-coated photographic papers were made available, printing of photographs became much easier and more predictable. From this point on, photography could be practiced by hobbyists or amateurs (literally, lovers of the medium). Perhaps predictably, since most who had the leisure for such an advanced hobby were educated and sophisticated, they wanted to make photographs that looked like Art.

Amateur Photography

Thus, aspiring to art, the late 19th to early 20th century amateurs were interested in aping the artistic formulae they had learned from Whistler and the Tonalist painters of the time. To do this, soft-focus lenses, matte papers, and elaborate mounting and framing techniques were employed by the so-called Pictorialist photographers. Sometimes unusual emulsions would be hand-coated onto the printing papers, and often drawing or other handwork was introduced onto the images, either onto the negative or onto the print itself as if to say: This is not a mechanical art.

These Pictorialist amateurs formed themselves into societies and clubs. Clubs were formed in many European countries as well as the United States, and exchanges between their members were common. Magazines, such as *American Amateur Photographer*, kept the network of amateurs connected and provided technical information and news, as well as criticism. Many of the clubs sponsored journals, such as the New York Camera Club's *Camera Notes* (edited by Alfred Stieglitz until the membership grew dissatisfied with him, whereupon he started his own publication, *Camera Work*, 1903–1917). In the clubs, annual and even monthly salon competitions were held, and these salons and clubs continued into the mid-20th century, eclipsed only when academic programs in fine art photography replaced them for the most part.

The Kodak

Meanwhile, late in the 19th century, a sense that amateur photography could be marketed to the masses was building. The first entrepreneur to be enormously successful at this challenge was George Eastman. Eastman's company, the Eastman Dry Plate and Film Company, had been in business since 1884 in Rochester, New York. His breakthrough product was the Kodak camera of 1888 (no special meaning to the invented word, Eastman just liked the letter K). The Kodak was a plain box camera with a reel of paper-backed emulsion. The lens was a wide-angle affair, the shutter simplicity itself, and the printed pictures were circular. The pictures were lively snapshots (a new word in the vocabulary). Kodak's now-notorious advertising slogan was "You press the button, we do the rest." This was an appeal to the masses, not to sophisticated amateurs.

The camera was purchased for $25 with a 100-exposure reel, and when the photos had all been taken, the whole thing was returned to the factory for development of the pictures and reloading of the camera for a modest fee. In its second year, 1889, the Kodak carried its emulsion on a transparent nitrocellulose support, introducing film to photography and eliminating the need for the delicate stripping of the emulsion from the original paper base. A variety of slightly more complex folding Kodaks (cameras with bellows that allowed more precise focusing) were added to the amateur lineup of equipment by Eastman. The folders, as they were called, were popular into the 1940s.

Keep a Kodak story of the children

Autographic Kodaks, $5 up

Eastman Kodak Company, Rochester, N.Y., *The Kodak City*

FIG. 1 This 1926 Kodak advertisement from *Good Housekeeping* magazine shared a family-centered photography theme, which turned out to be a huge phenomenon and the rock-solid base of the Eastman Kodak's success. Early on, the Eastman Kodak Company emphasized the importance of family snapshots in their advertising and often the photographer pictured was a woman. (Image reproduced with permission of the Eastman Kodak Company, Rochester, New York.)

George Eastman realized early on that there was no existing need for his cameras. He had to create a need. Therefore, he invested heavily in advertising from the beginning. One of Eastman's prescient views was that women must be targeted, because women were the most likely recorders of family events and of their children's lives. From the early, rather saucy Kodak Girl to the mothers tenderly recording their offspring, women were seen as the largest potential amateur market for Kodak products—both cameras and films—and were pictured constantly in Kodak advertisements.

One of Kodak's most notable advertising campaigns was the series of Colorama pictures—enormous back-lit color transparencies, 18 × 60 feet—that hung high at the end of Grand Central Station in New York. The Colorama campaign extended from 1950 to 1990 and concluded when the station was renovated. The depictions featured family (or couple) activities, with the amateur photographer the focus of attention—either with a snapshot camera, like the Instamatic, first marketed in 1963, or with an 8 mm movie camera. The Kodak scenes were always ones of middle-class happiness and social activity, with the exception of a few dramatic NASA photographs such as Colorama #284, *Earthrise from the Moon*, 1967.

In Europe no marketer reached the populace with Eastman's success, yet the most important technical camera advances in the early decades of the century would happen there. These were more sophisticated cameras than the simple Kodak, adopted mostly by professionals and advanced amateurs.

The new miniature cameras

In 1924 the Ermanox camera was put on the market in Europe. This radical new instrument was very small, and it could be hidden in a vest for surreptitious shooting or held at eye level for quick framing and shooting. The Ermanox had a maximum f/2 lens (meaning a lens opening one-half of its focal length, quite a wide aperture), and could thus photograph in low-light situations. All this was almost revolutionary, but unfortunately, for its future, the Ermanox did not handle roll film. The truly revolutionary camera came along a year later in 1925 when the Leica was invented by Oscar Barnack. The Leica had the diminutive size of the Ermanox and a wide aperture on its excellent Leitz lenses, but, more important, used a length of 35 mm motion picture film. This allowed the sequential shooting of up to 36 exposures, instead of the single image taken in the Ermanox. The impact on professional, as well as amateur, photography was profound. Henri Cartier-Bresson was the most notable early practitioner with the Leica, but thousands of others—professionals and serious amateurs—soon followed.

Closely following the Leica came the Rolleiflex (1928), another German machine and also what was then called a miniature camera, although its negatives were 6 × 6 cm, and the camera was a twin-lens reflex held at waist level (now we call this a medium-format camera). Many imitations of both types of cameras ensued, several made by Kodak, and then the mix was enriched by the Japanese single lens reflex (SLR) cameras that came on the market in the 1950s (the pioneering Nikon was first marketed in 1948). These cameras also took 35 mm roll film, but the viewing and focusing mechanism, instead of a rangefinder, was a mirror/pentaprism that was more easily mastered for focusing by most amateur photographers. The Japanese SLRs were also more competitive in the amateur marketplace (many Korean War vets had also come home with these cameras).

Continuously, photography was made more accessible to the amateur. Even those who could not buy the Leica, the Rolleiflex, or the Nikon were able to buy knock-offs made by Kodak or other manufacturers like Ansco. At the same time, film was improving for amateurs. For example, Verichrome film, a wider-latitude black and white film, was introduced by Eastman Kodak in 1931, and in 1935 the still-unequaled Kodachrome color transparency film was introduced. It was followed in 1942 by Kodacolor film (color negative film, making color prints). These materials were used by professionals, but also were accessible to amateurs.

Polaroid

In 1947 Edwin Land introduced his instant Polaroid camera system. Its film/paper pack, as soon as the exposure was made, was pulled through rollers that released the chemicals that would develop the print. In a matter of seconds, the 4 × 5 print could be peeled from its negative, fixed with a saturated pad provided with the film pack, and enjoyed. Land invited many professionals to test his system, thus assuring a professional acceptance of Polaroid, but he also marketed the camera to amateurs. In 1963, color Polaroid material was introduced, and in 1973 the SX-70, the camera that had the most impact on amateur photographers, was put on the market. This oddly shaped little camera spit out square color images that developed right before the eyes, and it became a popular sensation. Although its technical problems (color balance and color stability) were formidable, the SX-70 was adopted by many.

As it had done with many other technical advances, Kodak came out with its own version of this camera, but this time Polaroid struck back in 1976 with a lawsuit against Kodak, suing for copyright infringement of their instant cameras. In 1985 Polaroid won their case against Kodak, and in 1991 Kodak paid Polaroid hundreds of millions. Such a big win did not save Polaroid, however, because the instantaneous possibilities of digital photography would make Polaroid's niche of instant imagery obsolete. In 2001 Polaroid filed for Chapter 11 bankruptcy protection, and the company's heyday seemed to be over. Ansco, an earlier competitor of Kodak, had also won a multimillion dollar suit against the Yellow Giant, as Kodak has been called, in 1914. Kodak was able to absorb these challenges, and although it has had its ups and downs, Kodak now survives in better condition than the now-defunct Ansco or the hobbled Polaroid companies. Kodak, after abandoning the serious camera market when the

FIG. 2 In this ad from 1947, Kodak appealed to the serious amateur who might like a Leica or Rolleiflex but also wanted a less expensive camera. Kodak also marketed its folding cameras in this ad. Later they would abandon serious camera manufacture as the American market became flooded with Japanese cameras, but recently has been very active with its highly acclaimed digital cameras for the amateur market. (Image reproduced with permission of the Eastman Kodak Company, Rochester, New York.)

FIG. 3 When Kodak introduced its Kodachrome film in 1935, it began using well-known photographers. In this example from 1947, Ansel Adams, who was not credited in the ad, was asked to test the film. The color negative Kodacolor was introduced to the market in 1942, the same year Agfa (Germany) and Sakura (Japan) introduced their color negative films. (Image reproduced with permission of the Eastman Kodak Company, Rochester, New York.)

Japanese had gained dominance, has now re-entered this arena with its digital cameras even as its film and paper markets diminish.

Photography without film

Digital, or film-less, photography has now gained dominance over film photography, especially in the amateur market. In 1981 Sony pioneered the genre with its Mavica camera, but without the supporting environment of Photoshop (first marketed in 1989), computers in every home, and high-quality digital printers, it took many years for digital photography to really catch on. In 2003, however, digital camera sales surpassed film cameras, according to the Photo Marketing Association. Many photo labs who have not accommodated the digital world have succumbed to this new regime. Kodak announced in 2005 that it would cease production of its black and white printing papers, further sealing the fate of darkroom photography. Meanwhile, the new giants in photographic printing, like Epson and Hewlett-Packard, are thriving in this new world.

Amateur photography for the masses can be seen as a positive, democratic social phenomenon—making everyone a visual recorder of his own life—but likewise it is a successful, capitalist business phenomenon. Without the lure of fortunes to be made from millions

of customers, it is unlikely that the businesses that have made such an impact would have entered the field.

Advertising Photography

Even as Kodak was using advertising to create a market for its cameras, films, and papers, the advertising industry itself turned increasingly to photography during the 20th century. Newspapers as well as the great number of popular magazines (especially in the pre-TV era) were the carriers of most of this print advertising.

The purpose of advertising was and is to create a desire for the new consumer products available to the public (sometimes advertisers call this education), and then, of course, to sell the products. Although drawings and painted illustrations were featured predominantly in ads during the early part of the century, gradually photography took over, and by the end of the 20th century virtually all visual advertising was photographic. Today, in the 21st century, digital photography has introduced the kinds of fantastic effects impossible in straight photography, further enriching the possibilities of advertising photography.

While half-tone reproductions of photographs had been possible since the 1880s, and magazines and newspapers regularly used them in their editorial pages, before World War I advertisers seldom did. The great shift happened in the 1920s and 1930s. By the mid-1930s photographs at least equaled hand-drawn illustrations in print advertising, and have only gained greater dominance since then.

Before WWI advertisements were generally reliant on copy to sell their products, which were often quite lengthy texts by modern standards. But after the war, a new attitude took hold. Some hopeful idealists saw advertising clients as modern society's new art patrons, the new Medicis, as it were, and felt there was no reason why the very best artistic talent should not be used in advertising. The advertising agencies hired art directors to manage this visual side of the work, and in 1920, The New York Art Directors' Club was founded to encourage advertising art by holding exhibitions and lectures.

European modernism/American realism

In Europe, which had been most disrupted by WWI, new artistic styles like Cubism, photo-montage, and even photograms were translated to successful effect in photographic advertisements and posters. In America advertising photographers generally practiced a more realistic style, albeit often with dramatic lighting and extreme close-ups. Edward Steichen was the most prominent example of these new advertising artist-photographers.

In the first decade of the century, Steichen had been a famous Pictorialist photographer, partner, and talent scout for art photography impresario Alfred Stieglitz. But after the War (in which he served as an aerial photographer), Steichen changed directions. When he returned to the United States in 1923 he began a career not only as a successful fashion and portrait photographer for *Vogue* and *Vanity Fair*, but he opened his own commercial studio to produce advertising photographs as well. Stieglitz disdained his new direction, maintaining that artistic and commercial work were irreconcilable, but Steichen made a great success of both. The two men never reconciled. Later, of course, Steichen served again as a military photographer in World War II, and then in 1947 became the Director of Photography at the Museum of Modern Art in New York, where his most famous exhibition was the vastly popular The Family of Man in 1955.

Other prominent early advertising photographers in the United States (whose work is now held by art museums) include Paul Outerbridge, Gordon Coster, John F. Collins, Alfred Cheney Johnston, Victor Keppler, Lejaren à Hiller, Nickolas Muray, Anton Bruehl, and Grancel Fitz.

The question whether the new patrons of art, the advertising clients, actually did encourage true Art is one that cannot be answered in the affirmative unless the pictures are removed from their intended purpose and somewhat cynically understood. Although Steichen may have created a fresh and striking image of cross-lighted Camel cigarettes and Fitz a wonderful view of sophisticates observing a new Chevrolet, the overriding ethos of the pictures was to sell the cigarettes and the cars.

And for that, no amount of glamorizing or fantasy was too much; in other words, these pictures did not partake of the highest modernist photographic value, truth. The people seem always content and upper class (there is never any sign of the Depression), and nondescript products are rendered as stunning, abstract, modernist designs or else not rendered at all, as in the case of the Chevrolet ad, where class atmosphere was the only thing pictured.

This truth about advertising photography—that it does not necessarily describe the truth—is understood now by one and all (including savvy consumers), yet commercial photography has continued to attract talent, and enormous amounts of money continually change hands in this field. After mid-century, any number of artistic giants gained prominence in advertising (Irving Penn, Richard Avedon, Bert Stern, Henry Wolf, and Hiro, among others) as advertising gave a kind of stylistic license to photo-

FIG. 4 Photograph by Grancel Fitz for a General Motors Company ad made in 1933 for a campaign produced by Campbell Ewald Company. (Image courtesy of GM Media Archive.)

graphic exploration. Especially as large photographs came to dominate advertisements late in the century, the sheer impact of the photographs demonstrate the creativity alive within advertising.

How well has photographic advertising worked? There is no truly objective answer to this question, but suffice it to say that increased desire for and consumption of goods bears tribute to the effectiveness of vivid and alluring advertising photography. Corporations with a product to sell, and brands looking for image identity, have continued to use photography to sell themselves to the public, continuing to believe in the 1930 ad copy by the Photographers' Association of America, headlined: "SELL MORE . . . with photographs."

Journalistic/Editorial Photography

As advertising photography has opened a Pandora's box of desires for the products consumers can buy, so has editorial photography opened the treasure chest of information the public can know and know in a visual, not just verbal, sense.

People love pictures. Text without pictures is boring to the mass audience. Drawings and engravings had been used in newspapers and magazines for as long as the technology had allowed, and in 1880 that technology expanded to include half-tone reproductions of photographs (the mechanical rendering of continuous tone photographs into larger and smaller dots of ink on the page).

Photographs soon became a staple of the daily paper. The development of the wirephoto, scanned photographs beamed across telegraph and telephone wires, also sped up the worldwide dissemination of news pictures. The Associated Press pioneered its AP Wirephoto, sending pictures to its member networks beginning on January 1, 1935. In terms of quality, rotogravure sections (higher quality printing devoted solely to pictures) were a feature of Sunday papers up until the introduction of the Sunday supplement magazines, mostly in color, that are familiar today.

In the last quarter of the century most newspapers made the transition to color printing for photographs on their news pages, led by the successful and colorful *USA Today*. Even the staid *The New York Times* made the transition to front page color in the 1990s. *The Wall Street Journal* remains the only holdout among the major papers.

FIG. 5 In 1935, when Berenice Abbott photographed this newsstand in Manhattan as part of her documentary, *Changing New York*, all of the covers on the magazines were painted illustrations. Today they would all be photographs. (Photograph credit from the Photography Collection, Miriam and Ira D. Wallach Division of Arts, Prints and Photographs, The New York Pubic Library, Astor, Lenox, and Tilden Foundations.)

The magazines

As important as newspapers were, the greatest mass vehicles for photographs in the 20th century were actually the picture magazines. With higher quality printing and coated paper, and less need for daily, topical news, the magazines had the liberty to present more features and greater variety in their coverage. And in a world before television, the weekly magazines were literally readers' windows on the world, eagerly devoured and subtly creating a common visual culture.

Magazines were a staple of early 20th century culture, as Berenice Abbott's 1935 photograph of a newsstand demonstrates, but covers and major illustrations were usually drawn or painted. Fashion and celebrity photographs, to be sure, were already being published in magazines like *Vogue* and *Vanity Fair*, but when *Life* came on the scene on November 23, 1936, America had its first completely photographic general interest magazine.

Life and the picture magazines

America did not lead the way, however, with picture magazines. The pioneer had been the *Illustrated London News*, and in the 1920s, the European picture magazines, particularly the *Berliner Illustrirte Zeitung* (*BIZ*), and in France, *Vu*, took the lead. So when publisher Henry Luce and his favorite photographer, Margaret Bourke-White, went on a European pilgrimage, they were looking for already existing models for the yet-to-be-born *Life*.

The prospectus for *Life* spelled out the challenge, and especially the visual emphasis, the new magazine would have:

To see life; to see the world; t o eyewitness great events; to watch the faces of the poor and the gestures of the proud; to see strange things—machines, armies, multitudes, shadows in the jungle and on the moon; to see man's work—his paintings, towers and discoveries; to see things thousands of miles away, things hidden behind walls and within rooms, things dangerous to come to; the

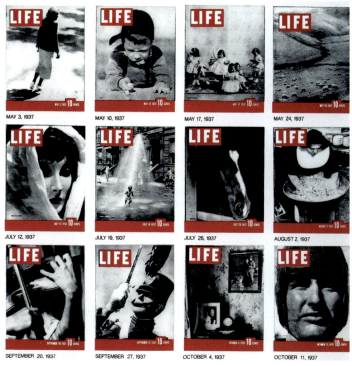

FIG. 6 When *Life* magazine came on the scene in November 1936, bold photographic covers were its style. *Life*'s dedication to using photographs extended from the covers into the entire contents of the magazines shared in a series of magazine covers from the publication's first year. (Reproduced with permission of *Life* magazine, New York.)

women that men love and many children; to see and to take pleasure in seeing; to see and be amazed; to see and be instructed.

To see, above all, was the mission of *Life*. At its initial newsstand price of 10 cents, it was irresistible. The magazine encouraged many superb photojournalists, such as W. Eugene Smith, especially in the development of photo-essays, whole stories that would be told visually, in contrast to the single images for which most newspaper photographers were known.

When *Life* was released on November 23, 1936, it began a hugely popular run that did not pause until 1972, when the impact of television (including lost advertising revenue for the magazine, as well as diminished interest in a weekly news magazine) caused *Life*'s demise. Although it has had monthly, annual, and semi-annual format revivals since then, *Life* has never regained the central position in American culture that it had between 1936 and 1972. Another picture magazine that met a similar fate was *Look*, also closing down in 1972.

In the era of television, beginning mid-century, the general interest magazines like *Life* and *Look* lost their grip on the imagination of the public. But since then, magazines that appeal to special interests, particular lifestyles, and celebrity culture have continued strong in the market, all of them featuring photography (now exclusively in color) in their pages. Today's magazine giants include the fashion magazines like *Vogue*, the lifestyle magazines like *Martha Stewart Living*, and the celebrity magazines like *People*. Any number of more specialized publications fit niche readerships: men, women, hobbyists, and enthusiasts of all kinds.

War coverage

The news in the 20th century was as visual as it was textual. Every 20th century war—from World Wars I and II, the Korean War, the Vietnam War, to Desert Storm, and many smaller,

often guerilla, wars in between—was covered photographically. Some well-known journalists such as W. Eugene Smith, David Douglas Duncan, Larry Burrows, and Susan Meiselas, for example, have become best known for their war photography. *Life* magazine came on the scene in late 1936 with World War II on the not-too-distant horizon. *Life*'s coverage of that war in both the European and Asian theaters was thorough, and many of the visual icons we all remember from WWII were first published there. Excellent war coverage was a strong element of *Life*'s success.

The kind of hopeful early idealism that held that if people could just see the devastation of war, they would stop it (W. Eugene Smith, for one, hoped his photographs would have this effect). Sadly this has not been realized. The thrill of violence in picture form continues as a staple, and it seems to titillate as much as it horrifies the public. Nevertheless, censorship of war pictures is currently a strategy of the U.S. government and its coalition forces fighting in the present Iraq conflict. In this war initial policies forbade press pictures of draped coffins, so that readers at home would not think of the inevitable—death—in relation to this war. Such was the government's thinking, but it seems that the public has become well aware of the price of death that American soldiers are paying, as numbers of casualties and deaths have risen and support for the war has declined. In another effort to control journalists and photographers in the current Iraq conflict, the policy of embedding them within defined military companies has limited their freedom to look for their own news.

Also, no end of trouble has ensued from the outrageous amateur images that a few American soldiers made of their torture of prisoners in the Abu Ghraib prison in Iraq. The scandals that erupted when the pictures became public have borne witness to the continuing power of photographs, whether professional or amateur.

Other news and technologies

Sports events and celebrities, natural disasters, great artists, entertainers, fashion, and food were also made visible to the daily reader of the paper or the weekly reader of the news magazines in the 20th century. Many photojournalists in the first half of the century continued to use their Speed Graphics when photographing news or celebrity features, but gradually the 35 mm camera became standard equipment after mid-century, and photographers armed themselves also with repeatable electronic flash units instead of the one-use flashbulbs that earlier had been standard.

The electronic flash was invented by Professor Harold Edgerton at MIT in 1931, but it took some years for the handy, small units that fit onto a camera hot shoe to become common. These automatic units (with a sensor that could shut off the brief flash when the right amount of light was received by the subject) were pioneered by companies like Vivitar in the late 1970s with its Vivitar 283 and the development of its Thyristor light-measuring circuitry.

Today, most photojournalists have quit their film cameras in favor of digital cameras gaining added speed from sending their pictures back to editors via the Internet, with no delays for film shipment, film development, or printing. Because their cameras record everything in color (but that color can be transformed to black and white with the click of a computer button), color is generally used in magazines and on the front pages of newspapers, while black and white

FIG. 7 Photograph by Joe Petrella for the *New York Daily News*, January 12, 1944, shows Mrs. Frank Sinatra and her newborn son Frank, Jr. surrounded by photographers in the hospital. Note all the photographers are using Speed Graphic cameras and flashbulbs. Frank, Sr. is present only in the framed photograph on her lap. (Reproduced with permission of the *New York Daily News*.)

may be used inside. Color, it is thought, is more appealing to the public, with an added level of realism.

National Geographic

The continual success of fashion and celebrity magazines throughout the 20th century has been noted already, and another, in a class by itself, was the monthly *National Geographic*. This magazine showed pictures of far-away locales and cultures that were exotic to the readers, and brought them to life in vivid, beautifully printed color photographs. Less dependent on topical stories than the weekly *Life*, it positioned itself as an educational journal of geography, and its subscribers as members of the National Geographic Society. This, and the increasingly lavish color printing of its photographs, has ensured its viability.

The *National Geographic* had printed photographs since 1895, and was an early pioneer of color, reproducing more than 1500 autochromes (an early type of color transparency) between 1921 and 1930. In 1936, when Kodachrome film became available, it became the standard film for the eventually all-color magazine.

National Geographic has continued to evolve in the kinds of stories it presents, as the exotic world seems to have been thoroughly explored. More stories today are about explorations of science, weather, and medicine, but the coverage is always strongly photographic, and the magazine continues to be hugely popular.

Printed photographs thus have played an enormous role in educating and informing the 20th century public, as well as entertaining them.

Documentary Photography

There is a final branch of photography directly related to popular social life, and that is documentary photography. Documentary projects generally focus on social reality and human life, informed by the strong feelings of the photographer. They are photographs with a point of view, focusing not just on events, but on the daily texture of life of their subjects. Many reformist projects in the earlier years of the 20th century were documents of disadvantaged social groups in dire straits, poverty, and cultural alienation. But projects toward the end of the century have tended to be more personal to the photographers, sometimes documenting the photographer's own social group and concerns.

Reformist photography

While documentary projects have not always appealed to a mass audience, they have played an important role in changing perceptions and sometimes even in influencing legislation. Lewis Hine said about his photographic efforts that he wanted to show both what should be appreciated but also what should be changed. And indeed, his documentary coverage of child labor in the first decade of the century was effective evidence used in the development of child labor laws in the United States. And his later documentary coverage of workers constructing the Empire State Building (1930–1931) turned these little-known men into 20th century heroes. Hine followed Jacob Riis, who similarly tried to reveal the deplorable living conditions in the tenements of New York in his book, *How the Other Half Lives* (1890).

Roy Stryker, director of the Historical Section of the Farm Security Administration (FSA) during the Depression, organized a federally subsidized documentary project (1935–1943) of a scope never seen before, or since. Stryker was proud to state that the FSA project introduced Americans to America. His large staff of photographers were sent around the country to record the plight of Americans suffering from the Depression, and the pictures were distributed to many papers and magazines, including *Life*. There, in the magazine pages, mostly middle-class readers were brought face to face with the kind of hardships suffered by less visible and less privileged Americans. While the reformist purpose of the photographs was less evident than their overwhelming appeal to human sympathy, the project as a whole was a public relations effort of an agency of President Franklin Roosevelt's government, an effort to popularize his agricultural reforms. Dorothea Lange, Walker Evans, Ben Shahn, Russell Lee, and Arthur Rothstein were a few of the important photographers employed by the FSA.

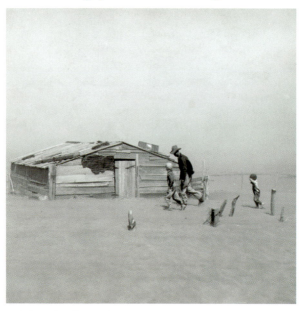

FIG. 8 Photograph by Arthur Rothstein. Farmer and sons walking in the face of a dust storm. Cimarron County, Oklahoma, 1936. Farm Security Administration—Office of War Information Photograph Collection. Library of Congress Prints and Photographs Division, Washington, D.C. [reproduction number LC-DIG-ppmsc-00241].

These photographs are now in the Library of Congress, and many have entered the iconic imaginations of Americans.

Other impressive 20th century documentary projects include Edward S. Curtis' massive documentation of the North American Indian, which was published in 20 volumes between 1907 and 1930, and in Germany a rather similar project by August Sander, conceived after World War I, which he called "People of the Twentieth Century," that he intended to publish in a series of 45 portfolios. Because of Nazi persecution much of Sander's work was destroyed, but some of his pictures had been in circulation and a large compendium, titled *August Sander: Citizens of the Twentieth Century*, was published in 1986. Sander photographed with an almost clinical neutrality. He believed the physiognomy of his subjects, posed very simply, would tell the story.

Sander's work has influenced many documentarists whose work is similarly evasive or neutral in terms of viewpoint; for example, Bruce Davidson's *East 100th Street* (1970), rather affect-less pictures of the so-called "most crowded block" in New York. Yet other strong documentarists have continued in the

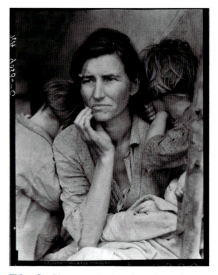

FIG. 9 Photograph by Dorothea Lange. Migrant Mother. A photograph from the Farm Security Administration Collection, made in February or March of 1936 in Nipomo, California. (Courtesy of Library of Congress, Prints & Photographs Division, FSA/OWI Collection. Reproduction number LC-USF34-9058-C.)

sympathetic, reformist mode: Sebastião Salgado in his mammoth study *Workers: An Archaeology of the Industrial Age* (1997); Eugene Richards in *Cocaine True, Cocaine Blue* (1994); Mary Ellen Mark in her *Streetwise* (1988), and Donna Ferrato in *Living With the Enemy* (1991). However, tendency toward more neutral viewpoints (as in Davidson) or more personal subjects has been the late-century trend.

The Family of Man

In mid-century, in the midst of the Cold War, Edward Steichen conceived and developed a hugely popular exhibition at New York's Museum of Modern Art called The Family of Man. The show was visited by thousands in New York in 1955 and by millions more at its many tour sites around the world (the international tour was sponsored by the U.S. Information Agency).

Steichen wanted to create an exhibition about the similarity of human culture all over the world, and to do so he solicited photographs worldwide, which he edited down to certain themes he had pre-determined. Most of the 500+ prints that ended up in the show were pictures in the documentary tradition. Unfortunately for the individual visions of the participating photographers, their own viewpoints were diminished in Steichen's grand scheme, based on his editorial vision and selection of single images. Nevertheless, most viewers seemed to appreciate Steichen's vision of the one-ness of mankind, and documentary photography (even though this was not a documentary project per se) was showcased in a very public, international forum. The Family of Man catalog is still in print and popular, 50 years after the exhibition.

Personal documentary

After mid-century, and after the uneasy critical reception of The Family of Man (despite its popular success), much documentary style photography turned in a more personal direction, and has been less appreciated (or even accessible) by the general public. The first notable project in this direction was Swiss photographer Robert Frank's *The Americans* (published in France in 1958 and in the United States in 1959). Not really a sympathetic portrait of Americans, not even a credible survey of American life, the book was a personal, melancholy (if not downright negative) view of Frank's adopted land. Critical reception was mixed, but in hindsight one can see the importance Frank's book had in turning documentary away from reformist or celebratory modes.

Several photographers began exploring their own social groups late in the century. For example, Bill Owens, in his *Suburbia* (1973) documented the very place where he lived with his young family, in suburban California, and British photographer Tony Ray-Jones offered a light-hearted spoof of his fellow countrymen at play, in *A Day Off* (1974). Larry Clark documented the drug culture he inhabited in Tulsa (1971). More recent examples of the genre include Larry Sultan's *Pictures from Home* (1992), Sally Mann's *Immediate Family* (1992), and even Nan Goldin's *The Ballad of Sexual Dependency* (1986).

Later, even more personal documentaries have given up, one might say, any kind of connection with a wide public, so they don't need to be mentioned here. Such pictures are generally exhibited in art galleries and published by specialized art publishers and don't reach a broad magazine or newspaper audience. And the general trend, toward the personal instead of the public and has made documentary less engaging to the general public. However, in its glory days in the first half of the 20th century documentary played a socially significant role in the culture by introducing its viewers to fellow humans whose lives they would have never glimpsed otherwise.

FURTHER READING

Bendavid-Val, L. (1994). *National Geographic: The Photographs*. Washington, DC: The National Geographic Society.

Bezner, L. C. (1999). *Photography and Politics in America: From the New Deal Into the Cold War*. Baltimore: Johns Hopkins University Press.

Capa, C. (ed.) (1968). *The Concerned Photographer*. New York: Grossman.

Fulton, M. (1988). *The Eyes of Time: Photojournalism in America*. Boston: NY Graphic Society/ Little Brown.

Garner, G. (2003). *Disappearing Witness: Change in 20th Century American Photography*. Baltimore: Johns Hopkins University Press.

Hall-Duncan, N. (1979). *The History of Fashion Photography*. New York: Alpine Books/ International Museum of Photography.

Hurley, F. J. (1972). *Portrait of a Decade: Roy Stryker and the Development of Documentary Photography in the Thirties*. New York: DaCapo Press.

Kunhardt, P. B., Jr. (ed.) (1986). *LIFE: The First Fifty Years, 1936–1986*. Boston, Toronto: Little Brown.

Meltzer, M. and Bernard, C. (1974). *The Eye of Conscience: Photographers and Social Change*. Chicago: Follett.

Sobieszek, R. (1988). *The Art of Persuasion: A History of Advertising Photography*. New York: Harry N. Abrams. ◎

Photography and Desire: Fashion, Glamour, and Pornography

BRUCE CHECEFSKY
The Cleveland Institute of Art

The invention of photography in the 1830s brought voyeurism to the masses. It made public what was previously only imagined and secret.

The great early erotic–pornographic photographers proved that high shock value and intense sensuality compelled the reader to pay attention, willingly or otherwise. Nineteenth century fashion photographers learned this lesson quickly. Desire has always been the common objective of pornography and fashion photography.

Many 19th century photographers who shot nudes chose to remain anonymous, so it is virtually impossible to attribute their work. Among the few who are documented are William (Guglielmo) Plüschow (1852–1930), Ernst Heinrich Landrock (1878–1966), Rudolf Franz Lehner (1878–1948), Vincenzo Galdi (active 1880–1910), Louis-Amédée Mante (1826–1913), Léopold-Emile Reutlinger (1863–1937), Wilhelm von Gloeden (1856–1931), Paul Nada (1856–1939), Gaudenzio Guglielmo Marconi (1841–1885), and Stanislaus Julian Walery (1863–1935).

Pornography undermines the power dynamics between male and female, photographer and subject. It reinforces crude, restrictive sex-role stereotypes and standards of beauty. Despite its adverse social implications, the pornography industry in the United States earns revenues of more than $10 billion annually, with up to $2 billion spent on porn Web sites. Pornography ranges from profound explorations of desire to highly stereotyped sexual explicitness, and from soft-core images of attractive models to graphic depictions of kinky sex acts.

Glamour photography, on the other hand, generally stops short of showing explicit sex; it is intended to be erotic. Mainstream erotic–pornographic imagery is as polished as fashion photographs from publishers Condé Nast or the Hearst Corporation.

Fashion Photography Pioneers

Fashion photography started in the 1850s when couturier Charles Worth began using live, moving models to show his clothes. While the half-tone process for printing photographs revolutionized print culture, the invention of the sewing machine made possible the mass production of clothing. By 1900, the number of national magazines carrying apparel ads grew tenfold.

Commercial photographers proliferated at the turn of the century and learned to adapt to the needs of potential clients. Some concentrated on fashion photography, furniture, or food, while others concentrated on automobiles or heavy machinery. Their styles were influenced

by the fledgling movie industry and companies such as the Jesse Lasky Feature Play Company, which designed detailed, convincing sets for film versions of Broadway hits. Photographers readily adapted the realistic style to their clients' products.

The new approach to editorial photography in magazines was met by an increasingly sophisticated use of photography in advertisements. For some couturiers, this style conveyed too much information; they were concerned about keeping exclusive rights to their designs, so they did not trust fashion photographers immediately.

The first illustrated fashion magazine, *Vogue*, was launched in 1892, but fashion photography did not replace illustrations until Condé Nast hired Baron Adolphe de Meyer in 1913 and Edward Jean Steichen during the 1920s to take experimental pictures. De Meyer (1868–1946) is best known for his effective use of backlighting and the soft-focus lens. Though static, the pose was often natural, and the picture was arranged using a strong pattern of vertical elements, which gave a sense of authority and formality.

Edward Steichen (1879–1973) was born in Luxembourg, moved to the United States in 1881, and first photographed fashion models in 1911 for the magazine *Art and Decoration*. His use of very simple props was modernist, but his elegant arrangement of forms was classical in its order. Steichen did not have a studio of his own, and he wrote that his first fashion photographs were made in a Condé Nast apartment:

For the first sitting, we had a good-looking young woman wearing a handsome and rather elaborate gown covered down the front with rich embroidery. I had never made photographs with artificial light, but there was the Condé Nast electrician with a battery of about a dozen klieg arcs, wanting to know where he should put the lights. I said 'Just wait,' and went to work with the model in the natural daylight of the room. . . . Not knowing what to do I asked for a couple of bed sheets. No one at a photographic fashion sitting had ever asked for bed sheets, but Carmel Snoa, fashion editor of Vogue *at that time, had a policy that a photographer should have whatever he required, no questions asked. When the sheets came in, I lined up the chairs in front of the electrician's lights and over them draped a four-ply thickness of sheets, so that when he turned on the lights, they didn't interfere with my model. The electrician was satisfied. I heard him say to one of the editors 'That guy really knows his stuff.' Applied to electric lights, this statement was as far from the truth as anything imaginable . . ."*

Steichen realized that adding artificial light to natural light was his greatest ally in getting variety into fashion pictures, transforming advertising photography from straightforward pictures of a product to more natural, sensuous depictions. This innovation made Steichen the most highly paid photographer of the 1930s.

Like Steichen, Anton Bruehl, Nikolas Muray, George Hoyningen-Huene, Horst P. Horst, and Cecil Beaton successfully manufactured consumer desire in the face of the great economic uncertainty of the 1930s.

Born a baron in St. Petersburg in 1900, Hoyningen-Huene left his country soon after the Bolshevik Revolution, traveling in a rarified circle that included Coco Chanel, Greta Garbo, Salvador Dali, Jean Cocteau, Cecil Beaton, Marlene Dietrich, and Kurt Weill. He began his career as a fashion draftsman publishing his drawings in *Harper's Bazaar* and *Fairchild's Magazine*. By 1925, he was the chief photographer for French *Vogue*. In 1935, he moved to New York and began working almost exclusively for *Harper's Bazaar*. His photographs, best known for their sensuous formality and sophisticated use of lighting, were void of deceit; they presented the model not the photographer.

Cecil Beaton recognized at the start of his career that print and other mass media had the power to make reputations. In 1929, he contracted with Condé Nast to photograph the new stars of cinema. His charm gave him access to celebrities; his romantic vision of royalty was increasingly in demand.

Beaton juxtaposed elegant and common objects to convey a comical sense of play. The images were shocking to *Vogue* editors, who were used to Steichen's formal, straightforward images. Beaton's fashion photography was influenced by his set design work in theater; in

1958 he won an Oscar for his costume design in *Gigi*, and in 1964 for costume design and art direction/set direction in *My Fair Lady*.

Beaton was working for British *Vogue* in 1930 when he received a visit by Hoyningen-Huene and Horst P. Horst, who had met that year and traveled to England together that winter. The next year, Horst began his association with *Vogue*, publishing his first photograph in that November's French edition.

Best known for his photographs of women and fashion, Horst also is recognized for his photographs of interior architecture. His work often reflects an interest in Surrealism. Most of his figurative work displays his regard for the ancient Greek ideal of physical beauty.

Horst carefully arranged the lighting and studio props before each shoot. He used lighting to pick out the subject; he frequently used four spotlights, often with one pointing down from the ceiling. Few of his photos contain background shadows. While most of his work is in black and white, much of his color photography uses monochromatic settings to set off a colorful fashion. A 1942 portrait of Marlene Dietrich is considered his most famous work.

Male nudes began to appear during the 1930s in the work of Herbert List, who made homoerotic photographs. By 1936, his pointed anti-Nazi opinions and homosexual friends forced his exile from Germany to London. He settled in Paris, where he worked as a fashion photographer for *Vogue, LIFE, The Studio, Photographie, Arts et Métiers Graphiques,* and *Harper's Bazaar*.

List's photographs featured young, healthy male bodies in strong sunlight, a significant contrast to the high-society fashion images of women from the same period. There is a feeling of voyeurism in work such as Amour II, taken on the beach at Hammamet, Tunisia, in 1934. His images are explicit without showing anything that would stir controversy. During the 1980s, Bruce Weber and Robert Mapplethorpe would follow List's path, pushing the boundaries of decency while raising important issues of homosexuality and society.

World War II

The development of hand held cameras, faster film (the 1/1000 Leica), the Rolleiflex, and color film during the 1930s elevated fashion photography from ad illustration to fine art. The easy portability of the new cameras meant fashion photographers were less bound to the studio.

Fashion photography was considered frivolous during World War II, however. The fashion industry in France effectively closed because it lacked materials, models, and safe locations. Photographers still working in London often had to shoot during air raids to meet production deadlines. Studio photography, with its props and setups, became too costly. The French *Vogue* studio closed its doors in 1940 as Hitler entered Paris, and many photographers, including Horst and Man Ray, immigrated to New York. There they found a new type of fashion photography in the youthful exuberance of American culture. Back in Europe, material restrictions changed fashion photography from decadent aristocratic images to straightforward, no-nonsense magazine work. For Lee Miller in wartime Paris and Beaton in war-torn London, fashion photography recorded important historical and social events. Miller, a *Vogue* war correspondent, produced photographs that were compassionate but unsentimental, even while she was under combat on the front. While men either were drafted or fled Europe, women like Miller pictured models in the latest version of a gas mask or military-influenced utilitarian clothing. Magazine publishers viewed the resulting photographs as intriguing staging grounds for a new type of fashion photography that concentrated on the interests of women.

In New York, commercial photography continued unaffected by the war, and Louise Dahl-Wolf did her first fashion work for *Harper's Bazaar* in 1936. She had trained at the California School of Design with noted colorist Rudolph Schaefer and had honed a flawless instinct for the psychological effect of luminosity. She had an eye for subtle change in tone, line, and color. A pioneer in large format photography, Dahl-Wolf brought high resolution and exact color to fashion photography with the new 8 × 10 Kodachrome sheet film. She influenced fashion photography for decades by depicting women as feminine rather than as objects of desire.

In 1943, the FSA disbanded, sending many talented documentary photographers looking for work elsewhere. Gordon Parks attempted to find a position with a fashion magazine, but

the Hearst Organization, publisher of *Harper's Bazaar*, would not hire a black man. Edward Steichen was so impressed with his work that he introduced Parks to Alexander Liberman, director of *Vogue*. Liberman, in turn, put Parks in touch with the senior editor of *Glamour*, and by the end of 1944 his photographs appeared in both magazines. Parks joined *Life* as a photojournalist in 1948, shooting a distinguished documentary series for Standard Oil on life in America. His work during the Civil Rights movement remains among the most compelling images of the 1960s.

Post-war Growth

The post-war increase in production of consumer goods shifted attention to mass-market, ready-to-wear clothing. Russian-born Alexey Brodovitch helped *define the new market* with unposed photographs and pioneering use of angular, Russian Constructivist influenced space, transcending the traditions of the fashion magazine.

Brodovitch was art director of *Harper's Bazaar* from 1934 to 1958. He replaced the narrow vertical layout with a compositional structure using single rectangles spread over several pages. His experiments with white space and different type styles challenged photographers. "Astonish me," he often said to them. "When you look into the camera, if you see an image you have ever before, don't click the shutter." Among his students were photographers Irving Penn, Richard Avedon, and Art Cane as well as art directors Bob Cato, Otto Storch, and Henry Wolf.

Lillian Bassman, born in New York City, was a painter with the Works Progress Administration in the 1930s when Brodovitch discovered her. From the 1940s through the 1960s, she brought a new aesthetic to fashion photography with her dreamy, moody abstract images. Bassman experimented in the darkroom, blurring and bleaching areas of the photograph for dramatic effect. Her personal project from the 1970s, Men, is a series of large cibachrome prints of musclemen in which she distorted her subjects into monsters and heroes.

Alex Liberman lived through the revolution in Russia and war in Europe, moving first to London, where he attended school, then to Paris, where he studied painting with Andre Lhote and worked briefly at the photographic newsweekly *Vu*. In 1941, he moved to New York, where a prize he had won for magazine design at the 1937 Exposition Universelle in Paris earned him a foot in the door at *Vogue*. Liberman was named art director in 1943. In 1962 he became editorial director of all Condé Nast publications, a position he held until 1994.

A painter, sculptor, photographer, and graphic designer, Liberman crossed the imaginary boundary between the commercial and art worlds, much like Brodovitch. Liberman commissioned artists Joseph Cornell, Salvador Dali, Marc Chagall, Marcel Duchamp, Robert Rauschenberg, and Jasper Johns to work on projects for the magazine. An often difficult and demanding editor, his tenacity for change in the fashion magazine culture influenced a younger generation of photographers, including Diane Arbus, Bruce Davidson, Robert Frank, Robert Klein, and Lisette Model.

For photographer Irving Penn, the aim of fashion photography was the truthful depiction of a sociological subject, stripped of props, beautifully composed, where women were sensitive and intelligent. Penn enrolled in a four-year course at the Philadelphia Museum School of Art, where Alexey Brodovitch taught advertising design. Three years after Penn graduated, Brodovitch hired him as his assistant. In 1943, Penn took up photography professionally when a still life photograph he arranged—consisting of a leather bag, scarf, and gloves; several differently colored fruits; and a topaz—was published on the cover of *Vogue*.

Influenced by the simplicity and natural light of painters Giorgio di Chrico and Goya, Penn quickly developed an expressive formal vocabulary. He dispensed with the naturalism, spontaneity, and the theatrical lighting so much a part of the previous generation's technique. He often posed his subjects in a blank white space, removing all references to their surroundings, keeping them emotionally detached. His elegant femininity was imitated in the work of Henry Clark, John Rawlings, and John French.

The 1960s as Reaction to the 1950s

Fashion photography at the start of the 1960s was revolutionary and futuristic. Photographers wielded considerable authority over magazine designers as experimental fashion rose to the forefront of design. Third-wave feminism, anti-war demonstrations, and Pop Art shook fashion photography out of its romantic retrospection. Photographers exposed the body with blatant sexuality; the playful and sometimes perverse eroticism between body and clothes promoted sexual liberation.

Bob Richardson emerged as one of the most influential fashion photographers during the 1960s. His work for *Vogue* anticipated the strategies of 1990s fashion photography by borrowing camera angles and lighting from experimental film directors like Antonioni and Goddard.

While Richardson's highly original images caused anxiety among editors at *Harper's Bazaar*, Richard Avedon quickly became recognized for his genius as a photographic dramatist. Avedon presented the model as pretty, but not glamorous. Gone were the goddesses of the 1930s and 1940s; Avedon's early work was spontaneous, improvised, and accidental. His photographs of models were real, and his subjects were full of life and vitality. Avedon depicted women as astute and resourceful.

Influenced by novelist Marcel Proust, Avedon sought insight into societal behavior. He viewed individuals as isolated, and throughout his career he would remove his subjects from their surroundings and place them in a neutral studio environment.

By the late 1950s, Avedon worked only in the stark white space of his studio. He believed the studio would "isolate people from their environment . . . they become in a sense symbolic of themselves." He developed his signature style: models set against a plain white background, often airborne, illuminated by the harsh light of the strobe.

Avedon's great achievement as a fashion photographer was to become a barometer of the times, reflecting back to the viewer—sometimes brutally—the realities of social conditions. To refocus his fashion interest, Avedon photographed mental patients in the East Louisiana State Hospital in 1963. He continued to photograph while traveling through the South, and in 1964 he published a collection of photographs of white racists and civil rights workers in *Nothing Personal*, with text by James Baldwin.

Around the same time, Avedon began using Twiggy, a 16-year-old model from London. Twiggy shot to fame in the 1960s as the boyish rage of the London fashion scene. Her skinny, boyish look was a radical reversal from the voluptuous female of the 1940s and 1950s. In the late 1960s *Newsweek* described her as "four straight limbs in search of a body," but her sex appeal captivated readers during the decade of the miniskirt and the birth control pill, a time when women asserted themselves as never before.

William Klein, by contrast, encouraged his models to act rather than pose. He photographed them on the street without regard for the background.

In 1954, Klein had returned to New York after six years in Paris when Alex Liberman unexpectedly hired him to photograph New York City for *Vogue*. Klein approached the city as an ethnographer. His snapshot-style aesthetic was crude, aggressive, and vulgar; his prints were grainy, blurred, bleached, or repainted. He experimented with wide-angle and long-focus lenses, long exposures combined with a flash, and multiple exposures.

The editors of *Vogue* were shocked by Klein's view of the city. Consequently, he wasn't able to find an American publisher for his book *New York, New York* (1956). In France, however, where the book was eventually published, he was a resounding success and won the Prix Nada.

Although not usually associated with fashion photography, Diane Arbus was hired by *Harper's Bazaar* in 1962 to photograph children's fashions. Her photographs made little distinction between fashion and the personal. She made three extensive series of remarkable photographs for the *The New York Times* in 1967, 1968, and 1970. The photographs show clumsy, outcast, and dejected children, making them the most disturbing fashion images ever published.

David Bailey, the prototype photographer–hero of the 1960s, was a young London-based member of the "Terrible Three," which also included Terrence Donovan and Brian Duffy.

Bailey's fashion photographs were stark, streetwise, and spontaneous beyond anything done before. His images were sexually charged by his notorious personal and professional relationships. Michelangelo Antonioni's film *Blow Up* exploited Bailey's rapid-fire shooting, where the camera-as-penis was the only thing between the viewer and the female subject.

In New York, art director-turned-photographer Bert Stern rose and fell in the fashion photography hierarchy. Stern reversed the outer-directed approach of George Hoyningen-Huene; Stern's photographs were about himself, not the model or the apparel. Pop culture defined Stern, and accordingly his contributions to fashion photography are best represented by his experiments with silk screening and offset printing. In 1971, Stern's lavish lifestyle, million-dollar studio, and thousand dollar fees caused his empire to collapse.

Post-war Porn

The 1960s marked a turning point in sexually explicit photography. Fashion magazines explored the sexual and social codes in clothing and gesture; style, elegance, and social status gave way to overtly sexual narratives.

By the late 1960s, however, nudity in fashion magazines had lost its shock value; it had become common. Meanwhile, American pornography, still comparatively conventional in the 1960s, evolved from *Playboy* and *Modern Man*—photographs of nude or semi-nude women, their genitals and pubic hair hidden—to the more explicit *Penthouse*.

In the 1970s, Helmut Newton and Guy Bourdin crossed boundaries with a style of fashion photography that was sexually aggressive and violent.

Berlin-born Newton fled Germany for Singapore in December 1938; a month after Nazi-led attacks on Jewish communities threatened his life. The experience had a profound effect on his photographs. He created an erotically charged world full of sexual predators and sexual prey. His unique mixture of sex and theater became his signature style. Newton's images for American *Vogue's* "Story of Ohh," featuring a man, two women, and a dog, are considered uncompromising in their depiction of open, forceful lust. The piece caused a scandal when it first appeared. The title refers to the French pornographic novel *The Story of O* by Pauline Reage (a pen name for Anne Desclos), in which the masochistic heroine is a fashion photographer.

Newton's fascination with photographing nude women led him to *Playboy*, where in the mid-1970s he photographed Debra Winger and Grace Jones. His edgy, erotic images changed not only fashion photography, but also fashion itself. He became a household name and the most copied fashion photographer of the 20th century. Newton later moved away from graphic violence to exploiting the relationship between sex and power: lovemaking without love.

Bourdin, however, increased the graphic display of horror. In a 1975 shoe advertisement for Charles Jourdan, Bourdin fabricated a car crash scene where a woman had been thrown from the car and killed. Her body had been removed from the scene, but a white chalk outline of her outstretched arms and legs remained. Bourdin strategically placed a red Jourdan shoe amid the wreckage.

The public response was outrage. Bourdin claimed to have taken his cue from another famous fashion photographer, Cecil Beaton. Beaton describes the scene forty years earlier: ". . . it would be gorgeous . . . to take the (same woman in a suit) in a motor accident, with gore all over everything and bits of car here and there." (From "I am Gorged with Glamour Photography," *Popular Photography*, April 1938.)

Some critics consider Bourdin's soft-porn images sexually liberating. In his lingerie photographs, Bourdin's subjects are lit softly and naturalistically. The clothing is sexualized; women stand next to a bed with their legs open. His concept of women as vulnerable is reinforced by his use of shadows to create a sense of mystery and threat. His images are painstakingly constructed. Clues are scattered throughout the image, but he puts the burden of interpretation on the viewer.

Despite Bourdin's use of violence as spectacle, he has created some of the most compelling images ever published in fashion magazines. Some of his 1970s photographs would raise issues of censorship even today.

Chris von Wangenheim avoided Bourdin's overt sexual violence. His photographs were published in the men's magazines *Playboy* and *Oui* in addition to fashion magazines. His fashion images from the 1970s, however, involve voyeurism and sadomasochism taking him closer to Bourdin's psychosexual images.

Post-1960s Fashion

The Vietnam War brought fashion down to earth. By the early 1970s clothes were more realistic and wearable and were depicted by women photographers like Eve Arnold, Deborah Tuberville, and Sarah Moon.

The style of French photographer Moon was grainy, out of focus, and mysterious. Subculture photographers revered her "moments of awakening" images. Moon was the first to photograph a bare-breasted young woman for the Italian tire company Pirelli's popular cheesecake calendar.

Questioning the very basis of fashion photography, fashion-editor-turned-photographer Deborah Tuberville once asked hairdresser and makeup artist Jean Paul Troili to make the models ugly rather than beautiful. Images from Tuberville's *Public Bath House* series from 1975 convey mystery and sugges-tion, but she was criticized for evoking a concentration camp.

During the early 1980s—the "Me" Decade—Ronald Regan won the presidency with a conservative agenda, AIDS appeared, and the freewheeling disco days ended. Women's fashion reflected responsibility and restraint as newfound wealth gave birth to a Nouvelle Society.

By the late 1980s, however, supermodels emerged as icons of perfection and material success. Waif-like model Kate Moss became a symbol of 1980s excess. The female body depicted in mass media became increasingly thin; *Playboy* centerfolds' bust and hip measurements increased while their waist measurements decreased significantly. At the same time, innovative fashion images spoke more about attitude than clothes. Images of prostitution, lesbianism, and transvestitism appeared in many fashion magazines.

Fashion photographer Herb Ritts became known for glamour photography, his black and white portraits of male and female nudes reflecting an interest in classical Greek sculpture. He first gained national attention with portraits of his friend Richard Gere, and often worked with *Harper's Bazaar*, *Rolling Stone*, *Vanity Fair*, and *Vogue*.

Newton and Bourdin continued to exert significant influence on young photographers. They made some of their best work during the 1980s.

1960s Fashion Precipitating 1980s Porn

Erotica and pornography looked more like fashion photography and pushed the boundary of high shock value further than before. Nude men, homoerotic images, and powerful, aggressive women challenged the conventions of erotic imagery.

The 1980s saw art photographers turn to fashion photography for inspiration. California photographer Jock Sturges best represents their use of erotica, which he claimed was unintentional.

Sturges introduced images of children and young people, some in full frontal nudity. In 1990, the FBI and the San Francisco Police Department raided his studio and they seized Sturges' camera and film negatives. The following year, a grand jury declined to indict him on charges of child pornography on constitutional free speech ground. The controversy over his pictures continues today. Sturges' books *Radiant Identities* (1994) and *The Last Days of Summer* (1991) have been banned in many public libraries throughout the country, but his photography career has flourished, with sold-out exhibitions in major cities like New York and Los Angeles.

Sally Mann also was accused of child pornography for *Immediate Family*, a series of portraits of her son and two daughters taken at home and in the nearby foothills of Virginia's Blue Ridge Mountains. Mann's photos are disturbing in their honesty and emotional intensity.

In David Hamilton's book, *The Age of Innocence* (1995), teenage girls, nude from the waste up, are posed boudoir style and photographed in color through a soft-focus filter.

Suze Randall garnered attention in the 1980s while working for top adult magazines like *Penthouse* and *Playboy*. Working as a fashion model in the early 1970s, she became known

for erotic photographs of her fellow model friends. Her breakthrough came when she spotted the pinup model Lillian Müller and photographed her for *Playboy* in 1975. Müller became Playmate of the Year in 1976.

Late-century Fashion

In the 1980s fashion photography lacked any clear direction, except in the work of Bruce Weber.

Europeans had grown tired of hard-core fashion pornography, and the erotic images of the 1970s had faded. In America, the 80s was the decade of kitsch and conspicuous consumption. Mediocrity was met with approval and acquisitiveness by the Nouvelle Society.

Weber became known for his Calvin Klein advertisements, which introduced the blatant male sexual object into the artistic canon of fashion. The male nude flourished in fashion photography, and as a result of Weber's work, the Adonis-like "New Man" emerged with a focus on the body, not the clothing. The photography was not unique except for the gender, but it pushed Puritanism and homophobia to their limits. It was overly erotic, said some critics, but Weber's homoerotic fashion photographs remain masterful examples of gender-specific images. Weber successfully sold male-on-male sex. The decade of uninhibited self-indulgence ended with fashion photographers setting up scenes: mini-docudramas that were culled from the archives of avant-garde cinema and were meant to intimidate. Photographers began to appropriate images from pop culture for psychological manipulation. Magazines like *Tank*, *W*, and *Harper's Bazzar* used this style of fashion photography to sell lifestyles, not products.

Artists and photographers crossed over to advertising throughout the 20th century with great success. Man Ray, Fredrick Kiesler, Herbert List, Edward Steichen, Irving Penn, and Andy Warhol all contributed significantly to fashion photography. In the 1980s, it became increasingly common for mainstream fashion magazines to hire artists and art photographers.

Nan Goldin, more than any photographer of the decade, epitomized this trend. She launched a style of fashion photography that was grittier than those of Helmut Newton or Deborah Tuberville. In 1985, *The Village Voice* commissioned Goldin to produce images for its first advertising insert, *View*. The resulting series "Masculine/Feminine," consists of pictures of Goldin's women friends dressed in men's underwear and lingerie. These images, taken in a Russian bathhouse on New York's Lower East Side, are highly personal snapshots, deliberately unglamorous and raw.

More 1980s Porn

Pornography became less glamorous as well in that amateur pornography grew steadily, capturing a significant portion of the non-commercial photography market. The videocassette recorder brought snapshot pornography within reach of anyone. It led to pro-am pornography; professionally produced pornography involving amateur or first-time performers. These pieces often started with a host introducing the new actor, then a minimum of dialog, followed by scenes in which the amateur is prompted on camera to perform various sex acts, including masturbation, oral sex, intercourse, and lesbian or gay sex. Married and same-sex couples were encouraged to experiment for the camera.

Soon, personal computers refined the process. Color monitors with improved screen resolution, greater graphics capabilities, and modems created a boom in adult movies and personal Web site pornography. Couples shot home movies and photographs and distributed them among friends. Baby Boomers, once the force behind the sexual revolution of the 1960s and 1970s, also fueled this industry.

Gay pornography, although evident in the 1950s in *Physique Pictorial* and *After Dark*, hit the newsstands in the late 1970s. It gained wide circulation in both the straight and gay communities during the 1980s.

Robert Mapplethorpe's politically explosive 1989 retrospective at New York's Whitney Museum was seen by tens of thousands of viewers in Cincinnati, Boston, and Berkeley. His highly stylized and eroticized imagery disturbed some critics and politicians. In 1990, Cincinnati Art Center director Dennis Barrie was tried on obscenity charges for refusing to

remove homoerotic images from Mapplethorpe's exhibit. The controversy dominated the news, and although Barrie was later acquitted, the trial added momentum to the religious right movement. It led to Congress's revocation of grants from the National Endowment programming for individual artists.

1990s Porn

Pro-am sex photography became an underground culture in the 1990s with a highly personalized style appealing to various sexual subcultures. By then, pornography was challenging societal boundaries as it featured sexual penetration, homosexuality, group sex, and fetishes.

Certain photographers became prominent with this culture. Michele Serchuk and Paul Dahlquist used a variety of soft-focus techniques to emphasize body form, while Michael Rosen's studio portraits involved sadomasochism, erotic piercing, gender play, and what he calls "non-standard penetration." Barbara Nitke used her friends to create beautiful, intimate images between consenting adults. Vlastimil Kula's photographs explored sexual territory in which sex, taboo, love, passion, and rebellion are the key themes. Roy Stuart's pictures were a fascinating look into explicit forbidden voyeurism. Ray Horsch, Will Roge, and Ron Raffaelli used various ways of altering their photographs, including computer manipulation, long exposure, and grainy infrared film. Sexual subculture is emphasized over technique in the work of Vivienne Maricevic (outlawed peep and lap dancing shows), Barbara Alper (sex clubs), Mark I. Chester (radical gay sex), and Mariette Pathy Allen (transsexuals and cross-dressers).

With the 1990s, the work of Nick Knight, Richard Kern, and Mark Borthwick brought grunge and *street* fashion to avant-garde fashion magazines such as *Dutch, Purple, The Face, Big, Spoon*, and *Visionaire*. Borthwick broke through the conventions of fashion photography with highly designed performances set against the backdrop of architecture. Kern, best known as an underground filmmaker, turned to still-frame photography. Like his films, Kern's fashion images explored the psychosexual drama of porn and punk. Knight, on the other hand, likes to refer to social issues like breast cancer awareness in his pictures.

The anti-fashion model Cindy Sherman focused the camera on herself for *Harper's Bazaar* in 1993. Her series *Fashion* explored voyeurism, femininity, and costume in the fashion industry using closely cropped photographs to emphasize voyeuristic impression. The bleak vulgarity of fashion photographs of the 1960s and 1970s by Guy Bourdin, Helmut Newton, Bob Richardson, James Moore, and Jerry Schatzberg reappeared in the 1990s in the youthful alienation images of Collier Schorr and Glen Luchford. Schorr's pictures of shirtless young men confuse gender in their sexual ambiguity. Her work is often about androgyny and identity, and boyish masculinity. Luchford collaborated with artist Jenny Savile in 1995 to produce a series of compelling photographs that capture the full tonality of flesh. Savile, a well-known figurative painter, underwent reconstructive surgery and wanted to express the violence and pain associated with the operation. Luchford photographed her body pressed against glass, producing grotesque images of distorted flesh. It was fashion collaboration unlike any seen before. Digital imagery and computer manipulation in David La Chapelle's work recalled surrealist photography, suppressing and blurring the visible facts. La Chapelle remains interested in an artificial, constructed and staged reality. His photographs express mixed feelings and unease about our world. Corinne Day, a self-taught photographer, was shunned by *Vogue* magazine for her unflattering images of supermodel Kate Moss. Day ignored the magazine and spent the last decade photographing her friends in confrontational, unconventional, and highly personal portraits, with drugs, sex, and abandonment as dominant themes. Day's most successful work revolves around her close friends Tara and Yank, and her own diagnosis, surgery, and recovery from a brain tumor in 1996. Steven Meisel embraced a sphere of elite in his fashion photographs, confronting us with excessive wealth unknown by most people. Meisel worked against the tide of youth culture seen in fashion photographs of Jurgen Teller and Wolfgang Tillmans.

Jurgen Teller, who does not consider himself an art or fashion photographer, has a casual and blunt documentary style. Teller is interested in the depth of a photograph rather than its surface. Wolgang Tillmans, one of the most influential photographers to emerge during the 1990s, produces raw images of traditional subjects like portraiture, landscape, and still life

meticulously arranged in classical compositions. His focus on the everyday resembles sociological and ethnographical inquiries. Both Teller and Tillmans have found success in the art world.

The interchange of ideas between the fashion and art worlds influenced Larry Sultan, who gained national attention as a photographer for his series of portraits of his parents in *Pictures from Home*. In his most recent book, *The Valley*, Sultan examines the complexity of domestic life invaded by the porn industry by focusing on porn's mechanics: set, actors, and equipment. The images are reminiscent of 1930s photographers Horst P. Horst and Cecil Beaton. Today, pictures by Horst, Beaton, and Sultan are displayed and sold in art galleries or auctioned for a dollar amount unimaginable just a few decades ago.

Other fine art photographers, including Philip-Lorca di Corcia, Tina Barney, Larry Sultan, and Ellen von Unwerth effectively worked both fashion and art. They paved the way for a new generation of photographers who again are reinventing fashion photography, including Paolo Roversi, best known for his romantic fashion images and portraits using 8 × 10 Polaroids; Mario Testino known for his highly polished, exotically colored scenes of aristocrats; and German-born Peter Lindbergh, influenced by his childhood background in the West German town of Duisburg near the Rhine River where one side of the river was flanked by green grass and tress, and stark industrial landscape on the other. Lindberg uses this contradiction to create dark, contrasting images of models set against decaying post-industrial architecture.

Current Work

Today's catalysts include photographer and filmmaker Craig McDean, renowned for his striking fashion imagery and portraiture. In 1999, McDean published *I Love Fast Cars*, a series dedicated to the world of drag racing. He has also directed commercials for Versus fragrance and Calvin Klein's Contradiction.

Alexei Hay draws on photojournalism and Hollywood inspired backdrops. Like Philip-Lorcia di Corcia, Hay moves effortlessly between magazine and gallery work. Hay sympathizes with his models, never concealing their personal identity. He challenges the stereotypical fashion image by using bearded and two-headed models and prosthetics.

Others who have made recent statements in fashion photography include Steven Klein, who stands out among his peers in his view of the hypersexualized male; self-taught photographer Mario Sorrenti, who rose to fame in the early 1990s with his candid black and white images of his daily life and his launching the career of supermodel Kate Moss; Richard Burbridge, whose close-up portraits are brutally confrontational; and Ruven Afanador Torero, whose work is heavily influenced by his native Colombian culture.

Commercial pornography is still directed toward a male audience and generally emphasizes sexual arousal and desirability. In recent years, however, pornography for women has become more common in magazines and on commercial Web sites. The poses and facial expressions follow a pattern similar to that of male pornography, and the results presumably are the same.

Despite its prevalence, sexual photography, pro-am photography and film, and pornography remain highly controversial. Sex is a private pleasure in Western culture, and witnessing other people performing it challenges society's boundaries. Sex today is more obsessive than the liberating 1960s and our visual culture is increasingly crowded with images of it.

Fashion photography and art have merged to form a new hybrid of fash-art photography. The influence of pornography on both forms is undisputable. Fashion trends construct gender identities that reflect our sexual fantasies. Fetish subcultures and an attraction to fashion's dark side have provided designers and photographers with a rich source of material for decades.

Ours is a sex-fearing culture, and as long as boundaries are drawn between what is "normal" and what is "subversive," fashion photography will survive, prosper, and challenge us.

Photography Programs in the 20th Century Museums, Galleries, and Collections

LYNNE BENTLEY-KEMP, PH.D.
Florida Keys Community College

Photography has benefited greatly from the vitality and intellectual curiosity of its practitioners and its audience since its inception in 1839. The history of photography has been recorded and preserved by collectors, artists, scholars, bon vivants, and adventurers worldwide. Collections of photography span the vastness of the medium itself. Photography has been embraced as an art form, document, scientific record, and means of remembrance. It has expanded our universe and given us a language that, like all languages, adapts and evolves with culture.

The act of collecting is as old as civilization. Human beings have collected walking sticks, shells, mineral specimens, toys, and objects of aesthetic interest throughout history. Curators, the people who manage and exhibit collections, have preserved many of the most valued objects in museums so that they could be appreciated by generations to come. Collecting as a personal passion has become more widespread in the 20th century, primarily due to the "broadened conceptualization of things that are collectible."

Photography has been attractive to collectors due to a multitude of factors, some personal, some universal. At first it engaged the curiosity of the viewer, with its seemingly magical capture of an image on a surface. Later photographs became collectible due to perceived meaning, subject matter, or maker. Beginning in the 1970s photography has grown as an art form and its acceptance by significant cultural institutions has contributed to photography's cultural and artistic status. Museums, galleries, and academic institutions have been major factors in the explosion of photography and have played an important role in creating the enormous demand for the medium.

"Museums make their unique contribution to the public by collecting, preserving, and interpreting the things of this world. Historically, they have owned and used all manner of human artifacts to advance knowledge and nourish the human spirit." This statement is part of the American Association of Museums Code of Ethics and presents the role of the museum as one that connects the public to material culture at large. Galleries tend to be more specific as to the type of art that is exhibited and sold to collectors. The function of a gallery tends to be more economic than historic. Therefore, a gallery's primary responsibility lies in marketing the work of artists. Both museums and galleries present the medium to the public and act as gatekeepers by signifying what objects possess cultural value and are worthy of exhibiting and collecting.

Looking at the many ways in which photography has affected the world it is no wonder that throughout the 20th century museums that house photographs and galleries that exhibit the state of the art, and collections of photographic materials have grown complex and become varied in scope and size. Artistic boundaries have blurred to an amazing degree and following major technological and aesthetic changes the photographic arts have evolved as a key element in multimedia, installation and performance art.

Art photography came of age in the 20th century and museum professionals and gallery directors have fostered its development into a mature art form. It is not surprising that the growth of photography has occurred predominantly within wealthier nations that have enjoyed relatively stable political climates. England, France, Germany, Japan, and the United States house many of the most important collections and support a substantial percentage of exhibition spaces. The industrialization of these countries in the early 1900s played a prominent role in the rise of photography and was largely responsible for the birth of the Modernist movement in art. Modernism became a catalyst for the acceptance of photography as an art form, but it was not until the late 1960s that photography was truly established as an art worthy of exhibition to the serious art collector and connoisseur.

During the Modern era photography was strongly influenced by avant-garde painting, sculpture, and architecture. The images of serious photographers were brought into the canon through the work of forward-thinking curators, collectors, and gallerists. By 1914 New York City had become the center of Modernist art and the toehold that Europe had on the art world shifted to major cities in the United States.

Alfred Steiglitz was a quintessential New Yorker and his contributions as a photographer, curator, collector, and critic did much to establish photography as a modern art form. Stieglitz' active promotion of the art created a platform from which serious photographers could display their virtuosity. Stieglitz' publication *Camera Work*, his galleries, and his association with the avant-garde community gave Stieglitz the fuel for his iconoclastic support of a modern aesthetic movement in photography. Steiglitz believed that photography was most certainly a fine art and that the artists he supported (i.e., Paul Strand, Charles Sheeler, and Morton Schamberg) represented "the expressive potential of photography."

Stieglitz' influence spans a pivotal era of photographic history beginning with his 291 Gallery in early 1900, the Photo-Secession Gallery with Edward Steichen, and An American Place, which endured until his death in 1946. He influenced a progression of New York galleries beginning with Julien Levy's gallery in 1930.

The galleries that exhibited photography reflected the passion of people who were singularly suited for the task. Alfred Stieglitz, Julien Levy, Helen Gee, Lee Witkin, and Harry Lunn were all seminal figures in the commercial marketing of photography as art. These people believed in the medium and had the prescience to exhibit and recognize many that would go on to become established as masters of photography.

The Julien Levy Collection, now housed in the Philadelphia Museum of Art (PMA), is made up of nearly 2000 images that Levy collected during the 1930s and 1940s. Levy was the most influential proponent of photography in New York from 1931 to 1948

FIG. 10 The White Fence, Port Kent, New York, 1916. Photogravure print. Photograph by Paul Strand. (Courtesy of George Eastman House Collection, Rochester, New York.)

FIG. 11 The Bubble, 1907. Photogravure print. Photograph by Anne Brigman. (Courtesy of George Eastman House Collection, Rochester, New York.)

exhibiting the work of Eugene Atget, Ann Brigman, Imogen Cunningham, Charles Sheeler, Man Ray, and Lee Miller to name just a few of the 130 artists represented in the PMA collection.

Although the market for photography did not come to fruition until the 1970s, Helen Gee's Limelight Gallery in New York in 1954 and Carl Siembab's gallery in Boston in 1961 managed to present a varied and vital presentation of the medium showing the work of Minor White, David Vestal, Wynn Bullock, Arnold Newman, Elliot Porter, Ruth Bernhard, Roy DeCarava, Nathan Lyons, Carl Chiarenza, Aaron Siskind, and many others who would go on to make an impact in the world of art photography.

FIG. 12 Peace Warrior (Samurai) 492, 2003. Gelatin silver print. Carl Chiarenza. (Courtesy of George Eastman House Collection, Rochester, New York.)

Lee Witkin entered on the gallery scene in New York in the 1970s. The Witkin Gallery was a presence in the world of photography for many years exhibiting the work of most of the important photographers of the time. The Witkin Gallery became one of the most successful commercial galleries of photography and ushered in the era of marketing photographs as legitimate fine art investments. When Witkin died in 1984, Harry Lunn, a fine art dealer in Washington, DC, took over as a pre-eminent collector and supporter of photography as a fine art. In 1970, when Lunn discovered Adams' "Moonrise, Hernandez, N.M.," he began a campaign to move photography into the realm of fine art collecting. His first show of Adams in early 1971 drew the attention of

FIG. 13 Avenue de l'Observatoire 1926. Silver printing out paper print. Photograph by Eugéne Atget. (Courtesy of George Eastman House Collection, Rochester, New York.)

the press and the public. His ability to market and publicize was legendary and he was one of the first to produce a catalog of photographs for sale.

With this interest in the photograph as a cultural artifact, museums and galleries were legitimizing its potency. John Szarkowski, Director Emeritus of the Museum of Modern Art's Department of Photography has stated, "the role of the photography collection is to present and make visible the prime examples on which we will form our understanding of the influence of photography on modern sensibilities." Szarkowski is one of the most influential curators and critics of the twentieth century. As director of MoMA's Department of Photography for 29 years, Szarkowski held firm to the belief that the curator was a critical liaison between the artists and the public. Photography's influence upon society was as seductive as it was ubiquitous. Photography became one of the most pervasive methods in recording the grand and subtle changes in society over the course of time. Forward-thinking people like Szarkowski, Beaumont Newhall, Sam Wagstaff, and so many others recognized this fact and kept photography in a prominent place on the public agenda.

The artist's camera recorded the reverberations of many of these changes throughout 19th and 20th century society. A select group of Modernists brought the art of photography into the forefront of the fine arts, but all photographers throughout the history of the medium are responsible for creating a visual time line for society. Collectors and curators have preserved and

signified an artistic, commercial, and documentary tradition that allows us all to participate as witnesses to history-making events.

The acute cultural observations of Alexander Rodchenko, Man Ray, Eugène Atget, August Sander, Dorothea Lange, and the architect of the decisive moment, Henri Cartier Bresson, helped establish photography as an integral part of western culture.

College and university programs in photography helped to establish the perception that photography was a vital part of the art scene and created an educated audience in the post-war world, an audience that expanded exponentially in the 1970s and 1980s. The audience, in turn, helped to encourage the growth of museums and galleries devoted to photography.

An active art scene in America has embraced documentary and commercial imagery as serious artistic work. This popular attention to method and craft further developed the perception of photography as a legitimate art form. Richard Avedon and Irving Penn created iconic images that have moved from the pages of fashion magazines to the walls of museums and galleries. WeeGee (Arthur Fellig), Diane Arbus, and Larry Clark redefined the meaning of documentary photography with their piercing gaze at ordinary lives. Robert Rauschenberg and Andy Warhol blurred the boundaries between photography and painting when they began exhibiting photographs on a very large scale with their silk screens on canvas. Works on this scale are commonplace today and occupy an important place in galleries and museums. In the Post-Modern era Andreas Gursky, Tina Barney, Robert and Shana Parke Harrison, Gregory Crewdson, Thomas Struth, and Adam Fuss all challenge modern artistic convention with the size of their works as they observe and construct the absurdity and drama of everyday life.

A glance at the art market today would demonstrate an active interest on the part of serious collectors for this work. As a result of this serious interest images have become investments as well as functioning as works of art and documents. The market for photographs has developed into a mainstream investment practice in the world of celebrities and the mega-rich. Now significant collections are routinely bought and sold through art auction houses such as Sotheby's, Christie's, Phillips de Pury & Company, and Swann Galleries. The first auction by Swann Galleries took place in 1952 and the first photographs that went on sale sold at "ridiculously low prices."

The market for photographs did not find a niche until 1970 when Parke-Bernet sold photographs from the Sidney Strober collection for a grand total of $70,000. The market went through quite a few ups and downs through the 1970s and 1980s, but continued to gain strength in the 1990s. Rick Wester, a fine art photography graduate of Rochester Institute of Technology, was an important catalyst in bringing the market for photography into prominence. He began his career at Light Gallery in New York and went on to become senior vice president and international department head of photographs for Christie's. He is presently the photography director at Phillips, de Pury & Company. During his tenure at Christie's he oversaw the heyday of photography auctions. In the fall of 1993 Wester auctioned a portrait of Georgia O'Keeffe by Alfred Steiglitz for the then unheard of price of $398,500.

Private collectors have been the lifeblood of the photography market and photographic collections are bought and sold for a variety of reasons. Wester likes to use the example of

FIG. 14 Murder Victim in Hell's Kitchen, ca. 1940. Gelatin silver print. Photograph by Weegee. (Courtesy of George Eastman House Collection, Rochester, New York.)

the three "Ds" as the motivation for the sale a collection. Death, divorce, and de-accessioning (when a museum decides to sell off works so that they may invest in other projects or collections) precipitate many changes in ownership. The reasons for buying photographs can be more esoteric. Sam Wagstaff, a curator of contemporary art for many years, amassed an impressive private collection of photographs in the late 1970s. "He saw collecting as a visual and intellectual pleasure, the happy indulgence of one's prejudices." Some collectors gravitate toward rarity, others for intellectual, sentimental, or aesthetic reasons.

FIG. 15 The George Eastman House International Museum of Photography and Film, Rochester, New York.

Along with prominent private collectors like Wagstaff, the corporate world turned to collecting photography in the 1960s and 1970s. Hallmark, Polaroid, Chase Manhattan Bank, Seagram's, and the Gilman Paper Company have all made a huge impact on the formal collection of fine art photography. In time many of these collections have been absorbed into the archives of museums. Chairman of the Gilman Paper Company, Howard Gilman, with the aid of master curator, Pierre Apraxine, assembled one of the finest private collections in the world and as an example of corporate philanthropy gave the collection to the Metropolitan Museum of Art in 2005. In 2006 many important images from the collection were sold, which allowed it to expand in other areas. The movement of collections through the hands of private collectors and public museums is ever changing and not without sentimental attachments.

Close ties to their hometown could be the primary reason that the Hallmark Collection has been handed over to the Nelson-Atkins Museum of Art in Kansas City. The gift of this multi-million dollar collection is a gesture that adds tremendously to the cultural life of Kansas City and to the perception that Hallmark's corporate leadership has strong attachments to the city.

Indisputably, one of the most important public collections is housed in the International Museum of Photography (IMP) at the George Eastman House (GEH). Beaumont Newhall can claim the credit for setting the standard for the Eastman House archives. Newhall assumed directorship of the museum in September of 1958 and maintained that position until 1971. He had been the first curator of photography and assistant director at GEH in 1948. He left his post as the first curator of photography at the Museum of Modern Art (1940) to set up a museum and archive of photography at the George Eastman House. He was extremely influential in the growth and development of the museum and a pivotal figure in a scholarly investigation of photography. One milestone in Newhall's career was his text, *The History of Photography from 1839 to the Present*, first published as a catalog accompanying an exhibit at the Museum of Modern Art in 1937.

The collection at IMP/GEH is made up of more than 400,000 photographs and negatives. While other collections may have more objects, the IMP has the most comprehensive selection of masterworks in still photography and film.

The depth of the IMP/GEH collection makes it one of the most popular sources for loans and collection sharing. The International Center of Photography (ICP) is an example of this kind of collaboration. IMP/GEH and ICP are collection sharing by using the same database system, creating a virtual collection of over 500,000 photographs. The ICP was the brainchild of Cornell Capa, a photographer for *LIFE* magazine and member of the photographic agency Magnum. The collection he has assembled contains over 50,000 images. Capa opened ICP in 1974 as a center for the promotion of documentary photography, or to use Capa's term, "concerned photography." The combination of the two collections is a synchronistic event that enhances the status of both institutions in disseminating and broadening the knowledge of visual culture.

The second largest collection in the United States is housed at the Center for Creative Photography (CCP) at the University of Arizona. Significant images from the 19th and 20th

century make up more than 60,000 photographs housed at CCP. The photographs and personal archives represent more than 2000 photographers at an impressive facility on the Tucson campus. Centers like ICP and CCP focus on specific collections of photography in great depth and take on a scholarly role hosting exhibitions, workshops, and seminars devoted to the advancement and analysis of photography and photographers.

In New York City the Museum of Modern Art houses its own substantial collection of 19th and 20th century works. It began collecting photographs in 1930 and the photography department, under the direction of Edward Steichen, was established in 1940 with Beaumont Newhall as the curator of photographs. Presently MoMA's holdings of more than 25,000 works constitute an important collection of photographs that reflects the substance and scholarship of its leadership. The Museum of Modern Art owes a huge debt to John Szarkowski for the breadth and depth of its involvement in the world of photography. For almost 30 years Szarkowski was the force behind an illustrious list of exhibitions, publications, and scholarly reviews of the medium. Szarkowski not only wanted to expose the public to important images, but made a great effort in getting the museum-going public to think differently about photography. His method for looking at photographs expounded on five qualities that all photographs had in common: the thing itself, the framing of the image, the details within the image, the moment in time that was forever captured, and the vantage point from which the photograph was made. This approach to photography raised photography to new levels of sophistication and emphasized Szarkowski's coda that "a good photograph is an experience; it enlivens truths, but does not prove them."

Alfred Stieglitz would have agreed that the great photograph is an experience, an experience that had to be shared on a grand scale. To this end Stieglitz was instrumental in establishing the photographic collection at the Metropolitan Museum of Art. The collection was formed in 1928 with a gift of his own photographs. Steiglitz augmented the collection in 1933 with a gift of Photo-Secessionist works. Throughout the 20th century photographers like Steiglitz, Steichen, Ansel Adams, Minor White, and more recently Nathan Lyons and Carl Chiarenza, have made significant contributions in critical areas of photographic history, theory, criticism, and archives establishment. The practitioners have always had a great deal to do with the advancement of their chosen art form and contemporary society owes them a great deal for their efforts. Everything these visionaries created, wrote about, and researched has prepared us for the next stage, the digital revolution.

The 21st century has brought huge advances in the sharing and archiving of visual information. Digital technology has become commonplace in the photographic realm, both in the creation of images and in the cataloging of historic and contemporary photographic production. Alliances between museums, galleries, and private and public collections have contributed to the accessibility of vast amounts of photographic information. Databases have helped to expand the sharing of images regionally and worldwide. In the 21st century it is rare to find a gallery, museum, or collector that does not utilize digital technology in the cataloging and archiving of collections regardless of size. Connoisseurs and scholars are able to access the Internet to peruse holdings from a wide variety of sources. The Library of Congress, the George Eastman House, the Center for Creative Photography, and the Museum of Modern Art are representative of only a very few of the many major institutions that present their collections in an easily accessible format on the Internet. Many of these sites are well worth looking at in terms of the skillful use of technology to engage an audience and the large numbers of photographs that are available to anyone with access to the Internet.

The use of the Internet to display collections of all kinds is commonplace and ever expanding. In keeping with a historian's sense of stewardship, enlightened archivists are preserving diverse storehouses of cultural artifacts that can be accessed by anyone with an interest in learning more about a particular aspect of photography. The late Peter Palmquist, historian and founder of the Women in Photography International Archive, created and maintained an archive of significant images made by women as a passion and his life work. Pam Mendelsohn continues to foster his legacy, dedicating the archive to maintaining the visibility of women photographers from the past and the present. The WIPI Internet site constitutes a vital source

of support for contemporary women artists and acts as a virtual gallery space. Specialists like Palmquist and Mendelsohn now have the ability to popularize their passions and add to an impressive storehouse of knowledge in the field by accessing and utilizing cyberspace. Entering the keywords "photography galleries" or "photography collections" on an Internet search engine will bring up thousands of sites representing brick and mortar exhibition spaces as well as the purely virtual.

Digital technology has profoundly affected the efficacy of photographic art practice and the publishing of photographic books. The digital camera has further democratized the art of photography by giving amateurs and professionals a tool that allows anyone to send a photograph anywhere, anytime. Many of these practitioners have created their own personal galleries online. The photograph as an art object has come out of the darkroom, with rich, long-lasting prints that are generated from a computer printer. It is evident from the changes that have already occurred throughout the medium that the evolution of photography has gained momentum from the digital age and has made a major contribution to the information revolution that is currently underway. Museums and galleries have risen to the challenge of new technology and added to this revolution by embracing the relevant digital applications. This reaction on the part of the institutions serving photography will continue to uphold the value of the photographic image as an artifact and as a universal means of communication far into the future. ◐

Photographic Higher Education in the United States

NANCY M. STUART, PH.D.
The Cleveland Institute of Art

That crazy feeling in America when the sun is hot on the streets and music comes out of the jukebox or from a nearby funeral, that is what Robert Frank has captured in tremendous photographs taken as he traveled on the road around practically forty-eight states in an old used car (on Guggenheim Fellowship) and with agility, mystery, genius, sadness, and strange secrecy of a shadow photographed scenes that have never been seen before on film.

Jack Kerouac, Introduction to *The Americans*

So began the introduction to Robert Frank's book first published in this country in 1959 heralding the beginning of photography's "golden age." Photography critic and curator, Jonathan Green stated "almost every major pictorial style and iconographical concern that will dominate American straight photography in the late sixties and throughout the seventies can be traced back to one or more of the eighty-two photographs in *The Americans*." Kerouac, whose book *On the Road* was published in 1957, wrote the introduction to Frank's book thereby, according to Green, linking photography to the "beat" generation and freeing the discipline from political or visual constraints as part of the anti-establishment movement.

Edward Steichen's Family of Man exhibit at the Museum of Modern Art in New York City four years earlier brought photography into the general public's consciousness, but Frank's book helped launch a revolution among young, politically disenfranchised, liberal thinkers throughout the country by showing a less than glamorous America. Photography, if considered an art at all, was considered a radical art at the time. Therefore, student demand for photography programs and workshops grew steadily in the sixties and the seventies in part to answer their demand for relevance in higher education. By 1980 there were photography and history of photography programs at universities in every state. One member of the board at the George Eastman House described photography's popularity on college campuses by saying, "they are wearing cameras like jewelry."

Enrollments were expanding at universities in all programs due to the perceived social and economic necessity of higher education combined with the "baby boom" after World War II. However, the interest in photography was impacted by the confluence of additional factors, including an expanding market for art and the formation of The Society for Photographic Education in 1963. In addition, the mechanics of photography became democratized with the introduction of Kodak's Instamatic camera designed by Frank A. Zagara of Kodak in 1963. Because the camera was easy to load with a 126 film cartridge, the photographer was ready to shoot for a $15.95 investment. Many students of photography in the 1960s and 1970s experienced making pictures for the first time through a Kodak Instamatic camera when they were younger. Between 1963 and 1970 over 50 million Instamatic cameras were produced. Photography came to be seen as both a common visual language and a revolutionary art.

Few disciplines have the distinction of functioning as a commercial product, an applied science, and a studio art discipline. As a result, Kodak's 1960 *Survey of Photographic Instruction* reported that photography courses were found in science departments, journalism departments, art departments, and architecture schools. "The tendency for photography to become increasingly important in the non-photo courses is also growing. It is more and more frequently recognized by science, medicine, art, and other departments that photography is a tool without which the graduate is not really adequately prepared."

The 1964 report *Photography Instruction in Higher Education* by Dr. C. William Horrell, Associate Professor of Photography at Southern Illinois University, indicated a total of 25 degree programs in photography graduating a total of 143 students per year. It also documents that photography was taught in 28 different departments or academic areas and covered 57 different approaches or types of photography courses. He felt that this was a reflection of the broad application of photography to many different disciplines and its relative newness as a college subject. The highest frequency of departmental location in the 310 schools surveyed was journalism with 99 schools (31%) reporting photography instruction within their journalism department. Art was second with 47 of the schools (15%) and audio-visual education was third with 38 schools (12%). Of the 310 schools surveyed only 22 reported (7%) having a department of photography. The remaining 104 schools reported photography offerings in departmental locations as wide ranging as Physics (20), Science (7), Police and Correctional Science (3), Engineering (2), and Liberal Arts (1).

The overwhelming impact, however, was the addition of photography majors within the university's fine art departments. Keith Davis notes the rapid change in the departmental location of the nation's college level photography courses:

In 1964, such courses were twice as likely to be found in departments of journalism as in departments of fine art. The number of fine art photography courses doubled between 1964 and 1968, and doubled again between 1968 and 1971. By contrast, the number of photography courses taught in journalism programs declined in these years. While this overall expansion of photographic education was clearly a positive sign, the shift from vocational training to self-expression prompted some to question the purpose of these new programs.

The proliferation of photography programs at the college level occurred during the later third of the 20th century. The annual Higher Education Arts Data Services (HEADS report) published by the National Association of Schools of Art and Design (NASAD) lists 109 colleges with photographic BFA degree programs in 2004–2005. According to the report there are 5118 students majoring in photography at the undergraduate level and 645 students at the graduate (MFA) level. This data would not include the equally numerous students enrolled in community college programs, proprietary (for profit) vocational institutions, or non-degree granting programs and workshops.

National Influence on Photographic Education

Some photographers who learned their skills in this era actually attribute the medium's popularity to Michelangelo Antonioni's 1966 film entitled *Blow Up*. The movie chronicles a hip

young professional photographer's attempt to solve a murder mystery detected through the repeated enlargement of one of his photographs. Though undeniably influential to young males in the 1960s, the movie is just one of many examples of the medium's appeal to popular culture. Other influences came from the popular press and the expanding number of galleries featuring photographic exhibits.

Though it may seem contradictory to photography's popularity, it was also a time when classic picture magazines like *LIFE* and *Look* were being supplanted by television images as a source of news. What the demise of these magazines in the early 1970s caused, however, was a release for photography from its role as objective witness. Just few years later, a surprising surge in new magazine production including *Smithsonian*, *Quest*, and *Geo* featured photography as beautifully crafted still images. The rising cost of television advertising prompted many firms to return to print-based mediums, but the loss of the image's utilitarian function allowed photographic illustrations to be appreciated for their artistic merit.

An expanding art market for photographic prints was in part a function of the establishment of the National Endowment for the Arts (NEA) in 1965. Bruce Davidson received the first photography grant in 1968 for his work *East 100th Street*, a documentary project focused on a New York City neighborhood. At the same time, the Guggenheim Fellowships in photography were awarded at an increased pace of 181 fellowships during the 19 years between 1966 and 1985, up from 39 fellowships awarded during the prior 19 years.

Time-Life issued their successful *Library of Photography* venture in 1972. Seventeen beautifully printed volumes were published about the history and art of photography. They were considered collector's items by serious amateur photographers including those bound for college studies in photography. In the same decade major magazines including *Newsweek*, *Esquire*, and *Rolling Stone* did cover stories devoted to photography. Photography was modern, artistic, and hip. Galleries were showing photographs at an increasing rate, particularly in New York City where in 1968 no less than 24 photographic exhibits were on view during a one-month period. An article reproduced in the journal *Image* in 1971 reports on a visit to Lee Witkin's Gallery in New York City where sales of photographs were "booming even with price tags from fifty to one hundred and fifty dollars per print!"

Cultural critic, Susan Sontag published a series of essays on photography in the *New York Review of Books* starting in 1973. The series was critical of the medium but served to legitimize photography as a subject worthy of consideration. The essays were later revised and published as a book, *On Photography*, in 1977. In this book Sontag examines aesthetic and moral problems raised by the authority of the photographed image in everyday life. The book considers the relation of photography to art, to conscience, and to knowledge.

The literary world applauded the book and Davis considered its publication a landmark event in the cultural history of photography. "Sontag changed the way the medium was perceived in at least two important ways: she confirmed its intellectual worth and expanded its critical audience."

While photography was welcomed into the art world, academia was showing an interdisciplinary interest in it. In 1975, Wellesley College sponsored a series of lectures around the theme Photography Within the Humanities featuring lectures by Susan Sontag, John Szarkowski, Robert Frank, W. Eugene Smith, Irving Penn, and Paul S. Taylor. Author Keith Davis states "many academic disciplines—including art history, American Studies, English, anthropology, and philosophy—suddenly took an interest in the photographic image."

Another factor increasing enrollment in colleges across the nation is that the "photography boom" was preceded by the Baby Boom. Returning WWII veterans fathered a population explosion that resulted in 76 million births necessitating major expansion of housing, schools, and services nationwide. At the same time the Servicemen's Re-Adjustment Act (GI Bill) was financing the college education of returning military personnel increasing the perception of the necessity of a college education. The expectation of a college education placed on the Baby Boom generation combined with the possibility of studying something as "fun" and current as photography caused enrollments to soar in the new photographic departments.

The confluence of the amplified demographics of college-aged individuals, the critical and cultural acceptance of photography as an art form, and the increased expectation for the attainment of higher education combined to escalate the enrollment in photography departments across the country.

Early College Level Programs in Photography

With the advent of any new technology and its requisite new tools, inventors themselves tend to provide the first instructions. Soon after the announcement of the daguerreotype process to the French Academy of Sciences in 1839, L. J. Mandé Daguerre published detailed instructions for each camera he sold. Forty-five days after the first public demonstration of Daguerre's invention, formal instruction in

FIG. 16 A view of Professor Charles Savage's class at the RIT School of Photographic Arts & Sciences downtown studios ca. 1940–1950s. (Image courtesy of the RIT Special Collections Wallace Memorial Library, Rochester Institute of Technology, Rochester, New York.)

picture making was offered at the Stuyvesant Institute of New York City. By 1856, the University of London was offering a course in photographic chemistry. Shortly following were courses in Berlin, Dresden, and Munich all introduced between 1863 and 1888. The speed at which the news traveled and courses were formed was indicative of the great interest in this new process.

The California College of Photography at Palo Alto, California, in the early 1900s was one of the earliest schools in the United States dedicated to training professional photographers. On the east coast, Clarence H. White began teaching photography at Teacher's College at Columbia University in New York City in 1906. In 1914 he opened the Clarence H. White School of Photography, and taught at both schools concurrently. White was associated with the Photo-Secession movement endorsing a revolt against the pseudo-impressionistic in photography on the grounds that photography must depend on its own unique capabilities rather than following the lead of painting.

Walter Gropius founded The Bauhaus in Weimer, Germany, in 1919. The program promoted the concepts of experiential learning, sound craft skills, and breaking down barriers between "fine art" and craft. Though not a photographic school, the students were encouraged to use photography in design, applied technology, and experimentation. Regular courses in photography were started in 1929. Laszlo Moholy-Nagy, a Hungarian painter, photographer, and graphic designer taught a foundation course starting in 1923 and, later, founded the New Bauhaus in Chicago after activities at the Bauhaus in Germany aroused the suspicions of reactionary political forces that brought about its closing in 1933. Moholy-Nagy was the first photographer to become a principle motivating force behind an American institution of higher learning believing that, "the illiterate of the future will be the person ignorant of the use of the camera as well as the pen." Lacking financial support from the founding organization, The New Bauhaus closed in 1938 but was opened again in another location in 1939 as the Chicago School of Design. Its final name change came in 1944 as the Institute of Design at the Illinois Institute of Technology. It has produced numerous graduates, many who became photography professors in the expanding programs across the county.

Henry Holmes Smith was hired to teach the first photography course at the New Bauhaus in 1937. Later, Smith taught the first History of Photography course for a fine art department at Indiana University at Bloomington in 1947. He started a small graduate program in 1952 that influenced the future of photographic education through graduates like Jack Welpott, Jerry Uelsmann, Betty Hahn, Robert Fichter, and Van Deren Coke, who became important photographic artists and teachers themselves. For all his success, however, Smith felt that the administration did not hold photography in high esteem, causing problems in

program development. Smith was a one-man department until Reginald Heron was hired in 1970.

Not far away, at Ohio University, a camera club's enthusiasm was so contagious that a course in photography was added to the curriculum of the College of Fine Arts. Ohio University was the first university to offer both a bachelor's and masters' degree in photography inaugurated in 1943 and 1946, respectively. This program was also the first to combine photography with other disciplines such as art history and design.

The San Francisco School of Fine Arts had courses conducted by Ansel Adams, Minor White, and others since 1945. Though not a degree granting school, the influence of the courses was significant. In addition, painters Clyfford Still and Mark Rothko taught there during the same era. The school was "aided by the mature students just out of the armed forces and the support of the G.I. Bill, there was undeniably a most stimulating assembly of teachers and students at this West Coast school during the decade after the end of World War II," according to Van Deren Coke's article.

Rochester Institute of Technology (then the Rochester Athenaeum and Mechanics Institute; RAMI) offered evening courses in photography as early as 1902. Eastman Kodak Company's Director of Training and Personnel, Mr. Earl Billings, founded the School of Photography at RAMI as a two-year work-study program in 1930. The first class consisted of twenty-four students. The first two teachers, Frederick F. Brehm and C. B. Neblette were reassigned from Eastman Kodak to the school on a part-time basis. The program changed in 1936 due to high enrollment numbers (30–40 per class) and the industry's inability to immediately absorb all the graduates. As a response, a three-year program was introduced with the first year being full time and the second two years being work-study. A student could opt for two full time years, eliminating the work experience.

By 1959 there were 400 students in the School of Photography earning a bachelor of science degree. A bachelor of fine arts degree was added in 1960 and a master of fine arts degree was first offered in 1969. By 1979 over 1000 students were enrolled in the school's comprehensive selection of photographic programs.

FIG. 17 C. B. Neblette, ca. 1940. (Image courtesy of the RIT Special Collections Wallace Memorial Library, Rochester Institute of Technology, Rochester, New York.)

The Society for Photographic Education

In the interest of formalizing their educational commitment, a few dedicated educators led by Nathan Lyons organized an Invitational Teaching Conference at the George Eastman House in November of 1962. During the three-day event it was unanimously decided to establish a permanent organization. Twenty-seven men participated including Beaumont Newhall, Minor White, John Szarkowski, Aaron Siskind, Clarence H. White, Jr., Henry Holmes Smith, and Jerry Uelsmann. Attendees represented institutions from locations as diverse as Ohio University, University of Minnesota, Kalamazoo Institute of Art, Rennselaer Polytechnic Institute, Philadelphia Museum College of Art, the University of Iowa, and the University of Florida. Only two attendees came from organizations other than a college or university: Museum of Modern Art and Eastman Kodak Company.

In the proposal for an association, presented by Henry Holmes Smith, the following goals were articulated: the organization would be built around the group assembled as its first members, they would collect and disseminate current teaching practices and principals of photography, act as an advisory group for school administrators interested in establishing photographic courses at any level, assist all organizations attempting to collect examples of photography, provide information as to current curriculum practices in schools that teach photography, help teachers advance their own skills, serve as a clearing house for teaching positions, establish a voice for teachers in relationship with the photographic industry, issue appropriate publications, and undertake cooperative efforts with other photographic groups. The original members were focused on their individual challenges in the classroom, and there is no mention of promoting scholarship within the discipline. The founders also did not seek to limit membership by setting standards or issuing licenses. Photographic education as proposed, was broadly located from primary to secondary institutions as well as post-secondary institutions though no attendees of the first meeting taught below the university level.

One of the attendees of the teaching conference was Professor Charlie Arnold from RIT. He recalled teaching in the early 1960s when the Society for Photographic Education (SPE) was in its infancy and articulates one reason it may have been needed.

SPE happened when everybody was up in arms to throw everything out the window and do everything different. The students wanted courses and they didn't want grades given. They wanted to choose any one of fifteen different courses. They wanted courses about unbelievable things. I mean, it was just mayhem but it was interesting mayhem.

Arnold and Ralph Hattersley had just introduced a BFA in photography at RIT. "Doing everything different" would be an alternative to the applied science program already established.

Topics discussed during the weekend conference included: Photography and General Education, The Needs of the People—Photo Instruction—Who Wants to Learn and Why?, The Place for Photography in the University Curriculum, Creative Photography for Advanced Students, A Function of the Teacher As Critic in the Arts, and Interrelationship of Image and

FIG. 18 A 1972 photograph made on the new RIT campus with 70 new enlargers and some of the 800+ students who were enrolled at the time. (Image courtesy of the RIT Special Collections Wallace Memorial Library, Rochester Institute of Technology, Rochester, New York.)

Technique. The subjects reflected the particular perspective of each panel's chair and reflected the diversity of questions surfacing in the new programs of photography.

Keith Davis refers to this first conference in his photographic history *An American Century of Photography* and states that the motivation for the conference was based on expanding the audience for serious photography.

The desire to expand the audience for serious work dominated the talks at the 1962 conference. Everyone agreed that the medium suffered a woeful lack of informed criticism and was viewed superficially by most art museums and members of the public. To this end, a deeper under-standing of visual literacy—accompanied by a refinement of critical terminology and meth-odology—was deemed essential. How was the photographic image related to the science and psychology of perception? How were the meanings of photographs derived from a larger context of social thought and cultural value? Such complex issues dominated thinking in the field, but resisted definitive analysis.

The first annual meeting of SPE was held in Chicago in 1963.

The organization had an important impact on the working lives of photographers who, in increasing numbers, were beginning to use the medium as an expressive form. With the grow-ing number of photography programs at the college level, for the first time photographers had an option to doing commercial work to make a living. Additionally, the academic calendar afforded many burgeoning artists the time needed to pursue creative work. Nathan Lyons spoke of the significance of this particular development:

. . . there seemed to be a need to get the teaching of photography into college curriculum so that the same advantages that art programs have would be there for photographers. It would open up job possibilities and I think people underestimated the significance of getting the SPE started and helping to grow the educational field so that photographers didn't have to work commer-cially to do their own work. And, that, I think was an incredibly significant development for the field in the 60s.

Today, with over 1800 members, SPE's stated mission reads in contrast to its earlier goals:

The Society of Photographic Education is a non-profit membership organization that provides a forum for the discussion of photography and related media as a means of creative expres-sion and cultural insight. Through its interdisciplinary programs, services and publication, the Society seeks to promote a broader understanding of the medium in all its forms, and to foster the development of its practice, teaching, scholarship and criticism.

Photographic education continues to transform itself through digital technology. The lines between traditional disciplines are blurring as new programs emerge in time-based mediums including multimedia production, film and video, animation, and Web design. New fields are forming as specialized skills are needed in information technology and communica-tion design. Photographic imaging continues to play a primary role in all forms of new media. The tools are changing but the talent of *seeing* can still be enhanced through education and training.

FURTHER READING

Arnason, H. H. and Prather, M. F. (1998). *History of Modern Art*, Fourth Edition. Upper Saddle River, NJ: Prentice Hall and Harry N. Abrams, Inc., p. 356.

Arnold, C. (2002). *Interview with Author*. Rochester, NY, February 15.

Bossen, H. (1983). *Henry Holmes Smith: Man of Light, Studies in Photography*, No. 1. Ann Arbor, MI: UMI Research Press, p. 128.

Coke, V. D. (1960). The art of college teaching. *The College Art Journal* **XIX**, No. 4, p. 333.

Coke, V. D. (1960). The art of college teaching. *The College Art Journal* **XIX**, No. 4, p. 334.

Davis, F. K. (1999). *An American Century of Photography: From Dry-Plate to Digital*, Second Edition. Kansas City, MO: Hallmark Cards, p. 314.

Davis, F. K. (1999). *An American Century of Photography: From Dry-Plate to Digital*, Second Edition. Kansas City, MO: Hallmark Cards, p. 390.

Davis, F. K. (1999). *An American Century of Photography: From Dry-Plate to Digital*, Second Edition. Kansas City, MO: Hallmark Cards, p. 389.

Davis, F. K. (1999). *An American Century of Photography: From Dry-Plate to Digital*, Second Edition. Kansas City, MO: Hallmark Cards, p. 393.

Davis, F. K. (1999). *An American Century of Photography: From Dry-Plate to Digital*, Second Edition. Kansas City, MO: Hallmark Cards, p. 399.

Eastman Kodak Company (1960). *A Survey of Photographic Instruction, Second Edition a Resume of Instruction in American Colleges, Universities, Technical Institutions and Schools of Photography*. Rochester, NY: Eastman Kodak.

Gantz, C. (2001). *100 Years of Design: A Chronology 1895–1995* [proposed book; cited July 22, 2003]. Available from www.idsa.org.

Gaskins, W. G. (1971). Photography and photographic education in the USA. *Image* **14**, No. 5–6.

Gaskins, W. G. (1971). Photography and photographic education in the USA. *Image* **9**.

Green, J. (1984). *American Photography: A Critical History 1945 to the Present*. New York: Harry N. Abrams, p. 92.

Green, J. (1984). *American Photography: A Critical History 1945 to the Present*. New York: Harry N. Abrams, p. 145.

Horrell, C. W. (1964). *Photography Instruction in Higher Education*. Philadelphia: American Society of Magazine Photographers, p. 1.

Horrell, C. W. (1964). *Photography Instruction in Higher Education*. Philadelphia: American Society of Magazine Photographers, p. 2.

Invitational Teaching Conference at the George Eastman House (1962). Paper presented at the Invitational Teaching Conference at the George Eastman House. Rochester, NY, p. 2.

Lokuta, D. (1975). *History of Photography Instruction*. Columbus, OH: Ohio State University.

Lyons, N. (2003). *Interview with Author*. Rochester, NY: June 13.

Shoemaker, William Soule. (1980). "History of Spas," RIT Archives and Special Collections, Rochester, NY, p. 2–3.

Society for Photographic Education (2001). *SPE Resource Guide and Membership Directory*. Oxford, OH: The Society for Photographic Education.

Sontag, S. (1973). *On Photography*. New York: Farrar, Straus and Giroux, jacket notes.

Stroebel, L. and Zakia, R. D. (eds.) (1996). *Encyclopedia of Photography*. Boston: Focal Press, p. 565.

Traub, C. (ed.) (1982). Photographic Education Comes of Age. In *The New Vision: Forty Years of Photography at the Institute of Design*. New York: Aperture, p. 27. ◯

Photographic Workshops: A Changing Educational Practice

CHRISTOPHER BURNETT
Visual Studies Workshop

Photography can be learned in a weekend.

It can take a lifetime to learn photography.

For decades, workshops have spanned these poles of photographic education and all levels of engagement in between. The versatility of workshops accompanies a range of educational needs and options according to which the format adjusts and adapts itself. A workshop can mean anything from an afternoon encounter of a group of camera buffs to the committed union of dedicated artists lasting a few months. The numbers involved may vary from a few

to a baker's dozen. The settings could be a photographer's living room, an ordinary classroom or darkroom, or the great outdoors within a national park or a tropical resort. The idea that a workshop idea encompasses so many experiences, and yet names such a distinctive means of learning and teaching, indicates that we have encountered a cultural practice.

Workshops, in the sense commonly used today, emerged as an educational practice in 1930s America with the progressive education movement set in motion before World War I. Cultural practices are not invented but emerge in the wake of social discussions, efforts, explorations, conflicts, negotiations, and the eventual formation of institutional programs. The labels arise from and help consolidate the customs. An early deliberate use of the term "workshop" as a special educational variety appeared in the summer of 1937 when teachers from public and private high schools gathered on the campus of Sarah Lawrence University. The principles that the group applied to themselves called for a kind of "recess" for teachers: there would be no grades, no credits, no required class attendance, and written examinations. Yet, even with an informal atmosphere, each teacher/student was strictly responsible to come to the workshop with a definite project in mind. The sessions unfolded around the interactions of the group as members helped each other with their projects. Other requirements were that they report to their school officials back home and document their results for the future. By the early 1950s, this "unshackled" way of learning had branched out to so many lines of endeavor that educator Earl Kelly considered it necessary to bring the workshop idea back to its original basis. He did so by defining workshops according to these essential components: (1) a planning session where all are involved at the beginning, (2) work sessions with considerable time for all to work together on their individual problems, and (3) a summarizing and evaluating session at the close. The combination of individual responsibility with group dynamics; the intensity of involvement with open, responsive forums; and improvisation tempered by accountability are the classic hallmarks of workshop practice.

The particular potency of the workshop model for photography comes out of this tradition of experimentation and its various combinations of educational values. Workshops have figured as a primary vehicle of photographic education because they combine progressive high-mindedness with a workable pragmatism, freedom combined with purpose; intensity with ongoing involvement on many levels of commitment. Perhaps it would be not too fanciful to say that these features are in accordance with the very status of photography itself as a cultural practice.

Origins of the Workshop

Photography would find a particular affinity with workshops as an informal, unshackled way of learning because the medium was never quite shackled from the start. From the time of its invention, the instruction of photography ran in side currents apart from the mainstream of 19th century art education. Photography was only slowly and reluctantly adopted by the academies, schools, and universities of Europe and the Americas. More common were impromptu forms of training demonstrations and ad hoc apprenticeships through which painters-turned-photographers and aspiring tradesmen learned their photographic techniques and practices. Shortly after the announcement of the Daguerreotype process by the French Academy of Science, François Gouraud came to America and exhibited Daguerre's pictures along with public demonstrations about the invention in New York, Boston, and Providence. He also took a small number of pupils to learn photography including Samuel F. B. Morse in New York and Edward Everett Hale, Albert Sands Southworth, and Josiah Johnson Hawes. These initial "demonstrations" were not workshops in the modern sense, but they shared similar aspects in their brevity, small numbers, and impromptu quality. They also held in common the workshop sense that the practical know-how of photography could be eagerly acquired and "passed on" to other receptive practitioners who would further develop and relay knowledge of the craft.

Along with these ad hoc meetings and relays, official institutions established more formal conduits for learning photography. The Royal Photographic Society played an important educational role from its founding in 1853. Camera clubs, such as the Camera Club of New York since 1884, provided organized contexts for meetings that provided a sense of community as

well as education. Out of these institutions grew dedicated schools such as the Clarence H. White School of Photography (1914–1942). Despite these developments, the place of photography in colleges and universities was as sporadic as it was scattered. Photography popped up haphazardly in any number of departments depending on the particular leanings of certain disciplines and their faculty. For example, the medium gained an early foothold within Sociology at Harvard University. To this day, the Kansas State University Geology Department still hosts the darkrooms where photographic practice first took hold on campus. One might have to be a sociologist or geologist to learn photography in these academic settings. Apart from the hodgepodge of these campus offerings and the insular nature of camera clubs and photography schools, serious photographers and artists would seek alternative forms of education.

The founding of the Bauhaus in Weimar, Germany, in 1919 would provide more consistent and purposeful paradigms of photographic education. Though the school was built around teaching architecture and the disciplines of painting, sculpture, textiles, graphic design, and others, photography was central to its curriculum. A full treatment of Bauhaus pedagogy and its importance to photography lies outside the scope of this essay, but I should note the central tension at the school between art and industry and visual concepts and practicality. The Bauhaus workshop became a significant site for playing out these tensions. This usage of the term workshop goes back to the Arts and Craft movement in England and Charles R. Ashbee's founding of the Guild and School of Handicraft in London's East End, in which training took place, not in the studio or atelier, but in workshops. At the Bauhaus, production operated alongside education as areas of practical training as well as embedded cottage industries. The textile workshop, for example, sold its wares to the public. Significant to the divided union of formal education and practical production was the pairing of the "Master of Form" with the "Master of the Workshop." This division and subsequent coupling of roles augured the later union of artistic vision and practice in the modern photographic workshop as it took root in the United States along with other pedagogical influences of the Bauhaus.

The Modern Workshop
Beginnings of modernist workshop: late 1930s to early 1950s
The first glimmerings of this modern workshop was in the newly reorganized Photo League of 1936 with the work and teaching of Sid Grossman and Aaron Siskind. Though they did not apply the term, their classes of advanced students in the production of documentary photo-series called Feature Group Projects had many of the earmarks of modern workshops influenced by both the Bauhaus and progressive social movements. These classes were occurring at the same time as the progressive education workshops for teachers on campuses. The Photo League classes had the critical feature of the individual project plan around which group interaction flexibly organized itself. Significantly, the pedagogy expounded by Siskind in the June–July 1940 issue of *Photo Notes* emphasized his progressive view of education as a laboratory. This work laid the foundation for his teaching credo emphasizing commitment and regular practical production. As Carl Chiarenza put it, "It is what inspired his formation of the so-called 'student independent' projects: work produced by students on their own initiative away from school. He taught by example, by being a working, committed artist." Siskind brought about the workshop ideal of practice and set it in motion.

Another very influential educational setting, Black Mountain College in North Carolina, had already activated the wheels of progressive education in the arts. Founded in 1933 by John Andrew Rice, Black Mountain College made a living laboratory of the movement's central tenets that education involved situation, self-defined problems and projects, cooperation, and a flexible curriculum fused with experience (as John Dewey understood it). At Black Mountain College the process of growth and change was more important than the assimilation of a body of information in a classroom. Teachers were guides, not dispensers of a syllabus and grades. As for art, the community understood it as a generative force in life that stood at the center of the curriculum.

Photography eventually worked itself into the fabric of Black Mountain College in the 1940s and its Summer Institute hosted groundbreaking events in photographic education

along the lines of workshop practice. Beaumont Newhall spent three summers there teaching and finishing his *History of Photography* in 1948. In the summer of 1951, photography erupted into full bloom with successful seminars organized by Hazel-Frieda Larson, with Arthur Siegal, Harry Callahan, and Aaron Siskind from the Institute of Design in Chicago. Photography was treated as a modern art form at Black Mountain College as opposed to an ordinary documentary or commercial medium. These seminal photographic educators interwove teaching with the development of their own work. Even as temporary summer visitors, they enjoined the college's way of thinking that education was a lifetime commitment and was never complete.

Even earlier, in 1940, Ansel Adams had begun his annual one-week workshop of landscape photography in Yosemite National Park. Though occurring across the gap of a continent and within a very different educational milieu, it shared many similar motives with Black Mountain College in using flexible, intensive educational meetings to combine high-minded vision with straight photographic practice. Between the Photo League feature group production units, the Black Mountain College photographic seminars, and Adams' Yosemite Workshop, the stage was set for the modern photographic workshop to bloom.

The Aperture "School": late 1950s to the early 1960s

A special issue of *Aperture* in 1961 expressed this bloom with lucid accounts of the seminal workshops of Minor White, Ruth Bernhard, Ansel Adams, Nathan Lyons, and Henry Holmes Smith. White, editor of the journal, introduced the issue with an overview of workshop at that opportune moment in history. White noted that the word workshop had been used loosely in the field of photography due mostly to the "healthy independence and lamentable isolation" of workshop leaders. Despite this, he found two broad classifications of workshops: the "blitz" and the "intermittent." The former takes advantage of the "effect of concentration [and fatigue] . . . as short as a weekend or as long as a fortnight." The latter are held evenings and/or weekends on a weekly schedule. In either kind, these workshops are a "personal matter" subject to individual variation. Each practitioner represents a type: Bernhard "represents those who eat sparingly in order to live fully in their own world of the camera"; Adams the nationally known photographer; Lyons, assistant director of George Eastman House, who supported his photography by work in an allied field; and Smith who performs in both classroom and workshop photography. White claimed that despite these variations, their workshops held in common the "indignations of the leader." For them, workshops were a form of protest against schools, training, advertising, propaganda, magazines, pictorialism, and all those, who were, in White's words, "deadset in promotion of visual blindness." Against this, the workshop leaders offered some form of "seeing" or "vision." Furthermore, their protest and promulgation of "seeing" was

not meant to be esoteric, but "plain." Their workshops were "makeshift" and unornamented, but offered an educational experience beyond description that each of these pioneers in photographic education would nevertheless go on to describe.

Bernhard emphasized the importance of a free exchange of ideas and work among all participants. As a "workshop leader," she did not consider herself so much a teacher, but, rather, a catalyst. Her workshops, purposely designed with "no system" incorporated a range of topics and disciplines such as philosophy, poetry, and music. White surveyed the several workshops he held across the country at places such as Portland, Oregon; Idyllwild, California; Denver, Colorado; and Rochester, New York. Though the workshops differed in

FIG. 19 Minor White was a major contributor at workshops across the country, shown in this photo taken in 1976 by Abe Frajndlich. (Image courtesy of the Visual Studies Workshop, Rochester, New York.)

format, they held in common the infusion of White's quasi-religious and therapeutic ambitions. Bound in prosaic worlds of "not seeing," the object was to free the individual to see and acquire, in the process, an "intensified consciousness." Clearly more grounded, Adams was concerned that he do nothing through habit or authority to destroy the informal character so necessary to the independent spirit of his annual Yosemite workshop. Nevertheless, he espoused a number of principles he hoped would lead to greater powers of visualization and creative excitement. For Lyons, the excitement was found in the tension between knowing and seeing. Projects or assignments were used simply as points of departure to encounter "the unfamiliar view" that tested boundaries and generated significant expression. Lyons' workshops were successful if they showed signs of challenging established visual and cognitive surroundings. Finally, Henry Holmes Smith used his article to announce his Conference and Workshop on Photography Instruction at Indiana University planned for the summer of 1962. Like the journal *Aperture* itself, the conference would aim to direct attention to problems of photographic education "on the highest level." Smith referred, along with the other educators, the implicit view that workshops held the key for enlightened considerations of photographic education in general. The workshop had become a concentrated vehicle of meta-education: learning how to teach; learning how to learn.

This meta-disciplinary or discursive function of the workshop reappears a few years later in *Aperture* with White's telling editorial "Transactional Photography." Here, the workshop becomes as integral to creative photography as the camera and as necessary to the broad process of "camerawork" as the vision behind it. As an educational apparatus, the workshop is not a means to an end but a destination itself where the photographer completes a process of visualization set in motion by the camera and darkroom. The workshop in effect took the place of the gallery and augmented display with the photographer's presence and the opportunity for the "transaction" with others. Tellingly, White grappled with the presence of language in this eminently visual process. He encouraged other means of communication in the workshop mix: gestures, "sketching responses," "inarticulate animal sounds, or eloquent silence." White ultimately struggled editorially with his own reliance on words, which could only hint at "the rarefied air of transaction photography."

The burden of language was not White's alone but shared by the other workshop leaders. Language's tricky relationship to the exalted status of sight figures as a paradoxical crease in their modernist discourse on workshops. Lyons saw pictures functioning linguistically in a sense (visual objects could serve as nouns or adverbs), but restricted conversational speech as a tool to be used only with "extreme caution." Their belief that projects should speak for themselves was caught up in a split orality that, on one hand, relied on the presence of speech and, yet, disavowed the mediation of words and the tongue in a bid for the directness of the eye and transcendent visual signs. The disturbance of language as mediation points to other contradictions in their formation of the workshop that is shot through with idealism and yet grounded in practice. White titled the issue "The Workshop Idea in Photography," and yet "practice" would stand out as much as "idea"—it was the ultimate value that they courted. These practical idealists wished to climb down from their high horse, and yet they would become the lofty maestros of workshops as a retreat for romantic visionaries. Out of this mixed soil of idealism and pragmatism, contradictory language and vision, the modern workshop would not only bloom but boom.

The modern workshop comes of age: late 1960s to the early 1980s

The special issue of *Aperture* closed with announcements of workshops by these forward-looking practitioners, and along with other offerings at the time (surveyed in two special issues of *Popular Photography* in 1961), they would herald the scores of workshops established in the late 1960s and early 1970s. Photographic education itself was taking off and finding more secure footings within art schools, colleges, and universities, and yet, as demonstrated by the Indiana Conference in 1962, workshops were not just a sideshow but often held center stage as models of value and educational practice. The burgeoning interest in photography as an art form coupled with a population of Baby Boomers signaled that workshops were ready to rock 'n' roll.

FIG. 20 The poster that was used to promote the Apeiron Workshops of the early 1970s. In the group is the former director of the apeiron, Peter Schlessinger. (Image courtesy of the Visual Studies Workshop, Rochester, New York.)

Most influential workshops on photographic education—many disbanded, some still in operation—grew out the "makeshift" efforts of the *Aperture* visionaries. Adams' Yosemite Workshop eventually became part of the Friends of Photography program (1967–2001). Lyons founded the Visual Studies Workshop (1969–present). White moved to the Massachusetts Institute of Technology and continued his workshop activity, until his death in 1976, at many locales such as the Hotchkiss Workshop in Creative Photography in Connecticut (1970).

These more institutionalized workshops influenced another generation to spawn their own workshop enterprises. Peter Schlessinger

FIG. 21 A photograph made during a workshop at VSW. (Image courtesy of the Visual Studies Workshop, Rochester, New York.)

founded Apeiron Workshops (1971–1981) in upstate New York implicitly under the influence of White. Carl Chiarenza, Warren Hill, and Don Perrin started the Imageworks Center and School in Boston (1971–1973). The Center of the Eye was founded by Cherie Hiser in Aspen Colorado (1969) and later connected to the Aspen Center for Contemporary Art and Anderson Ranch Arts Center in Snowmass, Colorado. Fred Picker operated his Zone VI workshops in Putney, Vermont (1970–2002) in much the same spirit and aesthetic as Adams' annual Yosemite Workshop. Magazine photographer, David Lyman, started Maine Photographic Workshops (1973–present) in Rockport, Maine, with a keen business model attracting clientele as diverse as artists, journalists, and amateurs of many professions who desired to mix photographic study with a vacation.

Important workshops popped up on the international stage based on the American model. In 1969 Lucian Clegue set up Rencontres d'Arles, an arts festival in the south of France including photography workshops. Earlier in Mexico, El Taller de Gráfica Popular (Popular Graphics Arts Workshop) involved photographers such as Lola Álvarez Bravo and Mariana Yampolsky. And, Paul Hill opened the Photographers' Place in Derbyshire, England, in 1976.

Back in the United States, many other institutions offering workshops included: The School at The International Center of Photography, New York; the Center of Photography at Woodstock, New York, the Penland School of Crafts, Penland, North Carolina; the Art Institute of Boston; Lightworks at Film in the Cities, St. Paul, Minnesota; Silvermine Guild Arts Center, New Canaan, Connecticut; Santa Fe Photographic Workshops; Summer Museum School, School of the Museum of Fine Arts, Boston and Ghost Ranch, New Mexico.

Some short-lived but influential workshops are Roy DeCarava's Kamoinge Workshop (1963); the Photo-Film Workshop at the Public Theater (1969); Real Great Society's Media Workshop; and Woodstock, New York (1970).

By the early eighties, the number and range of workshops had risen to the point where A. D. Coleman would survey them as "the workshop circuit." And if the term workshop seemed loose to White in 1961, it was even more so for Coleman writing in 1982: "The time space it encompasses apparently runs anywhere for half a day to two weeks; the number of participants can range from 5 to 20 or more, and the nature of the encounter can be almost anything." But it wasn't the vagueness of the practice that bothered Coleman so much as the posturing. Authentic master–apprentice relationships and informal synergies of participants had fallen to opportunities for "workshop junkies and dabblers" to pad their resumes with the names of luminaries. In 1982 Apeiron Workshops closed its doors, and Coleman quotes Schlessinger, "I think something called workshops became big business in the mid-1970s and mostly garbage shortly thereafter. Any gathering in the presence of a star photographer was suddenly a 'workshop.'" Coleman does acknowledge the continuing value of workshops, but his article seems to mark a turning point and the end of an era for the modernist workshop.

How much the workshop environment has changed since then becomes even more pronounced with the publication in 1999 of Mark Goodman's book, *A Kind of History.*

His photographs and narrative poignantly describe the experience of Apeiron Workshops and nearby Millerton, New York. His "perpetual" residency for years in the 1970s goes well beyond White's categories of "blitz" and "intermittent" to total immersion in a kind of visual subculture. But more than a "workshop junkie," Goodman carried with him the innate sensibilities of an anthropologist and committed photographer who could use his workshop experience to reveal the multi-dimensional life of a small town over years of involvement. His attachments to photography and the people of Millerton amount to a tale of two cultures involving the tension of proximity and distance and mixed allegiances as he moved back and forth between Millerton and Apeiron at Silver Mountain. His work reflects back on Apeiron and the capacity of workshops to form, complete, and project an extended body of work beyond the internal "transactions" of an artists' enclave. He embraced the several levels of workshop involvement from short-term intensity, intermittent study, to persistent residency. He demonstrated the purpose of workshops to integrate learning and life growth.

Current Trends and Future Directions

With further proliferation, the "circuit" of workshops that existed in 1982 has grown into an "intercircuit" of workshops in a manner similar perhaps to networks aggregating themselves to become an Internet. Not only are there myriad workshops to choose from, but many types, formats, aesthetics, styles, genres, and payment plans. Certainly the field has become commodified, but more telling, the workshop has become globalized, often figuring as gateways to other worlds, landscapes, and global cultures. The combination of recreation and travel with workshops is not new, but it has been amplified to a level that distinguishes our current period.

Like planning for a trip, there are a number of published guides to cope with the number of options and arrive at a decision point. In the early 1990s, there were guides in print such as Jeff Cason's *The Photo Gallery & Workshop Handbook* (1991) and ShawGuides' *The Guide to Photography Workshops & Schools* (1994). The former lists over 200 workshops, seminars, and photo-tours arranged by category and by geographic index. The ShawGuide lists over 400 workshops and tours. But these listings are small compared to the current online edition that, according to the banner headline, is "A Free, Online Directory from ShawGuides with 536 Sponsors of 2655 Upcoming Photography, Film & New Media Workshops Worldwide!" The Guide to Photography, Film & New Media Workshops is one tab among other related zones such as Art & Craft Workshops, Career Cooking & Wine Schools, Cultural Travel, Golf Schools & Camps, Writers Conferences & Workshops, and Language Vacations. A few of the leading workshops on the home page include the Venice School of Photography, Exposure36 Photography, American Photo/Popular Photography Mentor Series, Sand Diego Photo Safari, Horizon Photography Workshops, White Mountain Photography Workshops, and Branson Reynold Photographic Adventures. Like many travel opportunities in global culture, the global

FIG. 22 Photograph made at the Ansel Adams Photo Eye workshop held at the Rochester Institute of Technology in spring 1990. (Professor Willie Osterman, Rochester Institute of Technology, Rochester, New York.)

workshop offers an educational encounter and an ephemeral sense of place in a placeless world. Here the classic, modernist workshop's commitment to participation and presence has become taunted by an ironic play of distance and proximity.

How the workshop in photography will adapt to future developments in technology and media is an open question. It is unclear if distance education systems will ever be a suitable vehicle for workshops in the classic sense. The gangly figure of a "distance education workshop" is almost a tautology in terms given that presence, not absence, defines the internal logic of workshops. Face-to-face communication and situated expression drives workshops whether it is in the "authentic" terms of modernism or the "simulated" experiences of postmodernism. Interestingly, back in the early 1960s, White held out the possibility of distance workshops with an experiment he conducted by exchanging photographs and audio-taped commentary through the mail. But, for White, the recorded voice supplied the necessary signifier of presence, and even with that reassurance, he never sustained the experiment. Apparently, new media communications will frame the continuing possibilities of the workshop as content, but they can never fully reproduce the workshop form.

The possibilities of new media as the subject-matter of workshops are equally questionable. Short courses and educational training classes for new media gravitate toward the "demo," or demonstrations of technical procedures, tours of the software package's interface, and the organization of a series of tasks. For example, digital photography is taught in terms of the delineation of "work flow" or the relationship of the activities in a project from start to finish. Demos as staged events require preplanning and are contrary to the classic manner of workshops that incorporate planning only as an immediate prelude to work sessions and group interaction. Even so, perhaps workshops can overcome these barriers and introduce more depth and two-way dialog into the process of learning and thinking about new media and digital photography. Perhaps with the use of computer technology becoming increasingly second nature, the time is right for workshops to engage the emerging media of our time in a more unshackled, progressive fashion. Workshops have proved to be an adaptable and robust educational vehicle and will continue to do so as long as individuals are ready to turn a passing encounter with photography into a life-long passion.

FURTHER READING

Cason, J. (ed.) (1991). *The Photo Gallery & Workshop Handbook*. New York: Images Press.

Chiarenza, C. (1988). *Chiarenza: Landscapes of the Mind*. Boston: D. R. Godine.

Coleman, A. D. (1982). Light readings. *Lens' on Campus*, **38**, p. 40.

Duberman, M. B. (1972). *Black Mountain: An Exploration in Community*. New York: Dutton.

Gernsheim, H. and Gernsheim, A. (1955). *The History of Photography*. England: Oxford University Press.

Goodman, M. (1999). *A Kind of History: Millerton, New York 1971–1991*. San Francisco: Marker Books.

Kao, D. M. and Meyer, C. A. (eds.) (1994). *Aaron Siskind: Toward a Personal Vision, 1935–1955*. Chestnut Hill, MA: Boston College Museum of Art.

Kelley Earl, C. (1951). *The Workshop Way of Learning*. New York: Harper, p. 137.

Scholastic principles applied to themselves by 150 teachers. *The New York Times*, August 1, p. 77.

ShawGuides (ed.) (1994). *The Guide to Photography Workshops & Schools*. New York: ShawGuides.

White, M. (1961). The workshop idea in photography. *Aperture* **9**, No. 4, pp. 143–144.

White, M. (1964). Editorial [transactional photography]. *Aperture* **11**, No. 3, p. 90.

Wick, R. K. (2000). *Teaching at the Bauhaus*. Ostfildern-Ruit: Hatje Cantz, Germany.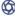

Magazines: The Photographers' Press in the United States and Great Britain During the Transition Decade of the 1960s

DAVID BRITTAIN
Manchester Metropolitan University

In a seminal essay called "Mirrors and Windows," John Szarkowski argues that there was a "sudden decline" in the fortunes and prestige of mass market pictorials such as Life, in the late 1950s. In former times, magazines had supported great photographers from Beaton to Bourke-White. But in response to the pressures of competing for advertisers, jobbing "amateurs" entered the profession, replacing the great talents. Szarkowski, a renowned curator, notes that the most ambitious photographers of the counter-culture viewed this new situation as an opportunity to pursue their artistic destiny elsewhere. The decline of the pictorials, then, instigated a transition during which the identity of the American photographer shifted from artisan to artist.

As is universally acknowledged, one of the models for the new American photographer (and an inspiration to young photographers, internationally) was the individualistic Robert Frank. The U. S. publication, in 1959, of his book The Americans, might be said to represent the start of the trajectory that ended with photographers being elevated to a new social status. Not only did The Americans set a high standard artistically, it also sent the signal that artistic control was possible, but only outside the constraints of the mass media and commercial photography. The sixties was a decade of transition in American photography. The milestones would include the founding of the Society of Photographic Education (SPE) in 1962, by such key figures as Minor White, Aaron Siskind, and Nathan Lyons; the 1962 publication of Marshall McLuhan's book The Gutenberg Galaxy; The Photographer's Eye curated by John Szarkowski at MoMA, New York in 1964; the publication in 1964 of The Painter and the Photograph by Van Deren Coke; the release of Antonioni's iconic film, Blow Up in 1966; and not forgetting the other MoMA exhibition, New Documents in 1967. The exhibition launched three talents—Lee Friedlander, Garry Winogrand, and Diane Arbus,—who would come to personify the poet-photographer of the post-Life era.

By the middle of the decade some of the conditions were in place to support independent photographic practice: an expansion of the provision for photography in higher education, offering some employment prospects, two major museums with dedicated departments and acquisition budgets, and the beginnings of a publishing culture for photographers' books. But much else would be needed if young photographers were to survive outside of the commercial systems. Photography as art was still in search of a scholarly discourse and the market for original prints was in its infancy. This meant that the sixties was a decade of promise and disappointment for photographers.

Szarkowski's main claim that magazines were in decline, and were no longer recognizing or attracting independently minded photographers, may have been true of big titles such as Life, but publishers and photographers alike were adapting and finding new audiences. Even as photography was beginning to become more widely exhibited and reviewed, reputations were still being made in glossy magazines such as the new color supplements in Britain and youth magazines such as Nova in England and Twen in Germany that were commissioning the most innovative photographers. A regular contributor was Diane Arbus, one of the sensations of the 1967 New Documents exhibition.

Before photography galleries became commonplace, the news kiosk was the photo gallery of its day. Many new photographers emerged out of the media because magazines were central to the economy and identity of photographic culture, and this is reflected in the fact that some of the first art exhibitions and publications originated with magazine assignments. Photographers still admired the old-style Life, not least because the magazine made

the profession seem respectable. In Britain photographers cherished a similar fondness for *Picture Post* (closed in 1957) in which Bill Brandt and others came to prominence during the war years, marking a "golden age." In the 1960s magazines—but also catalogs and annuals—were still very important for the interchange of issues, ideas, and images among young photographers, providing them with a cast of indomitable role models. Readers and editors alike scanned pages for the best images, often removing them for future reference and memorized the bylines of the photographers they admired. Long before most learned of Walter Benjamin's notion of the reproduction as a popular art gallery, the illustrated press made photographers feel connected, even as they were scattered. In an address to the readers of *Camera Arts*, in 1980, the celebrated editor Jim Hughes sums up the impact of the magazines on his generation of photographers. "Via the medium of the printed page and in the quiet of my own room, I was moved by the eloquence of Edward Weston, Dorothea Lange, Paul Strand, W. Eugene Smith, Lisette Model, Ansel Adams . . . and so many others . . . I began to comprehend that there was art in life."

The decline of *Life* (whether as a result of TV or not) coincided with an expansion of the alternative press in major cities across America, Europe, and Australasia. This global network of small magazines catered to specialist literary, cultural, and political audiences and included a number of titles produced by art photographers. The best known and most established is *Aperture*. Like *Aperture*, many of the magazines that comprised the photographers' press possessed names evocative of the technology of photography such as *Image*, *Halide*, *Camera*, *Photography*, and so on. And it was in the pages of these titles that some of these best young photographers of the 1960s were first introduced to their peers as authors, as opposed to jobbing illustrators.

As the interface between image-makers, audiences, and taste-shapers, photographers' magazines participated in a climate in which art photography became institutionalized during the 1960s and 1970s. Yet the titles were so marginal they hardly comprised a network; nor have they been well chronicled by histories of photography. More accurately, they belong to the social history of photography as collaborative projects.

There is no agreement about what to call such a publication: terms include portfolio or folio magazine, art photography magazine, and photographers' magazine. Database evidence suggests that the decade of the seventies saw the biggest expansion in small photographic magazines. The sharp statistical blip coincides with the expansion of photography courses in higher education, in the United States especially, and might reflect evidence of publishers targeting new academic markets. Less is known about the scene in the 1960s, which (in the United States at least) was a golden age for the photographers' press. A survey in a 1978 issue of the trade magazine, *Printletter*, reveals that about ten "art photography magazines" survived from the 1960s from Italy, Japan, the United States, the UK, Switzerland, the Netherlands, and Germany. It is not known how many folded or did not respond to the survey, or indeed how many worthy of the name were still in print, but were excluded because they were classified as something else. Most of those listed were, in fact, commercial operations. While many of these contained informed commentary about photography, they were run for the benefit of publishers, rather than photographers who regarded them with some suspicion.

For the purposes of this essay, let's assume the photographers' press of the 1960s is distinguished by a few titles (perhaps as few as 20 in English) that were edited, for love not money, by photographers and their supporters. It would be foolhardy to hazard any general observations because so many variations existed within the type: in ownership, editorial philosophy, geographical spread (whether regional or national), frequency, and quality. To complicate matters, a title also tends to change radically with each new editor or new owner. *Aperture* is typical in some ways but untypical in others. The first issue announced itself with a cover picture of a sign-post indicating dozens of destinations that symbolized the adventure ahead. Like many magazines it was founded (in 1952) in a flush of idealism at a meeting of friends. The difference is that these included the most influential figures of the day, such as Ansel Adams, Beaumont and Nancy Newhall, Barbara Morgan, and Dorothea Lange, who were all part of Stieglitz' circle. They were keen to launch a magazine fashioned on *Camera Work*. Stieglitz'

lavish periodical "fought" for the art of photography (1903–1917) with firebrand conviction, intelligence, taste, and high production values. While it was common knowledge that *Camera Work* only survived because Stieglitz subsidized it, this was no deterrent when it came to launching *Aperture*. As a result of chronic underfunding the quarterly scraped by, once saving money on repro with a text-only issue, eventually becoming bankrupt in 1977 before being rescued. *Aperture* was also unusual because it was under the control of one editor for the first half of its existence (Minor White died in 1976). It was suspected that White got to exert such enormous control over the editorial in a contra deal for donating his time. Most titles are not as well known as *Aperture* nor so long-lived. Much has been written about *Aperture* as the ultimate modernist organ. I believe that this reputation was attributable partly to a combination of tasteful presentation and impeccable production standards. By floating reproductions inside generous white margins, the design evoked an original black and white print set in a matte; it seemed to demand that the reader take a step out of the noisy modern world into contemplation. The photographs tended to be "timeless" and "universal" subjects taken in recognizable genres (still life, nude, landscape, and so on).

More by example, than anything, Minor White established an agenda that was adopted and improvised upon by most of the editors that came along in the 1960s. First, that the mission of the photographers' press was to complete the daunting task begun with *Camera Work*: to win academic respectability for the art of photography, improved social status for art photographers, and to cultivate a sophisticated audience to support their cultural activities. Secondly, that excellence must be a high priority. By far the most important of these was the pedagogic insistence that photographer/readers must be active in the realization of these objectives. *Aperture*'s campaign to get photographers to convert indifferent audiences into "visually literate" ones began in the 1950s, and was inspired by Henry Holmes Smith.

It has always been a matter of speculation what, if any, influence small photography magazines have on the direction of the events they mirror. Compared with the circulation figures of *Life*, the average photographers' magazine addressed a ridiculously small audience (measured in the low thousands or lower) and this tended to be restricted within the country of origin. Yet its loyal and passionate audiences were the ones that serious photographers wanted to reach and their contributors included the most influential figures of their day such as Szarkowski who was a regular contributor to *Contemporary Photographer* and then later to *Creative Camera*.

I want to speculate upon the successes and failures of two key titles of the photography scene in the 1960s. *Contemporary Photographer* was published between 1960 and 1969 in New York and Boston and was *Aperture*'s rival for a while. *Contemporary Photographer* was more pluralistic than *Aperture* and is interesting because it tried to encompass all styles of art photography during the 1960s. The last two editors were Lee Lockwood and Carl Chiarenza. *Creative Camera* may be one of the first of the photographers' magazines to appear outside America. Because of its monthly frequency, the magazine could be (and was) even more eclectic in its tastes. *Creative Camera* was founded in London in 1968 by a photographer called Colin Osman. But its editor, Bill Jay, began commenting on the English scene a year earlier at the helm of *Creative Camera Owner*, *Creative Camera*'s predecessor. In many ways *Creative Camera* looks like a British version of *Contemporary Photographer*. The logo is similar and Jay's crusading tone is identical to Lockwood's. With its iconic silver cover, *Creative Camera* was thinner than the quarterlies and more disposable looking.

The editors of these magazines saw it as their mission to rally their readers round the cause of "good photography" through the cultural isolation of the 1960s. Editorials testify that this was an era that was full of false dawns on both sides of the Atlantic. The photographers who subscribed to *Contemporary Photographer* and *Creative Camera* experienced contrasting cultural situations but thought of themselves, for a short while, as a community—united perhaps by their frustrations and marginalization. These magazines helped to focus that sense of community, acting as a mirror to enable this community to see an image of itself. *Contemporary Photographer*'s perspective was limited to developments on the East Coast of the United States where Lockwood and Chiarenza were based. It did not cover Europe. By contrast, *Creative*

Camera focused on Europe and the United States. Europe had its émigré photographers and its classic pictorials as well as a great heritage of avant-garde photomontage. Readers were probably more excited about reports from America where exciting trends were being set. American contributors included John Szarkowski and Peter Bunnell of MoMA and Robert Frank had a column for a while. For Jay, America represented an encouraging model for the future shape of what in Britain was called "creative photography."

Editors were good at informing their communities of readers about what had to change and why and were, I would argue, very effective at motivating them to participate in change, or at least to feel they were involved in change. To compensate for their comparatively small audience numbers, the photographers' magazines had one advantage: that was an intimacy between editors and readers that helped them work together to try to change things. The intimacy of the small magazine, then as now, is in contrast to the "editorial distance" of the daily newspaper. Editors and readers were the same people and used the same language. The editors of *Lightwork* addressed their readers as equals when they apologized for offering to pay $10 for each photo they printed: "That's shamefully little but it's the best we can do . . ." Small magazines make effective catalysts because readers and editors share the same values, if not the same opinions. Editorials, some almost confessional, promoted a sense of community and common ownership. A leader in *The Boston Review of Photography* January 1968 refers to the magazine as "your magazine" and as a "workshop for the entire photographic community." The inaugural issue of the newsletter, *Minority Photographers Inc.*, answers the rhetorical question, Who are we? ". . . photographers who have joined together in a mutual effort to overcome discrimination in the exhibition of their work . . ."

The bond between readers and their titles was strengthened in the knowledge that the magazines were produced by photographers for photographers. At its inception, *Creative Camera* instigated "postal circles," urging keen photographers to form social networks of up to 15 people. Each put one print each into a box and circulated it, offering and receiving constructive criticism as it went. In ways like this the magazines acted as catalysts and their editors became well-known activists within their communities. A magazine came to stand for something that was rare or missing in the commercially driven mainstream such as a commitment "to provoke rather than to inform" (*Contemporary Photographer*) or to "quality" over "quantity." Readers were prepared to lend support because editors and the contributors were all in some way committed to photography and prepared to forfeit financial gain to prove it. Boston Review's editor writes, ". . . letters from readers constitute my salary as Editor, I consider myself well paid." The editors of the Toronto-based *Impressions* announced, "The only ideological bias of the magazines is against commercialism . . ." In contrast to the mainstream magazines, the photographers' press carried no advertising. Big business prospered by selling photographers essential materials, but refused to support these magazines. Some editors bemoaned their enforced marginal status but others celebrated it. An editorial in *Contemporary Photographer*, "The Uses of a Small Magazine" announces that "owing allegiance to neither advertiser not to mass readership . . ." a small magazine can remain, "serious and non-commercial."

Editors devoted themselves to mapping the transition years, highlighting new developments that would interest and possibly hearten discouraged readers. *Contemporary Photographer* sounded upbeat about the New York scene in the early 1960s: "Photography as a fine art is only now crossing the threshold of its potentiality . . . but its future promises even greater things." The fortunes of independent photography in Britain did not look up until the 1970s. But things were changing in the late 1960s. When Jay could not report good news from home he referred readers to encouraging trends in New York or Rochester, home of the George Eastman House.

By highlighting the lack of many crucial things for the health of photography—great pictures, great photographers, mature critical writing and so on—the magazines put the onus on readers to supply these missing essentials. *Contemporary Photographer* appealed to "serious photographers" for photographs and manuscripts but mostly for dialog in the form of comments on the contents of past issues. Their failure in attracting critical and other texts may explain why these magazines may now seem so improvised and parochial.

Editors recognized that the single most important missing element was a sophisticated audience for photography and made this one of their favorite topics. Lee Lockwood once quoted Walt Whitman, "To have great poets, there must be great audiences too." Without an audience there could be no "print-buying public," Lockwood notes.

Contributors to *Creative Camera* and *Contemporary Photographer* urged photographers to start a dialog with the public. Young photographers were regularly applauded for trying, the more opportunistic the better. Lockwood reported favorably on an initiative by three young photographers who exhibited at the New York School for Social Research in 1962. Each produced and marketed a small portfolio comprising ten photographs. Each was signed and numbered and cost $25.00. Lockwood supposed that this innovation might have implications for other "serious cameramen" who would prefer to avoid soul-destroying commercial work. In a time of "shrinking markets for photojournalism . . . the small, personal portfolio such as described above may one day be one way out of the dilemma."

Bill Jay endorsed such enterprise too, but he had his eye on the eventual prize of state subsidy from the Arts Council of Great Britain. If this body already distributed funding to the fine and performing arts, then why not to photography? In one 1969 issue Jay reported the encouraging news that an Arts Council committee had been set up to "discuss the place of photography in future art gallery programmes." "It's a big step forward," he conceded. But then he cautioned that no one with "vision and passion" about photography was represented on the committee. Jay was the master at stirring up passions. "The fate of photography in this country is at stake," he concluded.

All magazines need role models, and the photographers' press needed people that would willingly inspire readers and give them hope during this testing decade. The past was a great source of colorful, crusading characters, and editors and photographers alike rummaged through the back catalogs of photography for material. As a result *Contemporary Photographer* published the first monograph of the photographs of Charles Sheeler. The English photographer Tony Ray-Jones tells readers of *Creative Camera* that the 1930s photojournalist, Bill Brandt, was a major influence and Diane Arbus is said to admire August Sander, a German portraitist of the pre-war era. Of course the thriving media scene produced its own cast of young, up-to-date role models, which inspired young photographers, often luring them into the media with its promises of globe-trotting adventures. Lee Lockwood and Bill Jay were both active in the commercial media and knew many of the photographers and the realities of the magazine world. These included upcoming talents such as Don McCullin, Phillip Griffith-Jones, and Bruce Davidson. The decline of *Life* coincided with the rise of art directors, such as Willy Fleckhaus at *Twen* and Michael Rand at the *Sunday Times* magazine, who were presented to readers as allies of photography.

Mainstream magazines traded money for images. By contrast the photographers' press traded images for cultural capital and access to appreciative, well-connected audiences. While *Contemporary Photographer* and *Creative Camera* took full advantage of what the mainstream could offer in terms of resources and talent, their editors were selective about the kind of image-makers they published. It is noticeable that the personality of the photographer was as important to these editors as were the images. These young, glamorous image-makers were enlisted to help reinforce some of the values of the community such as independence, altruism, tenacity, and self-sufficiency.

Editors and readers valued photographers that did not "sell out," who kept their integrity. Both Robert Frank and W. Eugene Smith were regularly covered in the photographers' press as men of integrity. It was not just editors who invoked the personality of talented photographers. In the essay "Mirrors and Windows" John Szarkowski observes that Smith "came to be regarded as a patron saint among magazine photographers, not only because of the excellence of his work, but because he quit *Life* magazine in protest not once but twice . . ." Smith's name was routinely invoked in the context of articles that carped at the press for interfering with pictures. In one such piece, in which Bill Jay challenges young photographers to change "the commercial world," Smith is described as a "constant source of inspiration to young photographers."

Frank was known to consider magazine work to be a sell out. He reinforced his contempt for magazine photographers in an unprecedented series of Letters from New York that were published in *Creative Camera* throughout 1969, which must have been awe-inspiring for young readers. In Frank's world view the line between art and commerce was clearly drawn. In one letter he describes meeting a well-known *Life* photographer at a Bill Brandt exhibition, who tells Frank that he "doesn't buy" Brandt. "Of course Mili and *Life* and 500 other editors wouldn't buy it either . . . you have to be an artist to do that kind of stuff."

Lee Lockwood's notion of the ideal young photographer is profiled in an issue of *Contemporary Photographer* along with a sketch of the daunting tasks awaiting him. The young photographer must articulate a "personal vision" of the world, Lockwood states. This would involve following the "pure" path that avoids "non-commercial photography" and salaried photojournalism. Because these were pioneering days, new photographers needed to act as activists too because outlets for their photography were scarce. Audiences would need to be awakened from "visual lethargy" induced by a media that has abandoned its commitment to hard-hitting, truth-telling photo-essays and dumbed down.

One can only speculate about the effect of this kind of rhetoric on young photographers. Lockwood's last issue as editor contains the thoughts of one ambitious young photographer who was trying to measure up to these impossibly high standards, both morally and artistically. If the values Lockwood articulated in his editorials can be said to reflect those of the photographic community, then Charles Harbutt embodied many of them. He was young, a Magnum member, therefore independent of big media and more likely to be motivated by something higher than the quest for financial reward. Harbutt has evolved an experimental type of picture essay, and so has pushed his medium toward a "personal vision" that is transcendent of the limitations of the press. His mentor was no less a person than Smith. Furthermore, Harbutt was altruistic; he was giving something back to the community in the shape of a new concept. Harbutt's essay, "The Multi-Level Picture Story" (which would be reprinted in *Creative Camera* two years later) was written in the spirit of a colleague sharing advice with his peers. By contrast with Frank, who seems sure of his place, Harbutt emerges as a man in transition, caught between the moral imperatives of photojournalism past, with its stress on intuitiveness and reverence for the mass audience, and yet burning to take creative control of his work, to create a "personal vision."

The article focuses on an 8-page picture sequence titled, The Blind Boys. The multi-level picture story attempts to bridge a gap between the "simple picture story" and something transcendent that can "tell 'stories' on deeper levels." Most of the article is taken up with describing how each of the "six levels" might be interpreted to complement the whole. Toward the conclusion Harbutt admits to a personal "quandary" which seems to be between heart/intuition and head/intellect. If the essence of photography is "life as it is lived" then the multi-level picture story has failed, because the intuitive rapport between image-maker and subject has been submerged by the complexity of the design.

Harbutt believes his pictures "do not have real existence unless they are published." Journalism is "socially useful and making photographs is more than valid . . ." For Smith, staying with *Life* was a sell out, but Harbutt is torn. He enjoys the editorial process but agrees that caption writers and designers can interfere with or contradict the photographers' message. "This is a particular problem in the contemporary magazine field . . ." admits Harbutt, and that is why "the 'multi-level picture story' is a rarity in photojournalism." Finally he renounces the experiment. Which route will he follow: the heart or the head? Will be stay the artisan or become the artist? "I have not resolved the problem as yet," he concludes. Harbutt was fortunate to be offered this platform for his views and we are lucky to have them on record. The photographers' magazines give us access to the human face behind the official rhetoric.

Traditionally, small magazines have been the mouthpieces for art movements because they are well suited to the role of catalyst. The editors of the photographers' press understood this when they appointed themselves in charge of bringing their photographer readers through transition. There is evidence that they were resourceful at selling the dream of a bright future for non-commercial photography. They harnessed the resources of their communities and

ruthlessly exploited the glamour and myths of the mass media, as well as its shortfalls. One of their biggest assets was the voice of the grassroots art photographer. Editors such as Jay and Lockwood spoke with the voice of their readers and they often succeeded in transforming their frustrations and aspirations into actions; for instance, getting together with others to stage exhibitions or lobby an authority. This voice—fatalistic and alternating between carrot- and stick-wielding—became the voice of the art photography establishment. It is detectable in the rhetoric of photography's greatest proselytizers from Stieglitz to Ansel Adams and including John Szarkowski, who were all photographers first and foremost.

A more ambivalent asset was a strong, moral role model. Based on an amalgam of Robert Frank and W. Eugene Smith, this complex "black and white" photographer appeared in countless guises and was courted by editors because he testified to the existence of a path outside "commercialism." While many young photographers were doubtless inspired by qualities such as independence, focus, and moral courage, these were also difficult to emulate and could be divisive, as photography historian Ian Jeffrey has observed. He once speculated that many young photographers of the period may have simply given up, fearful of being unable to make the sacrifices demanded. Harbutt's essay is valuable because not only does it give a human dimension to the high ideals expressed in editorials such as Lockwood's, but it illustrates, quite movingly, this dilemma. By taking the pure path, into books and exhibitions, a photographer might exchange a mass audience for an elitist audience but trade a cherished social role for the loneliness of the poet.

The magazines promoted an "us and them" mentality, but that is a function of any small magazine. But they also championed a very restrictive range of artistic identities. Even though Harbutt had the skills of an editor and designer, he seemed unwilling or unable to imagine himself transcending the role of picture-taker/artisan. By contrast, outside the narrow world of photography, artistic identities were in flux as boundaries were perceived to be melting between high and low cultures, artist-as-author, and author-as-consumer. This was the view of Susan Sontag in her influential 1965 essay, "Against Interpretation."

One of the key roles of the photographers' magazine was as a benchmark of high standards and best practice. But there was mystery and some anxiety surrounding the criteria that editors (and curators) used to elevate average photographers to great ones. How much was it to do with personality or how one earned a living? This uncertainty was satirized in an article in the Californian artists' magazine, *The Dumb Ox*, in an exchange between two editors. "Most people have very bizarre opinions about things but are socialized into suppressing those views," James Hugunin observes. "Like how many people would have the guts to say that Jack Welpott's most recent photographs belong in a camera club salon and not in an art museum? Well, even I don't have that much guts!"

While *Aperture* and *Creative Camera* both continued to publish into the 21st century (albeit after a succession of identity changes since the 1960s) many of their rivals closed. *Contemporary Photographer* folded in 1969 but not before producing one final issue that neatly symbolizes the end point of the trajectory begun in the late 1950s. The editor, Carl Chiarenza, made a special point of inviting women writers to contribute to this predominantly male domain. More pertinently, the Boston art historian Samuel Edgerton takes photography a significant step out of the ghetto toward the cultural mainstream. Edgerton suggests that the "specialism" of photography as an art was not derived from its technical and chemical processes (as argued by formalists), but rather that it was encountered in reproductions. Acknowledging McLuhan ("the medium is the message"), and with a nod to Walter Benjamin, Edgerton notes that museums confer status on photography, but the ideal context is "the medium of its original appearance"; i.e., printed matter. In challenging norms, this final edition of *Contemporary Photographer* (appearing a year after Aspen published Barthes' essay, "The Death of the Author") anticipates the pluralism of the 1970s.

The photographers' magazines delivered their audiences to the altered cultural climate of the 1970s, but did not die; new ones adapted to changing situations. But many of the values that the magazines of the 1960s represented—photography as an autonomous art, the photographer as author, and the original print as the marquee of genius—were soon eclipsed, first in

the United States, then in Britain and then later further afield. As the critique of photographic modernism gathered momentum, from various "counter-hegemonic" cultural sites, the distinctive voice of the grassroots art photographer lost its prominence within discourse. By the mid-1980s the photographers' press contained a diversity of titles that attested to the broadening of photographic discourse. Talk of a homogenous community of art photographers gave way to talk of multiple communities, each representing a competing yet complementary philosophy or practice.

Arguably, one of the most valuable things about the photographers' press of the 1960s is that it represents an alternative photographic history, a kind of folk history, that takes its authority from the voices of photographers and their supporters.

FURTHER READING

Batchen, G. (1999). After Postmodernism. *Art Monthly Australia* No. 124, 22–25.

Benjamin, W. (1969). The work of art in the age of mechanical reproduction. In *Illuminations* (Ardent, H., ed.), New York: Schocken Books.

Bourdieu, P. (1990). *Photography: A Middle-Brow Art*. Cambridge: Polity Press.

Brittain, D. (ed.) (2000). *Creative Camera: 30 Years of Writing*. Manchester: Manchester University Press.

Coleman, A. D. (1979). Minor White: Octave of prayer (I), Minor White: Octave of prayer (II). In *Light Readings: A Photography Critic's Writings 1978–78* (Coleman, A. D., ed.), pp. 140–150. New York: Oxford University Press.

Coleman, A. D. (2000). Toward critical mass: Writing and publishing in the Boston area, 1955–1985. In *Photography in Boston: 1955–85* (Rosenfield, L. R. and Nagler, G., eds.), pp. 118–135. Cambridge, MA: MIT Press.

Craven, R. H. (2002). *History of Aperture. Photography Fast Forward: Aperture at 50*. London: Thames & Hudson, pp. 8–197.

Duncombe, S. (1997). *Notes from the Underground: Zines and the Politics of Alternative Culture*. London: Verso.

Evans, J. (ed.) (1997). *The Camerawork Essays: Context and Meaning in Photography*. London: Rivers Oram Press.

Finnegan, C. (2003). *Picturing Poverty: Print Culture and FSA Photographs*. Washington and London: Smithsonian Books.

French, B. (ed.) (1999). *Photo Files: An Australian Photography Reader*. Sydney: Power Publications and Australian Centre for Photography.

Sellers, S. (1997). How long has this been going on? *Harper's Bazaar*, Funny Face, and the construction of the modernist woman. In *Looking Closer: Critical Writings on Graphic Design* (Bierut M., Drenttel, W., Heller S., and Holland D. K., eds.), pp. 119–130. New York: Allworth Press.

Stein, S. (1990). The graphic ordering of desire: Modernization of a middle-class women's magazine, 1914–1939. In *The Contest of Meaning, 2nd edition* (Bolton, R., ed.), pp. 145–161. Cambridge MA: MIT Press.

Taylor, J. (1986). Ten.8 Quarterly Magazine. In *Photographic Practices: Towards a Different Image* (Bezencenet S. and Corrigan P., eds.), pp. 95–99. London: Comedia.

Histories, Theories, Criticism

GARY SAMPSON, PH.D.
The Cleveland Institute of Art

The story of photography's past is usually characterized now in terms of histories, and no serious student or scholar of the medium would assume that one single account could pass as

an exhaustive reference for such a pervasive phenomenon in modern culture. Neither would one consider without suspicion the argument that a single line of thinking about the meaning of photographic images might somehow comprise the essential properties of their form and significance. The modernist rhetoric of essential meanings and overarching narratives, so crucial for the historical and critical interpretation of the past two centuries until the 1960s, has given way to a more varied cultural discourse, which has fostered contemporary awareness of formerly undisclosed social functions and meanings of visual culture, photography included. This essay will thus first highlight select events, movements, written accounts, and compilations of work, especially with respect to the emergence of a modernist historical and theoretical casting of 20th century photographic image production and reception. It will then take up developments in the later part of the century that led to the expansion in the literature of photography to include a broader regard for its social and theoretical meanings. This essay will not concern itself with the impact of photography on artists who worked in other media (see Photography, Fine Art Photography and the Visual Arts, 1900–2001). With the exception of some concluding remarks, it also will not engage the complications of digital image-making, such as the further challenge to photography's believability or whether the digital really constitutes "photography" as conventionally conceived by the modernist position.

As a point of entry into the discussion, the reader may find it useful to briefly reflect on the three categories considered in this essay, their interrelationship as well as their distinctiveness. In taking a historical view, one also assumes, whether explicitly stated or not, a theoretical one, in which one can discern a particular way of thinking; for instance, about events, individuals, innovations, institutions, forms of production, which provides a framework for understanding an aspect of the past over a period of time. Any thinking in retrospect is hence theoretical, although it need not be the immediate concern of the writer to call attention to this. This should be distinguished from the kind of writing that foregrounds theory as a chief concern either in grasping the causes and effects pertinent to the meaning of the past, or proposes a new theory for getting at the significance of things as they are in the present. Further, when historians or theorists make judgments about something, whether implicitly or explicitly, they are being critical. When, however, the writer presumes to make judgments that are backed up by argument (not necessarily rational), and puts it out in the public arena, one can call this criticism. As a fairly recent profession that emerged in the 18th century, being a critic entailed making judgments about cultural activities in a way that could ideally assist the public in attaining a discerning eye and an intelligent regard for things presumably worthy of attention on the basis of noble sentiment and witty observation, universally understood ideas, and formal values.

While one could surely split hairs over these basic distinctions of history, theory, and criticism, they are immediately appropriate to thinking that occurred concerning photography early in the 20th century. By this time a considerable body of material already existed that had laid the groundwork for further response from an historical as well as a theoretical point of view. When closely studied, such sources reveal a history of thinking about the medium in terms of practical application and subject categories for the professional and serious amateur, technical advancements and advice, and more philosophically disposed issues regarding the nature of photography—whether, for instance, a mechanical device like the camera could turn out anything like a conventional work of art. George Eastman's roll film camera, known as the "Kodak," and related developments in the late 1880s and 1890s had made it relatively easy for anyone to "snap" pictures, a popularization of photography that annoyed a number of elite practitioners who would rather think of themselves as artists than shutterbugs.

In the United States one of the arch proponents of the photograph as art was Alfred Stieglitz, who broke from the club set to form the Photo-Secession, thus implying there was something special about what he and his affiliates were doing with the camera. Stieglitz was adamant about distinguishing between work of a commercial nature, popular amateur uses of the camera, and pictures by serious photographers who aspired to artistry by endowing the photographic image with expressive qualities. Critically speaking, photographs might then be judged in accordance with similar stylistic and formal criteria that had previously been

reserved for painting and the graphic arts. Stieglitz set about supporting an aesthetic line-age for art photography by calling attention to exemplars of the medium including pioneers D. O. Hill and Julia Margaret Cameron in the Photo-Secession's journal *Camera Work*. He thus began a tradition of the "canon," an authoritative selection of artists deemed important enough to consider in any serious history. The brilliance of Stieglitz is that he was able to con-struct a history, together with an institutional apparatus consisting of a gallery, a journal, and a network of artists and writers. This made a forceful case to establish photography as art.

Secessionists and their allies in pictorial photography had counterparts in Europe, includ-ing England, Germany, and France. Together they formed an "international" movement that was essential to the furtherance of critical discourse premised on simulating or applying artis-tic effects. Writers like Sadakichi Hartmann and Charles Caffin were among the critical voices that took the cause in intriguing directions greatly infused with the aestheticism and japonisme that had endowed western European art with a stylish verve, seductive atmospheric effect, and restrained decadence late in the previous century. Precision of detail was too close to docu-mentary work, to the applied, contrary to the artful manipulations employed by the majority of pictorialists in their portraits, genre scenes, nudes, and landscapes. This fusion of art and photography would be the catalyst for a profusion of popular and sentimentalized pictures that continued to prevail in regional photo clubs well into the 20th century.

Out of the earlier specialized network of artist photographers and their supporters, how-ever, came a resistance to any direct tampering with the negative and print surfaces for aesthetic ends. A respect for what was considered the inherent properties of the medium—maximum depth of field, high resolution, maintaining the integrity of the initial exposure—gave rise to a modernist rhetoric in the next wave of critical material on photography. Proponents of this attitude included Hartmann and Stieglitz himself, who renounced pictori-alist devices for the direct or "straight" approach, as it would come to be known to future gen-erations. Paul Strand would come to embody for Stieglitz the new direction, as witnessed in 1916 at the final photography show of the latter's Manhattan gallery "291" (originally the Little Galleries of the Photo-Secession). By the 1920s, Strand, Stieglitz, Charles Sheeler, Edward Weston, Imogen Cunningham, and the young Ansel Adams, among others, would contrib-ute to a critical and theoretical engagement with their craft, which activated subsequent gen-erations of writers, scholars, and practitioners in either supportive or critical response. That the reductionist forms and tropes of early modern abstraction were influential in this regard is witnessed in Strand's corresponding attention to the close-up and the machine. Similarly, Weston would write of "the thing itself" in his daybook entry of March 10, 1924, paralleling what John Tenant said of Stieglitz in 1921; that his work focuses on "the subject itself, in its own substance or personality. . .without disguise or attempt at interpretation." The new mod-ernist criticism, so much a collective project of the artists themselves, was further supported by writers and reviewers of the radical journals of the period, such as *The Little Review*, *The Dial*, *Broom*, and *The New Republic*. The short-lived Group f.64, formed in 1932 to champion the straight approach on the west coast, included Adams, Cunningham, Weston, Willard Van Dyke, and others. Adams, best known for his extremes of delicate grace and epic grandeur in his photography of the wilderness, was particularly emphatic in a series of writings and books about the proper use of photography. He theorized about the notion of "pre-visualization" while strategizing a fool-proof method for obtaining consistently superior exposures called the zone system.

In Europe and the fledgling Soviet Russia, where modernist experimentation had achieved new force following WWI, the "new photography" (as it was often referred to by its proponents) was closely associated with a "new vision" in which radical art and social action would con-spire to lead the masses into the future. The Russian Constructivists El Lissitsky and Alexander Rodchenko found new strategies in both the straight radical view and the montage practices that also informed the European vanguard of the 1920s. In Germany, Bauhaus designer Laszlo Moholy-Nagy's *Painting, Photography, Film* (1925) demonstrated how innovative uses of the medium might transform one's view of the world; in a prophetic utterance quoted by his con-temporary, the cultural theorist Walter Benjamin, Moholy-Nagy declared, "The illiterates of the

future will be the people who know nothing of photography rather than those who are ignorant of the art of writing." Though it explored all varieties of photography and recent productions in film, a similar visionary impulse was at the heart of the 1929 international exhibition in Stuttgart, Film und Photo (or simply Fifo), which was sponsored by the Deutscher Werkbund, the German industry and design collaborative. The show was a significant testimony to the industrial world's embrace of photography in general; a recognition of the camera's potential for expression and for its applied use as an extended way of seeing and knowing the world. Both sides of the Atlantic were also represented, as Edward Weston and Edward Steichen, Stieglitz' photographer friend and associate, assembled an American section. From an historical perspective, written support for the serious implications of the work on display came not from the catalog, but from other publications of the period. These include Werner Gräff's foreword to *Es kommt der neue Fotograf!* (*Here Comes the New Photography*, 1929), and *Foto-Auge* (*Photo-Eye*), in which Franz Roh offers intelligent commentary on the classes of photography previously explored by Moholy-Nagy and further demonstrated by the photographer's section of Fifo. In contrast to the diverse techniques encouraged by Roh, Moholy-Nagy, and the Russians, the direct approach represented by the American contingent was only one of numerous possibilities for modern innovation, paralleling especially The New Objectivity, exemplified in close-ups of plants by Karl Blossfeldt (*Urformen der Kunst/Art Forms in Nature*, 1929) and the patterns of industrial and natural forms in Albert Renger-Patzsch's pictures (*Die Welt ist schön/The World is Beautiful*, 1928).

The rhetoric of modernism, having fully emerged in the 1920s and early 1930s, infused the use of the medium in documentary and photojournalistic enterprise with a revelatory sensibility related to Surrealism. Advances in hand-held cameras like the 35 mm Leica and the advent of magazines like *Münchner Illustrierte Presse* and the French *Vu*, whose popular appeal depended on the picture story, encouraged a special kind of awareness of the social landscape. Books of photographs appeared of both cosmopolitan and provincial subjects, culturally savvy and formally sophisticated. Paris *Vu*, for instance, ran pictorials by the Hungarian André Kertész, and his compatriot Brassaï produced in *Paris de nuit* (1933) a haunting impression of the city's cafes, its denizens, and boulevards at night. In 1952 Henri Cartier-Bresson, whose prolific career ran well into the century, articulated his personal theory of photography in *The Decisive Moment*. Here he called for an almost preternatural sense of convergence at the time of exposure, which for him resulted in pictures of spirited formal and social piquancy. Undoubtedly inflected by André Breton's Surrealist notions of the uncanny and marvelous, such photographers incorporated a special awareness of the extraordinary power of the medium to convey the odd spectacle of life. Surrealism offered alternative avenues for expressive photography; Breton and his cohorts had already grasped the aspect of "making strange" the environs of Paris at work in the documentary imagery of Eugène Atget, who became adopted as a precursor of the movement before his death in 1927. The critical reception of Atget's pictures indicates an awareness of photography's potential—seen also in Kertész, Brassaï, and Cartier-Bresson—to provide a politically subversive strike against the appropriation of the medium for extremist propaganda, in which a battle was waged for the attention of the masses (Hitler himself had well understood the utility of photography and film in this regard). In his 1931 essay "A Short History of Photography" (published in *Literarische Welt*), Walter Benjamin noted with respect to Atget's "voiceless" and seemingly "empty" pictures of the city that "These are the sort of effects with which Surrealist photography established a healthy alienation between environment and man, opening the field for politically educated sight, in the face of which all intimacies fall in favor of the illumination of details." Though not to be truly appreciated in the United States until the political foment of the 1960s, Benjamin's writings were nonetheless prescient with respect to the understanding of photography as integral to the development of modern culture, affording insights that few had made thus far.

With the proliferation of pictures in reproduction during the Interwar period, Benjamin had also recognized the crucial importance of the caption to anchor meaning for the reader. The coupling of words and pictures for both informing and entertaining reached a climax in the photo-essay, which in America was the chief form of reportage for magazines like *Life*

and *Look*, whose circulation began in 1936 and 1937, respectively. A documentary ethos was soon to be articulated, exemplified in bold black and white images, varied scale, and the succinct texts of the essay. As later studies of the photo-essay have demonstrated—for instance, the question of authenticity of Robert Capa's treatment of the Spanish Civil War or of shifting contexts for W. Eugene Smith's 1951 Spanish Village pictorial in *Life*—the persuasiveness of a narrative depended not only on these variables, but on the political ideological persuasions of the popular media in which they appeared. Art editors, who must work with the explicit aims of their publishers in mind, and not necessarily on behalf of the photographers' own wishes, understood that they had the power to shape conditions of representation that in turn would have a pronounced impact on public reception, and hence issues of public debate of sometimes major political importance. The photography journals in America tended to support populist sentiments that at once both reiterated and departed from the high modernist aesthetics related to the New Photography and the straight approach of the 1920s and 1930s. Elizabeth McCausland's "criteria," which appeared in the *U.S. Camera Annual* for 1940, included the terms "honesty," "truthfulness," "a popular art," "historical value," and "propaganda."

Distinctive theoretical differences between photography and art are often not easily discerned, complicated by photography's multiple applications, structural properties, and cultural reception. In the March 1946 issue of *The Nation* the American critic Clement Greenberg published a review of the work of Edward Weston, titled "The Camera's Glass Eye." Greenberg wrote in his review that the appropriate province of photography was the "literary," which correlated with his modernist narrative of the inherent characteristics appropriate to any given medium. Weston was a case of a photographer who had gone inappropriately in search of a formalist aesthetic more suitable for contemporary painters. By way of contrast, the work of Walker Evans was singled out as "modern art photography at its best." Evans came into the limelight as the first photographer to have a solo exhibition at the Museum of Modern Art in New York (or simply "MoMA"), which occurred in 1938—a critical gesture in itself from the principal American museum dedicated to modern art. The photographer exercised control over the sequencing of the images in the accompanying publication, *American Photographs*. Captions were limited to lists of generic titles and place names, allowing the images, some of which dated back to the late 1920s, to convey the passing of an earlier age in America, and the impact of industrialism and the automobile especially on the built environment. (Evans had briefly been one of Roy Stryker's photographers for the Farm Security Administration (FSA), a New Deal program that sought to create a visual account of the wretchedness of the rural poor and other visible signs of the impact of the great Depression.) Evans actually had more in common with Weston than Greenberg's criticism would allow. Weston, who tended to disavow theoretical explanations of photography including his own, published several volumes of his work during his lifetime (see, e.g., *California and the West*, with Charis Wilson Weston, 1940). These were the product of "mass production seeing," according to him, relating to the rapidity with which photographs could be made, and to other forms of modern technology that symbolized speed. "Authentic photography," he declared, "in no way imitates nor supplants paintings: but has its own approach and technical tradition." Weston repeatedly claimed intrinsic properties for the medium, and thus was actually posing a similar modernist argument for photography as Greenberg had for painting. Greenberg, however, would appear to have missed the point of Weston's strong sense of form, as witnessed, for instance, in his landscapes and close-ups of vegetables, shells, and nudes. For both Weston and Evans, photographs, whether leaning toward a modernist emphasis on form or a narrative approach, underscored the free expression of ideas through "recording the objective, the physical fact of things."

From its inception in the late 1920s, the mission of MoMA was to inform the public concerning the art and design of the modern age. The selection of certain cultural objects as modern led to its embrace of photography, and in 1937 its first major show was organized by Beaumont Newhall. Trained as an art historian, Newhall brought a significant intellectual framework for comprehending photography as a narrative that paralleled the history of modern culture. Newhall's exhibition became a central force in shaping the public's understanding of the medium's past. The exhibition catalog, revised in 1938 as *Photography, A Short Critical*

History, formed the basis of Newhall's *History of Photography*, which told the story in terms of technological developments and practitioners whose photographs were particularly compelling for aesthetic merit and the revelation of events. Twentieth century scholarship owes an enormous debt to him, as well as to his wife Nancy Newhall, for bringing to the foreground numerous photographers whose bodies of work adhered to high standards of practice and stylistic presence. Newhall's specific contribution in the form of exhibition and the subsequent expansion of the catalog into the book (with editions in 1949, 1969, and 1982) marked another major turning point following the Film and Photo show. Important for its evaluation of genres of images and the articulation of aesthetic lineages like the straight approach and a documentary style, Newhall's treatment of the photograph as an expressive object tended to overshadow his attention to photography as a social formation responsive to seminal events and world-changing circumstances. It further legitimated the importance of photography through the art museum, but lacked the theoretical specificity found in the literature associated with the German exhibition and critics such as Benjamin. Social history specific to photography in America was explored by Robert Taft in *Photography and the American Scene*, which came out in 1938. Unusual for its treatment of the history of the medium from a nationalist perspective, Taft's book focused only on the 19th century.

The immediate post-war period saw an increase in attention to making photography even more intelligible to the public while continuing the historical and critical emphasis on the object, the photographer as artist, and the overall potential to enlarge one's awareness of the world. Thus, by 1955 Helmut and Alison Gernsheim had brought their sensibility as serious collectors to their own historical account, *The History of Photography from the Earliest Use of the Camera Obscura in the Eleventh Century up to 1914*, which was dedicated to Beaumont Newhall. This volume, subsequently revised and enlarged to two volumes (1969, with a third edition in 1982), clearly demonstrated the Gernsheims' interests by using their extraordinary collection of 19th century photographs. It also underscored the importance of collectors and curators, with all their idiosyncrasies, in bringing to light topics germane to photography, culture, and society that were worth careful scholarly consideration. The release of the Gernsheims' history coincided with Edward Steichen's Family of Man exhibition at MoMA, which comprised the work of numerous operators who were selected not for espousing any one individual position, but instead for projecting a collective optimistic vision of a world brought together by common aspects of humanity. This was understood by some of the more critically astute writers of the period. The French structuralist Roland Barthes, who would become an influential theorist of photographic meaning a few years hence, noted the exhibition's imperialist overtones. Steichen's production, which included a widely distributed catalog, also suggested to later commentators that his was a mission as much as anything else to use the photograph as an ambassador of goodwill in the face of Cold War fears. In retrospect, Family of Man has taken on additional meaning because it puts into high relief several lines of photographic discourse that contributed more specifically to historical and critical assumptions about how the medium could operate as an agent of spiritual rumination and speculation on the one hand, and of photographic wit and socially caustic commentary on the other.

Minor White is generally credited for establishing a path of philosophical inquiry into photography paralleling the subjective experiments and existential evocations in the visual arts and literature of the late 1940s and 1950s (one thinks here of the Beat generation of poets as well as the New York School of Abstract Expressionism). The thrust of White's concerns together with a number of other American photographers, including Aaron Siskind, Harry Callahan, Frederick Sommers, Walter Chappell, and Henry Holmes Smith, represented a counter-phalanx to the mass appeal of the medium. The writings and photographs of these artists formed a collective body of esoteric, quasi-mystical material that ventured from the popular, tending again—as Stieglitz and company earlier in the century—toward a romantic enchantment with the photographic image as having the potential for expression equivalent to art. The ideas can best be seen in the essays and images published in the journal *Aperture*, edited by White himself beginning in 1952. It was White too who responded to a call for a method of explicating a photograph that could succinctly be conveyed to the uninitiated.

He promoted the reading of images beyond the superficial recognition of its subject to see the possibility of the image as a source of revelation, and finally as a bridge to expression through words. Such a platform encouraged experimentation related to finding startling juxtapositions and features of abstract beauty in the environment, which could then act as poetic metaphor.

If White and *Aperture* represented an essentially modernist reaction to popular conceptions of photography, another occurrence pressed the case for photography's importance as a catalyst for reflection on the repressed social realities underlying American cultural values and institutions of the 1950s. The Swiss-born Robert Frank had made an automobile trip across America with a grant from the Guggenheim Foundation in 1954 and 1955. As a result, in 1959 he published *The Americans* (first produced in France as *Les Américains* in 1958), something of a 1950s reprisal of Evans' *American Photographs*. The popular response to Frank's penetrating experience on the road was anything but positive; his was a vision few would have called beautiful or appropriate for upholding the myth of a heroic and unified world led by America—highway diners, roadside accidents, racially divided buses, movie premiers, patriotic displays, black funerals, and working class ennui. This off the cuff record from a European perspective would soon be joined by the imagery of Bruce Davidson, Danny Lyon, Diane Arbus, and others. Their probing of the subcultures of American society had a hip insider edge that came to comprise a newer, darkly cast mode of urban photography. Such work would come to be characterized as part of the "social landscape," a term used in conjunction with several shows of the mid-1960s, including the 1966 exhibition curated by Nathan Lyons at the George Eastman House in Rochester, Toward a Social Landscape. Street photography had a long tradition extending back to the mid-19th century, but Frank's strategies of skewed framing and variable focus led to new approaches in the 1960s in which fortuitous alignments, instantaneity, and a perceptive scavenging for quirky human behaviors challenged the metaphorical assumptions posited by White and his associates. Garry Winogrand and Lee Friedlander, both of whom acknowledged the significance of Frank's road trip, developed ambiguities of form and subject that would seem to defy any specific reading. Winogrand's best known statement, "I photograph to find out what the world looks like photographed," provides a glimpse into his theoretically subversive posturing.

John Szarkowski, Edward Steichen's successor as director of the Photography Department at MoMA, championed both Winogrand and Friedlander. He articulated a concise theory of photography in terms of identifiable aspects of production and outcome related to practitioners of all subjects and backgrounds, while still celebrating the canon of previously established photographers and critically distinguishing new artists on the basis of a set of formal principles. These were set down as five key elements in *The Photographer's Eye*, his companion volume to the MoMA's show of 1966: "the thing itself," "the detail," "the frame," "time," and "vantage point,"—all of which acknowledged the selective process of the photographer in taking from the "actual" world and making a "picture." For the fourth element, time, Szarkowski revealingly called attention to Cartier-Bresson's concept of the decisive moment by stating "decisive, not because of the exterior event (the bat meeting the ball) but because in that moment the flux of changing forms and patterns was sensed to have achieved balance and clarity and order—because the image became, for an instant, a *picture*." This had the ring of Greenberg's earlier notions of the appropriate characteristics for each medium, but Szarkowski clearly saw form as equally important to a photog-raph as it might be for a painting, where the critic had more narrowly gauged a successful photograph in terms of how well it functioned as part of a larger narrative construct. Moreover, Szarkowski seemed to close the door on White's romanticized vision of photographs as symbolic images, which could be translated into verbal equivalents that would make legible hidden meanings. Szarkowski's initial theoretical clarity, with its emphasis on the autonomy of the picture, was later complicated by the curator himself, most notably in his exhibition and book of the same title, *Mirrors and Windows: American Photography Since 1960* (1978), which actually acknowledges White's notion of the photograph as a mirror.

Theories of the photograph as social artifact manifested themselves increasingly in the 1970s following critical responses to the urban landscape, cultural difference, civil unrest,

racial and sexual oppression, politics, and war. Accelerated interest in the medium may also be credited to wider recognition of photographs as a relatively untapped source of collecting, connoisseurship, and scholarship, and the related expansion of museum collections and art and art history programs at colleges and universities now convinced of photography's importance. And the critics would look to photography as a fertile ground for examining issues of modern culture. Susan Sontag's commentary on photography, best seen in *On Photography* (1977), a collection of essays that first appeared in *The New York Review of Books*, came to represent a newer intellectual stance with regard to the potential of images to take on multiple meanings beyond any specific intent of the photographer. One can never actually acquire knowledge from photographs in themselves, but "are inexhaustible invitations to deduction, speculation, and fantasy." Neither metaphysically esoteric nor predicated on the subjective vision of the artist photographer, Sontag's affecting criticism, which drew from her wide knowledge of literature and art, stimulated thinking about the medium as a collective social experience. This awareness stood in contradistinction to prior theories that reduced the meaning of photographs to an easily graspable set of inherent characteristics related to technique and the indexical properties of the analog image, which downplayed the differentiations of historical, emotional, and social reception adhering to the subject. Greater attention to the theory and criticism of photography also became apparent in art journals such as *Artforum* and *October*, which by the mid-1970s were challenging the modernist rhetoric of the work of art as an autonomous form and increasing awareness of the potential of photographic images to expand the philosophical investigation of meaning in art. It is not the intent of this essay to explore this avenue (see Photography, Fine Art Photography and the Visual Arts, 1900–2001), but it is important to acknowledge how this recognition of the photograph's structural peculiarities—its direct indexical and iconic relationship to the phenomenal world—served to expand the scope and depth of inquiry related to the nature of the medium. Paralleling and infusing the art world discussion with a new critical rigor from outside this rather insular circle, the semiotic and social theorist Roland Barthes called the photograph "a message without a code," while looking at the *polysemic* function of images in advertising and journalism, instruments of persuasion in the political, racialist, and economic ferment of late modern society. Barthes' analysis was readily adopted by those who found too self-reflexive the photography-as-art idea witnessed earlier in the thinking of Stieglitz and White. A seminal instance of the challenge is found in Alan Sekula's essay "On the Invention of Photographic Meaning," published in the January issue of *Artforum* in 1974, in which the photographer and author took a semiotic approach to question the former pat assumptions made concerning art photography.

The seventies also saw new histories and specialized studies such as Gisèle Freund's groundbreaking *Photography and Society*, first published in French in 1974, and Tim Gidal's important introduction to the early picture story, *Modern Photojournalism: Origin and Evolution, 1910–1933*, published in English translation in 1973. Reassessments of specific episodes of photography's past, exhibitions and studies of important collections, and compilations of writings by photographers and their contemporaries continued to enlarge the public discussion. Alfred Stieglitz' contribution was re-examined in light of his extraordinary collection of photographs of others (see, e.g., *Camera Work: A Critical Anthology*, 1973, edited by Jonathan Green, and The Metropolitan Museum of Art's *The Collection of Alfred Stieglitz: Fifty Pioneers of Modern Photography*, 1978, edited by Weston Naef). The writings of Sadakichi Hartmann, Stieglitz' contemporary who was full of insights about photography as a fine art, filled a volume in *The Valiant Knights of Daguerre* (1978). Peninah R. Petruck's two-volume *The Camera Viewed: Writings on Twentieth-Century Photography* was published in 1979 and a year later Alan Trachtenberg's *Classic Essays on Photography* appeared. In 1981, Vicki Goldberg's *Photography in Print: Writings from 1816 to the Present* was published. The importance of making this material available in such "readers" should not be underestimated as a means of stimulating dialog, scholarship, and innovative responses among photographers and students of photography. In addition to earlier influential figures in American and European circles, they also served to disseminate the critical ideas of more recent writers such

as Barthes, Sekula, Sontag, and John Berger, whose widely read *The Look of Things* (1974) and *About Looking* (1980) emphasized the importance of photographs as a facet of visual culture.

Following the arc of this concentrated attention to the medium, new historical surveys entered both the academic arena and the public mainstream. Naomi Rosenblum's *A World History of Photography* appeared in 1984, and *A History of Photography: Social and Cultural Perspectives* by Jean-Claude Lemagny and André Rouillé was published in 1987 (originally published in French as *Histoire de la photographie*, 1986). Challenges to orthodox views of the photograph as an aesthetic object continued as the academic climate shifted within the discipline of art history itself toward interdisciplinary activity and theories of the post-modern. The development of cultural studies, literary theory, feminist theory, Marxist-informed social history and theory, cultural anthropology, and post-colonial studies contributed to nuanced perspectives on how photographic images had an important function in the cultural and social formation of attitudes and ideologies in the modern world. John Tagg examined photographic agency in legal and political contexts in *The Burden of Representation* (1988), and Rosenblum wrote a *History of Woman Photographers* (1994). Christopher Pinney and Elizabeth Edwards brought semiotics, anthropology, and photography together in their analyses of images of non-Western peoples in, respectively, *Anthropology and Photography, 1860–1920* (1992), and *Camera Indica: The Social Life of Indian Photographs* (1997); Richard Bolton edited *The Contest of Meaning: Critical Histories of Photography* (1989), an influential assemblage of essays whose authors utilized the new methodologies to examine photography and issues of identity, sexuality, and documentation. The sesquicentennial of photography's public introduction (i.e., its 150th anniversary) in 1989 led to a flurry of reassessments, such as Szarkowski's *Photography Until Now* at MoMA. Szarkowski's overview, long awaited but now somewhat passé in treatment, only served to underscore how far the scholarship and thinking about photography had come.

Perhaps the passage of the modern age of photography has fostered an even greater zeal to recognize the international scope and culturally diverse uses of the medium (see, e.g., *A New History of Photography*, edited by Michel Frizot, 1998 and Mary Warner Marien, *Photography: A Cultural History*, 2002). Among the telling indications that the community of critics and scholars in the field have not arrived at a comprehensive theory of photography, however, is reflected in papers associated with symposia and conferences: questions of whether photography has anything that approaches a consistent theory are evident in such publications as *Photography: A Crisis of History* (2002). Spanish photographer and historian Joan Fontcubara asked a number of colleagues from a wide variety of institutions a set of questions related to former histories and their shortcomings, wondering if there was indeed any possibility of a consistent theory of photography. Complicating the situation further has been the ascendancy of digital photography and related computer applications. This strategic development has enabled the hybridization of photographs outside the technical parameters of conventional processes, thus precipitating further discussion of cultural perceptions of photography and its meaning. This is seen to be far more elusive than once was believed, so that former modernist assertions about the nature of the medium seem almost naïve. Analog photography seems destined to become a facet of practice that will become ever more arcane as the years pass, but digital photography promises to make the phenomenon all the more acutely intriguing for subsequent generations of thinkers and practitioners.

FURTHER READING

Barthes, R. (1972). The great Family of Man. *Mythologies*. Trans. by Annette Lavers. New York: Hill and Wang.

Barthes, R. (1985). The photographic message. *The Respon-sibility of Forms: Critical Essays on Music, Art, and Representation*. Trans. by Richard Howard. New York: Hill and Wang.

Benjamin, W. (1978). New things about plants. In *Germany: The New Photography, 1927–33* (Mellor, D., ed.). London: Arts Council of Great Britain.

Benjamin, W. (1980). A short history of photography. In *Classic Essays on Photography* (Trachtenberg, A., ed.), pp. 199–216. New Haven: Leete's Island Books.

Bunnell, P. C. (ed.) (1980). *A Photographic Vision: Pictorial Photography, 1889–1923*. Salt Lake City: Peregrine Smith.

Green, J. (1984). *American Photography: A Critical History, 1945 to the Present*. New York: Abrams.

Green, J. (ed.) (1973). *Camera Work: A Critical Anthology*. New York: Aperture.

Greenberg, C. (1986). *The Collected Essays and Criticism. Vol. 2: Arrogant Purpose, 1945–1949* (O'Brian, J., ed.). Chicago and London: University of Chicago Press.

Marien, M. W. (2002). *Photography: A Cultural History*. New York: Harry N. Abrams.

Mellor, D. (ed.) (1978). *Germany: The New Photography, 1927–33*. London: Arts Council of Great Britain.

Sontag, S. (1977). *On Photography*. New York: Farrar, Strauss and Giroux.

Szarkowski, J. (1966). *The Photographer's Eye*. New York: The Museum of Modern Art.

Tenant, J. (1921). The Stieglitz exhibition. *The Photo-Miniature* **16**, 135–139.

Wells, L. (ed.) (2000). *Photography: A Critical Introduction, 2nd edition*. London and New York: Routledge.

Westerbeck, C. and Meyerowitz, J. (1994). *Bystander: A History of Street Photography*. Boston: Little, Brown and Company.

Weston, E. (1931). Statement. *Experimental Cinema* No. 3, 13–15.

Weston, E. (1973). *The Daybooks of Edward Weston. Vol. 1, Mexico*. New York: Aperture.

Willumson, G. (1992). *W. Eugene Smith and the Photographic Essay*. Cambridge and New York: Cambridge University Press.

Winogrand, G. (1977). Public Relations. New York: Museum of Modern Art.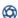

African Americans as Photographers and Photographic Subjects

DAVID C. HART, PH.D.
Cleveland Institute of Art

Stereotypes, Racial Uplift, and the Democratic Medium

By the end of the 19th century, African Americans in the United States had considerable experience with and access to the medium of photography allowing them, as image-makers and as subjects, a degree of control over their representations. The body of images that have come down to us by, and of, African American photographers over the course of the 20th century reveals that they were not singularly obsessed with racism. This photographic imagery can generally be said to reflect the interior lives, communities, and aspirations of African Americans, a testament to the very humanity that racism in American society denied.

Any discussion of African American photography necessarily engages the scholarship of Deborah Willis, an art historian and photographer whose numerous books constitute a significant contribution to the literature in the field. Willis has shown that the history of African American photographers in the United States begins at the time photography made its debut in the United States as the careers of two of its most successful practitioners reveal. Among the first daguerreotypists in the United States was Jules Lion (1810–1866) who learned the daguerreotype process in France in 1839 and operated a successful lithography and daguerreotype studio in New Orleans. In 1847 James Presley Ball (1825–1905) opened his Great Daguerrean Gallery of the West in Cincinnati, the largest such studio in the region, and later operated studios in Minnesota and Helena, Montana. Typical of Ball's output were portraits of prominent members of his community with dignified, erect poses before painted backdrops, conventions borrowed from earlier grand manner portraiture and romantic painting. Although formally and technically similar to the work of their European American counterparts, portraits of and by African Americans at the turn of the century have significance

beyond merely "documenting" businesses or middle-class membership. Such images countered the gross caricatures of African Americans as sambos, mammies, and pickaninnies prevalent in American print media throughout the 19th century.

Grounded in white supremacist fantasies and fears, stereotypic images of African Americans were inextricably linked to a larger social and political context after the Civil War, which saw the retreat from the efforts to grant African Americans the rights of citizenship. By the turn of the century Reconstruction had been abandoned and the Fourteenth and Fifteenth Amendments to the constitution granting former slaves full citizenship rights were undermined by the growth in racial segregation in the form of Jim Crow laws (upheld by the United States Supreme Court in 1898), mob violence by the Ku Klux Klan, and a system of tenant farming in the south that was, in effect, economic slavery. This led the historian, novelist, and political activist, W. E. B. DuBois, to declare in *The Souls of Black Folk* (1903), that racial division would be the problem of the new century, a sobering statement in an era of positivist rhetoric. DuBois' most powerful metaphor, however, captured the psychic conflict resulting from racial division that African Americans possessed. African Americans were born with two warring identities, a double-consciousness, he argued, forming their world view. One was American, through which its darker citizens were viewed with contempt, the other Negro.

Old and New Negroes

In the wake of virulent mob violence and widespread white supremacist ideologies at the dawn of the 20th century, African Americans began an effort to redefine themselves through a discourse forming another dichotomy; that between an old Negro and a new Negro. Key to this effort was the cultivation of an educated black leadership who would not simply serve as an example of social and economic betterment but who would "reconstruct" and re-conceptualize themselves by turning their backs on the legacy and associations of an old Negro as dependent and deserving of pity and replacing it with a self-sufficient, confident, and creative new Negro.

One solution was education, and photography figured prominently in it. Many elites, both African- and European-American, felt that the task of the assimilation of vast numbers of poor and uneducated African Americans, many in the South, clearly fell on African Americans themselves. Historically black institutions such as Hampton University in Virginia and Tuskegee University in Alabama had been established to educate African Americans in skilled trades thereby "uplifting" them from the poverty and ignorance in which they were left after the Civil War. This was a goal and philosophy of Hampton graduate and Tuskegee founder Booker T. Washington. In keeping with Washington's emphasis on trades-based education as a vehicle for social and economic betterment, in 1916 Tuskegee hired photographer Cornelius Marion Battey (1873–1927) to head its Photography Division in order to teach photography as an employable profession. Battey produced work that established his reputation as an accomplished portrait photographer and educator in the North, which would later win awards in the United States and Europe, an example of the viability of photography as a profession as well as photography's aesthetic potential.

The benefits of education and the results of assimilation by African Americans were depicted in photographic form in the Exhibit of American Negroes organized by DuBois and mounted in 1900 in the Negro Pavilion at the Exposition Universelle in Paris. It consisted of hundreds of photographs of middle-class African Americans such as business owners, institutions of higher education, and their students. The photographs were accompanied by books, objects, and demographic statistics, with which DuBois sought to document, as a social scientist, a narrative of social uplift, the face of stereotypes, and re-position of African Americans in the national march toward progress only 35 years after emancipation. The Negro Pavilion also included images by Frances Benjamin Johnston (1864–1952), a white photographer who was commissioned to take a series of over 150 photographs at Hampton, some of which contrasted poor rural African Americans with educated middle-class Hampton students and graduates. The Negro Pavilion's photographs reflected a philosophy that appeared in a book published that same year by Washington and others titled *A New Negro for a New Century*, whose accounts and portraits of African Americans who had struggled against the odds to both advance themselves

and thereby contribute to society were intended to shift the image of African Americans in the new century toward a new Negro and away from the gross stereotypes, black-face minstrelsy, and pseudoscience which were now relegated to the province of the old Negro.

The idea of representing a self-constructed, self-sufficient, and self-assured Negro that was distinct from, and contrasted with, an older, debased Negro was therefore not entirely new when Alain Locke published the *New Negro: An Interpretation* (1925), a highly influential anthology of artistic, literary, historical, sociological, and political essays. Locke, a professor of Philosophy at Howard University, called for a race-based aesthetic that looked to Africa for inspiration just as the Western tradition was grounded in the legacy of classical antiquity. Locke also characterized the Great Migration, the movement of thousands of African Americans from the south to northern cities (making New York's Harlem the nation's largest African American neighborhood), as a sign of modernism. The largely literary flowering of art production by and patronage of African Americans in the 1920s known as the Harlem Renaissance or New Negro movement was a phenomenon that actually took place in several cities such as New York, Chicago, and Washington, DC. Unprecedented artistic patronage flowed from individuals and organizations of both races such as the National Association for the Advancement of Colored People (NAACP), founded in 1909, whose magazine *Crisis* was edited by DuBois and which published the work of black photographers; the Harmon Foundation, which granted awards and funded exhibitions of African American artists; and white critic, writer, and photographer Carl Van Vechten (1880–1964). James Latimer Allen (1907–1977) was one of the few photographers to win a Harmon Foundation prize. Allen did not often engage African-inspired subject matter or modernist abstraction. Instead, he employed a soft-focus pictorialism as, for example, in a portrait of the New Negro movement's most celebrated poet, Langston Hughes.

James Van Der Zee (1886–1983), a largely self-taught studio photographer unfamiliar with Locke's ideas, owned one of Harlem's most prominent studios and was also employed as photographer for pan-Africanist Marcus Garvey's United Negro Improvement Association (UNIA). Like other African American commercial photographers such as Addison Scurlock (1883–1964) in Washington, DC; Richard S. Roberts (1881–1936) of Columbia, South Carolina; and Prentice Herman Polk (1898–1984) in Tuskegee, Alabama; Van Der Zee photographed his community's leaders, intelligentsia, and middle class. Regardless of their familiarity with Locke's ideas, many of the portraits by these photographers constituted a type of modernism, not necessarily dependent on formal abstraction, but rather associated with the intellectual and creative achievement, social engagement, upward mobility, and urban sophistication of African Americans.

Van Der Zee actively worked to manipulate an image through careful composition, use of multiple negatives, retouching, dramatic lighting, and skillfully painted backdrops and props. An example is *Wedding Day* (1926), a photograph of a couple made in Van Der Zee's Harlem studio. It is tempting to compare this multi-layered image to a photomontage created in the 1920s and 1930s. Van Der Zee was not familiar with either the avant-garde photographic practices in Europe nor the modernist straight photography created closer to home by Alfred Stieglitz (1864–1942) and Paul Strand (1890–1976). Van Der Zee's skillful manipulation of his photographs reflects instead the efforts of the photographer and his clients to represent their urban and modern aspirations. The painted backdrop of a fireplace and a superimposed image of a girl (who plays with a newly available black doll) all speak to the couple's dreams of a middle-class status, a domestic family life, and black pride; ideas in keeping with the New Negro movement.

The popularity of the New Negro in art and commercial portrait photography lasted for the first four decades of the 20th century as another type of old Negro emerged. Derived from a construct of the southern African American "folk" culture populated by humble, unassuming people whose way of life had remained unchanged, these images could be found in the photography of white photographers such as the pictorialist Rudolph Eickemeyer (1862–1932) and some images of "old" Negroes in Frances Benjamin Johnston's Hampton photographs. Prentice H. Polk's portrayals of poor and working class southern African Americans differed from these images of the folk old Negro in some crucial respects. Polk's portraits from his *Old Character Series* such as *The Boss* (1932) evinces material lack in terms of sartorial appointment, but this

unidentified woman's confident pose, direct gaze, and serious expression exude the same dignity and self-confidence as the photographer's wealthier sitters. Regardless of whether depictions of rural blacks were characterized as something outmoded, and to be abandoned in favor of the new and modern; or whether viewed nostalgically as a vanishing relic of American history; the taste for the folk would give way to the lure of the immediacy, claims to documentary truth, and hope of progressive social action in the era of Roosevelt's New Deal.

Documentary Photography in Black and White

The liberal sensibilities of Roy Stryker (1893–1976), head of the Historical division of the Resettlement Administration (later the Farm Securities Administration or FSA) during the Roosevelt administration led a bevy of socially conscious photographers including Dorothea Lange (1895–1965), Ben Shahn (1898–1969), Walker Evans (1903–1975), Marion Post Wolcott (1910–1990) and others to depict the plight of poor rural workers including unprecedented numbers of images of African Americans. Although tenant farming in the rural south and the squalid conditions of urban slums affected African Americans disproportionately during the Great Depression, it was Dorothea Lange's *Migrant Mother* (1936) that would emerge as the iconic face of rural poverty. The FSAs only black photographer, however, Gordon Parks (1912–2006), on the suggestion of Stryker, created his best known photograph of Ella Watson, who worked for the federal government for twenty-five years as a cleaning woman.

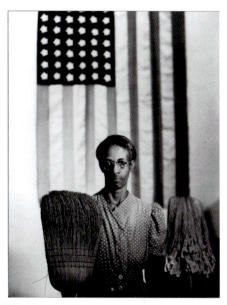

In an ironic take on Grant Wood's *American Gothic*, Watson stands, with mop and broom in front of the American flag prompting the viewer to ask why this woman should suffer, by virtue of her race and class, the denial of civil rights and poverty in the land of wealth and freedom. Parks later went on to a successful career for *Life* where he published photo-essays on such racially charged issues as gang violence in Harlem and segregation in the South and then as a film director.

FIG. 23 American Gothic, Mrs. Ella Watson, Government Charwoman, by Gordon Parks, Farm Security Administration—Office of War Information Photograph Collection. Library of Congress Prints and Photographs Division Washington, D.C. [reproduction # C-DIG-fsa-8b14845 DLC].

Aesthetics and Politics

Roy DeCarava (b. 1919), who also worked for *Life*, credited Parks' success as having opened doors to other African American photographers. DeCarava's 1955 collaboration with Langston Hughes resulted in the publication of *The Sweet Flypaper of Life* in which the photographer's images of real people were coupled with the writer's fictional narrative. This nuanced glimpse into Harlem from "within" by two artists who knew it very well was an early precursor to street photography. Dissatisfied with the ideological bend of 1930s documentary photography, DeCarava's work became increasingly modernist formally by combining reductive and abstracting qualities with the qualities inherent to the medium, such as the "decisive" photographic moment that characterized the work of French photographer Henri Cartier-Bresson (1908–2004).

In 1955 African American photojournalist Earnest C. Withers (b. 1922) self-published the *Complete Story of Till Murder Case*, an account of the brutal murder of African American

teenager Emmett Till in Mississippi by two white men for having spoken to a white woman. These images also appeared in *Jet*, a photo and news weekly by Johnson Publications marketed to African Americans nationally. Like Gordon Parks' socially conscious photojournalism in *Life* the following year on segregation in the South, Withers' work provoked greater public consciousness of the horrors of racism as the Civil Rights movement gained strength.

Canadian theorist Marshall McLuhan's claim that what was important about any medium was the degree to which it changed social relations was played out in the 1960s as television, radio, and photographs, especially those in magazines, brought visceral evidence of the violent tumult of the Civil Rights Era. Perhaps the best known of the photographers who documented the moments of the Civil Rights Era of the 1960s was photojournalist Moneta J. Sleet, Jr. (1926–1996) whose images of civil rights marches, boycotts, and meetings were viewed by the readership of *Ebony* magazine. His photograph of Coretta Scott King and her daughter at the funeral of slain civil rights leader Martin Luther King, Jr. received the Pulitzer Prize in photography, the first such award given to a black photographer. As the integrationist ideals of the Civil Rights movement represented by Martin Luther King, Jr. gave way to more confrontational approaches to confront racism, images of Malcolm X by photographers such as Robert L. Haggins along with books such as *The Autobiography of Malcolm X*, co-authored by Alex Haley, were consumed by large numbers of Americans interested in understanding his legacy, even as many condemned and often misunderstood Malcolm.

The 1980s and 1990s witnessed a revival of interest in Malcolm X as evidenced by the neonationalist lyrics of rap music, an array of commercial products such as baseball caps sporting an "X", and Spike Lee's 1992 film *Malcolm X*. T-shirts and books, both new and reprinted, made significant use of the slain leader's photographic image. This cultural phenomenon occurred in quite different circumstances than those of the 1960s. As British cultural theorist Stuart Hall observed, by the 1980s the "age of innocence" had passed in which fixed notions of black identity generated within the black community that employed sexism, homophobia, or binary oppositions of "good" versus "bad" public images could go unchallenged. It was a nuanced and diverse approach to African American identity that informed cultural critic Michael Eric Dyson's 1995 book that analyzed the image of Malcolm X in American culture, *Making Malcolm: The Myth and Meaning of Malcolm X*. Designer David Tran followed suit with a dust jacket for the book whose aged, creased, and unattributed photograph of its subject spoke to the cultural construction of Malcolm's legacy and the contested terrain on which it was played out.

Negotiating African American Cultural Identities

The de-colonization of Africa beginning with Ghana in 1956 and followed in rapid succession by other West African nations in the 1960s coincided with a growing consciousness in the United States among African Americans of the need for, and achievement of, civil rights, and black identity as part of an African Diaspora. For many people, Africa did not represent a foreign land to which contemporary African Americans had no cultural connection, but an ancestral home and legacy. Renewed interest in the 1970s with African cultural influences still present in the United States and the controversy over the displacement of residents of the South Carolina Sea Islands where these cultural practices were still evident served as the impetus for Jeanne Moutoussamy-Ashe's (b. 1951) photographic essay documenting the people of Daufuskie Island, South Carolina, in 1982. With a forward by Alex Haley, whose book *Roots* popularized the historical legacy of the African Diaspora, Moutoussamy-Ashe's project was informed by a fear—dismissed by contemporary scholars—that these enclaves of Africanisms needed to be captured in photographic form before they vanished forever. Although this fear was similar to the sense of nostalgia and loss that motivated white photographer Doris Ulmann's (1882–1934) photographs of African Americans in the same region some 50 years earlier in *Roll Jordan Roll*, Moutoussamy-Ashe's collection of photographs, taken together, allow for a sense of the transformation and change that characterize all cultures over time. For example, the man in his boat on the cover of the book illustrated the residents' need to travel to the mainland and thus undermined the sense of physical and

cultural isolation upon which the concept of a vanishing culture in earlier photographs of life on the islands depended. It is this approach that would, in a deeper and more complex way, characterize the meanings of Africanisms and our relationship with them in the work of Chester Higgins (b. 1946) and Carrie Mae Weems (b. 1953) in the 1990s. Weems, who has degrees in both fine arts and folklore, combined in her mixed media works objects, photographs, and text that speak to the material culture, oral histories, and the cultural memories associated with places such as the sea islands that have long held interest for the students of African American history and culture. Far from treating the sea islands as a rare site from which to trace "authentic" African cultural "roots" or as a cultural museum to be preserved, Weems' works, as Lisa Gail Collins has observed, conveyed the dynamic nature of cultural exchange over time and how any exploration of the past is necessarily viewed through the lens of the present.

By the 1980s the lessons learned from the Civil Rights Era, the women's movement, and post-colonial and post-modern theory were employed by artists questioning national, gender, class, and racial identities including African American artists who worked in photography. An example is the public debate in the mainstream media, and among politicians, artists, and intellectuals concerning the development and meaning of hip-hop music and culture in the 1980s. The people who listened to and dressed like the performers of this music, whose hard-hitting lyrics "rapped" about the drugs, violence, and other realities of life in poor, inner city neighborhoods were often conflated in public discourses with the very subject matter of these lyrics. The result was that both the music and those who listened to it were seen as threats, especially if they were African American or Latino. It is in this context that we understand the photographs of Coreen Simpson (b. 1942) who depicted the urban youths of New York's hip-hop culture. Works in her *B-Boy* series, by lending dignity to their subjects, countered a widespread vilification of these youths and their distinctive forms of dress and music. Dawoud Bey (b. 1953) likewise questions identity in the large format Polaroid that he created. The multi-paneled individual and group portraits, taken from slightly different positions that sometimes fragment the subjects, evoked the dynamic processes of becoming who we are like the unfolding narrative of a triptych, comic strip, or film.

The work of several photographers in the 1980s including Robert Mapplethorpe (1946–1989) and Lyle Ashton Harris (b. 1965) reveal how the intersections of racial, gender, and sexual identities are a contested terrain. Mapplethorpe, a gay, white photographer, intended his photographs of nude African American men in his *Black Book* (1986) to highlight their beauty by referring to the artistic conventions, some associated with the sculpture of classical antiquity, that have long equated idealized beauty with whiteness. Kobena Mercer, drawing in part on feminist analyses of pornography and Laura Mulvey's analysis of how women are filmed, made the most thoughtful critique of Mapplethorpe's work regarding race by arguing that these photographs were also exercises in racial fetishization, ugly re-inscriptions of the black body as hypersexual and as an erotic object offered up for the delectation of a mastering white gaze.

African American photographer Lyle Ashton Harris' self- and group portraits treat black, gay, male, and national identities as complex and intersecting categories. In *Miss Girl*, 1987–1988, from his *America's Series*, Harris presents himself in a contrived, campy pose, and the drag of whiteface, women's makeup, a wig, and the Styrofoam hat commonly worn at political conventions. The artifice of these disjunctive contrivances can be read as an indicator of how personal identities are socially constructed categories, but also how to desire is an inherent part of the photographic process.

In the 1980s and 1990s several African American women artists including Pat Ward Williams (b. 1948), Carrie Mae Weems, and Lorna Simpson (b. 1960) combined text with photographic images in ways that questioned both image and language as signifying systems and by extension other categories such as gender, race, history, and the politics of media and other institutions. Such work was informed by post-colonial, African American, feminist and post-structuralist theory that was profoundly influential on a wide range of artists working in a variety of media in the 1980s. The use of image and text in art in the 1980s by African

American artists often simultaneously questioned the ability of any text—and by extension an image—to convey fixed, universally understood meanings while at the same time uncovering the ways that language and images can be used as tools of oppression. Precedents for artists who combined images and text necessarily drew on a number of artists both black and white. The conceptual art of John Baldessari (b. 1931) and Joseph Kosuth (b. 1945) in the 1960s and 1970s provoked and confounded our notions of how systems of signification function with works that juxtaposed images and text in works such as Kosuth's *One and Three Chairs* (1965). Conceptual artist Adrian Piper's (b. 1948), *Mythic Being* series in the 1970s included several works where the artist often posed as a black male. The images of these performances served as the basis for posters with text that confrontationally addressed issues of race, class, and gender and social attitudes about these categories.

The work of Lorna Simpson juxtaposes images and text to reveal how both function, in the post-structuralist sense, as slippery signifiers at several levels, especially as they relate to the experiences of black women. Like much of her work from the 1980s, *Three Seated Figures* (1989) is a multiple image of a black woman's torso dressed in a loose fitting shift with the head cropped, accompanied by a series of individual words or short phrases on labels. Artist Barbara Kruger combined the image-text vocabulary of advertising to confront the viewer's assumptions about desire and the degree to which even the act of looking, the gaze, is invested with the power politics that place women and men on different rungs of the social ladder. Simpson's works also interrupt the power of the viewers gaze, but also evoke the histories and legacies of racism as they are intertwined with gender. By fragmenting and covering the body Simpson denies the gaze, the means by which racial fears and fantasies are played out. By being open-ended, the text is similarly disruptive of clear or simple interpretation, juxtaposing the individual, subjective experience of women and the supposedly objective systems by which facts are determined, thus calling into question the validity of each. Vacillating between image and text, the work asks us to contemplate notions of the personal and the universal and the means by which photographs and language convey meanings.

The work of African American photographers in the 1980s and 1990s reveals broader lessons about how we conceptualize African American photography in the 20th century. What is fundamentally important is not so much the race of the photographer or the search for an authentic and singular expression of blackness. Ultimately such designations guarantee nothing in terms of artistic expression; rather understanding African American cultural products necessarily means the simultaneous recognition of the variety and diversity of African American expression on the one hand and the commonalities in African American communities, culture, and practices, what Powell calls "the dark center," on the other. Whether a simple portrait in one's Sunday best, a visual testament of social conditions or protest, or a multi-layered and multimedia critique of systems of communication and cultural categories, African American photography in the 20th century faces us with the challenges of the human condition.

FURTHER READING

Collins, L. G. (2002). *The Art of History: African American Women Artists Engage the Past.* New Brunswick, NJ and London: Rutgers University Press.

Gates, H. L. (1990). The face and voice of blackness. In *Fac-ing History: the Black Image in American Art, 1710–1940* (McElroy, G., ed.). Washington: The Corcoran Gallery of Art.

Jones, K., Golden, T., and Iles, C. (eds.) (2002). *Lorna Simpson*. London and New York: Phaidon Press Limited.

Lewis, D. L. and Willis, D. (2003). *A Small Nation of People: W. E. B. DuBois and the African American Portraits of Progress*. New York: Amistad.

Mercer, K. (1994). *Welcome to the Jungle: New Positions in Black Cultural Studies*. New York and London: Routledge.

Natanson, N. (1992). *The Black Image in the New Deal: the Politics of FSA Photography*. Knoxville: The University of Tennessee Press.

Patton, S. F. (1998). *African-American Art*. Oxford and New York: Oxford University Press.

Powell, R. J. (2002). *Black Art: A Cultural History* (2nd edition.). London: Thames & Hudson, Ltd.

Willis, D. (1985). *Reflections in Black: A History of Black Photographers 1840 to the Present.* New York and London: W.W. Norton & Company, Inc.

Willis-Braithwaite, D. (1993). *VanDerZee, Photographer: 1886–1983.* New York: Harry N. Abrams in association with The National Portrait Gallery, Smithsonian Institution.

Biographies of Selected Photographers From the 20th Century

Editor's note: The following pages include an alphabetical listing sharing over 250 short biographies of some of last century's most influential photographers. These entries were compiled by authors and photographers Robert Hirsch, Ken White, and Garie Waltzer. This selection concentrates on image-makers rather than related influential individuals such as authors, curators, editors, educators, or inventors. Determining which photographers were included was left up to the discretion of each author with the guideline of selecting those key individuals who in effect represent a larger group of practice or ideas. The biographies indicate what a given photographer accomplished and why it is considered of importance. Additionally, at least one significant publication from each photographer was referenced. The decision to include such a small reference of people's work was influenced by the limitations of the book's size and the sheer numbers of some of the photographer's publications.

A–K
ROBERT HIRSCH
Independent Scholar and Writer

L–P
KEN WHITE
Rochester Institute of Technology

R–Z
GARIE WALTZER
Photographer and Consultant

ABBOTT, BERENICE (1898–1991)
American
Man Ray's Paris assistant. She met Atget just before his death in 1927, subsequently rescuing and promoting his photographs. Opened a New York studio in 1929 and used an 8 × 10 inch camera to create a photographic record of the city that fused Atget's unadorned realism with the playfulness and humor of her Parisian modernist experience. Stylistically, she worked from many viewpoints often cropping her prints to manifest the chaotic and complex relationship of beauty and decay within an urban environment.

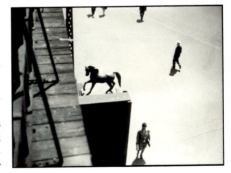

FIG. 24 Horse in Lincoln, Square, 1930. Gelatin silver print. Berenice Abbott Commerce Graphics, Ltd, Inc. (Courtesy of George Eastman House Collection, Rochester, New York.)

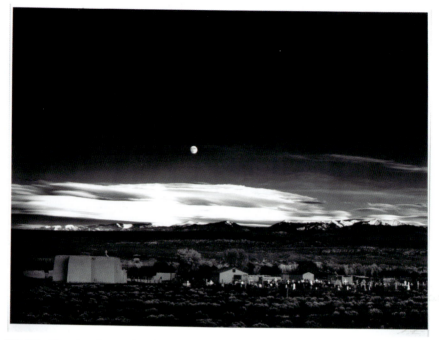

FIG. 25 Moonrise, Hernandez, New Mexico 1941. Gelatin silver print. Ansel Adams Publishing Rights Trust. (Courtesy of George Eastman House Collection, Rochester, New York.)

Publications
Abbott, B. (1939). *Changing New York*. New York: E. P. Dutton.

ADAMS, ANSEL (1902–1984) American

Through his writings, environmental activism, and photographs, Adams's images are seen as the quintessential pictorial expression of the American Western landscape, a site of inspiration and redemptive power to be preserved. Adams' visual power came from an awareness of light's changing nature and its movement within the landscape. With the help of Fred Archer (1888–1963), he developed the Zone System in the late 1930s, adopting the science of sensitometry to a system of tonal visualization of the image. Adams compared the negative to a musical score and the print to its performance. Images like Moonrise, Hernandez, New Mexico (1941) utilized the straight photographic precepts of Group/64 not to simply document, but to convey a transcendental sense of optimism about the vanishing pristine space of the American West. His book, *Born Free and Equal* (1944), testifies to the World War II internment of Japanese Americans. By the 1960s, the accessibility of Adams' images, the respect for his technical brilliance, and the ability of his work to command higher prices helped photography reach a broader range of venues.

Publications
Adams, A. (1985). *An Autobiography*. Boston: Little, Brown.
Szarkowski, J. (2001). *Adams at 100*. Boston: Bulfinch Press.

ADAMS, (EDDIE) EDWARD T. (1934–2004) American

Over a 45-year career in photojournalism, during which he covered 13 wars and was regularly published worldwide, Adams was renowned for his Pulitzer Prize winning photograph of a South Vietnamese general firing a bullet into a suspected Vietcong prisoner's head that took on mythical proportions in the public's memory. With his hands tied behind his back, the victim's contorted face at the instant of death transformed the event and became a symbol summarizing the bitter Vietnam legacy.

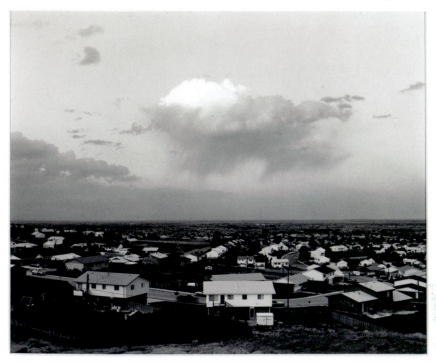

FIG. 26 Tract housing, North Glenn and Thornton, Colorado 197. Gelatin silver print. Robert Adams. (Courtesy of George Eastman House Collection, Rochester, New York.)

Publications
Image: Eddie Adams. Saigon, 1968. (General Loan executing prisoner).

ADAMS, ROBERT (1937) American

Adams' "New West" photographs express the diverse interaction between culture and nature. His minimal landscapes acknowledge that the beauty, grace, and order of the open American West has been obscured by the confusing commercial disorder of freeways, road signs, strip malls, and tract and trailer homes. This New Topographics outlook refers to the human-altered landscape characteristic of photographers who sought a contemporary landscape aesthetic dealing with those living in it without the romantic notions of the picturesque or the sublime.

Publications
Adams, R. (1974). *The New West: Landscape Along the Colorado Front Range*. The Colorado Associated University Press.

ARBUS, DIANE NEMEROV (1923–1971) American

In her teens, Arbus worked in fashion photography with husband Allan Arbus, eventually being hired by *Harper's Bazaar*. Studying with Lisette Model (1955–1957) produced a profound shift in her work. Arbus pioneered a confrontational street style that relied on frontal light and often a flash to sharply depict people who seemed willing to reveal their hidden selves for the camera. Accused of appealing to peoples' voyeuristic nature, Arbus believed that "a photograph is a secret about a secret. The more it tells you the less you know." Her curiosity led her to unblinkingly photograph people at the margins of society making images not of them as individuals but as archetypes of human circumstance. Controversy followed Arbus as she broke down public personas by pushing the boundaries of what was permissible and heroically visualizing

her subjects. Arbus' final series of retardates, whose being and identity take us to an edge of human experience, created a sensation by challenging the definition of self and confronting viewers with the "secret" fact that nobody is "normal."

Publications

Bosworth, P. (1984). *Diane Arbus: A Biography*. New York: Knopf.

Phillips, S. S. et al. (2003). *Diane Arbus Revelations*. New York: Random House.v

ATGET, JEAN-EUGÈNE-AUGUSTE
(1857–1927) French

From 1897 until his death, Atget created a massive methodical photographic survey of over 10,000 images of the old quarters of Paris and its surrounding parks with an outmoded wooden view-camera, often using a wide-angle lens that did not match the camera format. Atget scratched out a living selling contact prints to artists, made from his glass plate negatives on printing-out paper

FIG. 27 Versailles—Bosquet de l'arc de triomphe. Eugène Atget 1904. Albumen print. (Courtesy of George Eastman House Collection, Rochester, New York.)

and toned with gold chloride. Atget's empirical observations of a pre-modern Paris are as much about the psychological nature of time as they are an extended architectural study. The surrealists saw Atget as a primitive in touch with his unconscious self: his storefront pictures of mannequins, window reflections, and odd juxtapositions of objects could distort time, space, and scale so that they appeared to have emerged from a dream. The value of his work was recognized only after his death when his glass plates and prints were rescued and promoted by Berenice Abbott.

Publications

Szarkowski, J. and Hambourg, M. M. (1981, 1982, 1983, 1985). *The Work of Atget*, 4 Vols. New York: Museum of Modern Art.

AVEDON, RICHARD (1923–2004) American

Closely working with his mentor, Brodovitch, at *Harper's Bazaar* (1945–1965), Avedon became a dominant practitioner of fashion photography. He opened the Richard Avedon Studio in New York City in 1946 and was a staff photographer for *Vogue* (1966–1990), and *The New Yorker* (1992–2004). His large format studio portraits isolated people from their environment by placing them in a white seamless void. Avedon's style embraced the minute details of the terrain of the human face and not the idealization of the sitter, reading more like topographic maps than traditional portraits.

Publications

Hambourg, M. M. (2002). *Richard Avedon Portraits*. New York: Harry N. Abrams.

BALDESSARI, JOHN (1931) American

Baldessari breaks down photography's boundaries by playfully commingling mediums to court ambiguity and the dualities of chaos and order and to free himself from the classic artistic expectation of organizing the world and giving it a defined, narrative structure. Baldessari appropriates images from popular culture, especially Hollywood film stills, taking the existential position that the act of making choices along with their accompanying chance occurrences is what makes life and art authentic.

Publications

Baldessari, J. (2005). *John Baldessari: Life's Balance; Works 84-04.* Köln: Verlag Der Buchhandlung Walther Konig.

BALTZ, LEWIS (1945) American

Baltz's New Topographics approach is emblemized in The New Industrial Parks near Irvine California (1974), a detached, minimalist social critique of the desolate sites of the contemporary urban/suburban landscape. Utilizing formalism to order and repossess a bland, mundane subject, his sophisticated, unemotional, conceptually based distancing strategy symbolically communicates an ever-present, dehumanized, placeless corporate warehouse sense of place that was rolling over California's then still-agrarian terrain.

Publications

Rian, J. (2001). *Lewis Baltz.* New York: Phaidon Press.

BARROW, THOMAS (1938) American

Barrow worked with numerous experimental processes that pried the photograph away as an automatic witness. In his Cancellation series (1974–1978), Barrow slashed an "X" onto the negative to point out that regardless of how much empirical data is knowable, reality remains a makeshift combination of belief, ignorance, and knowledge. Barrow also agitated the flat surface of the fine photographic print by adding caulk, spray paint, and staples. His multi-layered actions signal his dissatisfaction with the straight print and the machine-like, spiritual detachment of the photographic process and provided a challenging model dealing with the complexity and the difficultly of deciphering any image. For Barrow photographic data is a jumping-off spot, as the immaculate print is discarded in the conviction that artistic response lies beyond the pictorial vision of the lens.

Publications

McCarthy Gauss, K. (1986). *Inventories and Transformations: The Photographs of Thomas Barrow.* Albuquerque: University of New Mexico Press.

BECHER, BERND (1931) and HILLA (1934) German

Collaborating since the late 1950s to document industrial structures like blast furnaces, grain elevators, and water towers as archetypes. Their dispassionate photographs are organized into a series based on functional typologies and arranged into grids or rows. This reinforces the comparative sculptural properties of their subjects, which they refer to as "anonymous sculptures" and allows for an empirical cataloging of forms by function for the purpose of creating a new grammar so people can understand and compare different structures. They have been highly influential teachers and their students include Andreas Gursky, Thomas Ruff, and Thomas Struth.

Publications

Becher, B. and Hilla (2002). *Industrial Landscapes.* Cambridge, MA: MIT Press.

Becher, B. and Hilla (2004). *Typologies of Industrial Buildings.* Cambridge, MA: MIT Press.

FIG. 28 From the series Cancellations (Brown). Lew's View, 1974. Toned gelatin silver print. Thomas Barrow. (Courtesy of George Eastman House Collection, Rochester, New York.)

BELLMER, HANS (1902–1975) German

Influenced by surrealism, Bellmer used sexually taboo imagery to symbolize and protest

Nazi German society of the 1930s. Bellmer fabricated a life-size doll of a pubescent girl to make ambiguously erotic and jarring tableaus. Published as an artists' book, Bellmer's hand-colored photographs contrasted Nazism's mythic, utopian celebration of youth with the reality that it fostered abuse, decay, and death.

BELLOCQ, E. J. (JOHN ERNST JOSEPH) (1873–1949) American

A New Orleans commercial photographer whose visual explorations of the forbidden world of prostitutes have inspired films, novels, and poems. After his death most of his work was destroyed, but his whole plate glass negatives of the Storyville red light district were later found and acquired and printed by Lee Friedlander. These surviving plates convey a relaxed sense of complicity between the male gaze and the female sitter while examining the shroud of languor and suppressed desire in a manner not possible before photography.

Publications

Szarkowski, J. (ed.) (1912). *E. J. Bellocq: Storyville Portraits: Photographs from the New Orleans Red-Light District*, circa 1912. New York: Museum of Modern Art, 1970.

BERNHARD, RUTH (1905) American

In 1930, learned photography and became a successful advertising photographer in New York. Met Edward Weston (1935) and moved to California, opening a portrait studio. Known for her superbly controlled studio compositions, sensually cast in glowing light and shade of young, nude female bodies, personifying classical, sculptural ideals of beauty. Taught thousands of students through workshops worldwide.

Publications

Mitchell, M. and Bernhard, R. (1986). *The Eternal Body*. Carmel: Photography West Graphics.

BLOSSFELDT, KARL (1865–1932) German

For over 30 years, Blossfeldt produced thousands of sharp-focus, black and white, close-up details of plant forms, frontally or from above, against neutral white or gray backgrounds, to reveal the elementary structures of the natural world and their relation to artistic form. By isolating and enlarging discrete portions of a subject—the characteristics, details, patterns, and textures that would otherwise go unobserved by human vision or conventional photography—Blossfeldt made the imperceptible perceptible. His book *Urformen der Kunst* (*Archetypes of Art*, 1928), became a landmark of the Neue Sachlichkeit (New Objectivity).

Publications

Blossfeldt, K. (1998). *Natural Art Forms: 120 Classic Photographs*. Mineola, NY: Dover.

BOUGHTON, ALICE (1865–1943) American

Trained in Gertrude Käsebier's studio. Highly regarded portraitist known for her illustrative and romantic images, often celebrating the beauty of young women. Member of Photo-Secession. Exhibited at 291 and published in *Camera Work* (1909). She wrote that good portrait photographers must have tact, social instinct, and infinite patience. Her book, *Photographing the Famous* (1928), included portraits of notables such as Maxim Gorky, Henry James, and William Butler Yeats.

BOURKE-WHITE, MARGARET (1904–1971) American

Studied photography with Clarence White. First staff photo-grapher for *Fortune* (1929), specializing in factories and machines. One of the original four staff photographers for *LIFE* (1933), where she produced the cover for its first 1936 issue, the Fort Peck Dam, Montana. Her photographs were included in Erskine Caldwell's You Have Seen Their Faces (1937), a gritty document of the Depression in the South. First official World War II woman military photographer, providing coverage from the German attack into Russia (1941) to the liberation

of Buchenwald (1945). Continued working for *LIFE* into the 1950s, documenting the world from India during and after Gandhi to the mines of South Africa.

Publications
Callahan, S. (1998). *Margaret Bourke-White: Photographer.* Boston: Bulfinch.
Goldberg, V. (1987). *Margaret Bourke-White.* Reading, MA: Addison-Wesley.

BRAGAGLIA, ANTON GIULIO (1890–1960) and **ARTURO** (1893–1962) Italian
Influenced by futurism, the Bragaglia brothers made photographs of moving figures that blurred the intermediate phases of the motion by having their subjects move while the camera lens remained open. Their blurry depictions connected the science of positivism with transcendental idealism, suggesting that beyond the visible lay a recordable dynamic of continuous movement at play. Anton's theoretical manifesto, Futurist Photodynamism (1911), claimed to free photography from brutal realism and instantaneity through movementalism—recording "the dynamic sensation of movement and its scientifically true shape, even in dematerialization."

BRANDT, BILL (HERMANN WILHELM BRANDT) (1904–1983) British
Influenced by the surrealists and became Man Ray's assistant (1929). Freelanced for *Lilliput* and *Harper's Bazaar.* During the Depression Brandt re-created scenarios he had witnessed of upper- and working-class people that showed the divisions of English social class. These docudramas, published in *The English at Home* (1936), *A Night in London* (1938), and *Camera in London* (1948), were expressionistic interpretations rather than reportage. In the 1950s Brandt used a pinhole camera to exaggerate perspective to create formal, high-contrast, often grainy, black and white prints of statuesque female nudes, reminiscent of El Greco, and eerily atmospheric landscapes possessing an ambiance of a troubled dream to poetically explore the anxiety of the new atomic era.

Publications
Delany, P. (2004). *Bill Brandt: A Life.* Stanford, CA: Stanford University Press.
Jay, B. (1999). *Brandt.* New York: Harry N. Abrams.

BRASSAÏ (GYULA HALÀSZ) (1899–1984) French
Motivated by Kertész and influenced by the surrealists, Brassaï contrived stylized tableaus of risqué Paris night life that revealed the subconscious "social fantastic," a place of the erotic and dangerous that lay outside of mainstream society. Dubbed "The Eye of Paris," Brassaï subjects re-enacted their concealed activities for his camera and flash, delivering a theatrical version of a candid moment that demystified and humanized the people from the world of night.

Publications
Paris at Night. (1976). *Paris: Arts et Metiers Graphiques, 1933; The Secret Paris of the 30s.*
 New York: Pantheon.

BRAVO, ALVAREZ MANUAL (1902–2002) Mexican
Coming from a family of artists, Bravo was encouraged in the late 1920s by Tina Modotti and Edward Weston to pursue photography. After meeting André Breton in 1938, he used surrealism to combine fantasy and Mexican societal customs. In enigmatic tableaux that often expressed anguish and irony, Bravo psychologically explored the interaction of Catholicism, peasant life, death, sexuality, and dreams. Bravo worked as a cinematographer (1943–1959) and was co-founder (1959) and director of El Fondo Editorial de la Plastica Mexicana, publishers of fine arts books.

Publications
Kismaric, S. (1997). *Manuel Alvarez Bravo.* New York: Museum of Modern Art.
La Buena Fama Durmiendo, 1939 (GEH).

BRIGMAN, ANNE (1869–1950) American
Actress, photographer, and champion of woman's rights, who separated from her husband to "work out my destiny." Brigman received acclaim and notoriety for her innovative interpretations of the female figure in nature, often inhabiting the landscape with her own nude body. Brigman's interpretation of the landscape removed the female body from the gaze of a clothed man in the confines of his studio. She was one of the 21 women of the 105 members of the Photo-Secession. Her work appeared in three issues of *Camera Work*. She was elected to the British Linked Ring Society, and published a book of her poems and photographs (*Songs of a Pagan*, 1950).

Publications
Ehrens, S. (1995). *Anne Brigman. A Poetic Vision: The Photographs of Anne Brigman*. Santa Barbara: Santa Barbara Museum of Art.

BRODOVITCH, ALEXEY (1898–1971) American
Pioneer of 20th century graphic design and highly influential art director of *Harper's Bazaar* (1934–1958), who devised a new compositional structure for the printed page that envisioned layouts as single rectangles that spread over two pages. He experimented with type, illustrations, white space, bleed photographs, and montage to expand and control the visual pacing of time. As a designer, teacher, and employer, Brodovitch affected the photographic styles of Lisette Model, Irving Penn, Richard Avedon, Louise Dahl-Wolfe (1895–1989), Hiro, and Robert Frank. Influenced business people who saw his trendsetting ideas in *Harper's Bazaar* and imitated them.

Publications
Purcell, K. W. (2002). *Alexey Brodovitch*. New York: Phaidon Press.

BUBLEY, ESTER (1921–1998) American
Pioneer woman photojournalist, mentored by Roy Stryker on his ongoing document of American life, which he started at the FSA, moved to the Office of War Information, and continued after the war by Standard Oil of New Jersey. In a male-dominated arena, Bubley rose to the top through her ability to document the rapidly changing interaction of modern industry/technology with the lives of everyday people.

Publications
Yochelson, B. et al. (2005). *Esther Bubley on Assignment*. New York: Aperture.

BULLOCK, WYNN (1902–1975) American
Steichen selected Bullock's psychologically based work as the opening piece to his humanistic exhibition, The Family of Man (1955), because he believed Bullock's visual language united the natural environment with the abstract symbolism of the inner world in an accessible way. Although highly structured, the authority of Bullock's images lies in their ambiguous temperament and their capability to express his belief that reality is constructed through personal experience.

Publications
(1971). *Wynn Bullock*. San Francisco: Scrimshaw Press.

BURROWS, LARRY (HENRY FRANK LESLIE) (1926–1971) British
Spent nine years covering the Vietnam War before being killed when his helicopter was shot down over Laos. Burrow's groundbreaking serial use of color for *Life* was part of the wave of appalling images that invaded America's living rooms (15 cover photographs). His brutal and poignant compositions plus his use of color, evoking a sense of Old Master paintings, bore witness to and became synonymous with a terrible war and the camera's ability to not only create a myth, but to show its exhaustion.

Publications

Halberstam, D. (2002). *Larry Burrows Vietnam*. New York: Alfred A. Knopf.

BURSON, NANCY (1948) American

Exploring perception and the interaction of art and science, Burson uses digital morphing technology to create images of people who never existed, such as composite person made up of Caucasian, Negroid, and Oriental features. Such images have no original physical body and exist only as pictures, showing the unreliability of images. Her work involving the unseen has enabled law enforcement officials to locate missing people; examined beauty, deformity, and gender; and allowed viewers to see themselves as a different race.

Publications

Burson, N. and Sand, M. L. (2002). *Seeing and Believing: The Art of Nancy Burson*. Santa Fe: Twin Palms Publishers.

CALLAHAN, HARRY

(1912–1999) American

Influenced by Ansel Adams, with Arthur Siegel (1913–1978), and Aaron Siskind, developed and taught an influential, expressive photography program at Chicago's Institute of Design (1946–1961) and later at Rhode Island School of Design (1964–1977). Covering themes from his daily life, such as his wife and daughter, the city, and the landscape, Callahan intuitively infused his elegant photographs with a sophisticated sense of grace that was simultaneously distant and personal. His spare, abstract, black and white compositions reflect his Bauhaus training in design and form, but he also worked later in life exclusively in color. Callahan's appeal was because he was a doer and not a talker, concerned with what he called "the standard photographic problems," such as composition, contrast, focus, motion, and multiple exposures. "Because I love photography so much I was a successful teacher, although I never knew what or how to teach. It's the same with my photography. I just don't know why I take the pictures I do."

FIG. 29 Untitled (89-22) 1989 computer-generated, digitized Polaroid Polacolor ER print. Nancy Burson. (Courtesy of George Eastman House Collection, Rochester, New York.)

FIG. 30 Harry Callahan. (Photograph by Nancy M. Stuart, April 2, 1992.)

Publications

Greenough, S. (1996). *Harry Callahan*. Washington, DC: National Gallery of Art.

Szarkowski, J. (ed.) (1976). *Callahan*. Millerton, NY: Aperture.

CAPA, ROBERT (ANDRÉ FRIEDMANN) (1913–1954) Hungarian/American

Perceptive photographer who inspired humanist photojournalism later championed and known as "Concerned Photography." Photographed the Spanish Civil War, the Japanese invasion

Publications

Shorr, R. et al. (1998). *Chuck Close*. New York: Harry N. Abrams.

COBURN, ALVIN LANGDON

(1882–1966) British

A member of the Linked Ring (1903) and the Photo-Secession, Coburn helped connect the European and American pictorial movements. His early work, influenced by Whistler, was soft-focus. Published *Men of Mark* in 1913, a significant volume of artists and writers portraits. In *The Octopus* (1912), he moved toward modernism by making pure form the content of the image through his use of aerial perspective, eliminating unwanted detail, and banishing the familiar, inviting viewers to celebrate formalistic beauty rather than the photographic impulse to identify and name subjects. In 1917 Coburn made abstract portrait photographs called "vortographs" by using a mirrored prism in front of the lens to distort, flatten, multiply, and transform his subject into a two-dimensional form, thus articulating how a photograph could be both subjective and objective.

FIG. 32 Working photograph for Phil, 1969. Gelatin silver print, ink, masking tape. Chuck Close. (Courtesy of George Eastman House Collection, Rochester, New York.)

Publications

Weaver, M., Coburn, A. L. (1986). *Symbalist*, Millerton, NY: Aperture.

Coburn, A. L. (1966). *Alvin Langdon Coburn, Photographer, An Autobiography*. New York: Praeger.

COPLANS, JOHN (1920–2003) British

Coplans began photographing his aging when he was sixty-four. His formal, faceless close-ups of wrinkles, sags, and varicose veins are unrelenting and unsentimental reminders of diminishing capacity and mortality, visualizing unidealized conventions that a media-driven "youth culture" has repressed as too ugly to be seen. His looming, highly detailed images, in which the body becomes landscape, possess a sculptural quality and point out how the male body has been largely excluded from the modernist aesthetic.

Publications

Coplans, J. (2002). *A Body*. New York: PowerHouse Books.

CREWDSON, GREGORY (1962) American

Using elaborate Hollywood production methods, Crewdson's stages condensed cinematic stills that explore the tension between domesticity and nature in suburban life, often with a Freudian twist. As a teacher, Crewdson has propagated the use of staged ingredients, resembling museum dioramas, which combine documentary and fictional components with an implicit sense of voyeurism. This results in a photographer who no longer passively experiences and edits the world, but is an active participant who creates a world and then photographs it.

Publications

Berg, S. (ed). (2005). *Gregory Crewdson: 1985–2005*. Germany: Hatje Cantz Publishers.

CUNNINGHAM, IMOGEN (1883–1976) American

Inspired to take up photography in 1901 after seeing the work of Gertrude Käsebier, she learned platinum printing from Edward S. Curtis, eventually opening a portrait studio in Seattle (1910). Her first work was romantic, soft-focus portraits and nudes. After moving to San Francisco in 1917, she adopted modernism. Cunningham's images came to reflect Group f/64's credo (of which she was a founder) that the "greatest aesthetic beauty, the fullest power of expression, the real worth of the medium lies in its pure form rather than in its superficial modifications." Her tightly rendered 1920s plant studies presents nature with machine precision or as sexual allusion, drawing sensual parallels to the female form that she explored through her long career. Although the picture is a faithful rendering of a plant, Cunningham's concern was not the subject itself, but what the subject could become under the photographer's control. She worked as a commercial photographer from the 1930s. Her last book, *After Ninety* (1979), was a sympathetic portrait collection of elderly people.

Publications

Dater, J. (1979). *Imogen Cunningham: A Portrait*. Boston: New York Graphic Society.

Lorenz, R. (1993). *Imogen Cunningham: Ideas Without End: A Life and Photographs*. San Francisco: Chronicle Books.

CURTIS, EDWARD SHERIFF (1868–1952) American

From 1900 to 1930, Curtis photographed about 80 Native American tribes of the Northwest, Southwest, and Great Plains, producing some 40,000 images, which resulted in The North American Indian (1907–1930). Curtis was not an objective documentarian. He suppressed evidence of assimilation and manipulated his images through romantic, soft-focus pictorial methods to create emotional and nostalgic views of the vanishing noble savage. Although criticized for treating native people as exotica, Curtis' fabricated images provide the only evidence of artifacts, costumes, ceremonies, dances, and games of many tribes' previous existence. Nobody wanted to look at the realism of reservation despair, but with the Native Americans' complicity, Curtis used his narrative skills to recreate idealized symbols of a vanished time in the West and represent the timeless myth of the virtuous primitive.

Publications

Curtis, E. S. (1997). *The North American Indian: The Complete Portfolio*. New York: Köln: Taschen.

DAVIDSON, BRUCE (1933) American

A Magnum photographer since 1958, whose work exemplifies the personal style of "New Journalism," which contains authentic details about people and their circumstances yet presents a highly subjective view of the situation being covered. Davidson's early photoessays about a circus midget, a New York City gang, and Spanish Harlem are indicative of his sympathetic representations of those who are not part of mainstream culture. His

FIG. 33 J.C. Strauss Edward Curtis, Seattle. Self-Portrait by Van Dyck from untitled album. owned by Elias Goldensky featuring portraits of photographers in costumes after figures in the history of art in 1904. Retouched gelatin silver print. Manipulated portrait of the photographer Edward S. Curtis who is rendered in the Flemish baroque style of a Sir Anthony Van Dyke painting. (Image courtesy of George Eastman House Collection, Rochester, New York.)

portraits reflect a direct, open approach of extended involvement and social conscience that relies on gaining the trust of his subjects so they might reveal unguarded moments to his camera.

Publications
Davidson, B. (1970). *East 100th Street.* Cambridge, MA: Harvard University Press.

DE MEYER, BARON ADOLF (1868–1946) American
A pictorialist and member of the Linked Ring (1903). His photographs were exhibited by Stieglitz at 291. In 1911, the de Meyers promoted Diaghilev's Ballet Russe in their first London appearance and de Meyer made his famous photographs of Nijinsky. From 1914 to 1935 he lived in America where he became the top fashion photographer. Also known for his portraits of celebrities for *Vanity Fair, Vogue,* and *Harper's Bazaar.*

FIG. 34 Child on Fire Escape, 1966. Gelatin silver print. Bruce Davidson, Magnum Photos. (Courtesy of George Eastman House Collection, Rochester, New York.)

Publications
Brandau, R. (ed.) (1976). *De Meyer.* New York: Knopf.

DECARAVA, ROY (1919) American
Provided an insiders look into black Harlem life with a formal grace that blends social and personal identity. His understated approach relies on examining the small impediments that define people's lives. His prints, whether of jazz musicians or tenement life, show the competing dynamism of darkness and light and the visible physical and invisible psychological forces that affect people. It contextualizes the racism that excluded most African Americans from the post-nuclear boom in the United States. First African American to receive a Guggenheim Fellowship (1952). Came into the public eye for *The Sweet Flypaper of Life* (1955), in collaboration with writer Langston Hughes. Opened A Photographer's Gallery in New York City (1955), an early effort to gain recognition for photography as an art. Ran the Kamoinge Workshop for young black photographers (1963–1966) and later taught at New York's Hunter College.

Publications
Alinder, J. (ed.) (1981). *Roy DeCarava, Photographs.* Carmel, CA: The Friends of Photography.

DEMACHY, ROBERT (1859–1936) French
The leading French pictorialist, member of the Linked Ring, exhibitor at Stieglitz' 291 gallery who championed the manipulated image with an outpouring of prints, lectures, and articles. Demachy's diverse subject matter often reverberated with the impressionistic style and always revealed the hand of their maker. Technically brilliant, especially in gum bichromate printing, Demachy was disdainful of the clarity of detail and the automatic trace of reality of the "straight," unmanipulated print and defended the painterly image arguing:

"A work of art must be a transcription, not a copy of nature . . . there is not a particle of art in the most beautiful scene of nature. The art is man's alone, it is subjective not objective."

Publications
Jay, B. (1974). *Robert Demachy, 1859–1936.* New York: St. Martin's Press.

diCORCIA, PHILIP-LORCA (1953) American

Representing a quintessential post-modern outlook, diCorcia meticulously photographs choreographed mundane and ambiguous scenes from daily life. Instead of capturing a moment, diCorcia reconfigures it and then permanently casts it. His strategy combines the documentary tradition with the fictional methods of advertising and cinema to fashion ironic links between reality, fantasy, and desire. His quiet, mysterious, cinematic narratives utilize saturated colors to create a psychological intensity, built by juxtaposing the spontaneity of the snapshot aesthetic with the formalism of a staged composition and the drama between artificial and natural lighting.

Publications

diCorcia, P.-L. and Galassi, P. (1995). *Philip-Lorca diCorcia*. New York: Museum of Modern Art; distributed by Abrams.

diCorcia, P.-L. (2003). *A Storybook Life*. Santa Fe, NM: Twin Palms Publishers.

DISFARMER, MIKE (MIKE MEYERS) (1884–1959) American

A self-taught eccentric, photographer who set up a portrait studio in the small farming town of Heber Springs, Arkansas, and was not recognized in his lifetime. He claimed he was not a Meyer, but blown into the Meyer family by a tornado as a baby, hence the name change to "not a farmer." His simultaneous familiarity and distance with this community enabled him to directly capture the essence of its people from 1939 until his death. By violating the etiquette of small town photographers, he allowed his subjects to simply be themselves before his camera. Favoring natural north light, simple backdrops, and a postcard format (3-1/2 × 5-1/2 inches), his portraits collectively present an utterly straightforward microcosm of anonymous rural people. When viewed outside of their original context, the images, resembling a naïve, mysterious, freewheeling blend of American Gothic, Arbus, Penn, and Sander, inadvertently pay tribute to a valuable service performed by small town photographers who documented daily life. A community member saved his glass negatives, leading to their belated public acclaim.

Publications

Scully, J. (2005). *Disfarmer, the Heber Springs Portraits 1939–1946*. New York: powerhouse Books.

Woodward, R. B. (2005). *Disfarmer: The Vintage Prints*. New York: powerHouse Books.

DOISNEAU, ROBERT (1912) French

Doisneau was a Parisian street photographer whose work from the 1930s to the 1980s can be seen as a humanistic visual social history of the city and its people. Doisneau called himself a "fisher" of pictures, a picture hunter who captured his observations of Parisian culture by immersing himself into the stream of life. Problems arose when Le Baiser de l'Hotel de Ville, 1950, a.k.a. The Kiss, was published in *Life* as an "unposed" icon of street photography and young love and it turned out to be reconstructions of scenes he had witnessed but had not been able to record. By accepting Doisneau's "unposed" picture his audience agreed to believe they were witnessing a scene from "real" life. Instead they were taken in by a docudrama. Doisneau's subjective-documentary approach breached the collective trust between the photographer and the audience, eroding public belief in the photograph's authenticity. It indicates seeing is not believing and that the age of the photograph being accepted as a non-fictional transcription of reality had to be re-thought and seen instead as constructed fiction.

Publications

Doisneau, R. (1980). *Three Seconds from Eternity*. Boston: New York Graphic Society.

EDGERTON, HAROLD (1903–1990) American

A scientist who, in 1938, developed the electronic flash tube that emitted a brilliant light lasting less than one-millionth of a second and was capable of being fired rapidly to obtain

multiple-image stroboscopic effects. Electronic flash photography is based upon his discoveries. Using the stroboscope, he explored the field of high-speed photography, becoming the first to make stop-action photographs of events unperceivable to the human eye. The formal compositions of ordinary subjects, such as a bullet exploding an apple, aroused wonder and crossed the borders of art, entertainment, and science, making the invisible visible and thereby expanding our notion of reality.

Publications
Jussim, E. (1987). *Stopping Time, The Photographs of Harold Edgerton*. New York: Abrams.

EGGLESTON, WILLIAM (1939) American
His exhibition at the Museum of Modern Art in 1976, William Eggleston's Guide, featuring lush dye-transfer prints of the banal made in the American South ushered in the acceptance of color photography as a fine art. By means of a sophisticated snapshot aesthetic, Eggleston uses color to describe scenes in psychological dimensions that makes everyday events look unusual. Initially criticized for making vulgar images of insignificant subjects, such as a light bulb or the inside of an oven, he promoted the notion that anything could be photographed by democratically filling the dull existential void of American culture with color. The skewed angles of his "shotgun" pictures, not using the camera's viewfinder, helped to open the traditional "photographer's eye" in terms of how images are composed and what is acceptable subject matter. In turn, this sparked questions about the interpretation and response viewers have to images, and what the role of makers is in educating their audience.

Publications
Eggleston, W. (2003). *Los Alamos*. New York. Scalo.
Eggleston, W. (1976). *William Eggleston's Guide*. Cambridge, MA: MIT Press.

EISENSTAEDT, ALFRED (1898–1995) American
German-born, an early photojournalist who in 1929 began working for the Associated Press in Berlin using a Leica and natural light. Emigrated to the United States in 1935 where the next year he became one of the original four staff photographers for *Life*. Eisenstaedt's belief that his job was "to find and catch the storytelling moment," made him a consummate *LIFE* photographer; contributing more than 2000 photo-essays and 90 cover images in real-time, assignment-driven situations.

Publications
Eisenstaedt, A. (1990). *Eisenstaedt: Remembrances*. Boston: Bulfinch.
Eisenstaedt, A. (1980). *Witness to Our Time*, rev. ed. New York: Viking.

ERWITT, ELLIOT (1928) American
A Magnum photographer known as the master of the "indecisive moment," black and white images of animals and people, usually dogs. Erwitt has an instinctual knack for capturing the significance of the insignificant—the irrational absurdities, coincidences, and incongruities of daily life often with Chaplinesque humor.

Publications
Sayle, M. et al. (2003). *Elliot Erwitt Snaps*. New York: Phaidon Press.

FIG. 35 Paris 1989. Feet and Legs of Man, Small Dog on Leash at his Side Jumping. Gelatin silver print. Elliot Erwitt. (Courtesy of George Eastman House Collection, Rochester, New York.)

EVANS, FREDERICK HENRY
(1853–1943) English
Best known for his delicately toned and unmanipulated platinum photographs of English and French cathedrals which were recognized for their atmospheric effects and handling of depth, height, and mass. Also took many fine portraits of his artistic and literary friends. Promoted by Stieglitz, who devoted an entire issue of *Camera Work* to Evans in 1903 as "the greatest exponent of architectural photography." A member of the Linked Ring and a purist who did not believe in retouching, Evans gave up photography when platinum paper became unaffordable after World War I.

Publications
Newhall, B. and Evans, F. H. (1973). Millerton, NY: Aperture.

FIG. 36 Wells Cathedral: Stairway to Chapter House 1903. Gelatin silver print. Frederick H. Evans. (Courtesy of George Eastman House Collection, Rochester, New York.)

EVANS, WALKER (1903–1975) American
The Godfather of large format American 20th century documentary photography, who was committed to straight, unadorned, black and white documentation. He established his transparent, unheroic, clinical style as a photographer for the Farm Security Administration (1935–1938). His book *American Photographs* (1938) established the idea that looking at photographs in a book is fundamentally different than looking at photographs on the wall and that how the photographs were sequenced was critical in establishing meaning. It also revealed his affection for photographing signs (text), which often self-labeled the photograph. Evans' self-effacing approach with its edge of pessimism, made people believe in the power of the plain photograph. His second book with James Agee, *Let Us Now Praise Famous Men* (1941), was illustrated with Evans' unsentimental portraits of Alabama sharecroppers. His puritanical objectivity and economy of composition made the hardship of their situation self-evident yet preserved their dignity. From 1945 to 1965 he was a staff writer and photographer for *Fortune*.

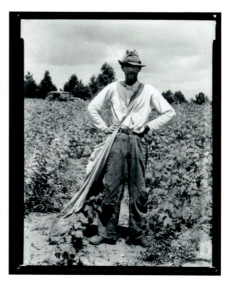

FIG. 37 Bud Fields Hale County, Alabama, 1936. Gelatin silver contact print. Walker Evans. (Courtesy of George Eastman House Collection, Rochester, New York.)

Publications
Hambourg, M. M. et al. (2000). *Walker Evans*. Princeton: Princeton University Press.
Szarkowski, J. (1971). *Walker Evans*. New York: Museum of Modern Art.

FAURER, LOUIS (1916–2001) American

A photographer's photographer who expanded the small camera aesthetic to reflect the energy of New York and Philadelphia street life. Although Faurer worked as a fashion photographer for nearly thirty years and is not widely known by the public, his psychologically charged and socially aware inner-city images were a major influence in the post-war New York street-photography movement. Faurer's soulful black and white photographs, full of shadows and silhouettes, integrated the visual code of film noir with irony and juxtaposition to represent the instability of the rapidly shifting urban environment.

Publications

Wilkes Tucker, A. (2002). *Louis Faurer.* New York: Merrell.

FICHTER, ROBERT (1939) American

Fichter exemplifies a movement by a group of Rochester, New York, image-makers in the later 1960s that challenged accepted methods and philosophies of photographic presentation. This loose group included Tom Barrow, Betty Hahn, Bea Nettles, and Judy Harold-Steinhauser who also pushed the boundaries of conventional content as they often obtained critiques of the media, the Vietnam War, and gender roles. Fichter, who studied with Jerry Uelsmann and Henry Holmes Smith, experimented with numerous alternative image-making methods including collage, cyanotype, plastic toy Diana camera, gum bichromate, hand-coloring, multiple exposure, Sabattier effect, and an old Verifax copy machine. This eclectic faction would have wide-ranging influence as they spread out and taught their alternative expressive approaches throughout the United States.

FLICK, ROBERT (1939) American

Flick's black-and-white gridded landscapes challenged 1970s presumptions about photographic process, space, and time. Now Flick uses a video camera to record entire Los Angeles streets, which he then presents as mosaic-like sequences that recreate the fragmented Southern California experience of viewing the world from the driver's seat. His visual development tracks both

FIG. 38 Geronimo (Apache Southwest) with Fold Mark. Gum biochromate print with oil and crayon. Robert Fichter. (Courtesy of George Eastman House Collection, Rochester, New York.)

technological changes and the conceptual transition dealing with the discourse about interpretation, evaluation, and assessment of visual constructs that make up our notions of the landscape.

Publications
Flick, R. (2004). *Trajectories*. Steïdel: London.

FRAMPTON, HOLLIS (1936–1984) American
In his short film, *Nostalgia* (1971), Frampton transformed himself from a photographer into a filmmaker by upending the predictable narrative relationship between images and words by burning twelve still photographs and not having the narration match the photograph being depicted. This was part of a larger investigation in the early 1970s by many photographers, such as Lew Thomas (1932) and Jan Dibbets (1946), questioning the notion of a singular stable existence. Frampton is best known for the Vegetable Locomotion series (1975) he did with Marion Faller (1941) in which adjoining 35 mm frames with a gridded background were used to humorously explore real-time activity and pay homage to Eadweard Muybridge.

Publications
Moore, R. (2006). *Hollis Frampton: Nostalgia*. Cambridge: MIT Press.

FRANK, ROBERT (1924) American
The Americans (1958–1959), constructed from 800 rolls of 35 mm film of Frank's travels across the United States, became the seminal photographic publication for mid-twentieth century street photographers. Frank powered his book by arranging his images in sequences, which have completeness and make-up that no single image possesses. Part of the restless New York City Beat scene, the Swiss-born Jewish photographer had the astute ability of an outsider to critically examine booming post-WWII American culture and found a languor of alienation and loneliness. Open to possibilities, Frank was able to imagine photographs that nobody else had thought to make. Intuitively using a small Leica in available light situations as an extension of his body, he disregarded the photojournalistic standards of construction and content matter. Frank's stealthful, disjointed form; his use of blur, grain, and movement; and his off-kilter compositions, became the emotional, unpicturesque, and gestural carrier of what would be the new 35 mm message: The freedom to discover new content and formal methods of making photographs.

Publications
Frank, R. (1972). *The Lines of My Hand*. Tokyo: Yugensha.
Greenough, S. et al. (1994). *Robert Frank: Moving Out*. New York: Scalo Publishers.

FREUND, GISÈLE (1912–2000) German/French
Wrote the first Ph.D. thesis on photography. Known for her direct, naturalistic, tightly cropped portraits of France's literati (from 1938 often taken in color) and published reportage in *Life*, *Paris Match*, *Picture Post*, and *Vu* magazines. Her expanded Ph.D. thesis was later published as *Photography and Society*, which examined the history of photography in terms of the social forces that produced and molded it.

Publications
Freund, G. (1980). *Photography and Society*. Boston: David R. Godine Publisher.

FRIEDLANDER, LEE (1934) American
In a stream of conscious that has spanned four decades and two-dozen books, Friedlander constructs an interior world that was not apparent until it was formally organized through his camera. The discontinuous urban landscape is raw material for a hybrid, formalized, and personalized aesthetic that reshaped American street photography. With satirical humor, Friedlander orders fragmented chaos to characterize his place within society as the defining concept of what he called "the American social landscape and its conditions." The urban landscape becomes a

stage for an investigation of the human pres-
ence within its enclosures, juxtapositions, and
reflective and transparent surfaces that form
overlapping realities within a single frame.
His images within images approach involves
an often extremely complex piecing together,
a reading of all the interconnected parts and
signs to determine meaning. Favoring the
ordinary subjects from televisions to trees,
Friedlander works in series to do away with
their hierarchical ordering, thus making
objects, people, places, and time interchange-
able. He forces viewers to search for a lone,
human presence, often Friedlander's shadow
(an assimilated Jew), which could be anyone's
shadow, in a desolate landscape from which God has vanished.

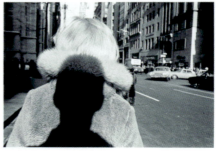

FIG. 39 New York City, 1966. Gelatin silver
print. Lee Friedlander. (Courtesy of George East-
man House Collection, Rochester, New York.)

Publications
Friedlander, L. (1970). *Self Portrait*. New York: Haywire Press.
Galassi, P. (2005). *Friedlander*. New York: Museum of Modern Art.

FUSS, ADAM (1961) British
In the gap between photography's metaphor-
ical and representational capabilities, Fuss
utilizes photograms, pinhole cameras, and
daguerreotypes to mine the margins of what
makes up a photographic image. Dealing with
themes of life, death, and protracted time,
Fuss transcends his organic subject matter,
including animal entrails, flowers, plants,
smoke, and water, and infuses them with a
spiritual, post-modern amalgam comprised
of the inner and outter worlds. Relying on
the medium's basic components—the inter-
play of light and objects with light-sensitive
material—Fuss' prolonged exposures produce
unique images that both capture and tran-
scend reality while evoking the unseeable.

FIG. 40 Butterfly From "My Ghost" 1999.
Daguerreotype. Adam Fuss. (Courtesy of
George Eastman House Collection, Rochester,
New York.)

Publications
Fuss, A. (2004). *Adam Fuss*. Santa Fe, NM: Arena Editions.

GIACOMELLI, MARIO (1925–2000) Italian
Giacomelli spent decades photographing the same piece of earth in his Italian village, from the
same vantage point, throughout the year, usually altering the perspective by excluding the hori-
zon line to deprive onlookers of any visual anchor. He foreshortened space by stacking up forms
as if they were on a vertical plane. By 1960, Giacomelli's response to his sense that humans had
overrun nature was to cut patterns into the landscape with a tractor. In 1970, he was pho-
tographing the plowed fields from the air, concentrating on details of texture and pattern.
The sensation of violent upheaval can be seen in Giacomelli's audacious framing and image
cropping along with his unconventional darkroom methods featuring grainy, high-contrast
prints, which often had only three tones. In 1956, Giacomelli began a long-term project about
old age that has been called bleak and pessimistic, but it accurately conveys the passionate
sense of enclosing darkness that his elderly subjects were experiencing. This was followed by
other series on butchered animals, gypsies, and war victims at Lourdes.

Publications
Crawford, A. (2006). *Mario Giacomelli*. New York: Phaidon Press.

GIBSON, RALPH (1939) American
In 1969 Gibson founded Lustrum Press, which during the 1970s published an unconventional collection of books. The Lustrum line included Robert Frank, Larry Clark, instructional books, and Gibson's dream-like trilogy of photo-novels *The Somnambulist* (1970), *Deja-Vu* (1973), and *Days at Sea* (1974). Gibson's grainy, tightly composed, high-contrast 35 mm work reflects the minimalist impulse to eliminate extraneous detail and get down to the essentials of producing a non-literal, but visually complex, yet beautiful symbolic system, often sexually charged, enigmatic settings beyond the realm of empirical thinking.

Publications
Gibson, R. (1999). *Deus Ex Machina*. Köln: Taschen.

GILBERT AND GEORGE [GILBERT PROESCH (1943) and
GEORGE PASSMORE (1942)]** British
Former performance artists Gilbert and George (Gilbert Dolomites [1943] and George Totnes [1942]) who played on their sense of photographic time as they posed for hours as living sculpture, manipulated themselves as the content in their series of photographs presented in a grid formation. Photography became their vehicle for suspending movement and memorializing their daily lives and blurring the boundaries between art and life. Their graphic, colorful, monumental pieces, having much in common with sculpture, confront viewers with modern British social anxieties. Under the guise of respectable dandies, this duo uses an orderly, repetitive and accessible style to examine taboo subjects, especially homosexuality. Recently the artists have been making digital pictures.

Publications
Dutt, R. (2004). *Gilbert and George: Obsessions and Compulsions*. London: Philip Wilson Publishers.
Jonque, F. (2005). *Gilbert and George*. New York: Phaidon Press.

GILBRETH, FRANK B. (1868–1924) and **LILLIAN** (1878–1972) American
To make work sites more efficient the Gilbreths developed the "stereo chronocyclegraph" in which tiny lights were attached to a worker performing a visual indication of the physical action. This produced the stereographic pattern for each employee to imitate the "one best way to do work." Their stereo "motion economy" studies had a financial and social effect: they helped businesses, such as Kodak, make their employees more productive resulting in greater profitability. Social critics saw their photographs as a pre-Orwellian photographic methodology that coupled science to a de-humanizing process of industrial sameness. Their treatise Cheaper by the Dozen, which Hollywood has turned into film comedies, celebrated their principals of motion studies.

GILPIN, LAURA (1891–1979) American
Studied at the Clarence H. White School (1916–1917) and opened a portrait studio (1918). Known for her command of platinum printing, Gilpin devoted over 60 years to photographing the relationship of the people and the American Southwest landscape of New Mexico and Arizona, especially her Canyon de Chelly project (1968–1979). Her 35-year sympathetic documentation of the Navajos (1946–1968) is a peerless record of Native American life during a time of rapid change.

Publications
Gilpin, L. (1968). *The Enduring Navajo*. Austin, TX: University of Texas Press.
Sandweiss, M. A. (1986). *Laura Gilpin, An Enduring Grace*. Ft. Worth, TX: Amon Carter Museum.

GOLDEN, JUDITH (1934) American

Golden's work represents the burgeoning feminist expression of the 1970s movement that rejected modernism's values of ideal beauty. Her extended investigation of female personas and roles examines the ways photography can transform a subject. By humorously hand-manipulating the picture surface, Golden disregards traditional aesthetic values and emotional responses. Her approach was indicative of artists who used hand-work and appropriation to blur the distinction between the beautiful chemically produced image and one that was graphically generated. Golden assumes control over her public representation, creating tableaus that deconstructed underlying assumptions about photography and society upon which artists would build.

Publications

Featherstone, D. (ed.) (1988). *Cycles: A Decade of Photographs (Untitled 45)*. San Francisco: Friends of Photography.

GOLDIN, NAN (1953) American

Goldin's vérité-style slide and music diary, *The Ballad of Sexual Dependency* (published as a book in 1986), used 700–800 images and popular songs to spin a constantly evolving tale of abuse, drugs, and sex. Goldin's camera is part of her intimate relationships, recording her subjective internal feeling about what is going on between Goldin and her subjects. Her images are a post-modern morality tale that chronicles the heyday and collapse of a nihilistic lifestyle. Her work embodies the shift in photographic practice from the single flawless black and white print to casually composed collections of color snapshots that emphasize autobiography, sexuality, and outsider culture.

Publications

Goldin, N. et al. (1996). *I'll be Your Mirror*. New York: Scalo Publishers, 1996.

GOWIN, EMMET (1941) American

Gowin's early work incorporated the personal iconography of his life in the rural South while combining the "snapshot aesthetic" with a view camera, often featuring a circular motif. Concentrating on his immediate family and surroundings, Gowin made extended portraits of his subjects, especially his wife, in allegorical roles. His later work documents the dramatic clash between nature and culture. His weirdly beautiful aerial photographs of gashed and polluted landscapes in the service of agriculture, mining, and war walks a tightrope between the real and the surreal, black and white and color, the microscopic and the panoramic, seeking to re-establish a spiritual connectedness with the natural world.

FIG. 41 Edith, Danville, Virginia, 1971. Gelatin silver print. Emmet Gowin. (Courtesy of George Eastman House Collection, Rochester, New York.)

Publications

Bunnell, P. (1983). *Emmet Gowin: Photographs, 1966–1983*. Washington, DC: The Corcoran Gallery of Art.

Reynolds, J. et al. (2002). *Emmet Gowin: Changing the Earth*. New Haven: Yale University Press.

GROSSMAN, SID (1913–1955) American

With Sol Libsohn co-founder of the Photo League (1936–51) as a meeting place, gallery, and educational site. The Photo League promoted the sanctity of the straight image and the belief

that photography needed to serve a sociopolitical purpose. Driving force that organized classes in documentary photography. He founded the Documentary Group and served on the board of directors. He was an editor, reviewer, and writer for Photo Notes, the league's newsletter. Advocate for art photography when few museums would show photography. His photography work involving labor union activity in 1940 sparked an FBI investigation. In 1947, Grossman and the league were blacklisted as a communist front, which lead to its demise.

Publications
Tucker, A. (2001). *This Was the Photo League.* Chicago: Stephen Daiter Gallery.

Group f/64 (1932–1935) American
Founded in Oakland, California, Group f/64 was a loose band of seven photographers—Edward Weston, Ansel Adams, Imogen Cunningham, Willard Van Dyke (1906–1986), Sonya Noskowiak (1900–1986), John Paul Edwards (1883–1968), and Henry Swift (1890–1960)—who promoted straight, modernistic photography. With their aesthetic stance based in precision-ism, they named themselves after the smallest aperture on the camera lens, expressing their allegiance to the native principals of "pure photography"—sharply focused images printed on glossy gelatin silver papers without any signs of pictorial "hand-work" and mounted on white board. Favoring natural forms and found objects, they offered an alternative to Stieglitz' urban bias against the naturalistic West Coast artists and the California pictorialist style.

Publications
Alinder, M. S. et al. (1992). *Seeing Straight: The F.64 Revolution in Photography.* Seattle: University of Washington Press.

GURSKY, ANDREAS (1955) German
A student of Bernd and Hilla Becher, Gursky's premeditated Olympian sized spectacles of color and pattern present a computer-altered zeitgeist of industrial culture that appears more real than reality. His seductively colorful, super-formalistic, and hyper-detailed hybrid compositions show everything as they catalog the phenomena of globalization. So perfectly beautiful they could hang in a corporate boardroom, yet they evoke a sense of post-modern indifference and sublime that leads us to feel inconsequential.

Publications
Galassi, P. (ed). (2001). *Andreas Gursky.* New York: Museum of Modern Art.

HAAS, ERNST (1921–1986) Austrian
Joined Magnum (1949–1962), moving to the United States in 1951. At a time when color photography was a second-rate, commercial medium to black and white, Haas' 24-page Magic Images of New York (1953) was a groundbreaking innovation for *Life* that introduced the artistic and poetic possibilities of color photography into the public's viewing habits. Noted for his experiments with color in motion and slow shutter speeds, his was the first exhibition of color photography at the Museum of Modern Art (1962).

Publications
Haas, E. (1989). *Color Photography.* New York: Harry N. Abrams.
Hass, E. (1971). *The Creation.* New York: Viking.

HALSMAN, PHILIPPE (1906–1979) American
The publishing world's desire to promote and capitalize on the notion of fame can be seen in Halsman's incisive celebrity portraits that appeared on over 100 covers of *Life* as well as in magazines such as *Saturday Evening Post* and *Paris Match.* Halsman believed the portrait-ist's most important tools were conversation and psychology, not technique. Halsman utilized playful methods, like jumping in the air, to unmask his subjects and divulge their essence.

FIG. 42 New York Reflections, 1962. Dye transfer print. Ernst Haas. (Courtesy of George Eastman House Collection, Rochester, New York.)

Publications

Halsman, P. (1959). *Jump Book*. New York: Simon & Schuster, 1959.

Halsman Bello, J. et al. (1998). *Philippe Halsman: A Retrospective—Photographs From the Halsman Family Collection.* New York: Bulfinch.

HEARTFIELD, JOHN (JOHN HELMUT HERZFELD) (1891–1968) German

A member of Berlin's Dada group and a pioneer of photomontage as a political method, Heartfield embodies the artist as activist. With cutting absurdity, he lambasted materialism, bourgeois pretensions, and the abuse of power in Germany in the late 1920s. During the 1930s he produced over 200 anti-Nazi and anti-conservative photomontages with captions. This combination, often featuring Nazi quotes, created ingenious visual puns that communicated a new message, which was the opposite of the original intent.

Publications

Heartfield, J. (1936). Hitler erzählt Märchen II. *AIZ*. March 5, p. 160.

Pachnicke, P. et al. (1993). *John Heartfield*. New York: Harry N. Abrams.

FIG. 43 Marilyn *LIFE* cover, 1952. Gelatin silver print ca. 1981 by Stephen Gersh under direction of Yvonne Halsman. Philippe Halsman. (Courtesy of George Eastman House Collection, Rochester, New York.)

HEINECKEN, ROBERT (1931–2006) American

Leader of the American photographic avant-garde during the 1960s through the 1970s, extending the expressive possibilities of what we call photography by using collage, lithography, photocopies, artists' books, altered magazines, and three-dimensional objects. A "photographist"—a photographer who doesn't use a camera—Heinecken appropriated and manipulated images from the mass media to fabricate droll and often controversial images often concerned with the erotica, the female body, and violence.

Publications

Borger, I. et al. (1999). *Robert Heinecken, Photographist: A Thirty-Five Year Retrospective*. Chicago: Museum Of Contemporary Art.

Enyeart, J. (ed.) (1980). *Heinecken*. Carmel, CA: The Friends of Photography.

HILLER, LEJAREN à (1880–1969) American Opened commercial photography to American print advertisers in 1913 by making less realistic and more fantastic images by combining fine art aesthetics and pictorialist methods to create subjective tableaux using elaborate sets involving costumed actors. Hiller used combination printing, dramatic lighting, soft-focus, and heavy retouching to produce narrative theatrical scenes that gave his images a sense of emotion and dreamy desire that delighted advertisers. Best known for his humorous and slightly erotic ad campaign, now considered sexist, Surgery Through the Ages (1927 and 1933) done for Davis & Geck, Inc. who were makers of surgical sutures. For this project Hiller concocted a historic series of tableaux vivants consisting of over 200 great moments in medical history that appeared in medical journals and hung in hospitals and physician's offices throughout the country.

FIG. 44 Mansmag October 1969. Lithographs (four-color) in the form of a pseudo magazine. Robert Heinecken. (Courtesy of George Eastman House Collection, Rochester, New York.)

Publications

Brown, E. H. (2000) Rationalizing consumption: Lejaren à Hiller and the origins of American advertising photography, 1913–1924. *Enterprise & Society* **1** (Dec. 2000), 715–738.

HINE, LEWIS WICKES
(1874–1940) American
Hine was a sociologist who took up photography in 1904 in the cause of social reform. He documented immigrants arriving at Ellis Island then followed them in their harsh new lives in the slums of America. In 1907, Hine photographed the Pittsburgh iron and steel workers revealing employment of children under grueling, dangerous conditions. As staff photographer to the National Child Labor Committee from 1911 to 1917, Hine's photographs exposed the negative consequences of a growing consumer society and contributed to the passing of child labor laws. In the 1920s, he embarked on "positive documentation" by making portraits of the

FIG. 45 Young Russian Jewess, Ellis Island, 1905. Gelatin silver print. Lewis W Hine. (Courtesy of George Eastman House Collection, Rochester, New York.)

FIG. 47 Chicago, 1961. Gelatin silver print. Kenneth Josephson. (Courtesy of George Eastman House Collection, Rochester, New York.)

JOSEPHSON, KEN (1932) American

Josephson's conceptual approach that humorously alters perspective, scale, and point of view emphasizes the relationship between a photograph of a subject and the subject itself. His black and white photographs from late 1960s and 1970s, which include pictures within pictures, reveal "the process of creating pictures as ideas rather than as representations." In one series, Josephson holds a postcard of each scene into his photographic frame, playfully interjecting himself as a performer who is formally distorting reality while mocking the idea of photographic duplication, demonstrating the absurdity of attempting to re-occupy the same space. Josephson reshapes the photograph to discover a new vantage point that disrupts Renaissance concepts of how the world is and what a picture is supposed to look like.

Publications

Wolf, S. et al. (1999). *Kenneth Josephson: A Retrospective*. Chicago: Art Institute of Chicago.

KARSH, YOUSUF (1908–2002) Canadian

Born in Armenia, he escaped the Turkish persecution, emigrating to Canada in 1924. Opened a portrait studio in Ottawa in 1932 where he established a reputation for photographing the powerful and famous of his era. His view-camera portraits were known for their clarity and dramatic lighting, emphasizing highlights, shadows, and rich textures. His 1941 *Life* cover of the imposing, wartime, bulldog-faced Winston Churchill infused the subject's personality with his public image to reveal what Karsh said was the sitter's "inner power."

Publications

Karsh, Y. (1996). *A Sixty-Year Retrospective*. Boston: Little, Brown.

KÄSEBIER, GERTRUDE (1852–1934) American

Opened a New York portrait studio (1897) where she created a reputation for her mother and child motifs that stressed tonality over formal compositional elements. Known as the leading woman pictorialist, she produced platinum, gum-bichromate, bromoil, and silver prints, and encouraged women to take up photographic careers. Founding member of the Photo-Secession in 1902. Stieglitz promoted her highly romantic work, reproducing it in *Camera Work*. Eventually, she broke contact with Stieglitz over the issue of "straight" photography, forming the Pictorial Photographers of America in 1916 with Coburn and C. White.

Publications

Caffin, C. H. (1901, 1972). *Photography as a Fine Art*. New York: Doubleday.

Michaels, B. L. (1992). *Gertrude Käsebier, The Photographer and Her Photographs*. New York: Harry N. Abrams.

KEÏTA, SEYDOU (1923–1998) Malian

Through his commercial portraits that chronicle the shift of the colonial and post-colonial urban West African experience by blending Western technology with an African aesthetic and viewpoint, the self-taught Keita became the official photographer of Mali from 1962 to 1977. To make his customers look their best, Keïta used backdrops and props, such as bicycles, musical instruments, radios telephones, plus traditional and European clothing to pose his subjects to achieve their desired look. Dating from 1949, Keita's oeuvre of over 200,000 images depicts African modernization and brought Western attention to his work and indigenous African photography overall.

Publications

Magnin, A. (ed.) (1997). *Seydou Keïta*. New York: Scalo Publishers.

KEPES, GYÖRGY (1906–2001) American

A close associate of Moholy-Nagy, who became the head of the light department at Chicago's New Bauhaus, proclaimed he was not a photographer but an artist "committed to working with light." An avid experimenter who explored clichés-verre and photograms, Kepes juxtaposed fragmented light spaces with structured rhythmic patterns of geometric shapes to create visual opposition. This use of opposites and natural forms in a dream-like field of geometric shapes, was a metaphor of alternating natural and technological realities. As an influential educator he investigated the effect of visual language on human consciousness, chiefly how the design elements of line and form are perceived and how new types of perspective can bring about more vibrant visual representations. Founding Director of the Center for Advanced Visual Studies at MIT (1967), which explores confluences of art and technology.

Publications

Kepes, G. et al. (1995). *Language of Vision: Fundamentals of Bauhaus Design* (reprint). Mineola, NY: Dover Publications.

KERTÉSZ, ANDRÉ (1894–1985) American

By the late 1910s, Kertész was demonstrating the visual language of modernism with asymmetrical compositions, close-ups, distortions, reflections, and unusual points of view. He came to use a Leica to geometrically order the unexpected moments of everyday life with a life-affirming sensibility that favored a play between pattern and deep space. He made his living as a European photojournalist before immigrating to the United States. Kertész' joyous "Leica spirit," the new small camera mentality, combined the formal design elements of De Stijl with a natural intuition to extract poetic "rest-stops" from the flow of time that alter expectations about common occurrences and objects. His spontaneous vision revealed a sweet, lyrical truth, celebrating the splendor of life and the pleasure of sight. Inspired Brassaï, Henri Cartier-Bresson, and Robert Capa.

Publications

Greenough, S. (2005). *André Kertész*. Princeton: Princeton University Press.

KLEIN, WILLIAM (1928) American

Klein, an ex-patriot American fashion photographer, filmmaker, designer, and painter has made Paris his home. He enlarged the syntax of photography by courting accident, blur, contrast, distortion, cockeyed framing, graininess, and movement. Rebelled against the 1950s notions of the decisive moment, which included not intervening into a scene, making good

compositions, and producing normal looking prints. His images are not those of a detached observer but those of a provocateur. Klein referred to his *Life is Good for You in New York—William Klein Trance Witness Revels* (1956) as "a crash course in what was not to be done in photography." His other photographic books of cities—*Rome* (1958–1959), *Moscow*, and *Tokyo* (both 1964)—are catalogs of irreverent "mistakes," revolving around aggression. The dynamic and unconventional framing and printing techniques present cities as théâtre noir, emphasizing a sense of anarchy, chaos, and dread of urban life that most people wished to ignore.

Publications
Heilpern, J. (1980). *William Klein: Photographs*. New York: Aperture.

FIG. 48 William Klein. Photograph by Nancy M. Stuart. Fall 1990.

KLETT, MARK (1952) American
As a member of the Rephotographic Survey Project (1977–1979), Klett helped precisely re-photograph 122 19th century western survey sites, pointing out how 19th century photographers saw the landscape and the unfolding interaction of human development and natural transformations over time. The pairing of old and new images showed how photography can display and measure time, establishing a dualistic meaning of time and space, putting viewers into a time machine that permits them to glance between then and now. This became central to Klett's work as in the Third View project, in which the locations from the first project were re-photographed again in the 1990s. Klett's photographic mapping of the past and the present illustrates the dynamic

FIG. 49 Petroglyphs in the Cave of Life, Petrified Forest National Monument, Arizona, May 31, 1982. Gelatin silver print. Mark Klett. (Courtesy of George Eastman House Collection, Rochester, New York.)

interaction of culture and geological forces, reflecting loss, and the encroachment of civilization on the wilderness.

Publications
Klett, M. et al. (2004). *Third Views, Second Sights: A Rephotographic Survey of the American West*. Albuquerque: University of New Mexico Press.
Klett, M. et al. (1984). *Second View: The Rephotographic Survey Project*. Albuquerque: University of New Mexico Press.

KOUDELKA, JOSEF (1938) Czech/French
Koudelka's graphic black and white images deal with those on the fringes of society. His formalized theatrical organization of reality looks at the daily community rituals of gypsies and exiles. His images of the invasion of Prague dramatically synthesized the terror and freedom of being isolated. His panoramic views search for a reprieve within a derelict landscape, where

our own bleak despair has ruined nature's pleasures. Koudelka's prints utilize deep, dark black tones to continually portray the mental and physical conundrums and world-weariness of being a refugee.

Publications
Koudelka, J. (1999). *Chaos.* New York: Phaidon Press.

KRIMS, LES (1943) American
In the early 1970s Krim's provocative, self-published, boxed folios on dwarfs, deer hunters, murder scenes of nude young women, and his topless mother making chicken soup offended Main Street while encouraging young photographers to visualize their inner fictions and explore forbidden subjects. These images were printed on a graphic arts paper to deliver dramatically grainy, high-contrast, brown-toned effects that challenged the conventions of the fine print aesthetic. Detractors did not find the work humorous and heavily criticized it as condescending, mocking, and misogynistic.

FIG. 50 Human Being as a Piece of Sculpture Fiction, 1970. Gelatin silver print, Kodalith. Les Krims. (Courtesy of George Eastman House Collection, Rochester, New York.)

Publications
Krims, L. (1972). *Making Chicken Soup.* Buffalo, NY: Humpy Press.

KRUGER, BARBARA (1945) American
Kruger spent ten years working as a graphic designer for various women's magazines that extolled beauty, fashion, and heterosexual relationships before producing photomontages, resembling billboards, with text that questioned capitalism's relationship to patriarchal oppression and the role consumption plays within this political and social structure. Turning the tables on the seductive strategies of advertising, Kruger reuses anonymous commercial, studio-type images to deconstruct cultural representations of consumerism, the power of the media, and stereotypes of women to show how images and words manipulate and obscure meaning. Her red or white banners of text stamped on black and white photographs pound viewers with curt phases, such as "Your Body is a Battleground" or "I Shop Therefore I Am," deliver unsettling jolts to male demonstrations of financial, physical, and sexual power.

Publications
Kruger, B. (1999). *Barbara Kruger.* Cambridge: The MIT Press.

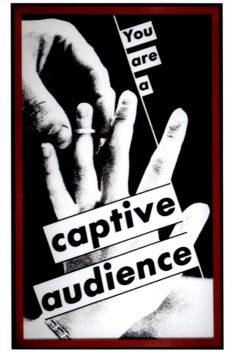

FIG. 51 Untitled ("You are a Captive Audience"), 1992. Photo silkscreen print. Barbara Kruger and the Mary Boone Gallery, New York City. (Courtesy of George Eastman House Collection, Rochester, New York.)

KRULL, GERMAINE (1897–1985) German

Often overlooked because of the diversity of her practice and the loss of her early work during the wars, Krull was an innovative, prolific, and versatile photographer whose advertising, architectural, fashion, industrial, montage, ironic female nudes, and reportage images were intertwined with her intense political and professional beliefs. Spanning nine decades and four continents, Krull broadly and expressively overlapped commercial and avant-garde approaches as she photographed in response to the situations and cultures she traveled through. Her Metall series (1927) sharply emphasized the abstract forms of industry and introduced German New Objectivity (Neue Sachlichkeit) photography to France.

Publications

Sichel, K. (1999). *Germaine Krull: Photographer of Modernity*. Cambridge: The MIT Press.

KÜHN, HEINRICH (1866–1944) German

Along with Hugo Henneberg (1863–1918) and Hans Watzek (1848–1903) formed the "Trifolium" of the Vienna Kamera-Club (1896–1903). Using the gum process, they exhibited under the collective known as Kleeblat (Cloverleaf) and were a driving force of the Austro-German secession/pictorialist movement. An amateur since 1879 and a member of the Linked Ring, Kühn made multi-layered landscapes and portraits in gum and, later, oil-pigment printing. His characteristic style featured bold, emblematic compositions on textured paper, printed in appealing brown or blue hues. His approach, to at times photograph from above eye-level, broke with the passé habits of professional portraitists and began a progressive photographic movement in Germany that reflected the concerns of similar pictorial groups that sprang up worldwide.

Publications

Kühn, H. (1988). *Heinrich Kühn: Photographien*. Munich: Residenz.

LANGE, DOROTHEA (1895–1965) American

Studied photography with Arnold Genthe (1915) and then Clarence White at Columbia University (1917–1918). Opened a portrait studio in San Francisco (1919–1934). In 1932, as the Great Depression deepened, Lange felt she must take her camera out of her studio into the streets where she recorded labor strikes, demonstrations, and unemployment lines. A woman of great commitment, Lange dedicated her photography to revealing "the human condition" and social reform. Employed by the Farm Security Administration (FSA) from 1935 to 1942, she established her reputation as one of America's most gifted documentary photographers. She photographed all over the United States, producing a rich portrait of a poor America (publishing *An American Exodus* with husband, Paul Taylor, in 1939). Best known for her gripping images of migrant workers, including the iconic, Migrant Mother (1936) (see Figure 9), Lange continued to work for Federal agencies during WWII. In 1941 she was the first woman ever to be awarded a Guggenheim Fellowship. She closely advised Edward Steichen on the Family of Man exhibit at The Museum of Modern Art (MoMA) in 1955. During her later years, though slowed by illness, she traveled, taught, and worked freelance for several publications including *Life*, with photo-essays on the Mormons with Ansel Adams and later, Irish country women. Originally published in the *Focal Encyclopedia of Photography, 3rd edition* by Mary Alinder. Updated by E. Ken White.

Publications

Borhan, P. (2002). *Dorothea Lange: The Heart and Mind of a Photographer*. New York: Bulfinch Press.

Coles, R. and Heyman, T. (1982). *Dorothea Lange: Photographs of a Lifetime*. New York: Aperture.

Lange, D.(1939, 1999). *An American Exodus: A Record of Human Erosion*. With P. Taylor. New York: 1939 [new edition, Paris: Jean Michel Place 1999].

Meltzer, M. (1978). *Dorothea Lange: A Photographer's Life*. New York: Aperture.

LARTIGUE, JACQUES-HENRI (1894–1989) French photographer and painter
Raised in a wealthy French family, Lartigue was given a camera by his father at age six. Though his life as a photographer and a painter spanned most of the 20th century, he is most fondly remembered for his charming childhood and adolescent photographs, most of which were unknown outside his family circle until showcased in 1963 by John Szarkowski, curator at the Museum of Modern Art (MoMA). Living a privileged life, he candidly recorded the astounding events as the century turned (the first motorcars and airplanes) and the everyday quirks of life—his cousin skipping downstairs, seeming to float in the absence of gravity, and a family friend plunging backwards into a lake. Lartigue's uncanny perceptions and the capture of motion by the newer "snapshot" cameras has preserved a vernacular record of the end of France's belle époque and the advent of mechanized transportation. Images by Lartigue also recorded European fashions on the street and in societal circumstances, and one of his favorite personal themes—women. Despite his reputation now, during most of Lartigue's mature life he was known in art circles for his paintings. Originally published in the *Focal Encyclopedia of Photography, 3rd edition* by Mary Alinder. Updated by E. Ken White.

Publications
Lartigue, J. H. (2003). *Jacques Henri Lartigue: A Life's Diary*. Paris: Centre Pompidou.
Lartigue, J. H. (1998). *Jacques Henri Lartigue, Photographer*. New York: Bulfinch Press.
Lartigue, J. H. (1970). *Diary of a Century*. Edited by R. Avedon. New York: Viking Press.
Lartigue, J. H. (1966). *Boyhood Photos of J. H. Lartigue, the Family Album of a Gilded Age*. Switzerland: Ami Guichard.

LAUGHLIN, CLARENCE JOHN (1905–1985) American
Self-taught photographer who spent most of his life in New Orleans, Louisiana, amid a personal library of over 32,000 volumes about fantasy. Laughlin is best known for his haunting images of Victorian-era architecture and surreal, ghost-like multiple exposures. His freelance photography began in 1934 and he also worked for the U.S. Army Corps of Engineers before serving in the U.S. military during WWII. After the war he was self-employed (1946–1967) selling views and details of architecture, giving lectures, and illustrating magazine articles. Influenced by Atget, Man Ray, and the French symbolist poets, Laughlin produced twenty-three themed groups of images such as Poems of the Interior World (begun in 1940). Most of his photographs were accompanied by voluminous writings and captions which often filled the reverse side of many prints. His black and white camera work is best represented by disquieting scenes of deserted architectural splendor (or ruins) and more self-conscious efforts to populate these spaces with veiled figures and spiritual ghosts. Admirers of his work may find an abundant intellect also revealed in his poetry and prose.

Publications
Brady, P. and Lawrence, J. H. (eds.) (1997). *Haunter of Ruins: The Photography of Clarence John Laughlin*. Boston: Bulfinch Press.
Davis, K. with Barrett, N. and Lawrence, J. (1990). *Clarence John Laughlin: Visionary Photographer*. Kansas City, MO: Hallmark Cards.
Laughlin, C. J. (1988). *Ghosts Along the Mississippi*. New York: Random House [New rev. ed.].

LEE, RUSSELL (1903–1986) American
Lee began his study of photography in 1935, ten years after earning a degree from Lehigh University (Pennsylvania) in chemical engineering. Photography, he thought, would aid his ability as a painter studying in San Francisco and at the Woodstock art colony (New York) in the early 1930s. His career took an abrupt shift when he was invited by Roy Stryker to join the government's Historical Section of the Farm Security Administration (FSA). Lee worked from 1936 to 1943 as a prolific photographer in the FSA combining his keen sense of documentary with an engineer's precise mastery of lighting (especially flash photography). Stryker called

him a "taxonomist with a camera." Besides making more FSA negatives than any other photographer, Lee was one of the first to utilize new color photography materials in his recording of people and events in Pie Town, New Mexico.

After leaving the FSA, Lee continued to work for various government agencies until 1947 when he was hired by Standard Oil of New Jersey. His industrial images were printed in *Fortune* and in *The New York Times*. A second career spanned the years 1956–1973 while Lee was on the teaching faculty of the University of Missouri, and later at the University of Texas at Austin. Despite an education in engineering, Lee's images and teachings never underplayed the role of photography as an objective witness to call attention to the pride and prejudice that characterized society in the mid-1900s.

Publications

Hurley, J. (1978). *Russell Lee: Photographer.* Dobbs Ferry, NY: Morgan & Morgan.

FIG. 52 Annie Leibovitz. Photograph by Nancy M. Stuart. September 26, 1991.

LEIBOVITZ, ANNIE (1949) American

Born in Connecticut, educated at the San Francisco Art Institute (BFA, 1971), Leibovitz ascended to the very apex of contemporary portrait photography at the beginning of the 21st century. Her most respected work is of celebrity and literati personalities often seen in spectacular display in the pages of *Vanity Fair* as cover shots or lavish fold-out group portraits and portfolios. She is also the artist of many notable photo-essays and advertising campaigns, especially the celebrity icons photographed for the American Express media ads (1987). Her first involvement with photography came in Japan when her father was stationed there with the U.S. military. After studying painting in college, Leibovitz' first break came when she was retained as chief photographer for a start-up West Coast publication called *Rolling Stone* (1973). Perhaps her most memorable image is the nude John Lennon with the clothed Yoko Ono—an image made the same day Lennon was murdered in New York City (1980). By 1983, Leibovitz was hired by Condé Nast to be the primary talent to photograph for *Vanity Fair*. Most of Leibovitz' work (color and black and white) exhibits her talent for incorporating environment, props, or an idiosyncratic gesture to resonate with her subjects' persona or "public trademark." Leibovitz' extraordinary range of subjects has spanned from portraits of athletes at Atlanta's Olympic Games to a more recent book collaboration with Susan Sontag, *Women* (1999).

Publications

Leibovitz, A. (1984). *Annie Leibovitz: Photographs.* Introduction by T. Wolfe. New York: Pantheon/Rolling Stone.

Leibovitz, A. (1992). *Photographs, Annie Leibovitz.* With I. Sischy. New York: Harper Collins.

Leibovitz, A. (1999). *Women.* Introduction by S. Sontag. New York: Random House.

LEVINE, SHERRIE (1947) American

Levine earned her MFA degree in photo/printmaking at the University of Wisconsin in 1974. She became a lightning rod for charged criticism in the early 1980s after she was thrust into the forefront of the new post-modernist vanguard by an influential essay by Douglas Crimp in October called "The Photographic Activity of Post Modernism" (Winter 1980). She was nominated by Crimp to represent the art gesture of "appropriation" whereby an artist uses (transforms, re-contextualizes, adds text to) existing art or photographs to make a commentary or create "critical discourse." Levine had made photographic copies of well-known images by

Edward Weston, Eliot Porter, and Walker Evans (all made from existing book reproductions) and exhibited the copies, uncropped and only altered by the act of photographic reproduction with titles like "After Edward Weston (by Sherrie Levine)." Levine's intention was to offer her art that questioned originality, the patriarchal system of art "masters," and the fundamental nature of any art that utilized a photographic process to inscribe creativity and aesthetic value onto an art object (as Walter Benjamin had outlined in the 1930s). The debate, carried on in art journals and in universities for the next two decades, influenced a new generation of artists and critics for whom "the gesture" (often informed by Marxist and Feminist theories) super-seded the modernist "object."

LEVINTHAL, DAVID (1949) American

Raised in California (art degree, Stanford 1970) Levinthal later earned an MFA at Yale where cartoonist, Garry Trudeau, was a classmate and early collaborator on the book, *Hitler Moves East* (1977), which featured Trudeau's text and Levinthal's table top photographs of toy soldiers in a mock-documentary style that was a precursor for the emerging post-modernist movement in photography. The use of toys, dolls, and scale models in the studio to produce faux docu-ments that offer variable comment upon history and culture was a trademark of Levinthal's many themes and book publications in the 1980s and 1990s. Levinthal's progression of themes has evolved from sly parody of the Western cowboy to more barbed visual pronouncements about T&A pin-ups, bondage, the Holocaust, pornography, and racism. Each theme, usually displayed in saturated colors, has been an exegesis of spectator voyeurism. Using ambiguous space and thin slices of selected focus, Levinthal offers viewers an artificial body or dramatic pose that transforms cultural stereotypes into visual codes that viewers recognize as reminis-cent of past memory—perpetuated in modern society by toymakers and tchotchke vendors. Levinthal's most intense work (*Desire, Mein Kampf, Blackface, XXX*) has raised controversy when critics can't agree on the propriety of an artist who trumps history with seductive images that are interpretations of society's coercion, lust, and depravity.

Publications

Levinthal, D. (2001). *David Levinthal: Modern Romance*. Essay by E. Parry. Los Angeles: St. Ann's Press.
Levinthal, D. (1997). *David Levinthal: Work from 1975–1996*. New York: ICP.
Levinthal, D. (1993). *Desire*. Essay by A. Grundberg. San Francisco: Friends of Photography.

LEVITT, HELEN (1949) American

By the time she turned sixteen, Levitt decided to become a professional photographer having learned darkroom practice from her job assisting a Bronx portrait photographer. Influenced by Walker Evans, with whom she studied (1938–1939), and by the work of Cartier-Bresson, Levitt purchased a Leica camera (with a right angle finder) to be a surreptitious photographer of street life. Her most notable work captures the parade of human comedy and mini-drama on the streets of New York, especially children at play. She was given her first solo exhibition at The Museum of Modern Art (MoMA) by the Newhalls in 1946. She had work published in *Fortune, Harper's Bazaar, Time*, and *PM Weekly*. James Agee became an admirer of her work and collaborated on two films and a book with Levitt. She is also known for her pioneer work using still color transparencies beginning in the late 1950s after more than a decade as a film maker. With the exception of images made in Mexico (1941), Levitt's photographs provide a candid, apolitical, look at the ebb and flow of life in her beloved New York—sidewalks, vacant lots, tenement stoops inhabited by children who paid no attention to the dark clad woman with the quiet, but omniscient little camera. She taught at Pratt Institute in the mid-1970s.

Publications

Levitt, H. (1965, 1981). *A Way of Seeing: Photographs of New York*. With J. Agee. New York: Viking Press (reprinted in 1981).
Phillips, S. and Hambourg, M. (1991). *Helen Levitt*. San Francisco: San Francisco Museum.

LINK, O. WINSTON (1914–2001) American

Born in Brooklyn, Link pursued an education at nearby Polytechnic Institute in civil engineering. He worked at several technical and industrial research jobs at Columbia University before deciding to teach himself photography, opening a commercial studio in New York in 1942. After WWII Link did mostly industrial photography. In the mid-1950s one of his assignments took him through West Virginia where he photographed rail lines and locomotives of the Norfolk & Western Railroad. His fascination with the prowess and photogenic character of the steam locomotive prompted him to seek special permission from the rail company executives to have extensive access to the railroad equipment and personnel. With this agreement he began to stage elaborate night exposures of the steam locomotives in settings that showed the juxtaposition of the railway to the rural villages and lifestyle of 1950s America. Using massive reflectors and banks of flashbulbs, Link made large-format exposures (2400 negatives) of the night landscape, people, and locomotives as the engines belched white steam on cue. Several well-known pictures from this series feature municipal swimming pools, drive-in movie theaters and the like as citizens of the nearby towns pose candidly to create a surreal blend of organic life with the gleaming black locomotives. These photographs only gained popularity after they were featured in an article in *American Photographer* in 1982, followed by an impressive monograph of Link's work in 1987.

Publications
Link, O. W. (1995). *The Last Steam Railroad in America: From Tidewater to Whitetop*. With T. Garver. New York: Harry N. Abrams.
Link, O. W. (1987). *Steam, Steel & Stars: America's Last Steam Railroad*. With T. Hensley. New York: Harry N. Abrams.

LIST, HERBERT (1907–1975) German

As a young student and protégé in his father's coffee import business, List traveled widely to the Americas before being encouraged as a photographer by Andreas Feininger in the United States. Returning to Europe in the early 1930s, he was influenced by Pittura Metafisica and the Surrealists (moved to Paris in 1936). His black and white images prior to WWII are divided between portraits of leading European artists and enigmatic scenes, with simple compositional elements, that are usually bathed in Mediterranean sunlight. The latter group derived more influence from the painting style of de Chirico than from the contemporary photographs by Man Ray or Max Ernst. Some of List's most important images were made in Greece, outdoors, unlike many other surrealists who primarily used studios, interiors, and night settings. List had images published in *Verve*, *Harper's Bazaar*, and *Life*, dedicating his work to photojournalism in Munich after WWII (extensively contributing to *Du* between 1945–1960). He made no photographs after 1960 preferring to collect Old Master and Italian drawings.

Publications
List, H. (1993). *Hellas*. Munich: Schirmer/Mosel.
List, H. (1983). *I Grandi Fotograf*. Milan: Gruppo Editoriale Fabbri.
List, H. (1976, 1980). *Herbert List—Photographien 1930–1970*. Munich 1976 [reprinted by London: Rizzoli 1980].
List, H. (1953). *Licht über Hellas*. Munich: Verlag.

LYNES, GEORGE PLATT (1907–1955) American

A self-taught photographer, Lynes' first business was as owner of a small publishing firm. He began making portraits in the mid-1920s and was fortunate to be able to travel to Europe where he earned early support for his photography from Gertrude Stein. In 1923 he opened a studio in New York. Alexey Brodovitch, art director for *Harper's Bazaar*, hired Lynes for some early fashion assignments. Lynes utilized an ample studio for large-format work often collaborating with the painter, Pavel Tchelitchev, who helped design and construct backgrounds. Commercial and fashion images by Lynes later appeared in *Vogue* and *Town & Country*. Artistically, he is

best known for his homoerotic male nudes and his mythology studies produced in the studio with dramatic lighting of muscular limbs and torsos. During the 1930s and 1940s Lynes made images for Lincoln Kirstein's American Ballet Company (Kirstein, a prep school classmate of Lynes). The photographer also enjoyed the patronage of Alfred C. Kinsey in the 1950s but, unfortunately, this alliance came too late to preserve some of Lynes' personal work, since the artist himself destroyed many negatives and prints that he feared would reveal his fascination with male sexuality.

Publications

Crump, J. (1993). *George Platt Lynes, Photographs from the Kinsey Institute*. Boston: Bulfinch Press.

Kirstein, L. (1960). *George Platt Lynes Portraits 1931–1952*. Chicago: Art Institute of Chicago.

Woody, J. (1981). *George Platt Lynes: Photographs, 1931–1955*. Pasadena, CA: Twelvetrees Press.

LYON, DANNY (1942) American photographer and filmmaker

Lyon, a New York native, studied history at the University of Chicago (BA, 1963) and became involved in the growing Civil Rights movement. He was self-taught as a photographer and his first images document this social struggle. It was a pattern to be repeated throughout his career—to actively live with subgroups or participate with segments of society he would document. He became a member of a Chicago motorcycle gang, The Outlaws, before producing the book, *The Bike Riders* in 1968. Later he spent time with construction workers, stock car racers, prison inmates, and peoples of the

FIG. 53 CAL, Elkhorn, Wisconsin, ca. 1965–1966. Gelatin silver print. Danny Lyon. (Courtesy of George Eastman House Collection, Rochester, New York.)

Third World to make his books and films. *Conversations with the Dead* (1971) was published with images, interviews, and writings of Texas prison inmates with whom he was allowed to visit intimately for a few months. Later work by this Jewish Caucasian has been especially empathetic with the plight of Latinos and Native Americans (he has lived in New Mexico since the early 1970s). Beginning in 1980 he has produced several autobiographical works (*Knave of Hearts*, 1999) and, among his films, *Little Boy* (1977) is a characteristic gem. Lyon remains a deeply committed artist/humanitarian who has expanded the public's awareness of individuals at the fringes of late 20th century society.

Publications

Lyon, D. (1981). *Pictures From the New World*. Millerton, NY: Aperture.

Lyon, D. (1969, 1980). *The Destruction of Lower Manhattan*. New York: Macmillan [reprinted by London: Rizzoli: 1980].

Lyon, D. (1980). *The Paper Negative*. Bernalillo, NM: Bleak Beauty.

LYONS, NATHAN (1930) and **JOAN** (1937) Both American

This dynamic pair, married in 1958, have lived most of their lives in Rochester, New York, and are both associated with the Visual Studies Workshop, (VSW) founded by Nathan Lyons in 1969 after working for a decade at the George Eastman House. Both received college degrees from Alfred State University (SUNY) in 1957. Nathan is a true renaissance man in photography—artist, author, curator, historian, educator, archivist, activist, mentor. He is best known as an image-maker for a lifelong trilogy of publications that are sequenced images of the urban landscape. Starting with *Notations in Passing* (1974), the work is densely referential to

FIG. 54 Untitled (woman with hair) 1974. Offset lithograph from Haloid Xerox masters. Joan Lyons. (Courtesy of George Eastman House Collection, Rochester, New York.)

FIG. 55 Paper construction of American Flag with children's drawings of faces and detail of a poster with expressions of sympathy. Nathan Lyons. *After 9/11* photographs by N. Lyons with a poem by Marvin Bell 2002. (Courtesy of George Eastman House Collection, Rochester, New York.)

American culture, symbols, and clichés. For some critics, the work could be labeled as "street photography" or as "equivalents," but the intellect that knits the image sequences together surpasses these insufficient comparisons. In addition to tireless work for the medium (editing/writing for *Image* and *Aperture*), Nathan Lyons founded Afterimage in 1972, was a founding member and the first Chairperson of the Society for Photographic Education (1963), and has the international respect of almost every person in the realm of photography.

Joan Lyons shares her husband's passion for photography, publishing, and education. She founded the VSW Press in the 1970s and teaches at VSW. Her artwork is generated—and modified—by various image systems (xerography, printmaking, non-silver processes), and her expressive ideas usually result in artist books whose themes are often self, family relationships, and women's issues.

Publications

Lyons, N. (2003). *After 9/11*. New Haven, CT: Yale University Press.
Lyons, N. (1999). *Riding 1st Class on the Titanic—Photographs by Nathan Lyons*. Andover, MA: Addison Gallery of Art.
Lyons, J. (1981). *Seed Word Book*. Rochester, NY: Visual Studies Workshop.
Lyons, J. (1977). *Abby Rogers to her Grand-daughter*. With text by A. Rogers. Rochester, NY: Visual Studies Workshop.
Lyons, J. (1973). *Wonder Woman*. With J. McGrath. Rochester, NY: Visual Studies Workshop.

MAN, FELIX (HANS BAUMANN) (1893–1985) German and British
As a student, Man studied art history at Freiburg University and had made his first photographs at age ten. Drafted into the German army during WWI, he made documentary photographs of the Western Front with a Vest Pocket Kodak (negatives later destroyed in WWII bombing).

After 1919 he resumed art studies in Munich and Berlin, and worked as a layout artist/photographer for the news agency Dephot (Deutscher Photodienst). He published over one hundred photo-essays in *Munchner Illustrierte Presse* (MIP) and *Berliner Illustrierte Zeitung* (BIZ) from 1929–1932. He used the Ermanox and Leica cameras for spontaneous reportage. His most remarkable published work was *A Day with Mussolini* (1931, *MIP*) made with the small camera and available light which lent an air of authenticity to the scenes. Mussolini did not notice at the time that Man was making candid, "unofficial" images of Il Duce using the Ermanox. The photographs were segments of reality taken from the flow of actual events, not staged or posed. In 1934, due to rising Nazi prominence, Man moved to London where he spent the rest of his career (naturalized British citizen, 1948). With Stephan Lorant he founded *Weekly Illustrated* in 1934 and later worked for the *Daily Mirror* (pictures credited to his moniker, "Lensman"), and the new *Picture Post* (1938–1945). In England, Man's subjects were non-studio portraits, location fashion, country life, and color studies. He also contributed to *Harper's Bazaar* and *Life* in the 1950s until he retired to study the history of lithographic art.

Publications
Man, F. (1948). *Man With Camera: Photographs from Seven Decades*. New York: Schocken.

MANN, SALLY (1951) American
Mann has lived her life in a small town in the Shenandoah Valley in Virginia (except for years at Bennington College, Vermont). She earned an MA (1975) in writing from Hollins College, although her considerable talent seems to be in recognizing and shaping intricate visual statements. Her work could be deemed "traditional" in its execution with an 8 × 10 view camera from which she makes exquisite black and white prints sometimes using wet plate collodion negatives. She is best known for a series of work that documents her own family, especially the lives of her three children (images of husband, Larry, have yet to be included in much of her public work). *Immediate Family* was published in 1992 (concurrent exhibition) and instigated intense controversy over the explicit frankness and intimacy revealed in some photographs of the children in various states of nudity. The debate about the propriety of showing adolescent sexuality or loss of innocence is, perhaps, not one to be won or lost on the photographic evidence, but waged by those with a variance in their interpretations of those images. Her work is often compared to that of Emmet Gowin (also originally from Virginia), however, Mann's children seem to animate her strongest work from the 1980s and 1990s—the unvarnished passage from childhood to young adult. Mann has previously photographed girls at the age of twelve and is working on landscape images of Virginia, Georgia, and other locations (Civil War battlefields). Her talent as a writer/artist is elegantly demonstrated in her most recent publications. In *Deep South* (2005) the images are more ethereal and mystical as she allows the hand-applied collodion more autonomy in its marriage with light.

Publications
Mann, S. (2005). *Deep South*. Boston: Bulfinch Press.
Mann, S. (2003). *What Remains*. New York: Bulfinch Press.
Mann, S. (1994). *Still Time*. New York: Aperture.
Mann, S. (1988). *At Twelve: Portraits of Young Women*. New York: Aperture.
Mann, S. (1938). *Second Sight*. Boston: David R. Godine.

MAPPLETHORPE, ROBERT (1946–1989) American
Mapplethorpe achieved saturated recognition for his elegant photographic still life, portraits, and nudes, before dying tragically of AIDS. Born in New York to a Catholic family, he studied at Pratt Institute (drawing, sculpture) before becoming a photographic artist (he had considered a career as a musician). His interest in camera images was piqued by access to closed collections maintained by John McKendry (curator at Metropolitan Museum of Art) and Sam Wagstaff. He started taking Polaroid images and was influenced by Warhol's art. Early portraits were of Lisa Lyon and Patti Smith. Mapplethorpe's work was presented in a relatively modernist,

aesthetisized style and his best known photographs featured nudes of black males and images with overt homoerotic subjects. The Corcoran Gallery canceled a solo exhibit, The Perfect Moment, by Mapplethorpe in 1989 due to pressure from groups voicing opposition to depictions of homosexual eroticism and the fact that the artist had received some funding from the National Endowment for the Arts. The show was put on in Cincinnati in 1990 and this resulted in litigation over obscenity charges (subsequently, charges against the show sponsors resulted in an acquittal). The death of the artist from AIDS just before this brought about a clamorous collision between art, reality, morality, and legal issues. At the same time, the "culture wars" between liberal and conservative viewpoints flared up in many arenas. As an indirect consequence of Mapplethorpe's photographs, public funding for the arts suffered drastic curtailment in the 1990s but the art world, for the most part, became more steadfast as a defender of freedom of expression.

Publications

Danto, A. C. (1996). *Playing With the Edge: The Photographic Achievement of Robert Mapplethorpe*. Berkeley, CA: University of California Press.

Mapplethorpe, R. (1999). *Pictures: Robert Mapplethorpe*. Edited by D. Levas. New York: Arena Editions.

Mapplethorpe, R. (1983). *Lady: Lisa Lyon*. New York: St. Martins.

Mapplethorpe, R. (1980). *Robert Mapplethorpe: Black Males*. Text by Edmund White. Amsterdam: Galeria Jurka.

Marshall, R., Howard, R. and Sischy, I. (1988). *Robert Mapplethorpe*. New York: Whitney Museum of Art.

Morrisroe, P. (1995). *Mapplethorpe*. New York: Papermac 1995.

MARK, MARY ELLEN (1940) American

Mark is among an elite group of photographers known around the world for her incisive style of documentary work that is both engaging and sensitive. Her subjects often seem exotic or unusual but Mark cultivates an intimate quality in the pictures that renders familiarity without diminishing the very human circumstances of the people in front of her camera. Before earning an MA (1965) in photojournalism at the University of Pennsylvania, Mark had bought her first Leica and had already traveled on a Fulbright grant to Turkey and later, India. By 1969 she had assignments doing production stills for films like Satyricon with Fellini. Her work has been published in *Look, Life, Time, New York Times Magazine, Vogue,* and *Vanity Fair,* only to name a few among a hundred periodicals. She was a member of Magnum from 1977 to 1981. High-quality book publications have been a major goal of Mark's involvement with defined subcultures in society for almost three decades. Featured among these are teenage drug users in Seattle, women in a mental hospital, prostitutes in India, Mother Teresa, circus performers, and more recently, sets of identical twins (using Polaroid 20 × 24). A characteristic of Mark's considerable talent is her ability to form a trusting relationship with her

FIG. 56 Tiny Seattle, 1983. Gelatin silver print. Mary Ellen Mark. (Courtesy of George Eastman House Collection, Rochester, New York.)

subjects to provide viewers with a compassionate, first-person encounter—almost as if Mark is a surrogate for the general public who would never otherwise have such privileged access to these vital human dramas. The emotions and intellects that Mark has affected with her photographic oeuvre is truly one of the outstanding contributions to the history of the medium.

Publications
Fulton, M. (1991). *Mary Ellen Mark: 25 Years*. Boston: Bulfinch Press.
Hagen, C. (2001). *Mary Ellen Mark*. London: Phaidon Press.
Mark, M. E. (2003). *Twins*. New York: Aperture.
Mark, M. E. (1993). *Indian Circus*. San Francisco: Chronicle Books.
Mark, M. E. (1988, 1991). *Streetwise*. Philadelphia: University of Pennsylvania Press [reprinted by Aperture, 1991].
Mark, M. E. (1981). *Falkland Road: Prostitutes of Bombay*. New York: Knopf.
Mark, M. E. *Ward 81*. Text by K. Jacobs. New York: Simon & Schuster.

McBEAN, ANGUS (1904–1990) Welsh

Born in South Wales, McBean studied architecture before settling for a banking clerk's job. By 1925 family circumstances forced him to move to London where he worked for a prominent antiques dealer for seven years (sales and restoration). He learned photography from Hugh Cecil and began constructing and photographing masks. This series of events lead to McBean's eventual talent as one of the world's leading theatrical photographers. He is best known for his work constructing elaborate studio sets, mask making, costuming, manipulation techniques— all to produce personality and stage production images that have a very surreal look—almost like photographic versions of a Salvador Dali landscape. He photographed stage versions of McBeth sixteen times in four decades. Noted celebrity subjects include Audrey Hepburn, Paul Scofield, Lawrence Olivier, and Vivian Leigh (the later photographed by McBean dozens of times over thirty years). Many of McBean's photographs are stark illusions and startling depictions of lifelike heads and torsos, pieces of classical architecture, emerging from a sandy wasteland. Later in his career he photographed the Beatles for 1963 and 1970 album covers, and did color fashions for *Vogue* in the mid-1980s. His annual Christmas card creations, sent to friends since 1936, have become a valuable auction item. In 1968 Harvard University purchased all of his theater negatives—48,000 images weighing four and a half tons.

Publications
McBean, A. (1982). *Angus McBean*. Text by A. Woodhouse. Foreword by [Lord] Snowdon. London: Quartet Books.

MCCULLIN, DON (1935) British

McCullin studied painting for two years before joining the Royal Air Force in 1954 where he became a photo assistant for aerial reconnaissance. By 1959 he began reportage with his camera and had pictures of a London youth gang published in *The Observer*. He won acclaim for 1961 images of the building of the Berlin Wall. As a conscientious believer in the power of photography to effect change, McCullin decided to try to curtail war and brutality by documenting conflict to reveal the true horror of violence. He covered the war in Cyprus in 1964 and later the Vietnam War (graphic images of the Tet offensive of 1968). He has been on the front lines of wars and human disasters (famine, genocide) around the world—Congo, Israel, Biafra, Cambodia, Lebanon, Pakistan, Northern Ireland, and India. For a time he was a member of Magnum. Book publications include *The Destruction Business* (1971) also published in the United States as *Is Anyone Taking Any Notice?* (1973). After many years on staff with *The Sunday Times* he went back to freelance assignments in 1985. In the early 1990s he had gone into seclusion in England, trying to force himself to make more lyrical "art" photographs of still life and landscape, often utilizing antique photo processes. Self-assessment of this activity as a nonfulfilling pursuit brought him back to the forefront of social activism. Since 2000 he has worked in Africa for the Christian Aid Society and has been active in AIDS awareness campaigns.

Publications

McCullin, D. (2005). *Don McCullin in Africa.* London: Jonathan Cape.

McCullin, D. (2001). *Don McCullin.* London: Jonathan Cape.

McCullin, D. (1992). *Unreasonable Behaviour.* New York: Knopf.

McCullin, D. (1980). *Don McCullin: Hearts of Darkness.* Introduction by J. LeCarré. London: Random House.

MEATYARD, RALPLH EUGENE (1925–1972) American

Born in Illinois, Meatyard attended Williams College on the Navy V-12 program. He became a licensed optician in 1949 after working for Dow Optical in Chicago. Moved to Lexington, Kentucky, for an optician job, became interested in photography, and sought out Van Deren Coke as a teacher/mentor; bought twin lens reflex in 1950. He also studied with Minor White but thought of himself as a "primitive" photographer. Meatyard's photographic work is primarily square, black and white images of children and anonymous figures wearing Halloween masks in rural fields, abandoned structures, or barns. He often experimented with movement of one or more human subjects producing enigmatic blurred features. The work creates macabre overtones with doll images and nightmare juxtapositions of innocence (children) and potential danger. Many critics have interpreted elements in Meatyard's photographs as metaphors for death and decay. He was influenced by literary sources, especially in his final work, *The Family Album of Lucybelle Crater*, published posthumously in 1974 after his untimely death. The names of characters in the photographs in this series were derived from *The Life You Save May Be Your Own*, a short story about an old Southern lady written by Flannery O'Connor. Meatyard's work appeared in print in the early 1970s just as university art programs in the United States began to experience a growing trend in creative photography; this, and the appeal of a psychological dimension, may explain the longevity of this man's influence.

Publications

Coke, V. D. (1976). *Ralph Eugene Meatyard: A Retrospective.* Normal, IL: Center for Visual Arts, Illinois State University.

Meatyard, R. E. (2004). *Ralph Eugene Meatyard.* Essay by G. Davenport. New York: ICP.

Tannenbaum, B. (1991). *Ralph Eugene Meatyard: An American Visionary.* Akron: OH: Akron Art Museum.

MEISELAS, SUSAN (1948) American

Meiselas has a BA degree (1970) in anthropology from Sarah Lawrence College and an MA in education from Harvard where she took her first photography course in 1971. She consulted with Polaroid Corporation on strategies for visual education in the nation's classrooms. Her earliest documentary book, *Carnival Strippers* (1976), is distinguished by her method of obtaining many of the images— she disguised herself as a man to gain entry to strip shows with her concealed camera. As a gatherer of "fact," she also made behind-the-scene images and sound recordings of women strippers she interviewed. Much of her career has been marked by involvement with the cultures and conflicts in Central America, particularly Nicaragua. Due to her tenacity and resourcefulness, she produced (and later published) an incredible record of civil war in Nicaragua (1978–1979) after determining that she needed to put herself in jeopardy in order to make the most

FIG. 57 Awaiting Counterattack by the Guard, Matagalpa, 1978. Color print, chromogenic development (Ektacolor) process printed 1985. National Origin: Nicaragua. Susan Meiselas, Magnum Photos. (Courtesy of George Eastman House Collection, Rochester, New York.)

compelling photographs. When she arrived alone in Managua she had little equipment, no press credentials, and could barely speak Spanish. She later documented civil strife in El Salvador, risking her life in areas where the government had banned all journalists. Her color photography documenting civil unrest is not so much a recording of "war" as it is a multi-layered view of a people's struggle to define and preserve their culture, religion, and methods of government. Meiselas has been a member of Magnum since 1976 and has had work published in *Time*, *Life*, *The New York Times*, *GEO*, and *Paris Match* among many other titles. She recently has documented events and peoples in Kurdistan and New Guinea.

Publications

Meiselas, S. (2001). *Pandora's Box*. London and New York: Trebruk.

Meiselas, S. (1981). *Nicaragua From June 1978–July 1979*. New York: Pantheon.

Meiselas, S. (1997). *Kurdistan: In the Shadow of History*. New York: Random House.

METZKER, RAY (1931) American

Metzker received his MS degree from the Illinois Institute of Technology in 1959 where he studied with Harry Callahan and Aaron Siskind. Prior to that he graduated from Beloit College and had begun photographing at the age of fourteen. His innovative contribution to creative photography in the 1960s was making large composites of still images. Assemblages of 50 or more prints measured 4 × 5 feet; the photographs, usually of banal urban scenes, would have slight alterations between them but from a distance the mosaic became a pattern of shapes. The rows and columns formed a synthesis that might resemble sheet music or an industrial form like a manifold or metallic grid. In fact, Metzker had written in his journals that as a young artist he worked with kinetic sculptures influenced by music and flux—percussion patterns that manifest themselves in his abstract compositions. The photographs are fragments linked by juxtaposition in a cumulative regimen that could be inspected one image (photographic print) at a time and, at least in theory, they form a cinematic chronology without the need for actors or any implied drama. Another theme of Metzker's (Sand Creatures, 1979) was photographs made at Atlantic City of random sunbathers sprawled out on the beach (taken from a slight aerial position). The contrast patterns of shadow and highlight, bathing suit and flesh, created a similar rhythm of formal design, but not as syncopated as the mosaic murals. A later series, Pictus Interruptus, included out-of-focus objects held up in front of the camera lens partially obscuring the scene. Recent images by Metzker have come from the organic landscape. Metzker has taught at the Philadelphia College of Art for four decades.

Publications

Tucker, A. W. (1984). *Unknown Territory: Photographs by Ray Metzker*. Houston: New York: Aperture.

Turner, E. H. (2000). *Ray K. Metzker: Landscapes*. New York: Aperture.

MEYEROWITZ, JOEL (1938) American

Meyerowitz enjoys a reputation as one of the most successful photographers to begin using large-format color materials in the 1970s when black and white was the palette of serious artists. Born in New York, Meyerowitz earned a degree in medical illustration and painting from Ohio State in 1959 and eventually took a job as an advertising art director. As part of his art directing job one day he had to accompany Robert Frank on a location shoot. Meyerowitz says his life changed completely after that (1963). He began using color slide film and then

FIG. 58 Couple holding hands, ca. 1964–1966. Gelatin silver print. Joel Meyerowitz. (Courtesy of George Eastman House Collection, Rochester, New York.)

black and white film to make "street photographs" (other influences were Cartier-Bresson and Winogrand). His rapid assimilation of many photographic techniques led him to purchase an 8 × 10 Deardorff that was exactly as old as he was. His first award-winning book, *Cape Light* (1978), included photographs that captured the essence of light and the nuance of color at the cape where sky meets water and sand seen through misty hues (at f/90 and 1/2 second). Meyerowitz' other work includes lyrical views of St. Louis near the Arch, redheads at the cape, flowers, and work from Tuscany. Meyerowitz lives in lower Manhattan; on 9/11/2001 he was away from the city. When he was able to return to Manhattan, he took it upon himself to be the photographer for posterity's views of Ground Zero and the long progress of recovery and renewal. His story of how he got exclusive access to the site of the former World Trade Center buildings should accompany his poignantly bittersweet photo-essay. The U.S. State Department has already circulated dozens of his complete exhibitions on this subject to tour the world. Meyerowitz has also co-edited a ponderous book on the history of street photography.

Publications
Meyerowitz, J. (2003). *Tuscany: Inside the Light*. Text by M. Barrett. Boston: Bulfinch Press.
Meyerowitz, J. (1996). *At The Water's Edge*. Boston: Bulfinch Press.
Meyerowitz, J. (1990). *Redheads*. New York: Rizzoli.
Meyerowitz, J. (1983). *Wild Flowers*. Boston: New Graphic Society.
Meyerowitz, J. (1980). *St. Louis and the Arch*. Boston: Bulfinch Press.
Westerbeck, C. (2005). *Joel Meyerowitz*. New York: Phaidon Press.

MICHALS, DUANE (1932) American

As a child, Michals, born near Pittsburgh, liked to draw and to look at picture books in the local library. He went to the University of Denver to study art (BA, 1953) and soon was employed as a paste-up artist (*Look* magazine) and art director. He borrowed a camera to take on a trip to the USSR in 1958 and returned with a desire to change his career to photography. He was self-taught in darkroom rudiments and by 1966 began work on sequences of tableaux scenes that have become his signature contribution to creative photography. Strongly influenced by artists Magritte and Balthus, Michals uses simple interiors, a few actors (often himself), sparse props, and a psychological precept to create a dream-like sequence told in the space of three to ten images. Since the mid-1970s, handwritten text endorses the surreal drama to validate memories and aspects of our own dreams or premonitions about the mystery of relationships, metaphysics, or the afterlife. One of Michals' most popular sequences is "Things Are Queer" (1973)—a visual illusion of scale and presumed chronology which is turned inside-out in ten short steps. Much of Michals' work uses mirror reflections, double-exposure, blur, and the simple construct of suggestion to move the viewer through a paradoxical interpretation about the artist's favorite themes—sex, mortality, and spirituality. Parallel success as a commercial photographer has brought Michals a highly lucrative career in published portraiture and fashion (*Vogue, Mademoiselle, Esquire, The New York Times*). With a bare economy of production, no digital manipulation, and a potent respect for the human imagination, Michals remains one of the most influential artists for current generations of photographers.

Publications
Livingstone, M. (1997). *The Essential Duane Michals*. Boston: Thames & Hudson.
Michals, D. (1990). *Duane Michals: Now Becoming Then*. Essay by M. Kozloff. Altadena, CA: Twin Palms Publishing.
Michals, D. (1988). *Album: The Portraits of Duane Michals: 1958–1988*. Pasadena, CA: Twelvetrees.
Michals, D. (1986). *The Nature of Desire*. Pasadena, CA: Twelvetrees.
Michals, D. (1976). *Real Dreams: Photostories by Duane Michals*. Danbury, NH: Matrix Publishers.
Michals, D. (1970). *Sequences*. New York: Doubleday.

MILLER, LEE (1907–1977) American photographer and model

Born ("Elizabeth") in Poughkeepsie, New York, Miller drew much inspiration from her father, an avid photographer and inventor. After modeling for Steichen and Horst, she moved to Paris and became a model and assistant (and lover) to Man Ray (1929–1932) where she learned the technical craft and became an accomplished photographer of the avant-garde circle. She opened her own New York studio in 1932 and was successful in advertising, fashion, and portraits, eventually working solely for *Vogue*. Married an Egyptian, Aziz Bey, and moved to Cairo (1934), but that relationship dissolved and she moved to England and married (1947) the author and prominent art collector, Roland Penrose. During WWII she served as a U.S. Army war correspondent. After some documentary work for *Vogue* about the war's effects on England, she boldly got herself transported just behind the Allied lines near the Normandy beaches. Miller was one of the first to enter and photograph the German concentration camps of Buchenwald and Dachau. Later she lived in Hitler's Munich apartment and was photographed bathing in Hitler's bathtub (photo by partner, D. Scherman). After 1945 her life was enriched by the comings and goings of the art elite at the Penrose estate in East Sussex. Miller accumulated over 1000 negatives of Picasso over 20 years. Her career, documented in several biographies, was fast paced and certainly, through a combination of myth and truth, one of the most fascinating in 20th century photography.

Publications

Burke, C. (2005). *Lee Miller: A Life*. New York: Knopf.
Calvocoressi, R. (2002). *Portraits from a Life: Lee Miller*. New York: Thames & Hudson.
Livingston, J. (1989). *Lee Miller, Photographer*. New York: Thames & Hudson.
Penrose, A. (1992). *Lee Miller's War: Photographer and Correspondent with the Allies in Europe 1944–1945*. Edited by A. Penrose. Boston: Bulfinch Press.
Penrose, A. (1985). *Lives of Lee Miller*. New York: Holt, Rinehart & Winston [biography].

MISRACH, RICHARD (1949) American

Native of California, Misrach earned a BA in psychology from University of California-Berkeley (1971) and was self-taught in photography. His early work was of street people who lived near the Berkeley campus, but by the early 1980s, he shifted his focus to the Southwest deserts lying beyond the Pacific coastal range. Night flash exposures of cactus were prominent in their toned, aesthetic appeal, but Misrach's mature work has evolved into a series of "cantos" (more than 20), which address complex issues of environment, pollution, and the notion of "beauty." The 18th century philosopher, Burke, could have written his essay on "The Beautiful and the Sublime" by seeing only Misrach's photographs. His landscape studies are sensory, precise records of the past, present, and future of American deserts littered with the remnants of human toil and discard—atomic craters, animal carcasses, tourist detritus, huts, bomb casings, toxic waste, and other archaeological debris. The cantos are given numbers and brief descriptions: Canto XVII: The Skies (The Flood, The Fire, The Pit). There is mixed optimism and apprehension in his oeuvre; amid the crystal atmosphere of a clichéd paradise we see the Space Shuttle, a distant freight train, and sun-gilded mountains. Misrach continues to explore and distill his experiences watching the desert, pointing out clues, sounding the alarm. His seductive perfection (with the camera and in his control over award-winning printed books) has an undertone of our mortal fear—toxic contamination, infection, destruction by fire or

FIG. 59 Desert Fire #42, 1982. Color print, chromogenic development (Ektacolor) process. Richard Misrach. (Courtesy of George Eastman House Collection Rochester, New York.)

submersion in a catastrophic flood (if the bombs don't kill us first). Recently he has expanded his sentry territory to areas around the Mississippi River in Louisiana (prior to Katrina).

Publications
Misrach, R. (2000). *The Sky Book*. Santa Fe, NM: Arena Editions.
Misrach, R. (1992). *Violent Legacies; Three Cantos*. New York: Aperture.
Misrach, R. (1990). *Bravo 20: The Bombing of the American West*. Baltimore: Johns Hopkins University Press.
Misrach, R. (1987). *Desert Cantos*. Albuquerque, NM: University of New Mexico Press.
Misrach, R. (1979). *A Photographic Book*. San Francisco: Grapestake Gallery.
Tucker, A. W. (1996). *Crimes and Splendors: The Desert Cantos of Richard Misrach*. Boston: Bulfinch Press.

MODEL, LISETTE (1906–1983) American photographer and educator
Born to affluence in Austria, Model studied music and voice, had private tutors and learned photography as a practical skill (introduced to the medium by her sister, Olga). Moved to Paris (1922–1937); first significant photographs were of tourists at the French Riviera in Nice. Emigrated to New York (1937) where her camera work was encouraged by Brodovitch and Beaumont Newhall, garnering her commercial assignments as well as exhibition venues. She sought out the support of the Photo League and became an active member (investigated by the FBI in 1954 for leftist leanings). She is primarily known for her black and white candid street portraits, unsuspecting subjects captured in a revealing pose and attitude, sometimes in a slightly offset or askew frame. In America, her favorite subjects were people at Coney Island and the Lower East Side. Many images have a slightly "grotesque" aspect partly due to Model's selection of bodies and physiognomy and partly to cropping and high-contrast lighting. Freelance assignments were published in *Look*, *Harper's Bazaar*, *PM Weekly*, and *Ladies Home Journal*. Her considerable influence extended through the university as she taught photography at New School for Social Research, New York, from 1950 until her death. Prominent students included Robert Frank, Diane Arbus, and Larry Fink.

Publications
Model, L. (1979). *Lisette Model*. Millerton, NY: Aperture.
Thomas, A. (1990). *Lisette Model*. Ottawa: National Gallery of Canada.

MOHOLY-NAGY, LASZLO (1895–1946) Hungarian photographer, filmmaker, teacher, painter
Moholy-Nagy was one of the 20th century's most influential creative intellects and theoreticians. He set new goals for all of the visual arts, promoting photography not as a picture-making medium, but as a method of experimentation for learning. He was a professor from 1923 to 1928 at the Bauhaus, the highly influential German school of art and design founded in 1919 by Walter Gropius. Moholy-Nagy had started his adult life studying law. After being wounded and held as a POW during WWI, the revolutionary art movement, MA, in Hungary got his attention. He then absorbed energy from the new Dadaist and Constructivist art he witnessed

FIG. 60 Sailing, 1928. Gelatin silver print. Laszlo Moholy-Nagy. (Courtesy of George Eastman House Collection, Rochester, New York.)

when he moved to Berlin. By 1922 he was making photograms and photomontage ("fotoplastik") with his artist-wife, Lucia Schultz Moholy (she gets half credit for these innovations as well as doing the darkroom work). When he was hired at the Bauhaus, Moholy-Nagy was in charge of the foundation year. He made all students make photograms and "light space modulators" which they had to photograph in variable lighting. "Light" was the magic catalyst in art he preached. His own work also included photographs made from unusual angles, negative images, and films. One of several books he wrote endorsed Neue Sehen (New Vision)— *Malerei, Fotografie, Film* (*Painting, Photography, Film*) published in 1925. He fled Germany when the Nazis took control and eventually came to Chicago where he was appointed Director of the New Bauhaus in 1937. A year later he created the Institute of Design in Chicago and taught there until his death.

Publications
Haus, A. (1980). *Moholy-Nagy: Photographs and Photograms*. New York: Pantheon.
High, E. M. (1985). *Moholy-Nagy: Photography and Film in Weimar Germany*. Wellesley, MA: Wellesley College Museum.
Kostelanetz, R. (1970). *Moholy-Nagy*. New York: Da Capo Press.
Moholy-Nagy, L. (1995). *In Focus: Laszlo Moholy-Nagy Photographs from the J. Paul Getty Museum*. Edited by K. Ware. Los Angeles: J. Paul Getty Museum.
Passuth, K. (1985). *Moholy-Nagy*. New York: Thomas & Hudson.

MORGAN, BARBARA BROOKS (1900–1992) American photographer and painter
Born in Kansas, Morgan studied art at UCLA and taught there from 1925 to 1930. She had decided at age four to become an artist. When she married photographer Willard Morgan they moved to New York and she continued her abstract painting until the birth of two sons. Having met Edward Weston in 1925, Morgan already knew that photography could be a potent art form, and with encouragement from her husband, she began making photographs. With a camera she could explore the rhythms of nature that she had learned about from her father as a little girl (that all things are made of moving, dancing atoms). Her most famous work soon followed; the dance movement photographs of Martha Graham. Morgan had said that dance was a "combustion" of energy and she felt challenged to capture this on film. Letter to the World—Kick (1940) is her triumph (Graham interpreting the life of Emily Dickinson). For ten years until 1945, Morgan documented the genesis of modern dance in America, dramatically capturing for posterity the graceful and athletic movements of Graham, Merce Cunningham, Charles Weidman, and Josè Limòn. Morgan was also a pioneer in her use of photomontage and moving light abstraction. Portraits and nature subjects also were found in her portfolio. She was a founding member of the Photo League (1937) and of the influential quarterly, *Aperture* (1952). She was co-owner, with her husband, of the photographic publishing house Morgan & Morgan, Scarsdale/Dobbs Ferry, New York (1935–1972).

Publications
Carter, C. (1988). *Barbara Morgan: Prints, Drawings, Watercolors & Photographs*. Dobbs Ferry, NY: Morgan & Morgan.
Morgan, B. (1980). *Barbara Morgan: Photomontage*. Dobbs Ferry, NY: Morgan & Morgan.
Morgan, B. (1972). *Barbara Morgan*. Dobbs Ferry, NY: Morgan & Morgan.
Morgan, B. (1964). *Barbara Morgan: Monograph. Aperture* issue #11.
Morgan, B. (1951). *Summer's Children: A Photographic Circle of Life at Camp*. Dobbs Ferry, NY: Morgan & Morgan.
Morgan, B. (1941, 1980). *Martha Graham: Sixteen Dances in Photographs*. Dobbs Ferry, NY: Morgan & Morgan [reprinted 1980].

MORIMURA, YASUMASA (1951) Japanese
Morimura has risen to fame as an artist featured in the 1988 Venice Biennale. Since 1990 his self-portraits combine complex tableaux and computer manipulation to allow him to

occupy the space of the main subjects in re-created famous paintings by Van Gogh, Manet, Rembrandt, Goya, Kahlo, and others. He has a BA degree in painting (1978) from Kyoto City University of Arts. As a child growing up in Osaka, Morimura states he learned about art history in school by seeing reproductions of famous Western masterpieces (oriental art was not emphasized). By using reproductions of famous Western paintings, changing gender roles (commonplace in traditional Japanese kabuki theatre), and restaging the painted scenes, Morimura is considered by some to be in tune with the post-modern critique of stereotypes, patrimony, and media saturation. Others find a complex yin/yang duality or racial re-identity in the substitution of previously painted subjects with an Asian face and a slim male physique. Still others find unabashed humor and delight at the props and costumes that the artist has constructed for the photograph. In assuming various roles for his camera, Morimura undergoes extensive transformation with make-up and clay augmentation to his face and body. His self-conscious display is a literal performance that goes beyond Duchamp's creation of "Rose Selavy" as the latter's alter ego. Morimura's most recent work is assembled from many studio stills (he plays all the parts in multi-figure compositions). Comparisons to the work of Cindy Sherman are frequent. Besides Western art history themes, Morimura has also made photographs of himself transformed into feminine idols (Monroe, Bardot, Minnelli). It is unusual to find vetted photographic art that is humorous, sardonic, entertaining, and perplexingly intricate all at the same time.

Publications

Morimura, Y. (2003). *Daughter of Art History: Photographs by Yasumasa Morimura.* Introduction by D. Kuspit. New York: Aperture.

MORTENSEN, WILLIAM (1897–1965) American photographer, teacher, and author

Mortensen, born in Utah, lived in Southern California and became the outspoken leader of the pictorialist movement in the United States during the 1930s. His photography consisted of Hollywood film stills, portraits of noted actors/actresses, and his personal art, and aggressively manipulated images of mythological, historical, and literary characters. He carried on an intense debate in camera periodicals (1930s) with Ansel Adams over contentious principles of Pictorialism vs. "straight" photography (the latter personified by Group f/64). As an unjust consequence for his stubborn defense of more romantic theories for photography, Mortensen was essentially ostracized from most authoritative canons of photographic history—especially those authored by Adams' good friends, Beaumont and Nancy Newhall. Renewed interest and respect for Mortensen, his work and writings, has been courageously led by the critic A. D. Coleman (see his essay and others in *William Mortensen: A Revival*, 1998). Mortensen perfected his metal-chrome process (bromoil derived) and pattern screen methods for modifying photographic prints, as well as publishing many books on abrasive-tone monoprints and technical hints on lighting, models, costumes, and darkroom modifications. His portrait subjects include Fay Wray, Jeanne Crain Lon Chaney, Clara Bow, John Barrymore, Jean Harlow, and George Dunham (his collaborator and favorite model). In 1932 he founded the William Mortensen School of Photography, Laguna Beach, California, and one of his students was Rock Hudson. Many contemporary critics and scholars point out the example of Mortensen's portrait style as a validated antecedent when considering the acclaimed praise and popularity of the manipulated images of Cindy Sherman and Yasumasa Morimura.

Publications

Mortensen, W. (1936, 1973). *Monsters and Madonnas.* San Francisco: Camera Craft Publishing [reprinted 1973].

Mortensen, W. (1937). *The Command to Look: A Formula for Picture Success.* San Francisco: Camera Craft Publishing.

Mortensen, W. (1937). *The Model: A Book on the Problems of Posing.* San Francisco: Camera Craft Publishing.

NACHTWEY, JAMES (1948) American

The title of Nachtwey's recent book, *Inferno* (1999), symbolizes not only the super-heated, destructive nature of the Hellish world events he has documented, it also asks his viewers for a pronouncement of guilt against the sins of sinister forces that destroy humanity and thrive outside the moral boundaries of common decency. In a way, Nachtwey's own career as a universally celebrated photojournalist has "caught fire" and has propelled his imagery into the forefront of the world's news and print media. Born in Syracuse, New York, educated at Dartmouth, Nachtwey learned the rudiments of newspaper photography in Albuquerque, New Mexico. He quickly rose to the top of documentary talents with membership in Black Starr (1981), Magnum (1986–2000), and more recently with Agency VII. He is on staff with *Time* magazine. He has traveled the world wherever hot spots are ignited by war, revolution, genocide, or mass famine—Belfast, Afghanistan, El Salvador, Bosnia, Rwanda, Sudan, Somalia, and Romania. He is the recipient of four Robert Capa gold medals, the Leica Medal, and the W. Eugene Smith award. His cumulative work is unquestioningly the ultimate visual summary of the worst unspeakable acts occurring in the last two decades. His dedication, not unlike many genuine photojournalists, puts him so close to the action he needs to use wide-angle lenses on his cameras. *Inferno* contains a brutal look at the savagery of the slaughter of Tutsis by the Hutus—pictures that Nachtwey hopes he will never have to replicate in another time and place. His desire is to compel world consciousness to undertake social and political action to prevent these kinds of horrors.

Publications

Nachtwey, J. (1999). *Inferno*. London: Phaidon Press.

Nachtwey, J. (1989). *Deeds of War*. New York: Random House.

NETTLES, BEA (1946) American

Nettles spent the first twenty years of her life in Florida—a fact that has motivated and influenced much of her personal art and self-published books, although the true inspiration for her has been her family and experiences as a daughter, wife, and mother. Nettles got her degree (BFA, 1968) at the University of Florida, working with Robert Fichter and Uelsmann (but majoring in painting/printmaking). Her MFA degree from the University of Illinois, Champaign-Urbana (where she has taught since 1984), was more photographic with mixed media. She has said her work is about "themes of loss and hope" (Tucker, *The Woman's Eye*, 1973). Many titles of books and series also reveal a sense of humor and we might assume that hope wins out in the end. For almost four decades she has used snapshots, plastic camera images, alternative processes, the physicality of mirrors, plastic, thread, and fabric to construct art objects. Nettles' work was selected by Peter Bunnell to be in an influential exhibit at the Museum of Modern Art (MoMA), Photography Into Sculpture in 1970. When she began teaching in Rochester, New York, in the 1970s, she produced many modest books (privately published by Inky Press). The first of these was *Events in the Water* (1973). In most of her work, usually accompanied by suggestive titles, Nettles has made use of family snapshots, self-portraits, and references to the stages of the life cycle to create metaphors and designate archetypal vehicles for her view of what really matters. Her reputation in the field is generally acknowledged to be equally important as an educator at Rochester Institute of Technology (1976–1984) and at the University of Illinois. She has also published a technical "recipe" book on alternative photographic processes.

Publications

Nettles, B. (1997). *Memory Loss: Bea Nettles*. Urbana, IL: Inky Press.

Nettles, B. (1990). *Life's Lessons: A Mother's Journal*. Norfolk, VA: Prairie Books Art Center.

Nettles, B. (1979). *Flamingo In The Dark: Images by Bea Nettles*. Rochester, NY: Inky Press.

Nettles, B. (1977). *Breaking the Rules: A Photo Media Cookbook*. Rochester, NY: Inky Press.

NEWMAN, ARNOLD (1918–2006) American

Born in New York, Newman might have become a painter but for the fact that his family's finances from several ocean-side hotels evaporated in 1938 while he was studying art at the

University of Miami. As compensation for disrupted academic study, Newman accepted work with a family friend who ran a chain of cheap, mass production portrait studios (Perskie's in Philadelphia area department stores). For about a year, Newman makes 49 cent portraits, toils in the darkroom but becomes encouraged by his vision for meaningful photographs. By 1940 Newman adopts the camera as his artist's tool and makes portraits (especially artists), abstractions, and social documentation. In 1946 he is in New York and begins freelance assignments for *Harper's Bazaar* and *Life*. His most famous image is a 1946 portrait of Igor Stravinsky in the extreme lower left corner of a graphic space dominated by the silhouette lid of his piano—ironically, rejected for publication by Brodovitch for *Harper's Bazaar*. During the next half century, Newman's portraits established the high water mark for "environmental portraiture." The highest echelon of these groups—artists, presidents, corporate

FIG. 61 Arnold Newman. Photograph by Nancy M. Stuart, 1996.

leaders, musicians, authors—have been the subjects of Newman compositions (most in black and white) that place the personality in a dynamic equilibrium with that person's tools, creations, symbols, or work space. Max Ernst sits in a high-back, ornate throne next to a kachina, his head wrapped in surreal curls of smoke; Mondrian is amid a geometric grid of his canvases and an easel. Shooting 24 covers for *Life*, Newman's work has also appeared in *Fortune, Look, Holiday, Esquire, Town and Country*, and *The New Yorker*. A recent monograph, *Arnold Newman* (Taschen, 2000), is a comprehensive survey of Newman's photographic oeuvre with biographical essays, a chronology, and extensive bibliography.

Publications
Fern, A. M. (1992). *Arnold Newman's Americans*. Boston: Bulfinch Press.
Newman, A. (1986). *Arnold Newman: Five Decades*. San Diego: Harcourt Brace Jovanovich.
Newman, A. (1979). *The Great British*. London: Weidenfeld & Nicolson.
Newman, A. (1974). *One Mind's Eye, The Portraits and Other Photographs of Arnold Newman*. Boston: David R. Godine.

NEWTON, HELMUT (1920–2004) Australian
Born (H. Neustaedter) in Berlin, Newton bought a box camera when he was twelve; schoolwork was replaced by photography of many girlfriends and he was expelled from two schools. Self-taught in some aspects, he apprenticed with Yva (Else Simon), a fashion/portrait photographer until Newman's parents insisted he leave Germany as the Nazi menace grew. He wound up in Singapore then became an Australian citizen (served 1940–1945 in the Australian military). He married June Brunell (a.k.a. Alice Springs) in 1948. His career took off when he returned to Europe in the late 1950s. He was on staff at *Vogue* for many years as his daring fashion work became more charged with erotic tension and voyeurism. His work was seen in *Elle, Stern, Playboy, Nova*, and *Queen*. His fashion images are noted for their depiction of somewhat aloof, domineering models that exude an aggressive power. His sets were not studios; Newman preferred fin-de-siecle hotel staircases, luxury apartments, lavish estates, and castles as backdrops for dramatic scenes that were fraught with jet set accessories and suppressed desire. His work, never understated, drew sharp criticism from a growing cadre of critics—both male and female—that denounced the images as abusive and degrading to women, promoting S & M behavior, and

nothing more than soft porn. Many Newton books were published that showcased images that had not appeared in the American media—photographs that broadly hinted at lesbianism, bondage, and fetish attraction. He died in an automobile accident in Hollywood in 2004.

Publications

Newton, H. (2002). *Helmut Newton: Autobiography*. New York: Nan A. Talese.

Newton. H. (2000). *Sumo*. Cologne: Taschen.

Newton. H. (1981). *Big Nudes*. Text by K. Lagerfeld. Paris: Xavier Moreau Inc.

Newton, H. (1978). *Sleepless Nights*. Munich: Schiermer/Mosel/Verlag GmbH.

Newton, H. (1976). *White Women*. London: Quartet Books.

NILSSON, LENNART (1922) Swedish

Known worldwide as a pioneer biomedical photographer, Nilsson was the first to photograph the growth of a live fetus inside the womb. Born near Stockholm, he never formally studied science or medicine, but by age five had a collection of local flora and fauna. He got a camera when he was 12 and became a press photographer in the 1940s. Some early images of workers resemble the documentary style of Farm Security Administration (FSA) photographers in the United States. He completed an in-depth photo-essay about the Salvation Army in Sweden. His work shifted to close-up magnifications; ants became the subject of his first book in 1959. In 1965 he published *A Child is Born*, which showcased his work photographing the growth of the human

FIG. 62 Lennart Nilsson, 2003. Jacob Forsell, Stockholm, Sweden.

embryo inside the mother's womb using special lenses with fiber-optic lights. One notable image of a human fetus was featured on the cover of *LIFE* April 30, 1965—the issue sold out—eight million copies in four days. He continued on staff at *Life* for seven years doing picture stories on polar bears and Ingmar Bergman, among others. His other remarkable accomplishments are images of the body (inside the beating heart during surgery, first photograph of an image registered on the human retina). More recently he has used scanning electron microscopes to photograph the fertilization of a human ovum by a single sperm and the first images of the isolated HIV virus. Although he never received proper credit in books on the history of photography, he has been honored to have his embryo images sent out into the universe aboard NASA's Voyager I and II spacecrafts.

Publications

Nilsson, L. (2002). *Lennart Nilsson: Images of His Life*. Jacob Forsell, ed., Stockholm: Bokförlaget Max Ström.

Nilsson, L. (1987). *The Body Victorious: The Illustrated Story of our Immune System*. New York: Delacorte Press.

Nilsson, L. (1966, 1971). *A Child is Born: The Drama of Life Before Birth*. New York: Delacorte Press (reprint 1971).

NIXON, NICHOLAS (1947) American

Born in Detroit, Nixon received his BA in American literature (University of Michigan) and his MFA in 1974 (University of New Mexico). His early photography was of architecture and city views; he was one of the artists featured in the important 1975 exhibition, New Topographics, at the George Eastman House. Since then his photography has been almost exclusively of

people, most made with an 8 × 10 view camera (Pictures of People, 1988). A concern for social issues was underwritten by his volunteer work for VISTA in St. Louis before he started graduate school. Nixon's choice of image groupings, often measured out in one year assignments, has included children and adults shown in the semi-public space of the "front porch," his wife, Bebe and her three sisters (The Brown Sisters, 1999), school pupils, and people with AIDS. His carefully controlled photograph situations, which still allow a surprising degree of spontaneity from subjects, is generated by the photographer's immense respect for his subjects and a keen intuition for visual density and detail. His AIDS documentation (exhibition at the Museum of Modern Art and book with text by Bebe Nixon, 1991) created public discord and controversy; in no way due to the photographer's lack of sensitivity, talent, or ethical standards. Most recently, Nixon has been photographing couples posed in intimate contexts, and people out and about in the Boston Public Gardens. Another recent project has been the documentation of his son's sixth grade class in the unfolding events of a typical year in public school.

Publications

Nixon, N. (1983). *Nicholas Nixon: Photographs from One Year*. Carmel, CA: Friends of Photography Bookstore.

Nixon, N. (1991). *People With AIDS: Photographs by Nicholas Nixon*. Text by B. Nixon. Boston: David R. Godine.

Nixon. N. (1998). *School: Photographs from Three Schools*. Essay by R. Coles. New York: Bulfinch Press/Little, Brown.

OUTERBRIDGE, PAUL, JR. (1896–1958) American

Trained in sculpture, illustration, and theater design, Outerbridge quickly switched allegiance to photography after service in the Canadian Royal Air Corps and a job photographing airplane parts in Oregon. In 1921 he enrolled in the Clarence White School in New York. Within a few years he was teaching aesthetics and composition there. By 1924 he did commissions for *Vanity Fair*, *Harper's Bazaar*, and *Vogue*. While in Paris (1925–1929) as art director of *Paris Vogue*, he was embraced by the group of avant-garde artists that included Duchamp, Dali, Picabia, and Man Ray. He returned to the United States in 1929 and continued as a popular commercial photographer for his usual magazine clients now including *House Beautiful*. During the 1920s and 1930s his platinum prints were mostly done in the studio and were characterized by bold composition, a concern for volume, line, and abstraction that were, as he stated, "devoid of sentimental association." His technical skill was unrivaled in the unique production of tri-color carbro prints; this process and his philosophy were described in his book, *Photography In Color* (1940). Later in his life he moved to Laguna Beach, California, and traveled extensively. After WWII his more provocative 1930s color work with the female nude gradually became known. This work, held in his private collection, revealed more Freudian preoccupations with sexual fetishism, decadence, and erotic surrealism.

Publications

Howe, G. (1980). *Paul Outerbridge, Jr., Photographs*. New York: Rizzoli (reprinted from a smaller 1976 exhibition catalog).

PARKER, OLIVIA (1941) American

Educated at Wellesley in art history (BA, 1963), Parker was self-taught as a photographer in 1970 after experimentation with painting. Most of her work has been close-ups (tombstone carvings), studio constructions,

FIG. 63 Saturday, 1980. Split toned silver contact print. Olivia Parker. (Courtesy of George Eastman House Collection, Rochester, New York.)

and arrangements using an assortment of objects, old engravings, and cast shadows. Making large-format contact prints from 4 × 5 through 8 × 10 negatives, one of Parker's particular stylistic traits has been a luscious split tone of cooler grays with eggplant purples (selenium toned gelatin silver prints). Compositions include floral subjects, fruit, and prisms, as well as old iron hardware and figurative elements such as small reproductions of classical busts. Objects and their arranged juxtapositions take on a new context of meaning that may hint at a multitude of intellectual interpretations. Her work offers up influences from Joseph Cornell and Frederick Sommer. Parker, in her artist statements, is quite forthcoming in listing her interests, yet she resists any direct suggestion of what her visual work may be about. A general theme for her photographs could be a mapping for understanding the unknown; a specific concern would be the emancipation of anima motrix—the spirit found inside special objects when they are aligned beneath the alchemist's illumination. One of her books, *Under the Looking Glass* (1983), features color images. She has also worked with the Polaroid 20 × 24 camera.

Publications
Parker, O. (1978). *Signs of Life*. Boston: David R. Godine.
Parker, O. (1987). *Weighing the Planets*. New York: New York Graphic Society.

PARKS, GORDON (1912–2006) American photographer, author, musician, composer, poet, and film director
A self-taught photographer who purchased a used camera in 1937, Parks was one of the earliest internationally praised African American photographers; his career has gone beyond stellar. He grew up in poverty (moving to St. Paul, Minnesota, in 1928) as the youngest of fifteen siblings. He worked as a busboy, lumberjack, professional basketball player, and piano player, but got paid for his first photographs of fashion made in Chicago. Sent on a fellowship to the nation's capital, Parks was hired by Roy Stryker to photograph for the Farm Security Administration (FSA) in 1942. One of Parks' most noted images was made right inside the FSA government office of custodian Ella Watson (whose husband had been lynched) holding her mop and broom in front of a symbolic American flag (see Figure 23). Parks later traveled the world making pictures for Standard Oil of New Jersey (1943–1948). He ultimately became a mainstay staff photographer for *Life* (1948–1972), producing such major photographic essays as "The Death of Malcolm X," "On the Death of Martin Luther King, Jr.," and the poignant story of a Brazilian child, "Flavio da Silva." He founded *Essence* magazine in 1970 and has photographed a range of personages from Gloria Vanderbilt and Ingmar Bergman to Muhammad Ali. He has also been successful as a mystery author and a Hollywood director (*The Learning Tree*, 1969; *Shaft*, 1971). Recently Parks has dedicated new energy as a post-octogenarian to still life and landscape photography in color and with digital technologies.

Publications
Parks, G. (1997). *Half Past Autumn: A Retrospective*. New York: Bulfinch Press.
Parks, G. (1990). *Voices in the Mirror, An Autobiography*. New York: Nan A. Talese.
Parks, G. (1948). *Camera Portraits: Technique and Principals of Documentary Portraiture*. New York: Franklin Watts.

PARR, MARTIN (1952) British
Parr has become the documentarian of Great Britain's middle class over the last three decades, working in black and white and color, publishing numerous books. Born in Upsum, England, he attended Manchester Polytechnic in the early 1970s. One of his first books was *Bad Weather* (1982), about the palpable curtain of mist, rain, and snow flurries that envelopes the British Isles; he purchased an underwater camera and flash attachment so he could defy the elements. Parr has been associated with Magnum since 1994. His newer work, almost always in super-saturated colors, takes stock of the public and semi-private life of the English; characters not so stodgy that they won't tolerate his incessant picture snapping, not too removed from distant claims to royalty or a dukedom that they totally lose all pretense of having that

FIG. 64 Weymouth, 1999. Color print chromogenic development (Fujicolor) process. Martin Parr, Magnum Photos. (Courtesy of George Eastman House Collection, Rochester, New York.)

stiff upper lip. In the sum of Parr's work we see an archive of things and people Aglaise—fish and chips stands, New Brighton beach bathers, Tupperware parties, Tudor style suburbia, the horse and hunt crowd, Piccadilly punks, and shoppers. Visually, his images often provide looming close-ups of hands, arms, or advert signage against a middle ground populated by a dense assortment of figures on holiday or shopping at Ikea. He uses fill-flash in daylight to throw a democratized illumination into all the important crevices of each scene. Writer Susan Kismaric has said that Parr's off-beat reportage is in harmony with many British authors, like Jonathan Swift, who portrayed society with a tinge of dry humor.

Publications
Parr, M. (2000). *Think of England*. London: Phaidon Press.
Parr, M. (1989). *The Cost of Living*. Manchester: Cornerhouse Publications.
Parr, M. (1986). *The Last Resort: Photographs of New Brighton*. Merseyside: Promenade.
Williams, V. (2002). *Martin Parr*. London: Phaidon Press.

PENN, IRVING (1917) American
Penn studied art and design with Brodovitch in the mid-1930s at the Philadelphia Museum of Art School. He spent a year in Mexico painting before moving to New York where he was hired by Alexander Liberman to assist with the graphics for covers of *Vogue* in 1943. Penn was so particular with the designs that he began photographing them himself. In his career he has done more than 130 *Vogue* covers. His photography during 1945 to 1960—portraits, fashion, still life—is characterized by cool, formal composition with simple backgrounds. In most instances he prefers diffused natural light to studio strobes. He opened his own studio in 1953 and continues to have many corporate clients (Clinique). Though best known for his work in fashion and portraiture, Penn has developed a varied body of creative work including photographs of ethnic peoples isolated from their environment, whether in New Guinea, Morocco, or Peru, by positioning them against plain backdrops (*Worlds In A Small Room*, 1974). In some ways these exotic subjects become "fashion" models or conceptual still life forms seen against a neutral field. He also has made elegant platinum prints of what could generically be termed "trash"—cigarette butts from the gutter outside his studio, discarded paper wrappers, and a torn and soiled glove. In the 1970s he added images of large-size nudes, studies of flower stalks and blooms, and arrangements of bleached animal bones and skulls to his oeuvre. Penn is one of the most prolific and well-respected of all photographers who have ever looked through a viewfinder or on the ground glass. Numerous books about his photography

have been published but many viewers still see Penn's work every day, without credits, on glossy advertisement pages.

Publications
Greenough, S. (2005). *Irving Penn: Platinum Prints*. New Haven, CT: Yale University Press.
Penn, I. (1991). *Passage: A Work Record: Irving Penn*. New York: Knopf.
Penn, I. (2001). *Still Life: By Irving Penn*. Boston: Bulfinch Press.
Szarkowski, J. (1984). *Irving Penn*. New York:

PORTER, ELIOT FURNESS (1901–1990) American
Porter (brother of the painter Fairfield Porter) graduated from Harvard Medical School (1929) after earning a degree in chemical engineering. He was a professor of biochemistry until 1939. He began photographing in Maine at his family's summer home at the age of 13 using a Kodak box camera. Introduced to Ansel Adams in the early 1930s, Adams encouraged Porter to switch to a large-format camera for increased quality and control. Porter's devotion to photography slowly escalated and from 1938 to 1939 Stieglitz exhibited his photographs at An American Place, the last solo exhibition by any photographer there (except for Stieglitz himself). Most of his subject matter was wildlife, especially birds, and the natural landscape. At first he made black and white prints, but with his background in chemistry, Porter became an early practitioner of color photography using the dye transfer process; he made his own three color separation negatives and prints. In 1946 he moved to Santa Fe, New Mexico, where he spent most of his remaining life, although he traveled for months at a time. An admirer of Henry David Thoreau, Porter was an ardent conservationist and many of his books were published by the Sierra Club. Books he published documented species of North American birds while other titles were more about geographic "place" including the final natural history documents of the Glen Canyon on the Colorado River just before it was dammed and flooded by the U.S. Corps of Engineers. Other places showcased in print by Porter were Penobscot Country (Maine), Antarctica, the Galapagos, China, and Greece.

Publications
Porter, E. (1987). *Eliot Porter*. Boston: Little, Brown.
Porter, E. et al. (1968). *Galapagos: The Flow of Wildness*. San Francisco: Sierra Club.
Porter, E. (1963). *The Place No One Knew: Glen Canyon on the Colorado*. Edited by David Brower. San Francisco: Sierra Club.

RAUSCHENBERG, ROBERT (1925) American
Born in Texas, Rauschenberg burst onto the New York art scene in the 1950s with his unconventional "combines," three-dimensional assemblages that brought together images and objects in a profusion of non-traditional materials. Referred to as Neo-Dada, his multimedia assemblages mixed eloquent passages of paint with transferred news photographs and photo silk screens as well as real objects in a spirit of Dada-like candor and spontaneity. The synergistic integration of highly charged photographic imagery with other media in his work raised new possibilities for photography, illuminating its multiple identities as fiction and fact, abstraction and allegory, enduring and ephemeral, and autobiographical and universal. His aesthetics were enormously influential in the cultural expression of the 20th century: While he blurred discipline-defining boundaries, his works resonate, as he hoped, in the "place between art and life."

Publications
Kotz, M. L. (1990). *Rauschenberg, Art and Life*. New York: Harry N. Abrams.
Rauschenberg, R. (1981). *Photographs/Robert Rauschenberg*. London: Thames & Hudson.
Rauschenberg, R. (1969). *Rauschenberg*. New York: Abrams.

RAY, MAN (EMMANUEL RUDNITSKY) (1890–1976) American
Noted for his "Rayographs," lens-less photograms exploring the pure use of light, his darkroom experiments with the Sabattier effect, and his innovative mixed media assemblages. A Dadaist

provocateur, he became the only American member of the surrealist movement. From 1921 to 1939 he combined artistic endeavors with commercial practice, becoming a noted portraitist of Parisian intellectuals and artists, and establishing a reputation as a fashion photographer. The Nazi occupation forced his escape to Hollywood where he established himself as a controversial figure of the American avant-garde before returning to Paris in 1951.

Publications
Baldwin, N. (1988). *Man Ray, American Artist*. New York: Clarkson N. Potter.
Perl, J. (1997). *Man Ray*. New York: Aperture Foundation.
Ray, M. (1997). *Photographs, Paintings, Objects*. New York: Norton.
Ray, M. (1982). *Man Ray, Photographs*. New York: Thames & Hudson.
Ray, M. (1963). *Self Portrait*. Boston: Little, Brown.
Tashijian, D. (1996). *Man Ray: Paris~L.A.* Santa Monica, CA: Smart Art Press.

RENGER-PATZSCH, ALBERT (1897–1966) German
A proponent of photography's Neue Sachlichkeit (New Objectivity.) Renger-Patzsch's collection of 100 photographs of nature and industry, *Die Welt ist Schon* (*The World is Beautiful*) published in 1928, exemplifies the rationality, precision, and faithfulness to subject he characterized as inherent photographic qualities. A purist, Renger-Patzsch helped define photography in the late 1920s and 1930s as a unique, autonomous art form with realism at its essence. His precisely crafted images of natural and factory made objects eschewed subjective influences, and strove to reveal, with rational purity, the material world's order and beauty.

Publications
Kuspit, D. (1993). *Joy Before the Object*. Los Angeles: J. Paul Getty Museum.
Wilde, A., Wilde, J., and Weske, T. (1997). *Albert Renger-Patzsch: Photographer of Objectivity*.
 London: Thames & Hudson.

RICHARDS, EUGENE (1944) American
World-renowned social documentary photographer following in the tradition of W. Eugene Smith. Born in Dorchester, Massachusetts, he was an activist and social worker before becoming a noted magazine photographer, prolific member of Magnum, filmmaker, author, and dedicated teacher. Co-director of Many Voices, a media group dedicated to producing films and books on contemporary social issues such as aging, pediatric HIV/AIDS, poverty, and the mentally disabled. Richards works in a compassionate documentary style to produce intimate long-term narratives that educate and promote dialog while sustaining an unflinching look at the hard realities of our contemporary social landscape. Honored for his many books that reflect concern for social justice, his seminal work *Exploding Into Life*, chronicles his wife's struggle with breast cancer.

Publications
Lynch, D. (1986). *Richards, Eugene: Exploding Into Life*. New York: Aperture.
Richards, E. (2005). *Cocaine True, Cocaine Blue*. New York: Aperture.
Richards, E. (2002). *Stepping Through the Ashes*. New York: Aperture.
Richards, E. (2000). *Dorchester Days*. London: Phaidon.

RODCHENKO, ALEXANDER MIKHAILOVICH (1891–1956) Russian
A versatile and influential artist in post-revolutionary Russia, Rodchenko helped found the Constructivist movement. His early Constructivist ideas regarding the artists' role in a progressive Communist society influenced the aesthetics of his wide-ranging projects in various fields of design, photography, and filmmaking. He is known for his experimental photomontage work and innovative photographic composition energized by extreme oblique angles, unorthodox perspectives, and unexpected framing. While he rose to prominence in the cultural bureaucracy of early Bolshevism, his artistic idealism was not able to survive the brutal cultural climate of Stalinism and he spent the last two decades of his life in isolation and obscurity.

Publications

Elliott, D. (1979). *Alexander Rodchenko*. New York: Pantheon.

Noever, P. (ed.) (1991). *Aleksandr M. Rodchenko and Varvara F. Stepanova*. Munich: Prestel.

ROTHSTEIN, ARTHUR (1915–1985) American

Notable as the first member of a team of photographers chosen by Roy Stryker for the Farm Security Administration's (FSA) ambitious documentary project, Rothstein photographed poverty in Gee's Bend, Alabama, life in farm labor camps in California, the struggles of cattle ranchers in Montana, and the devastation of the Dust Bowl, creating iconic images of depression America that influenced public policy. His controversial photograph, Fleeing a Dust Storm, made in the Oklahoma panhandle, created a dialog about documentary practice when it was determined that aspects of the scene had been manipulated by the photographer for dramatic effect (see Figure 8). His dedication to the truth, and his ability to simultaneously picture the dramatic and the ordinary, propelled his photojournalistic career. He photographed for *Look* magazine, and became head of the photography departments for both *Look* and *Parade* magazines. He was a founding member of the American Society of Magazine Photographers, now American Society of Media Photographers (ASMP).

Publications

Rothstein, A. (1986). *Documentary Photography*. Boston: Focal Press.

Rothstein, A. (1984). *Arthur Rothstein's America in Photographs, 1930–1980*. New York: Dover.

RUSCHA, EDWARD (1937) American

Employing a wry taxonomical approach to the photographic documentation of West-Coast vernacular structures, Ruscha's work from the 1960s and 1970s embraces photography in the service of conceptual art. *Twenty-Six Gasoline Stations*, *Every Building on the Sunset Strip*, and *Thirty-Four Parking Lots in Los Angeles* are among his commercially produced and widely influential books. A painter, printmaker, and filmmaker, Ruscha combines Dadaist sensibilities, articulate painting style, and fascination with language into dreamily elusive wordscapes: a poetic blend of word and image that is both critique and celebration of contemporary culture.

Publications

Rauscha, E. (1966). *Every Building on the Sunset Strip*. Los Angeles: Edward Ruscha.

Ruscha, E. (2004). *Leave Any Information at the Signal: Writings, Interviews, Bits, Pages*. Edited by Alexander Schwartz. Cambridge, MA: MIT Press.

Ruscha, E. (1965). *Some Los Angeles Apartments*. Los Angeles: Anderson, Ritchie & Simon.

SALGADO, SEBASTIAO (1944) Brazilian

Educated as an economist, Salgado became a photojournalist in 1973, working for the Sygma, Gamma, Magnum Photos, and eventually founding his own agency, Amazonas Images in 1994. His long-term documentary projects, rendered with haunting chiaroscuro, capture the dignity and endurance of humanity against oppression, war, and famine. With a detailed panoramic grandeur, his essays on the inferno of Brazilian gold-ore mines, the end of large-scale manual labor, and the plight of refugees and migrants across 21 countries, chronicle this century's brutalities. "The planet remains divided," Salgado explains. "The first world in a crisis of excess, the third world in a crisis of need."

FIG. 65 Sebastian Salgado. Photograph by Nancy M. Stuart, February 15, 1990.

Publications

Salgado, S. (2000). *Migrations*. New York: Aperture.

Salgado, S. (2000). *The Children: Refugees and Migrants*. New York: Aperture.

Salgado, S. (1997). *Terra: Struggle of the Landless*. New York: Aperture.

Salgado, S. (1993). *Workers, An Archaeology of the Industrial Age*. New York: Aperture.

Salgado, S. (1990). *An Uncertain Grace*. New York: Aperture.

Salgado, S. (1986). *Other Americas*. New York: Pantheon Books.

SALOMON, ERICH (1886–1944) German
Using available light and the new miniature cameras with fast lenses, first the Ermanox f.2 with glass plates and then the Leica Model A which used 35 mm motion picture stock, Salomon pioneered modern photojournalism. Beginning in the 1920s, he successfully captured unaware and unposed politicians, diplomats, business magnates, and royalty with his often hidden camera, a keen sense of timing and an uncanny ability to gain access to his subjects. The phrase "candid photography" was coined by a London art critic in 1929 in response to his work. His published work *Celebrated Contemporaries in Unguarded Moments*, exemplifies his remarkable talent for capturing the revealing psychological moment. Interned by the Nazis and killed along with his wife and a son at Auschwitz concentration camp.

FIG. 66 Summit Meeting in 1928. The architects of Franco-German Rapprochement, Aristide Briand and Dr. Gustav Stresemann, meet in the Hotel Splendide in Lugano with British Foreign Minister, Sir Austen Chamberlain. Left to right: Zaleski, Poland; Chamberlin; Briand; and Scialoia, Italy. Erich Salomon 1928. (Courtesy of George Eastman House Collection, Rochester, New York.)

Publications

Salomon, E. (1978). *Erich Salomon*. Millerton, NY: Aperture.

Salomon, E. (1975). *Portrait of an Age*. New York: Collier Books.

SAMARAS, LUCAS (1936) American
Known as a sculptor, painter, and performance artist, Samaras explored the malleability of photography's descriptive powers in his complex psychological portraits and tableaux. In his series of AutoPolaroids and PhotoTransformations of the late 1960s and 1970s, Samaras focused on himself as subject, playing multiple roles as artist, subject, actor, director, audience, and critic. With theatricality and narcissistic abandon, he used the baroque and claustrophobic space of his apartment studio for his performance: Exaggerated gesture, garish lighting, and post-exposure photo manipulation characterize his probing meditation on identity. His work revels in the interplay of photographic materials and illusion, enhanced by manipulation of Polaroid's SX-70s wet

FIG. 67 Self Portrait, November 16, 1973. Color print, internal dye diffusion (Polaroid SX-70) process. Lucas Samaras, Pace/MacGill Gallery, New York. (Courtesy of George Eastman House Collection, Rochester, New York.)

photo dyes. He painted directly on the surface of images, splicing together panoramic tableaux and illuminating the simultaneously narrative, documentary, and imaginary character of the medium.

Publications

Lifson, B. and Samaras, L. (1987). *Samaras: The Photographs of Lucas Samaras*. New York: Aperture.

Prather, M. and Samaras, L. (2003). *Unrepentant Ego: The Self Portraits of Lucas Samaras*. New York: Harry N. Abrams.

SANDER, AUGUST (1876–1964) German

Sander's portraits of the German people of the 1920s and 1930s made with uncompromising clarity and directness deeply influenced a century of portraiture and documentary work. In 1910, he began work on Menschen des 20 Jahrhunderts (Man of the 20th Century) which, never fully realized, was intended as a comprehensive typological portrait of German society. Eschewing the use of a traditional painted backdrop, he posed his subjects outdoors or in their own environments; his subjects represented every social strata and occupation, from formally posed industrialists to cooks in their kitchens. By organizing his full figure portraits of people into typologies, he hoped to create a total portrait of German society. The first volume of this project, *Antlitz der Zeit (Face of Our Time)*, was published in 1929, but Sander's work was banned and all existing books were seized and destroyed by the Nazis. Sander's studio was bombed during the war. After the war he continued to photograph mostly landscape and architectural studies.

Publications

Sander, A. (1999). *August Sander, 1876–1964*. London: Taschen.

Sander, A. (1986). *August Sander: Citizens of the Twentieth Century: Portrait Photographs 1892–1952*. Edited by Gunther Sander. Cambridge, MA: MIT Press.

Sander, A. (1980). *August Sander, Photographs of an Epoch*. Millerton, NY: Aperture.

SCHAD, CHRISTIAN (1994–1982) German

While recognized as a painter and proponent of the Neue Sachlichkeit (New Objectivity) whose cold realist portraits reveal the hedonism and apathy in Weimar Germany, he is also acclaimed as the 20th century's earliest practitioner of experimental camera-less photography in the tradition of Talbot's "photogenic drawing." Using torn tickets, receipts, and other "trash," he created chance arrangements on photographic film called "Schadographs," so named by the Dada artist and leader Tristan Tzara. In the iconoclastic aura of experimentation that European Dada and Surrealism engendered, artists such as Lazlo Moholy-Nagy and Man Ray independently discovered the creative capabilities of the photogram, but Schad's experiments preceded theirs by several years and exemplified the Dada ethos of making art from junk.

Publications

Lloyd, J. and Peppiatt, M. (2003). *Christian Schad and the Neue Sachlichkeit*. New York: W.W. Norton & Co.

SHEELER, CHARLES (1883–1965) American

Known primarily as a Precisionist painter, Sheeler's photographic work was inspired by both the rural and industrial landscape, and was intimately connected, both ideologically and formally, to his painting. His exacting precisionist vision, eye for abstraction, and expressive use of form were central in his photographs, drawings, and paintings. His commercial photographic work for *Fortune*, *Vogue*, and *Vanity Fair* during the 1920s and 1930s gave him a platform to develop his growing interest in architectural and industrial form. Beguiled by the ideology of American industrialism, he produced his most notable photographic series for Ford Motor Company in 1927 at the River Rouge Plant. "Our factories," wrote the artist, "are our substitute for religious expression."

FIG. 68 Sonia Through the Planet/Sonia Through Marilyn Goldstein, 1974. 3M color-in-color print. Sonia Landy Sheridan. (Courtesy of George Eastman House Collection, Rochester, New York.)

Publications

Lucic, K. (1991). *Charles Sheeler and the Cult of the Machine.* London: Reaktion.

Lucic, K. (1997). *Charles Sheeler in Doylestown: American Modernism and the Pennsylvania Tradition.* Allentown, PA: Allentown Art Museum and University of Washington Press.

Stebbins, T. E., Jr. and Keyes, N., Jr. (1987). *Charles Sheeler: The Photographs.* Boston: Little, Brown.

SHERIDAN, SONIA LANDY (1925) American

Sheridan's pioneering work during the 1970s and 1980s focused on the use of contemporary communications technology in the practice of art. Working with early reprographic systems, she went on to experiment with an array of imaging tools that included video, computers, and sound, which explored the intersection of photography and binary code. Artist and educator, Sheridan created the Department of Generative Systems at the Art Institute of Chicago based on the notion that art, science, and technology are interrelated conceptual systems. Her work encouraged theoretical discourse essential to our understanding of photography's changing nature in a global communications environment.

SHERMAN, CINDY (1954) American

Sherman emerged as a key figure in the art world in the 1980s with her series Untitled Film Stills—black and white images that explore gender, identity, mythmaking and the media. She combines performance, masquerade, and photography's innate collusion with veracity to create film stills of herself as the solitary female heroine in an American drama; her fictional identities were inspired by movies of the 1950s and 1960s. Sherman's chameleon-like capacity for self-transformation, her blurring of the real and unreal, and her use of saturated color materials and large scale audaciously explore her notion of human identity as a cultural construct.

Publications

Krauss, R. E. (1993). *Cindy Sherman, 1975–1993.* Essay by Norman Bryson. New York: Rizzoli.

Sherman, C. (2003). *Cindy Sherman: The Complete Untitled Film Stills.* New York: Museum of Modern Art; London: Distributed outside the United States and Canada by Thames & Hudson.

Smith, E. A. T. and Jones, A. (1997). *Cindy Sherman: Retrospective. Exhibition Catalogue.* Essay by Amanda Cruz.

FIG. 69 Untitled #85, 1981. Chromogenic development print. Cindy Sherman and Metro Picture Gallery, New York. (Courtesy of George Eastman House Collection, Rochester, New York.)

Museum of Contemporary Art, Los Angeles, and Museum of Contemporary Art, Chicago. New York: Thames & Hudson.

SISKIND, AARON (1903–1991) American
A member of the New York Photo League through the 1930s, Siskind's early projects such as Dead End: The Bowery and The Harlem Document are rich contributions to the social documentary tradition. In the 1940s he developed enduring connections with artists of the New York School and his work was transformed by a growing interest in abstraction: A visceral and metaphorical abstract expressionism evolved in his richly textured black and white images of found objects, graffiti, peeling posters, and other urban detritus. He became a renowned educator at Chicago's Institute of Design (1951–1971) and Rhode Island School of Design (1971–1976) and a founder of the Society for Photographic Education.

Publications
Chiarenza, C. (1982). *Aaron Siskind: Pleasures and Terrors.* Boston: Little, Brown.
Featherstone, D. (ed.) (1990). *Road Trip.* San Francisco: The Friends of Photography.
Siskind, A. (2003). *Aaron Siskind 100.* New York: powerHouse Books.

SMITH, W. EUGENE (1918–1978) American
Smith's extended photo-essays in *LIFE* magazine (1939–1955), Man of Mercy (on Albert Schweitzer), Country Doctor, Spanish Village, and Nurse Midwife helped define a new style of magazine photojournalism in America. Forming an ideology of social responsibility and humanism during his years as a WWII photographer in the Pacific, Smith returned from the war to produce picture stories for *Life* that resonate with depth, optimism, and belief in the human spirit. His moral and visual standards have had a lasting impact on today's photographers. "My principle concern is for honesty, above all honesty with myself . . ." He eventually left the constraints of magazine work to pursue personal projects of greater depth and scope (in Pittsburgh and New York), defining himself as an artist and producing prints of outstanding tonal richness and beauty. His final work, Minamata (1975), produced in collaboration with his second wife, is an essay in photographs and words of the tragic effect of mercury pollution on this small fishing village in Japan. He taught at New York's New School for Social Research, and served as president of the American Society of Magazine Photographers.

Publications
Hughes, J. W. (1989). *Eugene Smith, Shadow & Substance.* New York: McGraw-Hill.
Maddow, B. (1985). *Let Truth Be the Prejudice, W. Eugene Smith, His Life and Photographs.* Millerton, NY: Aperture.
Smith, W. E. and Smith, A. M. (1975). *Minamata.* New York: Alskog-Sensorium Book.

SOMMER, FREDERICK (1905–1999) American
Known for his black and white contact prints of exceptional tonal beauty and his probing philosophical approach, he explored a wide range of visual expressions that merged painting, drawing, music, and the photographic image. Influenced by Alfred Steiglitz and Edward Weston, he began making photographs in 1935. His idiosyncratic choices of still life objects steeped in putrescence have a formal elegance, their structure

FIG. 70 Eight Young Roosters, 1938. Gelatin silver print. Photograph by Frederick Sommer, Frederick & Francis Sommer Foundation. (Courtesy of George Eastman House Collection, Rochester, New York.)

and associations laden with psychological depth. His photographs of cut paper constructions, assemblages and lens-less images of smoke on glass are a fantastical counterpoint to his horizon-less depictions of the southwest landscape. Sommer worked in relative isolation in Arizona for more than fifty years, his prominence coming late in his career.

Publications
Conkelton, S. (ed.) (1995). *Frederick Sommer: Selected Texts and Bibliography*. New York: G. K. Hall.
Sommer, F. (1980). *Frederick Sommer at Seventy-Five*. Long Beach: The Art Museum and Galleries, California State University.

STEICHEN, EDWARD JEAN (1879–1973) American

A pivotal figure in the growth of creative photography in America, Steichen was one of the founders, with Steiglitz, of the Photo-Secession (1902) and The Little Galleries of the Photo-Secession (known as 291) in New York. Introducing the modernist work of Picasso, Matisse, Cezanne, and Rodin to America with debut exhibits at 291, he was also a frequent contributor to Stieglitz' *Camera Work* magazine. He produced images of rich tonal depth and romantic sensibility; his early pictorialist use of manipulated gum and pigment printing processes were abandoned for a more precise, pragmatic style. His stylized fashion and celebrity images of the 1920s, published frequently in *Vanity Fair* and *Vogue*, were notable for their simple, theatrical settings; dramatic lighting and architectonic backdrops; and had an aura of impersonal cosmopolitan elegance. Shaped by his entrepreneurial spirit and his infatuation with celebrity and prestige, Steichen's career flourished as Director of Photography for Condé Nast publications (1923–1938). His career, twice punctuated with army and navy combat photographic service during both world wars, eventually led to the museum world. One of his most celebrated achievements came as Director of the Photography Department, Museum of Modern Art, New York (1947–1962) with his marketing of large themed exhibitions of photography, including the hugely popular The Family of Man (1955).

Publications
Niven, P. (1997). *Steichen: A Biography*. New York: Clarkson Potter.
Smith, J. (1999). *Edward Steichen: The Early Years*. Princeton, N.J.: Princeton University Press and the Metropolitan Museum of Art.
Steichen, J. (ed.) (2000). *Steichen's Legacy: Photographs, 1895–1973*. New York: Alfred A. Knopf.

STEINER, RALPH (1899–1986) American

Known as a modernist photographer and filmmaker, Steiner was a founding member of the New York Film and Photo League. His sharp focus, carefully composed photographs portray quotidian America, their exquisite detail and textures presented with a modernist's eye for meaning in form. A successful career in magazine and advertising photography supported his passion for art photography and avant-garde film. In 1929 he produced his first film, H_2O. Steiner's artistry in documentary filmmaking led to his collaboration with photographer Paul Strand as cameraman on Pare Lorentz' documentary film, *The Plow that Broke the Plains*, and in 1938 with Willard Van Dyke, on *The City*, a critically acclaimed film about New York.

Publications
Steiner, R. (1978). *A Point of View*. Middletown, CT: Wesleyan University Press.
Steiner, R. (1985). *In Pursuit of Clouds: Images and Metaphors*. Albuquerque: University of New Mexico Press.
Steiner, R. (1986). *In Spite of Everything, Yes*. Albuquerque: Harwood Museum of Art, Dartmouth College, University of New Mexico Press.

STEINERT, OTTO (1915–1978) German

One of the most important post-war German photographers and founder of the Subjective Photography movement in post-war Germany, Steinert was also curator of the international exhibition Subjektive Fotografie in 1951, 1954, and 1958 in Saarbrücken. Steinert's view of photography as an expression of an individual's inner state advocated dialog with plastic qualities, graphic manipulations, and concern for form associated with experimental Bauhaus photography of the 1920s. From 1959 until his death he was an influential teacher at the Folkwang School in Essen.

Publications

Steinert, O. (1999). *Der Fotograf Otto Steinert/Herausgegeben von Ute Eskildsen, Museum Folkwang Essen.* Göttingen: Steidl.

Steinert, O. (1952). *Subjektive Fotografie; ein Bildband moderner europäischer Fotografie. A collection of modern European photography.* Bonn: Brüder Auer.

STIEGLITZ, ALFRED (1864–1946) American

The 20th century's greatest champion of photography as an art form. Editor of *Camera Notes,* the journal of the Camera Club of New York, Stieglitz soon became leader of the Pictorialist movement in New York, co-founder of the Photo-Secession in 1902, and editor and publisher of the masterful periodical *Camera Work* from 1903 to 1917. With Steichen's assistance, his Little Galleries of the Photo-Secession, later called 291, then The Intimate Gallery (1925–1929), and An American Place (1929–1946) first showcased in America the new modern art from Europe by Picasso, Matisse, Braque, Cézanne, Brancusi, and Rodin and introduced American painters O'Keeffe, Marin, Hartley, and Dove. Exhibiting painting with photography, his gallery showed photographers Clarence White, Coburn, Strand, Steichen, Adams, and Porter. Abandoning the soft-focus aesthetic of Pictorialism by World War I, Stieglitz became a staunch advocate of straight photography, adopting less self-conscious methods to depict the fast-paced cacophony that defined modern life, and simplifying his compositions to clarify light and form. His highly regarded images using a hand-held camera of the streets of New York City, portraits of his wife, the painter Georgia O'Keeffe, and his "equivalents" series of cloud studies that were analogs for emotional experience, helped realize the profoundly metaphorical possibilities of the medium.

Publications

Greenough, S. and Hamilton, J. (1983). *Alfred Stieglitz: Photographs and Writings.* Washington, DC: National Gallery of Art.

Lowe, S. D. (1983). *Stieglitz: A Memoir/Biography.* New York: Farrar, Straus & Giroux.

Whelan, R. (1995). *Alfred Stieglitz: A Biography.* Boston: Little, Brown.

STRAND, PAUL (1890–1976) American

Strand believed in the redemptive power of art that is rooted in the reality of everyday life, and was an articulate advocate for a "pure" aesthetic in creative photography. Believing in the "absolute unqualified objectivity" of photography, Strand created tightly structured compositions printed in rich chiaroscuro, innovative for their authenticity and dynamism. His early subjects included street people of New York, nudes of his wife Rebecca, still lifes, landscapes of New Mexico, and experiments with abstraction and movement. By 1916 his work was championed by Steiglitz with solo exhibitions at 291 and publication in *Camera Work*'s final issues, devoted exclusively to his photographs. An active filmmaker through the 1920s and 1930s, Strand returned to his interest in portraiture by the mid-1940s when his primary goal was to reveal the essential character of his subject with its physical and psychological ties to the larger world. Motivated by his ideology and influenced by his experience in film, he created a series of cultural portraits, exploring both the portfolio and book form: Photographs of Mexico (1940), Time in New England (1950), Un Paese (1955), Tir a'Mhurain: Outer Hebrides (1968), Living Egypt (1969), and Ghana: An African Portrait (1976). He emigrated to France in 1950 in response to the growing oppression of McCarthyism.

Publications
Greenough, S. (1990). *Paul Strand, An American Vision*. Washington, DC: National Gallery of Art.
Stange, M. (ed.) (1991). *Paul Strand, Essays on His Life and Work*. Millerton, NY: Aperture.
Strand, P. (1976). *Paul Strand: Sixty Years of Photographs*. Millerton, NY: Aperture.

STRUTH, THOMAS (1954) German
Studied with Gerhard Richter and Bernd and Hilla Becher at the Kunstakademie in Dusseldorf, Germany, where a new generation of photographers emerged in the 1980s and were noted for the cool intellectual detachment and epic scale of their color photographic work. The conceptual underpinnings of Struth's training find form in psychological landscapes of contemporary urban malaise. With precise detail, saturated color, and grand scope, he pictures such public spaces as church and museum interiors with a contemplative detachment that can also be found in his earlier black and white images of city streets. He has exhibited internationally since the late 1980s, and has numerous monographs published of his work. He lives in Düsseldorf.

Publications
Struth, T. (1993). *Museum Photographs*, Munich: Schirmer/ Mosel.
Struth, T., Lingwood, J., and Teitelbaum, M., eds. (1994). *Thomas Struth: Strangers and Friends: Photographs 1986–1992*, Cambridge, MA: The MIT Press.
Essay by Dieter Schwarz. (2001). *Thomas Struth: Dandelion Room*, NY.: DAP/Shirmer/ Mosel.
Struth, T. (2001). *Still*, New York: The Monacelli Press.
Essays by Norman Bryson, Benjamin H.D. Buchloh, and Thomas Weski. (2001). *Thomas Struth: Portraits*, Munich:P Schirmer/Mosel.
Essays by Ingo Hartmann and Hans Rudolf Reust. (2002). *Thomas Struth: New Pictures from Paradise*, Munich: Schirmer/Mosel.

STRYKER, ROY EMERSON (1893–1975) American
Director of the most extensive documentary photography project undertaken by the U.S. Government, for the Farm Security Administration (FSA) (1935–1943). Selecting such photographers as Walker Evans, Dorothea Lange, Russell Lee, Arthur Rothstein, and Ben Shahn, the FSA under Stryker's leadership produced a massive document of 250,000 negatives, archived in the Library of Congress, that captured the broad face of rural America as it weathered the Great Depression.

Publications
Stryker, R. E. (1973). *In This Proud Land*. With Nancy Wood. New York: Galahad Books.

SUDEK, JOSEF (1896–1976) Czechoslovakian
Working in Prague all his life, Sudek devoted himself to creating a portrait of his city, with mystical panoramic views of its streets and buildings, poetic still life images taken from his studio window and atmospheric depictions of his garden. His magical orchestration of rich, dark tones and the ethereal luminescence of his highlights render Sudek's world in a spiritual and dreamlike tone, where light is substance. The difficulties in Sudek's life, the loss of his right arm during World War I and the hardships suffered during the Nazi and Soviet occupations of Prague, color his evocative and emotional work. Despite his handicap, he used large view cameras, including a 12×20 panoramic format that he wielded both horizontally and vertically, photographing without the help of an assistant. He compiled seven books of Prague photographs, working in the streets until old age and his physical limitations made it too difficult to haul his cameras around.

Publications
Bullaty, S. (1986). *Sudek*. New York: Clarkson N. Potter.
Farova, A. and Sudek, J. (1990). *Josef Sudek: Poet of Prague, A Photographer's Life*. Millerton, NY: Aperture Books.

SUGIMOTO, HIROSHI (1948) American, Japanese born

Sugimoto's extended-time images of the interiors of movie theaters, atmospheric seascapes, dioramas, and waxworks probe the wonders of perception, time, transience, and memory. He first came to public attention with his images of the interiors of movie theaters, their delicate details rendered by the movie's cumulative illumination; the shutter was timed for the duration of each movie. His series of seascapes that divide the frame horizontally into sky and sea render in exquisite tonalities, the endless variations of atmosphere, tone, and light. Like reverberating echoes, his images are mesmerizing, evocative, and enigmatic. With simultaneous simplicity and depth, they give substance to the passage of time. Born in Tokyo, Sugimoto left Japan to study at the Art Center College of Design in Los Angeles. In 1974 he moved to New York City and now lives in both New York and Tokyo.

Publications

Bashkoff, T. and Spector, N. (2000). *Sugimoto Portraits*. New York: Guggenheim Museum Publications.

Kellein, T. (1995). *Hiroshi Sugimoto: Time Exposed*. New York: Thames & Hudson.

Schneider, E. (ed.) (2002). *Hiroshi Sugimoto: Architecture of Time*. Cologne: W. König, New York: DAP (outside Europe).

SZARKOWSKI, JOHN THADDEUS (1925) American

Following Edward Steichen as the Director of the Department of Photography, Museum of Modern Art, New York, Szarkowski was instrumental in shaping America's view of photography: MoMA produced 160 photo exhibitions during his tenure (1962–1991), many directed by Szarkowski. His role as critic, educator, and curator found form in a stream of books and critical writings, many associated with his exhibitions at MoMA. With a keen eye and thoughtful pen, he was a significant force in the careers of numerous contemporary photographers, championing the work of young photographers such as Arbus, Friedlander, Eggleston, and Winogrand, and paying homage to 20th century masters Adams, Callahan, Steiglitz, Penn, Kertesz, Atget, and more. Having achieved success as a photographer in his own right early in his career, he returned to photographic practice after his retirement from MoMA and in 2005 mounted his first retrospective.

Publications

Phillips, S. S. (2005). *John Szarkowski: Photographs*. New York: Bulfinch Press.

Szarkowski, J. (1973). *Looking at Photographs: 100 Pictures from the Museum of Modern Art*. New York: Museum of Modern Art.

Szarkowski, J. (1978). *Mirrors and Windows: American Photography Since 1960*. New York: Museum of Modern Art; Boston: distributed by New York Graphic Society.

Szarkowski, J. (1989). *Photography Until Now*. New York: Museum of Modern Art.

TOMATSU, SHOMEI (1930) Japanese

Japan's premier post-war photographer, Tomatsu chronicles the complex cultural changes from Japan's traditional pre-war society through the ravages of World War II, American occupation, and its ambivalent struggle with Western influences. His historic documentation of the lives of atomic bomb survivors in Nagasaki is distinguished for its metaphorical depth and intimacy. Co-founder of the VIVO cooperative agency in 1959, he advocated a new social landscape of photography in Japan, influenced by the humanist subjectivity and surrealism of Europe and America. Initially black and white, characterized by graphic minimalism and dramatic composition, his later works embrace color. His portraits of bohemian nightlife in Tokyo's countercultural Shinjuku, his elegies to traditional life remaining in remote islands of Japan, and his ironic depictions of the collision of Western and Eastern cultures are powerful documents that simultaneously mourn and celebrate.

Publications

Jeffrey, I. (2001). *Shomei Tomatsu*. London: Phaidon.

Rubinfien, L., Phillips, S. S., and Dower, J. W. (2004). *Shomei, Tomatsu: Skin of the Nation*. Preface by Daido Moriyama. San Francisco: Museum of Modern Art in association with New Haven, CT: Yale University Press.

Tomatsu, S. (2000). *Tomatsu Shomei 1951–1960*. Tokyo, Japan: Sakinsha.

Tomatsu, S. (1998). *Visions of Japan, Tomatsu Shomei*. Korinsha Press, Distributed Art Publishers, New York.

UELSMANN, JERRY N. (1934) American
Creator of enigmatic, surreal images, Uelsmann was first known for his mastery of complex, multiple negative darkroom printing techniques and for his philosophy of post-visualization of the image. He creates composite images from his personal vocabulary of image fragments, with psychological association and metaphor at the heart of his work. In transitioning to digital production methods, he continues to create magically convincing paradoxes of time and space. An influential professor at the University of Florida, he is now retired.

Publications

Enyeart, J. L. (1982). *Jerry N. Uelsmann, Twenty-Five Years: A Retrospective*. Boston: Little, Brown.

Uelsmann, J. N. (2000). *Approaching the Shadow*. Tucson, AZ: Nazraeli Press.

Uelsmann, J. N. (2005). *Other Realities*. New York: Bulfinch Press.

FIG. 71 Hands with Round Object in Mountainscape, 1970. Gelatin silver print. Jerry Uelsmann. (Courtesy of George Eastman House Collection, Rochester, New York.)

ULMANN, DORIS (1882–1934) American
Studied with Clarence White. Her photographs provide a respectful portrait of the rural culture and craftspeople of the southern highlands of the Appalachian Mountains and the Gullahs of the Sea Islands of South Carolina. Bringing pictorialist techniques to documentary work, she used a view camera and made platinum prints based on her annual "folklore and photographic expeditions." Her images provide an important ethnographic and historical record.

Publications

Featherstone, D. (1985). *Doris Ulmann, American Portraits*. Albuquerque, NM: University of New Mexico Press.

Peterkin, J. and Ulmann, D. (1933). *Roll, Jordan, Roll*. New York: Robert O. Ballou.

Ulmann, D. (1974). *The Darkness and the Light: Photographs by Doris Ulmann*. Millerton, NY: Aperture.

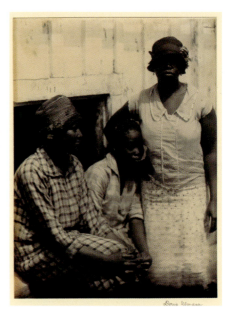

FIG. 72 Waiting for the Excursion Train, ca. 1930. Platinum print. Doris Ulmann. (Courtesy of George Eastman House Collection, Rochester, New York.)

VAN DER ZEE, JAMES (1886–1993)

Chronicler of the Harlem Renaissance. Self-taught, he opened his Guarantee Photo Studio on famed 125th street in Harlem in 1917 making artistic studio portraits that celebrate Harlem's emergent black middle class. He used ornate furniture, painted backdrops, and props to stage his portraits, posing each sitter ". . . in such a way that the picture would tell a story." His signature style often included retouching the final image with color and the use of photomontage. The official photographer to Marcus Garvey's United Negro Improvement Association, he photographed church functions, parades, and funerals, providing a valuable document of the vibrant life of African Americans in Harlem. After the war, Van Der Zee struggled to make a living and it was only in 1967, when The Metropolitan Museum of Art mounted the controversial exhibit Harlem on My Mind, that renewed interest in his work refueled his career.

Publications

Van Der Zee, J. (1968). *Harlem on My Mind: Cultural Capital of Black America, 1900–1968.* Edited by Allon Schoener. Preface by Thomas P. F. Hoving. Introduction by Candice Van Ellison. Metropolitan Museum of Art Exhibition. New York: Random House.

Van Der Zee, J. (1978). *The Harlem Book of the Dead: James Van Der Zee, Owen Dodson, Camille Billops.* Foreword by Toni Morrison. Dobbs Ferry, NY: Morgan & Morgan.

VISHNIAC, ROMAN (1897–1990) Russian-American

Produced a heroic photographic record of the final hours of pre-holocaust Jewish life in Eastern Europe in the late 1930s. At great personal risk, traveled through Lithuania, Poland, Hungary, Czechoslovakia, and Latvia, compiling over 16,000 images (of which 2000 remain) of Jewish village life soon to be eradicated by Hitler. His poetic images, bravely captured with a hidden camera, are a most poignant reminder of photography's gift of memory. He emigrated to the United States in 1940, where he pursued a remarkable career in the biological sciences and was a renowned pioneer in photomicrography and time-lapse cinematography.

Publications

Vishniac, R. (1969). *A Vanished World.* New York: Farrar, Straus & Giroux.

WARHOL, ANDY (WARHOLA, ANDREW) (1928–1987) American

The most famous Pop artist of America, Warhol came onto the art scene in the early 1960s with his Campbell's Soup Cans, a campy image of a product he loved elevated to iconic status. His affect-less images of mass-produced American products and his Pop Culture portraits used images appropriated from mass media as their source; with stylish simplicity he transformed photographic information, using garishly bright silk-screened colors and flat painted forms to raise banality to monumental status. Aiming for robot-like authorship, Warhol's work was itself often mass-produced, with assistants creating repetitive, multiple-image silk-screened pieces. Moving fluidly from one medium to another, his prolific output also included the publication of his magazine *Interview* and over 60 films produced from 1963 to 1968.

Publications

McShine, K. (ed.) (1989). *Andy Warhol, A Retrospective.* New York: Museum of Modern Art.

Warhol, A. (1999). *About Face: Andy Warhol Portraits.* Essays by Baume, Nicholas, Crimp, Douglas, Meyer, and Richard. Hartford, CT: Wadsworth Atheneum and Pittsburgh: Andy Warhol Museum, Cambridge, MA: Distributed by MIT Press.

Warhol, A. (1989). *Andy Warhol, Photobooth Pictures.* New York: Robert Miller Gallery.

Warhol, A. (1988). *Andy Warhol: Death and Disasters.* Houston, TX: Menil Collection: Houston Fine Art Press.

WEEGEE (ARTHUR H. FELLIG) (1899–1968) American

Born in Lvov, Ukraine, Weegee was a photojournalist who rose to celebrity status for his on-the-spot photos of daily news events in New York City. Taking the name Weegee (Ouija)

from his ability to be at the scene within moments, he actually had a police radio in his car and hook-in to police alarms near his bed. He used on-camera flash with a 4 × 5 Speed Graphic to photograph crime scenes, urban disasters, celebrities, and everyday street life, famous for his strategic, confrontational approach and sardonic sensibilities. His first exhibit, Weegee: Murder is My Business, opened at the Photo League in 1941, and his first book, *Naked City*, was published in 1945 to be followed by a series of books, museum exhibitions, and freelance projects.

Publications

Weegee (1975). *Naked City*. New York: Da Capo.

Weegee (1978, 1997). *Weegee*. Millerton, NY: Aperture.

Weegee (1975). *Weegee by Weegee: An Autobiography*. New York: Da Capo.

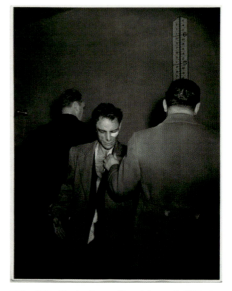

FIG. 73 Booked on Suspicion of Killing a Policeman, Anthony Esposito, Accused Cop Killer, January 16, 1941. Gelatin silver print. Weegee/International Center of Photography/Getty Images. (Courtesy of George Eastman House Collection, Rochester, New York.)

WEEMS, CARRIE MAE (1953) American

Weems is notable for her works that fuse words and image to create psychologically and politically charged explorations of identity and wrestle with complex issues of gender, race, age, and ethnicity. Whether focusing on personal narrative or larger cultural histories of the African American experience and the issues of Diaspora, her works delve deeply into prejudice, politics, history, folklore, and the human condition. She often groups images with words, using folkloric constructs of language and storytelling, or creates installation works with audio. Her notable series, Family Pictures and Stories, Colored People, Kitchen Table, Sea Islands, and Landed in Africa have been important contributions to our collective visual and social history.

Publications

Piche, T., Golden, T., Weems, C. M., and Everson Museum of Art. (2003). *Carrie Mae Weems: Recent Work*. George Braziller.

Willis, D., Zeidler, J., Weems, C. M., and Johnston, F. B. (2001). *Carrie Mae Weems: The Hampton Project*, Millerton, N.Y.: Aperture.

Kirsh, A., and Sterling, S. F. (1993). *Carrie Mae Weems*, The National Museum of Women in the Arts.

WESTON, EDWARD (1886–1958) American

Renouncing his early commitment to a soft-focus pictorialism, Weston became one of the most influential advocates of straight photography in America. His images of the ARMCO Steelworks in Ohio, made in 1922, soon after meeting Steiglitz, Strand, and Sheeler, marked a radical shift toward a straight, unpretentious realism in photography. While in Mexico, where he lived for several years with photographer Tina Modotti (his assistant) and befriended artists of the Mexican Renaissance, Rivera, Siqueiros, and Orozco, his aesthetic matured. Upon returning to California in 1927, he began his remarkable close-up photographs of shells and vegetables, including the famous Pepper, No. 30. His studio in Carmel was the site of his lifelong project to photograph the cypress trees, rocks, and beaches of Point Lobos. Working with an 8 × 10 view camera, he made silver and platinum contact prints with exquisite attention to

light and form, photographing natural forms, the landscape, and nudes, including a series of his second wife, Charis Wilson. In 1932 he was a founding member of the Group f/64, along with Adams, Van Dyke, Cunningham, and Noskowiak who were proponents of straight photography. The first photographer to be awarded a Guggenheim Fellowship in 1937 and 1938, he produced *California and the West* (1940). Increasingly incapacitated by Parkinson's disease, Weston made his last photographs in 1948, and supervised the printing of his life's work by his sons, Brett and Cole.

Publications

Maddow, B. (1979). *Edward Weston: Fifty Years.* Millerton, NY: Aperture.

Newhall, B. (1986). *Supreme Instants: The Photography of Edward Weston.* Boston: New York Graphic Society.

Newhall, N. (ed.) (1990). *The Daybooks of Edward Weston, Two Volumes in One.* Millerton, NY: Aperture.

WHITE, CLARENCE HUDSON (1871–1925) American

A self-taught photographer of soft-focus images of family life in rural Ohio, White joined with Steiglitz in 1902 to help form the Photo-Secession. The first teacher of photography at Columbia University, New York in 1907, he founded the Clarence White School of Photography in 1914. An influential teacher, whose students included Bourke-White, Gilpin, Lange, Outerbridge, Steiner, and Ulmann, he became the first president of the Pictorial Photographers of America in 1916 in reaction against Steigliz' shift to straight photography.

Publications

Bunnell, P. C. (1986). *Clarence H. White: The Reverence for Beauty.* Athens, OH: Ohio University Press.

White, M. P., Jr. (1979). *Clarence H. White.* Millerton, NY: Aperture.

WHITE, MINOR (1908–1976) American

Photographer, poet, and influential teacher. Drawing from Steiglitz' ideas of the photograph as an equivalent for human emotion, White's photographic philosophy emphasized the image as metaphor and as spiritual experience. He combined Eastern philosophy, meditation, Gestalt psychology, and the teachings of Gurdjieff as avenues to access creative expression, and focused on the meaningful interaction of images in series. His own exquisitely printed black and white images reflect his spiritual journey. In 1952 White helped found *Aperture* magazine, serving as its editor until 1975. He was a curator at George Eastman House in Rochester, New York, an influential teacher at Rochester Institute of Technology, San Francisco Art Institute, and Massachusetts Institute of Technology. A guru-like presence, many students lived with and studied under his mystical tutelage.

Publications

Bunnell, P. C. (1989). *Minor White, The Eye that Shapes.* Princeton, NJ: Art Museum, Princeton University; Boston in association with Bulfinch Press.

White, M. (1992). *Minor White: Rites & Passages.* Millerton, NY: Aperture [reissue edition].

White, M. (1982). *Mirrors, Messages, Manifestations: Minor White.* Millerton, NY: Aperture; distributed in the U.S. by Viking Penguin.

WINOGRAND, GARRY (1928–1984) American

Winogrand's new brand of documentary photography—raw, spontaneous, inclusive, and irreverent—helped define the 1960s. The controlled turbulence of his images, with their ironic juxtapositions, grainy energy, and complex content, reveal a voracious curiosity and obsession with photography. Influenced by the American photographs of Walker Evans and Robert Frank, Winogrand wandered the streets with his hand held 35 mm Leica, moving in fast and close to shoot wide-angle views of people and places with tilted framing. He was championed

by Szarkowski, Director of the Department of Photography at the Museum of Modern Art in New York and had his first major exhibition there in 1963. His books, including *The Animals* (1969), *Women Are Beautiful* (1975), *Public Relations* (1977), and *Stock Photographs: Fort Worth Fat Stock Show and Rodeo* (1980), only hint at his prolific output; at his untimely death from cancer he left thousands of undeveloped and unproofed rolls of film.

Publications

Friedlander, L. and Harris, A. (eds.) (2002). *Arrivals & Departures: The Airport Pictures of Garry Winogrand*. New York: Distributed Art Publishers.

Szarkowski, J. (1988). *Winogrand, Figments from the Real World*. New York: Museum of Modern Art.

Winogrand, G. (1999). *The Man in the Crowd: The Uneasy Streets of Garry Winogrand*. Introduction by Fran Lebowitz. Essay by Ben Lifson. San Francisco: Fraenkel Gallery and DAP.

WITKIN, JOEL PETER (1939) American

Witkin's dark, shocking tableaux portray beauty in the grotesque and give form to photography's power to confront taboos. Populated by deformed people, hermaphrodites, dwarfs, corpses, and body parts collected and combined to make psychologically charged, highly controversial images, Witkin's images "reflect the insanity of life." Drawing from the history of art and his personal spirituality, Witkin conjures a darkly mythological imagery, compelling and provoking us with his exquisitely beautiful grotesqueries. His black and white prints, toned, bleached, and containing scratches and scars made to the negative, are coated with wax overlays on the print's rich surface. Active as an exhibiting artist since the 1970s, Witkin lives in New Mexico.

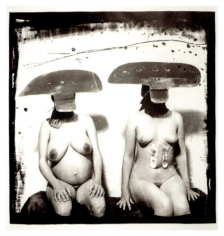

FIG. 74 I.D. Photograph from Purgatory: Two Women with Stomach Irritations, 1982. Gelatin silver print, toned. Joel Peter Witkin. (Courtesy of George Eastman House Collection, Rochester, New York.)

Publications

Celant, G. (1995). *Witkin*. Zurich; New York: Scale, distributed in North America by DAP.

Witkin, J. P. (1998). *The Bone House*. Santa Fe, NM: Twin Palms Publishers.

WOLCOTT, MARION POST (1910–1990) American

A courageous social documentarian, Post Wolcott's short photographic career is highlighted by her three years photographing for the Farm Security Administration (FSA). Strand and Steiner, friends from the New York Photo League, introduced her to Roy Stryker, Director of the FSA's photography project who hired her to join the project from 1938 through 1941. Her growing social awareness was fueled by her encounters with race and class inequality in the pre-war rural South; with humor and pathos, her photographs often explore the politics of poverty.

Publications

Alinder, J. (ed.), Wolcott, M. P., and Stein, S. (1983). *Marion Post Wolcott: FSA Photographs*. San Francisco: Friends of Photography.

Hurley, F. J. (1989). *Marion Post Wolcott, A Photographic Journey*. Albuquerque, NM: University of New Mexico Press.

Wolcott, M. P. *Looking for Light*. New York: Random House. Out of print.

CONTEMPORARY ISSUES

J. TOMAS LOPEZ, EDITOR
University of Miami

A Different Set of Questions for a New Age

J. TOMAS LOPEZ

University of Miami

Since its inception, photography has functioned as a catalyst for change and revolution, not just in the recording of world events, but as a tool for many disciplines. One could argue that photography's discovery has had the same impact on art, communication, and the sciences as the printing press had on the distribution of literature. The printing press at the time of its invention may have primarily been thought of as simply a tool to facilitate the reproduction of manuscripts and bibles, but what could not be predicted at the time was the impact it would have on the democratic distribution of ideas across social classes and borders that would change the perception of the world. The definitional rights of people would no longer simply be controlled by a few and books became the currency of ideas.

There is very little doubt that photography has changed the way we perceive the world. The early photographs that were made by Eadweard Muybridge (to settle a bet as to the position of a horse's legs when full out running to confirm if they were ever all completely off the ground) established photography as the definitive tool for empirical evidence. Harold Edgerton's high-speed flash images of playing cards ripped by a bullet as well as Lennart Nilsson's life before birth photographs revealing life and creation did not lessen that epistemology. When one considers photojournalism, modern history has been more clearly defined by photographic coverage than by the words that were used to describe the same events.

For the first time in the history of this book, the *Focal Encyclopedia of Photography* has included content that does not simply define chemistry, physics, or the history of photography; rather it describes the contemporary issues found in photography and the contemporary image-making processes. This section also speculates what the future trends and directions in photography may be.

From these larger concerns, I formulated a series of specific queries directed at individual professionals in the field. I chose four topics and sought writers actively engaged in the issues: photographic theory, which included modernist and post-modernist approaches; professional practices, addressing changing methods in professional photography, both in the classroom and in the studio; the process of seeing and perceiving, or decoding images toward an understanding of their function in art and society; and the hypothetical future, examining new directions in technology and their impact on photography.

For the pedagogical section I asked how the transition to digital imaging has impacted schools, faculty, and their curriculums. I queried them as to how this shift affected space, budgets, and the missions and objectives of current photo programs. Specifically I asked how the individual instructors had transitioned from silver to silicon and to briefly share their own personal transition. Margaret Evans elected to write a narrative of personal and professional considerations for the mission of education. John Kaplan's essay addressed the issues of teaching and thinking about journalism as well as how journalistic ethics and practices changed. Fundamentally, "Are there new considerations that must be taught and instilled to this generation of image-makers?"

In the section on signs and codes I asked whether there was such a thing as photographic "seeing" and whether language or the syntax of photography was at risk in considering such a semiological and theoretical argument. Richard Zakia's long and respected interest in the semiotics of sign systems made him uniquely qualified to address these issues in his thorough investigation.

A. D. Coleman is interested in the implications of digital on the world and the chasm between artist and audience. This gap is not just of message or meaning but also of

accessibility. Does an artist working at the cutting edge of digital imaging continue to distance himself from those whose hardware/software tools are incapable of accessing? Photography in the 19th century became a tool for creating democratic multiples. Does digital technology return us to an elite world of only the *haves* accessing these art forms and artists?

In considering publishing/distribution Millard Schisler and Barry Haynes were asked to ponder how the digital evolution has impacted that field. New possibilities in hardware and software have made publishing widely accessible, but do these same possibilities present challenges to the future of published material? Mr. Haynes, co-author of *Photoshop Artistry*, releases a new edition of his manual every year (or certainly every time the software is upgraded). Has this created a modern day version of Sisyphus? Professor Schisler notes that the transition from "everybody wants to publish" to "everybody can publish" brings along an interesting conundrum: It is at once more democratic yet the economic realities of the digital divide create a new paradigm of privilege and marginalization.

Daniel Burge examined the issue of preservation. Since photographs function across so many interdisciplinary fields, the concern that they remain accessible and vibrant is crucial. Images are not to be thought of as objects placed in a time capsule, they are an essential part of the ongoing debate of culture. Formats, storage, costs, and access are in a crucial stage of development and must be considered.

Doug Manchee provides us with a practical hands-on approach to the studio of the 21st century. What should the considerations be for space, electricity, computers, cameras, and future tools. There have been suggestions that the simplicity and ease of digital image-making will make everyone a professional photographer. It has proven to be a false concept. It is and will still be necessary for master image-makers to provide excellent images for advertising, journalism, portraiture, and fine art.

John Craig Freeman is a hypermedia artist. What is that? Is it a new discipline or is it the next stage in the natural evolution of photography? Hyperlinks offer a generation that is comfortable conflating image, audio, and text in a non-linear way to resolve the interplay between form and content. Does it (or did the invention of photography itself) mark the beginning of a post-literate culture? The inclusion of a glossary of new-media terms helps the reader understand this language with its own syntax and usage.

Daile Kaplan, director of Swann Galleries, has written an essay entitled "Photography Marketplace and Contemporary Image-Makers." She raised the possibility that photography has ascended to become a dominant medium in the art world with prices rivaling those of paintings. It is extremely difficult to visit any international art exhibit without the presence of photography and digital imaging among the celebrated displays. As photographs begin to sell for seven figures, it would seem that the future of this medium is very positive. Michael Peres and David Malin's eassay, *Science as Art*, reminds us that whatever aesthetic or theoretical perspectives one may hold, it is the wonder of the image that unites the viewer in assigning definitions. Whether an image was made for scientific purposes or to explore personal angst, the object the viewer sees must engage and transport the viewer as if by magic. It may be that at this juncture, where art, science and metaphysics touch that we find our most universal pictorial truths.

Part page photograph: Examples of contemporary photography by Professor J. Tomas Lopez. Top: Parisian Dream, © 2006—New York City, USA. From the "Subway Series"—life below ground. Bottom: Assassins © 2002 Paris, France. From the "Non a La Guerre" series—war protests around the world.

Academic and Pedagogical Issues: The Impact of Digital Imaging on Photographic Education

MARGARET P. EVANS
Shippensburg University

History

In the fall of 1993, after 20 years of working with a variety of traditional photographic media, I enrolled in the first of four courses in digital photography at Rochester Institute of Technology (RIT). I was between teaching positions at the time. Previously, I had taught photography courses in two separate photography degree programs, using traditional materials, processes, and creative methods. Increasingly, teaching position announcements were calling for knowledge of or experience with electronic imaging. My enrollment at RIT was an effort to prepare myself for one of these new positions. I was the oldest person in all of my classes.

The administration of the School of Photographic Arts and Sciences at RIT had been encouraging all members of the faculty to participate in seminars designed to introduce this new technology, which would eventually be phased into the curriculum as degree component requirements. Nevertheless, some of the photography faculty at the time were reluctant to believe that computer imaging could rival the traditions of film cameras and chemical darkrooms. Admittedly, despite the various forecasts that computer imaging would become dominant, the idea seemed far-reaching in 1993. By today's standards, computers, especially the Apple Macintosh for which most of the computer imaging programs were created, were expensive and slow. The software, including the foremost Adobe Photoshop, was tediously limited. Digital cameras were completely outside of most individual budgets, even for many professional photographers, and the image resolution remained seemingly light years away from that attainable with film. The best the industry could offer at the time was high-quality and expensive drum scanners and film writers that offered a "hybrid" of film and computer technology.

Computer imaging had been a common tradition in the publishing and advertising industries for many years before Adobe Photoshop or Apple Macintosh computers. However, those processes that mysteriously transformed photographic images into composites for the printed page were, in the early 1990s, for technicians rather than the creative minds behind a camera. Camera and darkroom traditions had been around for more than 150 years. By 1993, engineers at companies like Kodak had been tenaciously re-inventing and enhancing the standard technologies of film and photographic chemistry for nearly 100 years.

Yet, twelve years later, on June 16, 2005, Eastman Kodak announced that the production of their black and white enlarging papers would cease. Fifteen thousand jobs throughout the company would be cut by 2007, and a plant in Brazil would close. The announcement coincided with continuing reductions in profits from the traditional photographic market combined with an increase in the production of digital materials and equipment.

These were changes occurring at Eastman Kodak, the world's first and largest photographic company; the company whose motto was "You take the picture, we'll do the rest." That motto has now been transformed: "We make the equipment, you do the rest."

Back in 1993, I interviewed a number of professional photographers regarding the influence of the new media on their work. Everyone, including commercial and news photographers as well as internationally acclaimed artists, spoke of the transitions they were making based on the trend toward computer imaging. These photographers had all become involved in some way with digital imaging technology.

In a rapid transition, the faculty at RIT's School of Photographic Arts and Sciences came to embrace digital imaging as part of the curriculum and in their own work.

Computer imaging technology is now an integral part of the curriculum in nearly every photography degree program across the nation. Every photographer has been touched in

some way by the new technology. Most of today's photographers own at least one digital camera.

Mission Statement

Following my year of RIT courses in digital imaging, I did find a new position teaching traditional black and white and digital photography in the Communication/Journalism Department at Shippensburg University, one of the 11 Pennsylvania state university campuses. My initial tasks were to set up a new digital imaging Apple Macintosh computer lab and develop a course in digital photography.

The first step in expanding a traditional photographic curriculum to include digital technologies seemed to develop a mission statement. Faculty members in my department decided to bring in a consultant who had been part of the initial transition to include digital imaging in the curriculum at RIT. Professor Douglas Ford Rea had been the first faculty member at RIT to organize and teach a course in digital photography and was invited to share his expertise.

Professor Rea presented a daylong seminar to the faculty of the Communication/Journalism Department at Shippensburg University. Discussion topics addressed recent shifts in the industry: ways in which to prepare students to use the changing current innovations in digital technology, curriculum planning to include digital imaging, emerging innovations in digital cameras and image capture peripherals, and challenges created by choosing appropriate desktop computers and graphics and visual communication software.

As a result of the seminar with Professor Rea, a department mission statement emerged for developing a computer-imaging curriculum in graphic design, desktop publishing, magazine and book publishing, photographic imaging, and video imaging. It was important to recognize the impact of electronic imaging on commercial markets if our graduates were to be competitive in the search for professional positions. Instruction in the tools of electronic imaging systems would be incorporated in the curriculum to meet students' needs. The change was inevitable, and the transition would take years of continued research. Grants were written to establish and upgrade computer labs. Searches were conducted for adequately prepared faculty to teach new and upgraded courses. The economic impact of this change would positively affect new student enrollment both in our department and in the university.

Curriculum Issues

Curriculum issues in the teaching of photography in the early 21st century are central. My experience with the transition from traditional imaging to current technologies has been in a department that teaches an array of imaging courses in print journalism, public relations, and electronic media. All these areas have been affected by the change to computer imaging.

We currently operate three state-of-the-art computer imaging laboratories: an Apple Macintosh imaging lab, a PC electronic publishing lab, and an Apple Macintosh electronic media lab. All three labs have been established through successive grants from the university's technology funding administration. Additionally, grants are written each year to upgrade hardware (computers, digital cameras, printers, scanners, and other peripheral equipment) and software, including that which is used to teach digital photography, desktop design and publishing, and video editing. (More on grant writing appears later in this essay.)

Initially this essay will address issues concerning the teaching of photography and the transition to digital imaging, concentrating on the pedagogy of photography and digital photography. The emphasis will be not on isolating the digital imaging process, but on bridging the connection between the two technologies by teaching traditional photography and digital imaging in tandem.

A principal component of teaching photography is to inspire a stronger understanding of critical thinking. Both photography and digital photography are taught as electives in our Communication/Journalism degree program. Students in my courses are juniors and seniors. The courses are technical and skills-oriented, yet students must engage a number of thought processes to communicate an appropriate message.

Traditional photography emphasizes four basic tenets in the Introduction to Photography course:

1. To see as the camera lens does
2. To understand that the camera is a mechanical instrument subject to human control
3. To view and interpret images in various contexts (e.g., art, advertising, documentary)
4. To comprehend that every viewer brings individual biases to the interpretation of images

To see as a camera lens does means to understand that the world through the lens is fragmented into small selected rectangles of information. These rectangles can be vertical or horizontal. They can be flat or reveal depth; include a small detail, a medium view, or a wide vista; and they will include every piece of information in the scene within range of the lens. For example, sometimes, inadvertently, we find a tree growing out of a subject's head. Chords, light switches, and distracting lines may "mysteriously" appear in the frame.

FIG. 1 © Stephanie Prokop, grayscale image created from a scanned black and white negative 6.2 × 4 inches.

The camera's lens mechanically translates what appears in front of it on film in a series of tones that reveals shadows and light. The image is an abstraction of the real world. Regardless of the mechanical nature of the medium, the photographic record is not the actual real world. Rather, it is a translation or interpretation of that world.

The camera has mechanical controls that determine exposure, depth of field, and point of focus. The photographer controls point of view, aperture or shutter priority, exposure override, type of film, lens focal length, specific focal point, framing, and distance between subject and camera. The various choices of camera settings and points of view will yield diverse results.

Following an initial assignment designed to teach students how to control cameras for correct exposure and focusing, students complete an exercise in equivalent exposure. They must choose three different subjects. Two of those subjects must include some kind of movement. For each chosen subject, once the correct exposure is determined, students must choose from a range of aperture/shutter combinations to produce equivalent exposures with varying results in depth of field and either blurred or stopped-action movement.

Students complete one additional assignment in exposure control by learning to interpret meter readings and bracket exposures. The negatives show that some difficult lighting situations may call for an override of the meter's indication of a correct exposure.

FIG. 2 © Jill Rakowicz, traditional silver halide black and white photograph. Original size 9½ × 6½ inches.

In the darkroom, students learn to print black and white negatives on standard 8 × 10 inch resin coated enlarging paper. They become increasingly skilled at manipulating the overall and local contrast of the image and in recognizing where, when, and how to enhance detail within the frame. All images are printed full-frame in order to teach the importance of seeing the image at the time of shutter release rather than later in the darkroom.

Viewing the results of exposure preferences helps students to understand how choices in range of focus and frozen or blurred action affect the message of the image. During critiques, students analyze their own results and those of their classmates. They begin to understand how critical thinking about the message within the frame is demonstrated by how the photographer manages the mechanics of the camera.

Elements of composition are taught early in the semester, as many of my students have not studied any form of visual art prior to taking the Introduction to Photography class. A slide presentation in the elements of composition teaches students that the rule of thirds, simplicity, line, shape, balance, and framing all contribute both aesthetics and meaning to an image.

The abstract concepts I introduce on the first day of class are the similarities between photographic language and written or verbal language. Both languages contain simile and metaphor. During the first class, students explore images by known photographers like Edward Weston and those taken by former students to look for these concepts. Through these exercises, students learn that photographs may look like something other than the literal object they represent and the image subject may be unrecognizable from that original object, despite the mechanical nature of the medium. The photographs may contain symbols that have different meaning for different people. Visual simile and metaphor add to the significance of the photographs by enriching their subject matter with multiple levels of meaning. Successful photographs connect verbal and visual language.

Once students understand the mechanics of the camera and film and have practiced composition in framing their initial assignments, they are given two important projects that demand more advanced critical thinking of the message within the frame. One assignment is a series of portraits taken both in the studio and on a location of their choice. In both cases they must learn to control the lighting and collaborate with their subjects in order to create a portrait that engages the viewer beyond the surface of the photograph.

The second of these assignments addresses photojournalism and documentary photography. These subjects require the greatest amount of critical thinking for students in a communication/journalism major. The study of these topics includes discussion of the concepts of objectivity and truth. All photographs are empirical and conceptual on some level, whether they are journalistic or works of art. There are agendas to be met when taking and publishing photographs in newspapers, magazines, and on the Web. Every photographer views a situation from a different perspective, and every viewer receives the information through a set of individual predispositions. There are no absolute truths. There is no possibility of simple objectivity. Point of view and interpretation are part of every image.

In addition to photographing an event or creating a short documentary, students must choose a controversial photograph from a newspaper, magazine, or book and write a critique, indicating how technique, lighting,

FIG. 3 © Amyee Faber, black and white image enlarged on watercolor paper coated with liquid emulsion, 5 × 6.3 inches.

perspective, point and range of focus, and framing affect the message of the image. Class discussion of this topic including analysis of images in a slide presentation, written image critiques, and class critique of the completed assignments promote a more complete understanding of how photographs, despite having been mechanically produced, are subject to the rational lens of both the photographer and the viewer.

By exploring the mechanics of photography, analyzing images presented in class, and creating and critiquing photographs from assignments, students learn the power of critical thinking. In a world in which photographic images inform every aspect of our daily lives, it is important to expand the depth of our thinking so that we can become more aware of how the camera serves agendas. We must question what we see and how we think about what we see.

Digital Photography

Digital cameras operate very much like traditional film cameras except that the image capture is on removable media rather than on film. No chemical processing is needed and no film is consumed or has to be stored under archival conditions. The results are immediately available, and the capture media can be used repeatedly. Because of the instant gratification nature of digital capture and the "click and undo" aspect of digital image processing, many of the critical thinking steps of traditional film photography have been eliminated. The photographer still has to consider how manipulation of camera controls affects the visual message, but one can effortlessly generate numerous images with different perspectives and ranges of focus faster, covering more possible interpretations of a situation, and subsequently and easily, either eliminate the unwanted views or decide later which is most effective. With film, all of these steps can require laborious, cumbersome, or time-consuming effort. Also, photographic information can be altered more quickly, easily, and spontaneously in the all-digital world than with the traditional film or the film-to-digital hybrid forms of photography.

For these reasons, I require a course in traditional photography as a prerequisite to enrolling in digital photography. The process of critical thinking is as important as creating the images. As I described earlier, traditional film and chemical processing teach critical analysis with each new step. Eliminating the tactile, hands-on work that promotes satisfaction with each roll of film that uncurls from the reel and every image that emerges in the developer often means taking shortcuts to achieve results that require control and thoughtful creativity. There are many important links between traditional photography and digital imaging. Grain size, contrast, burning and dodging, cropping, and masking all have equivalents in both worlds. The frame of reference from the study of traditional film and darkroom processes allows students to make the transition to digital imaging responsibly and thoughtfully, with their critical thinking fully engaged.

Although my course is called "digital photography," digital cameras and their use are only one component of the syllabus. I present the camera and send students out to take pictures, which are subsequently downloaded and converted to TIFF images. The cameras are available for loan throughout the semester, and students are encouraged to use them to create images for the course as well as for their own creative use. However, much of the course includes working with image processing in Adobe Photoshop and with peripherals such as scanners and printers.

I teach as many hands-on tutorials as possible so that students can learn the processes of image manipulation, while also learning to consider the technical requirements. Thinking creatively is essential. These tutorials also allow students to work together in class, following instructions and learning to use Photoshop tools.

The three major and somewhat demanding major technical areas of digital image processing are presented as lectures and demonstrations. These areas are input (getting images into the computer with digital cameras, scanners, and photo CDs), color management, and output (or printing or optimizing images for the Web and other electronic publication). Each of these steps includes an important course assignment that reinforces the classroom discussions, demonstrations, and presentations.

FIG. 4 © Michael Profitt, digitally restored old family color photograph, original size 2.5 × 4.5 inches.

FIG. 5 © Rebecca Myers, digital photographic composite image, original size, 5 × 7 inches.

In the tutorials, students learn how to use selection tools, how to create and manage composite and adjustment layers, how to restore and use color creatively, how to choose and apply filters, how to create effective shadows, and how to blend image elements to create believable composites. The course assignments require that students scan and repair grayscale negatives and prints; scan, repair, and restore color photographs; create composite images; and create posters that depict messages regarding socially relevant issues. The color images are printed on color photo inkjet printers. Many are placed on view in our building's hallway display cases.

Students' previous experience with traditional photography has established knowledge of lighting and image contrast as well as critical analysis of image messages. One of the most difficult things to learn in the digital darkroom is when to stop working an image. Someone once said that Henri Cartier-Bresson's famous "decisive moment" has become the "decisive three weeks" in the digital world.

Making the Transition

For an institution that has not yet made the transition but would like to make the move to digital imaging, there are a number of important considerations:

Finances
Equipment and software
Computer lab space
Qualified faculty
Library and other resources
Developing appropriate courses

Financing the establishment of a digital imaging facility, qualified faculty, and library resources is the biggest issue. At my university and throughout the state system in Pennsylvania, grants must be written to establish need, academic integrity, coordination with other programs,

periodic assessment methods, library and other resource needs or sufficiency, impact on educational opportunity, identification of qualified faculty, space availability, and budget requirements for equipment and software. Additionally, since hardware, software, library resources, and faculty qualifications are ongoing costs requiring frequent upgrades, new grants must be written to cover these costs every one to two years. Additionally, faculty must refresh their knowledge and update their presentations to meet the ongoing changes in the field.

A private institution with a large endowment may not require grants to cover initial foundational costs, nevertheless, it may require substantiating narratives in the form of curriculum rationales to add facilities, equipment, and faculty resources.

The most efficient way to gain qualified faculty, if an added tenure-track line is not feasible, is to retrain existing photography faculty to teach the new courses. A photographer can learn digital imaging fairly quickly. Proficiency rapidly improves over time by working with the equipment and software. If the institution is fortunate enough to have funds for additional faculty lines or if a line opens due to a retirement, there should be no problem filling the position. Qualified MFA graduates with digital imaging credentials are now readily available.

Developing appropriate courses is a matter of writing proposals that list many of the same proponents as grants that establish the facilities, excluding the budget but including a detailed syllabus. At Shippensburg University, one course must be dropped if a new one is to be added. As the curriculum changes to emphasize computer and digital technology in all phases, some previously existing courses will become obsolete. It is usually not difficult to find courses that have not been taught in three years or more.

How to Find the Right Photography Degree Program

Students looking for the right photography degree program should consider the following questions:

Do you want to make photography your career?

What are your goals as a photographer?

How far from home are you willing to go to attend a college or university?

What are your family financial resources?

How much financial aid do you require?

What colleges or universities will offer you the best financial aid package?

Do you qualify for financial aid grants, loans, work-study, or scholarships?

What kind of climate is best for you?

Are you looking for an urban or rural setting?

What approach to learning is best for you?

Do you want to focus primarily on your career skills or are you looking for a more liberal education?

What photography and electronic imaging facilities does the college or university offer?

What degree level do you want to achieve?

What level of diversity of student body are you hoping to find?

Do you want to study abroad for part or all of your education?

When the above questions have been considered, the student can go to the Web sites listed below and begin to search for a photography school that most closely matches personal expectations. A student may have to settle for one or more trade-offs (such as a cold climate when a warmer place is preferred) if the program offered most closely matches one's professional needs. This research requires plenty of time. A prospective student should not be shy about calling a faculty member or admissions office personnel for further information. Sometimes making that personal connection can be the strongest influence in making a final selection. The faculty and administrators are themselves interested in increasing enrollment in their program, and they are customarily friendly and welcome calls from those who are considering their program.

It is advisable to attend admissions fairs. Representatives from many colleges or universities are usually there and will be happy to speak with prospective students and parents. Once

three to four applications have been completed, campus visits are advised as they are valuable in making the final decision. Viewing the campus and facilities for a major in photography and meeting some of the faculty give the visitor a definite sense of what to expect once enrolled in the program.

Conclusion

The study of photography opens avenues into a variety of career choices. The technical and visual skills required of a professional photographer provide the essential foundation to communicate ideas. The camera and the images created with it are ways to bring photographers closer to personal experiences and to critically evaluate world views. Digital photography is part of an increasingly large infrastructure of information technology. While electronic communication moves us into the world of the nanosecond, we should not lose sight of the fact that the flow of real content is the goal. Process generates ideas, which in turn produces content. Photography is a language that must be studied slowly, carefully, and methodically to understand its vocabulary.

Photography is an interdisciplinary study that contains rigorous theoretical connections to other disciplines such as philosophy, literature, history, social science, physics, chemistry, mathematics, communication, fine art, and journalism. The photographic medium can organize all of these disciplines through process and analysis of images. Digital photography is a way of advancing the discipline into the technology of the 21st century. However, electronic imaging requires a full and concrete basis in the original traditions of the medium to adequately comprehend the nature of creating images and the significance of those images to both the photographer and the viewer.

ADDITIONAL INFORMATION

http://www.photographyschools.com/
http://www.collegeboard.com/csearch/majors_careers/profiles/majors/103185.html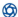

Ethical Photojournalism: Its Authenticity and Impact

JOHN KAPLAN
University of Florida

I had been an avid photographer since ninth grade and enthusiastically decided to enroll in the photojournalism program at Ohio University. With portfolio in hand, 5 years shooting experience, and more confidence than a 19-year-old deserved, I showed my work to renowned professor Chuck Scott.

Chuck was a bull of a man. Brawny and intimidating but also, as I later grew to learn, an unrelenting supporter and coach for the hundreds of young photographers who have come through his door. The master carefully eyed my work. He took particular interest in a scenic photograph of mine from Yosemite National Park. Taken during a multi-year drought in California, the shot showed an evaporated riverbed transformed into a dry, smooth granite earthscape. Captured at night with a tripod, the composition was made stronger by a bright full moon hovering over the textured composition.

The professor reached into his pocket, pulled out a shiny nickel and said, "Hey. Look here. Just about the right size." He laid the nickel on my print and had found a perfect match.

It was true, I said, proud of my naive creativity. When I made the print, I placed a nickel on the piece of enlarging paper as it was being exposed in the darkroom, thinking I had come up with a better solution to my novice, blurry technical rendering of natural full moon. As a freshman in college, I yet knew nothing of the ethics and mores of photojournalism, having

no idea that I could likely be fired for doing such a thing as a working photojournalist. Despite the power of his personality and God-like influence within the profession, Chuck was gentle with me. He told me to go back out and make pictures that viewers should have every right to believe in.

At that time, the post-Watergate era of the late 1970s and early 1980s, the public perception of journalism was riding high. Colleges were jammed with would-be journalists and newspaper photography was making a transition from craft to equal counterpart to the writing side of the profession. For example, starting about that time, as a hiring requisite, photojournalists were finally expected to have journalism degrees too.

Because of staunch supporters of visual truth like professors Chuck Scott and Terry Eiler at Ohio, Cliff Edom and Angus McDougall at the University of Missouri, John Ahlhauser at Indiana, and Howard Chapnick of the Black Star picture agency, the photojournalism industry was making an important transition. Strides toward credibility and equality were being made and photojournalism was on the path to no longer being seen as a second-tier operation in the newsroom. Such gains were made by advocacy of honest picture taking and the resulting integrity that it brought.

A few years before my unknowing indiscretion with the Yosemite picture, I remembered how a well-known photographer had shown me how he painted in birds with "spot-tone" ink on scenic photos of his own. And, when I arrived at the *Pittsburgh Press* in 1984, I was told that just until that year, sports editors would keep a bunch of cutout photos of hockey pucks in their desks for those prints that needed to have them glued on when the photographer missed the hard-to-capture timing of the stick slapping the puck past the goalie.

Decades later, the profession pretty much recognizes that pictures should not be "set up." Many newspapers have ethics policies that include staunch photo guidelines. Like most other contemporary professors, I tell my students at the University of Florida not to pose pictures and include an honesty policy with my syllabi. If a spontaneous situation cannot be captured with good planning and astute timing, it is always better to do a strong, posed portrait rather than create a pretend, tellingly stiff situation. When viewers look at a portrait, there is no "illusion of spontaneity," I say. Viewers should understand that a portrait is posed — the eyes of the subject usually look directly into the eyes of the reader. There is no misrepresentation.

As I mentioned, prior to the past few decades, posed photos rarely were questioned as non-representational of ethical photo-journalism. Joe Rosenthal's Pulitzer Prize-winning photograph of American soldiers raising the flag at Iwo Jima during World War II remains one of the most revered "news photographs" of the 20th century. Yet, despite common knowledge that the photograph was an elaborate reenactment made the next day, the photo is still deemed a seminal one.

A minority of photojournalists, including a few famous ones, still espouse that it is okay to consciously stage a scene. By asking their subjects to more dramatically re-create a moment actually makes it easier for their photographs to communicate more intensely, thus revealing a "greater truth," they say. Yet, I remind my students that rationalizing what might seem like minor choreography in photojournalism opens the door to having none of our work seen as believable.

For example, let us say you are a newly hired photojournalist asked to look for a feature picture for the next day's paper. You find a child having fun on a swing set in the local park. To get a better picture, you could say, "Hey Johnny, can you swing a little higher?" Or even, "Can you ask your friend, Jimmy, to come join you on the swing next to you so I can get a nice shot of you happy together?"

These are small things, still true to the reality of the scene, with the good intent of trying to get something more impactful for the next day's paper, right? Well, the kid would likely go home happy, proudly tell his family at the dinner table, and be pleased when seeing his picture in the paper the next morning.

Yet, in some small, but significant, way he will no longer fully trust every other picture he forever sees in the paper, or the pictures he sees online, as well as newsworthy situations portrayed on television. Was it posed, he will wonder? Is it truthful or was it created?

Also, do not forget the issues of financial liability if you asked a child to swing higher and then he fell off!

We must be believable. Each year, I ask my students, all journalism majors, if they trust what they see in the press as truthful. And, almost universally, even budding journalists say they do not.

Our modern-day interpretation of simply knowing not to pose a shot other than a portrait is, in my opinion, a too simplistic foundation for photojournalistic ethics. Merely not setting up a shot is not the same as telling the truth. What about authenticity? Consider deeper questions that every photojournalist should ask himself or herself.

Let us picture a hypothetical situation. A news photographer is sent out to document a routine story about police officers doing surprise vehicle stops to check for seatbelt compliance. An unappreciative motorist argues with officers that he had no right be indiscriminately stopped, leading to an escalation of tension, an abrupt pushing match, and ultimately a situation of possible police brutality as officers subdue the motorist by force with their nightsticks.

The photographer faces a quandary. She is not sure if the policemen actually crossed the line, perhaps knows one of the officers involved, and may even rationalize that the use of force may have been a one-time indiscretion due to provocation or job stress. If the photographer then chooses not to share the image with an editor, or does not advocate strongly to have the photo published, it is a denial of the truth.

If the photo editor also sees the picture but deems it not germane to the theme of the assignment and also neglects to advocate for its publication, it could be argued that no ethical breach occurred. But the choice of whether or not to publish transcends a simple definition of photojournalism ethics. Not publishing the controversial shot shirks photojournalism's responsibility to society and to the reality of what occurred.

In such a situation, I believe it is always best not to self-censor. Publish the picture and let the readers make up their own minds about the proprietary of the situation. Should publication of the photograph also have the very real ability to possibly incite civil unrest, the photographer and editors would also have a responsibility to carefully, painstakingly, study the image before putting it in the paper, and to seek out both sides of the story before publishing it. This balances the public's right to know with social responsibility. Since the photo was captured in public, privacy is not an issue here.

The ethics of photojournalism must be about so much more than easy definitions of not contriving a shot. It means being true to yourself and true to your community, too. In fact, the modern photojournalism movement was founded more than a century ago through the publication of photographs that cried for a halt to injustice and the move toward social change.

When we lift the camera, we each make both conscious and subconscious decisions about what is interesting, what is relevant, and what is just. When we click the shutter, those decisions are shaped by our backgrounds and belief systems.

Paul Lester of the University of California describes seminal early 20th century events in the history of social documentary photography in *Photojournalism: An Ethical Approach*.

Lewis Hine of Oshkosh, Wisconsin, worked in a factory for long hours during the day when he was a boy. Consequently, his photographs of children suffering for many hours at low pay and with dangerously, fast-moving machines were vivid and disturbing. Child labor laws were passed to protect children, a direct result of his photographs.

Fellow social reformer Jacob Riis used his camera to document *How the Other Half Lives*, a late 1800s photographic chronicle of conditions of terrible poverty among New York immigrants.

Most photojournalists that I know would describe themselves as socially conscious and open-minded. But when the mind is open to one point of view, is it not also closed to others? Although we would all like to pretend we do not possess prejudices, we must even consider our own range of cultural and political influences.

When up-and-coming photographers look at awards, they readily see certain themes repeated. Prize-winning shots are often about various social problems, disease, conflict, and the "negative" sides of life. And, as one builds a reputation in the field, it is only natural to emulate the sorts of topics earning recognition by peers.

Winning awards can certainly be important for career development or landing a better job. Yet awards have nothing to do with our higher calling in photojournalism. We should all ask ourselves the hard questions of truth and authenticity—questions that rarely pose simple answers.

I recommend an annual exercise in authenticity to photojournalists at any level in their careers. At the end of the calendar year, try making at least a dozen prints of your favorite images of the past twelve months. Look carefully at the range of topics and themes presented in what you deem to be your strongest work. Here are some questions to consider. Just remember that in a subjective profession like photojournalism, our diversity as visual communicators can be our collective strength. We are probably not meant to agree on each of the answers.

In your work, have you consciously sought to capture a balance of topics and types of people?

Do your images go beyond just the literal capturing of too-easy images of social problems?

Do the pictures that do show problems also provide insight and induce a feeling of empathy? And, are they intimate without being exploitive?

Do your photographs portray people's lives merely on the surface from the outside looking in, or do they communicate the intimate moments of your subjects from the inside looking out?

Is your best work of the year a balanced portrayal that does not ignore important social problems, but also seeks to show solutions and positive happenings, too?

As my mentor Chuck Scott told me only recently as I interviewed him for my book, *Photo Portfolio Success*, make pictures with "real, meaningful content, not just pretty pictures. They ought to say something important."

Personally, I do not believe in absolute objectivity but I do believe in fairness. When I traveled to West Africa to do a self-assigned portrait series on torture survivors in Sierra Leone and Liberia, to be honest, I was not seeking to be objective in any way. What had occurred in the civil wars of Sierra Leone and Liberia was as horrific a genocide as had occurred anywhere in the world in the past century. My hope was to photograph portraits of the survivors with dignity and to give a voice to the voiceless by telling personal stories of torture largely ignored in the West.

The goal was true to the precepts of what is commonly known as social documentary photography. Like Riis, Hine, W. Eugene Smith, and so many others before me, I wanted the power of the pictures to move people, and to affect them deeply, hopefully doing my small part to galvanize the movement against the recent use of torture by more than 150 governments, negating any seeming rationale for its use.

My photographs did not seek balance because, when genocide is concerned, there are not two sides of the story. It is horror and nothing else, despite the barbarians who still justify it as a valid information-gathering technique.

Still, when I arrived home after two weeks in the field with achingly dramatic portraits of those who had been tortured, I wondered if I truly had something worth publishing. Or, was I just rationalizing what I term *photojournalistic pornography*, raw imagery with no real redeeming social value?

Truthfully, I badly wanted to see the photo essay published, but tried to ask myself those hard questions mentioned above. I was not absolutely certain the work truly communicated, rather than exploited.

I decided to telephone Kim Phuc, whose name you may know. She was, as a young girl, the subject of another of the most famous 20th century photographs, a Pulitzer winner of a child running from a napalm attack during the Vietnam War. Nick Ut's photograph of her is often credited with hastening the war's end.

Phuc now lives in Toronto and is a happily married mother, directing a human rights foundation bearing her name. After she invited me to send my portrait series for feedback, she convinced me that I must find a way to publish it. Here are her comments:

When I see these pictures they break my heart. I feel the pain and suffering and relate to them from my own experience. I know how these people are feeling, how hurt and how hopeless.

I was also an innocent child surrounded by war. I remember hiding in the temple as we saw the war come to our village. The children ran . . . I saw the airplane. I saw firebombs raining down; fire was everywhere. My clothes were burning off . . .

Now I see these people in Africa, even girls and boys, in a situation because of terrible human behavior. I can feel it because I also have suffered. I can see how these people relate to me, because they also come from a different culture and country. But when I read their stories, it helps me to know that they still can have hope.

We cannot change what has happened in the past but can move on for a better life. Each of these people has their own personal story. People suffer. Their lives are destroyed for nothing. We don't need that. We need love and to help each other. We are all human beings. We must move on and choose the way to find forgiveness.

I cry out to ask people to help each other as much as you can. Do something. Not talk, but action. People have to love and lead with love and compassion.

As Kim Phuc's life so clearly reminds us, pictures can change the course of history, a high ethical calling indeed. My photo essay was published in the *St. Petersburg Times*, and in magazines and books, later winning Overseas Press Club, Pictures of the Year, and Robert F. Kennedy awards. The positive reaction to an inherently negative topic helped me to be confident that the story did indeed have social value.

Even more satisfying was the United Nations request to use the work to facilitate contact with the victims as part of its Sierra Leone war crimes tribunal. This was certainly no objective journalistic use of the work, but, instead, a deeply meaningful one to me, and to the victims who sought justice.

Portraits from my photo essay, *Surviving Torture*, have won many major awards in the photojournalism field, including the Overseas Press Club Award for Feature Photography, and honors from Pictures of the Year International, the Robert F. Kennedy Foundation, PDN Best of Photography, and The Best of Photojournalism Awards. Kaplan was invited to show the work at the best-known symposium for photojournalism, *Visa Pour L'image* in Perpignan, France.

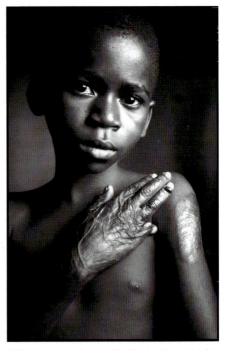

FIG. 6 Tamba Saidu, 10. Koidu, Kono district, Sierra Leone. "What we should do is to learn to forgive those who have done this act. If we do not learn to forgive the war, it will continue to the next generation." John Kaplan.

As technology continues to change how we capture and disseminate images, and impact our work habits, let us keep in mind the sage words of Bob Gilka, the former Director of Photography at *National Geographic*. In his career, Gilka has seen the typical photojournalists go from using bulky 4 × 5 inch Speed Graphic cameras, to 35mm, and now to all-digital image capture. As Bob says, "Bright as he is, man has not developed an electronic successor to creative thinking."

Technology helps us, but also opens a Pandora's Box of temptations to cut ethical corners. When citing ethical lapses of judgment, many refer to the infamous "moving of the Great Pyramid" by *National Geographic* in 1982. When a gorgeous horizontal shot from Egypt did not fit the magazine's cover format, an unwise designer used digital software to slide the mighty Pyramid a bit to the left, making for a *better* cover, and a major mistake in ethical judgment.

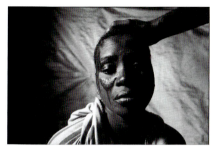

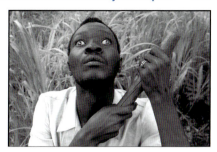

FIG. 7 Cumbay Samura, 28. Falabah, Koinadougou district, Sierra Leone. "Her father disappeared in the attacks on Nyaeudou camp. We don't know where he is. Many people lost their lives." John Kaplan.

FIG. 9 Fayia Skeku, 34. Shamabu, Kailahun district, Sierra Leone. "They made me to open my eyes and forced sand into them . . . They made me look at the sun for three hours . . . I don't know where my family is. I got separated from them." John Kaplan.

FIG. 8 Aiah Tomboy, 29. Soewa, Kono district, Sierra Leone. "I was forced to watch as three men lifted a heavy rock and crushed my mother's head. I could not bear to watch and burst into tears. Because I cried, a guy came and cut me in six places with a machete." John Kaplan.

FIG. 10 Fayia Mondeh, 51. Seima, Kono district, Sierra Leone. " 'Lay down your hand,' they said . . . Five were killed in my presence, as if normalcy." John Kaplan.

It should be noted that Gilka and his photography staff had nothing to do with the transgression.

In 1994, *Time* severely darkened the face of murder suspect O. J. Simpson for its cover. Reducing the photo's color to nearly black and white while lowering contrast to a murky tone made Simpson appear that much more suspect. Readers may not have noticed if not for the fact that rival magazine *Newsweek* used the same police mug shot without manipulation for its own cover that same week.

In 2003, *Los Angeles Times* photographer Brian Walski transmitted dramatic war photographs back from the Iraq War of a British soldier attempting to calm desperate Iraqi civilians. The problem was that a picture editor from a sister newspaper, the *Hartford Courant*, realized that similar faces in the crowd repeated themselves exactly within the best photo. It was also later determined that, through the misuse of Photoshop software, the soldier's most dramatic gesture was transposed from one photo onto another. When confronted by his boss,

Times director of photography, Colin Crawford, the photographer owned up to his visual lie, saying "fatigue" had gotten the best of him.

Walski was immediately fired. As Crawford told Kenneth Irby of the Poynter Institute for Media Studies, "What Brian did is totally unacceptable and he violated our trust with our readers . . . If our readers can't count on honesty from us, I don't know what we have left."

The photographer later apologized to his co-workers via e-mail:

This was after an extremely long, hot and stressful day but I offer no excuses here. I deeply regret that I have tarnished the reputation of the Los Angeles Times, a newspaper with the highest standards of journalism . . . I have always maintained the highest ethical standards throughout my career and cannot truly explain my complete breakdown in judgment at this time. That will only come in the many sleepless nights that are ahead.

While the *Los Angeles Times* is a publication that clearly realizes it must be believable, many magazines now intentionally seek out illustrative imagery in their use of photography, rather than literal, narrative photos. With fewer magazines publishing traditional reportage these days, most magazine photographers are self-employed as *editorial photographers*, rather than strict *photojournalists*.

"Editorial photography clearly encompasses more than photojournalism," says Tom Kennedy, another former *National Geographic* Director of Photography. "The environmental portrait, or celebrity portrait, has grown up as a genre. As a matter of economics, the photographer is asked to create a reality rather than be an observer of the human condition. Working hand in hand, there is a direct collusion between the subject and photographer."

As publicists and art directors also shape this "new" view of reality, a photographer runs the risk of forgetting how to capture images spontaneously. By creating artificial realities in highly paid commercial work, the photographer should also be sure that it does not bleed away authenticity, Kennedy says.

"I want to see who you really are. Work out of a wellspring of personal commitment," he advises.

A commitment to authenticity can also extend to a photographer's decision on when to raise the camera, and when not to. So much in today's media culture is about representation of truth, rather than truth itself. For example, *Reality TV* is anything but.

Although several of my good friends are practitioners in the field of public relations, and ethical ones at that, the blurring of news and the world of promotion has allowed those who seek to distort the facts to hide under the cover of calling themselves journalists. Instead, they hawk a clearly biased agenda and the public is none the wiser. Today's typical television viewer may often have trouble differentiating a slanted version of the news promoted on a program such as *The O'Reilly Factor* with organizations that really do strive to be *fair*, rather than purposefully twist the word *fair* into a manipulative sales slogan.

What does this all have to do with photography? Well, when the photojournalist goes on assignment, agendas at every end of the political spectrum will always look to find novel ways to make news. If a photographer is sent to cover a protest, and arrives to see the protestors calmly sitting on the curb waiting for the media to arrive, raising the camera is only asking for a choreographed show. If the protest is created merely for the sake of media coverage, the photographer's overly eager presence encourages such stage acting. The only way to know for sure is to get out onto the scene, be observant, and use wise judgment.

Similarly, when the subject of a story first meets the photojournalist, he or she will often seek to please, perhaps changing a daily routine by doing the sorts of things thought to yield better photos. I was confronted with this issue when doing a project about the diverse lifestyles of American 21-year-olds that later won the Pulitzer Prize for Feature Photography. One of my subjects was Brian, a San Francisco prostitute who left a good home in the Washington suburbs; he was rejected after coming out to his parents.

Brian would turn tricks just often enough to get enough money to buy amphetamines; he would then shoot up in local flophouses. He had a likeable personality, so much that the

other streetwalkers had nicknamed him, "The Ambassador of Polk Street." As I documented his tragic life, it became apparent to me that he enjoyed the attention brought by the photographer's presence, and was eager to be photographed in any situation.

Brian lives on the edge and by the needle. He has no permanent home and supports himself on San Francisco's infamous Polk Street. When not on the street, he works the bars. He says he takes precautions to prevent AIDS but many fellow prostitutes have contracted the disease.

From the photo essay, Brian: Shooting Drugs and Selling Himself, published as part of John Kaplan's Pulitzer Prize winning series, 21: Age Twenty-One in America.

After a few months of photographing him as he drifted from San Francisco, to Sonoma County, and then Los Angeles, my photo story was nearly complete. Since I also was the writer for the project and had interviewed him about his self-professed love of speed, I thought that a picture of him shooting up would show the full scale of his tragic reasoning for becoming a prostitute.

He knew that I was interested in capturing that particular situation and cheerfully asked me one afternoon if I wanted to see him shoot up. I reluctantly agreed but only after a deep discussion about his motivations, and even a conversation about photojournalism ethics. Although I had never previously had occasion to talk about ethics at this level with a story subject, I had to be as sure as possible that my presence was not serving to encourage his dangerous behavior. Indeed, if Brian had shot up only for my benefit, I could have never lived with the guilt, had he overdosed.

FIG. 11 Brian shoots up speed at a Hollywood, California, hotel. "I need to get high . . . high as a kite and then deal with the world," he says. John Kaplan.

FIG. 12 Without a home and living on the street in Hollywood, Brian scavenges in a trash dumpster. He thought he saw a watch. John Kaplan.

A discussion of photojournalism ethics and authenticity would also be wise to consider another subjective factor, rarely discussed. What about the ethics of interpersonal relationships within the profession? Social responsibility in photojournalism must extend well beyond the shooting process.

I have known otherwise dedicated photojournalists who care deeply about communicating issues through their images, who, at times, cut ethical corners in their relationships with peers back in the newsroom. What good is living up to the highest standards of truth telling with the camera if a photographer is not also willing to carry through by dealing with editors and co-workers with the same care?

As I tell my students, "you are responsible not only for your own success, but also for the success of the group." We have a responsibility to photograph passionately, but also to contribute to the shared goals of the photojournalism community. This will help ensure that up-and-coming photographers have the same zeal for ethical, story-telling photography for generations to come. To my mind, those who tell half-truths to promote their own work, or to slyly demean others, without also making an effort to support and encourage the good work of peers, do a disservice to the cooperative spirit of the world of photojournalism.

When we speak of truth, up-and-coming photojournalists may be reminded that, in a free society, we have the right to be there. To get to the truth, we need to fight together for access.

Always assume that in most any public place, the First Amendment guarantees this right. Although diplomacy and good sense are important traits of the photojournalist, if you too eagerly look for permission to shoot, your access will often be denied for no good reason.

Remember that it does not matter which side of a particular story you most identify with personally. Seek to tell the truth and ask yourself the soul-searching questions to consider your own biases and to be sure you are not being manipulated.

When it comes to competition, an adrenalin-producing component of the world of journalism, the most important thing to remember is to only compete with yourself. You cannot control what others do or how they shoot. Contests can be good motivators but are inherently subjective. Five different judges will often yield five different winners. Go ahead and enter them but have the fortitude to follow your own personal sense of vision.

Each and every shooter is capable of great work if he is willing to work toward excellence. When shooting, have patience and wait for the moment. Arrive early and stay late. Take the safe shot first and then dare to be innovative. Try to spend enough time with your subjects so they will soon become comfortable with your presence; that is when the real moments will begin to happen.

Seasoned photojournalists understand ethical guidelines and mechanics of making good photographs early in their careers. The ones who succeed over the long term possess these three traits:

1. They like people.
2. They have a curiosity about the world.
3. They are committed to telling stories with integrity and honesty.

Lastly, believe in yourself. Do not be perfect. Be passionate. Great, important, pictures will follow.

FURTHER READING

Kaplan, J. (2003) *Photo Portfolio Success*. Cincinnati, OH: Writers Digest Books.

The Future of Publishing

MILLARD SCHISLER
Rochester Institute of Technology

New hardware products and software developments have made publishing widely accessible to the masses, but these same possibilities also present their challenges to the future of published materials.

Introduction

To talk about the future of anything is definitely a challenge unto itself. Things have changed so much in the last 20 years in the publishing industry and how people communicate that it becomes difficult to predict where this industry will be in the next 20 years. We can, however, talk about some very important ideas and lessons that we have learned in the recent past and make attempts at intelligent remarks on some of the roads the publishing industry is heading.

What is Publishing?

Initially, we must look more carefully at the term publishing. This term has seen a significant change. If one were to look at the Wikipedia definition of publishing, we would see:

Publishing is the industry concerned with the production of literature or information—the activity of making information available for public view. Traditionally, the term refers to the

distribution of printed works such as books and newspapers. With the advent of digital information systems and the Internet, the scope of publishing has expanded to include Websites, blogs, and other forms of new media.

Notice the expression "production of literature or information" and then consider the rest of the definition. Publishing today could be encompassed by this underlined phrase. Publishing makes information available for public view. Producing information is the key concept here. The format that conveys the information does not matter. The traditional information channels in this concept are referred to as books and newspapers. These channels are now coexisting with a large array of digital information channels. Information can also be conveyed through photographs, videos, music, Web pages, blogs, electronic newsletters, journals, etc. What is even more interesting is to realize that all these formats might have different modes of capture but they all end up in the same digital data stream.

Even when we talk about ink on paper such as books, magazines and newspapers, the original data that generated them is digital. Therefore, the road ahead holds a shift from publishing to the model of digital publishing. Many traditional printing companies that are eyeing the future have transformed their profiles into communication/publishing companies capable of handling the dissemination of information in all possible venues.

Making something available for the "public view" is also an important notion. If you write or photograph for yourself only and never make this information available to others, one would consider this material as never before seen and/or published. It is when you take this information outside of your own group or circle that we start to consider the concept of publishing.

Publishing and Photography

Hopefully this initial introduction can help explain why publishing and the future of publishing is being discussed and is so relevant in a book like this one. Photography is still the "writing with light," as the name implies. The analog signal is no longer embedded into silver grains but converted to a digital signal. This signal then becomes a part of this larger field of digital information/communication. Therefore, we can consider photographers as publishers of visual information and photography a visual channel, part of the multi-channel publishing universe—magazines, books, Web, screen displays, cell phones, PDAs, prints, blogs, etc.

Photography as a technology is also converging into the electronics industry. The players of the photo world are no longer dominated by Fuji, Ilford, Agfa, and Kodak. Many of the traditional camera manufacturers are out of business. Sony, Epson, Hewlett-Packard, Samsung, Apple, and some of the stronger camera manufacturers like Nikon and Canon are the players in the digital imaging world. Kodak has moved into digital imaging and publishing. The electronics are what bring these companies together. Your phone becomes your camera, your camera becomes your video recorder, your video recorder can be a camera, and your phone/camera can play digital music and access the Internet. These are all devices that work with semiconductors and digital signals. Certainly we will see more of this convergence in the future.

Therefore, it is easy to understand that photography is deeply tied in as a component of this revolution in publishing from "everybody wants to be published" to "everybody can publish." If we go back to the Wikipedia description, we will see that traditionally, publishing is related to "the distribution of printed works such as books and newspapers." Being published used to mean that someone took enough interest in your work to print it; to put ink on paper. In non-digital, traditional printing processes, this also meant large up-front costs in the production cycle in hopes of having a successful return on investment. Only select works would be published.

Being published carried and still carries an aura with it. Just the distinguished accomplished this in the prior era of publishing. The common saying "plant a tree, have a child, write a book" as the benchmark of achievement seems to convey three important ideas of leaving a trace in humanity after you are gone. The tree and the children will grow and replicate, the book will disseminate itself throughout time—all ways of leaving something behind, being immortalized. Being published is still for a select minority.

For the other vast majority, it is no longer necessary to wait to be published, and photographers and artists can self-publish for themselves. Publishing is no longer just ink on paper. The many different venues available today have made this possible. You can start a blog or an online journal. These can also have images in them. They can eventually end up as ink on paper with the ease of digital printing. Books can be designed and printed; images and text can be published on the Web. These are just a few of the ways that information can be made available for public view by groups and individuals.

A More Democratic Publishing Network

Publishing has become more democratic and less aristocratic. It is not in the hands of a few decision makers anymore. Independent presses are growing all over the place, community interest groups are producing their own publications, and individuals are acting as independent publishers. This will continue to grow and expand as more people have access to cheaper technologies. The newer generations will have more hardware and software knowledge as they incorporate the tools and products into their daily lives.

This spread has most certainly diminished the impact and aura of publishing, allowed for more ideas to be out in the public, and given all of us a better chance to be seen and heard. Although, in this new paradigm, no one will be immortalized anymore for "writing a book" or for being published.

Changes in Printing

The possibilities of printing have changed. Photo quality and longevity of inkjet printing are common realities as are high quality and lower costs in color laser printing. These printers are declining in price, increasing in speed and quality, and becoming more and more accessible. The home office of today can easily publish "one of a kind" publications in full color.

Large-scaled digital printing presses have made the concept of print on demand (POD), a reality allowing the printing of only one copy if needed of any publication or small runs of a few dozen copies. It would have been cost prohibitive in the past to make printing plates, get an entire press inked up, and run hundreds of sheets of paper to get consistency in ink density and registration to then print a few dozen copies of a job. Digital printing allows us to go from digital files straight to paper. Distributed printing is possible—printing closer to or at point of use. Variable data printing is another possibility. It consists of printing a project connected to a database of names and information so that in a print run of 1000 postcards, for example, each individual card can be personalized based on the database provided.

Digital Divide

The digital divide is something we must not dismiss when considering the fact that anyone can now publish. The digital divide represents the socioeconomic difference among communities in their access to computers and the Internet. It is also about the required knowledge needed to use the hardware and software, the quality of these devices and connections, and the differences of literacy and technical skills between communities and countries. All of these concepts define who can really publish and this should make us re-think the term "everybody can publish." When we think of the World Wide Web, as of today, it does not yet encompass the entire world. Many of the countries on the African continent, for example, have less than 5 Internet users per 100 inhabitants as opposed to the richer countries in the world that have over 50 Internet users per 100 inhabitants. We are seeing a small but decreasing gap in this divide, and this trend will continue.

Lessons We have Learned

Data storage problems, legacy software and hardware, finding and losing digital information, and preservation are still real issues in the digital world. Most users have lost at least some degree of digital information. Digital information is easy to generate, but can be easy to lose and hard to find if careful strategies are not in place. We can type away, take hundreds of pictures with a digital camera, download the digital data from the card, and repeat this process

over and over again, and generate hours of digital recording of music or video. The problem is keeping this information, organizing it, seeing it, and not losing it. Much like a traditional library, we need ways to catalog and preserve digital information so that it can become an asset for use in publishing venues, and be available for future generations.

The response to this has been the growth of digital asset management (DAM) and metadata (data about data) as ways of keeping track of digital information. This will allow us to find, retrieve, and commercialize these data. It is clear now that individuals and organizations need to invest in this area to have their data survive in the digital world. Data that do not have metadata attached to it or do not belong in a larger DAM structure will not survive. This can resolve the problem of finding the information, but it still needs to be stored somewhere.

We have realized that hard drives are not permanent storage devices. They have a rather short life span. Even though there are many variables that affect the duration, many companies that opt to play it safe will move their data to new devices every four to five years. CDs and DVDs of today are contemporary ways of storing data but may not be able to be read in future devices. Even if they could last 50 to 100 years as readable physical objects, the more immediate threat will be technological obsolescence that will make currents discs obsolete within a few years. Think about large 5 inch floppy disks, magnetic tape drives, zip disks, and the more recent 3.5 inch diskette. Very few systems are available today to retrieve information from these devices. And these have been the main storage devices for the past 20 years.

Software is temporary. Upgrades, newer versions, and new concepts make software obsolescence a reality. Publications built in older versions have to be converted, sometimes through cumbersome and lossy processes, to newer formats. If software used to read data becomes unavailable, a migration or emulation technology is needed to access the data.

Consequently, because of software and hardware limitations, consumers and businesses alike need to have a migration plan to new storage technologies and upgrade plans for the format of the digital data if they want their information to survive over time. As we see publishing residing in the digital world, these lessons learned will help us prepare for the future.

What We are Learning Now

There are several things that are becoming mainstream that will have an important effect on the future of publishing. We are learning about the impact of these ideas and technologies and about how they will change our notions of information exchange in the years to come.

XML—Structured Publishing and the Semantic Web

There are several technologies that are works in progress that will push publishing to new directions. XML (extensible markup language) is presenting a wide array of possible models for cross-media publishing. If structured with purpose during the document design stage, a correctly tagged master document could be created once and subsequently published in any array of different formats, hence the term cross-media, which would include screen displays of all kinds (PDAs, cell phones, etc.), the Internet and, of course, print.

The critical transition necessary to fully realize the next generation cross-media publishing model will be a shift away from document structure tags that strictly articulate the format of content, but also articulate the contextual meaning of that format.

To understand the limits of basic document structure tags, consider the following example. If there is a section of text that has a tag like <Bold>text</Bold>, the text contained will be displayed as bold and the function of the tag is to define the appearance of that text. If we consider moving this text to other platforms, from the Web to print, or the Web to a PDA, or print to the Web, the text will still be displayed as bold, as defined by the tag. This may not always be appropriate for that particular output/device. In this case we would say that the tag is defining the appearance/content of the entity.

In a tagged XML structure, we are able to create and define our own unique structure. We could define that this piece of text is important, thereby creating a markup such as <Important>text</Important>. We can use style sheets to create conversions that are customized to the medium being published to. For example, in printed text we could set

the "important" tags to be defined as bold, in a cell phone they could be defined as flashing reversed text, on the Web as a larger font, etc. In this case, we would say that the tag is defining the meaning of the entity. Its appearance is defined based on the style sheets that set how to display this information based on the meaning/XML tag from one source to another.

This concept of structured information will allow us to think in terms of semantics—the study of meaning. This will be the age of semantic publishing. The structure of documents and the Web today are based on the appearance of objects. Upcoming publishing and the Web will be semantic, based on the meaning of objects.

Extensible Metadata Platform

Created by Adobe and immediately made available as a non-proprietary format like XML, extensible metadata platform (XMP) provides a way of embedding metadata right in binary files. This allows us to give meaning or add intelligence to images, illustrations, and page layout designs. Computers only recognize digital images, for example, as bits of information and not what the image means. It is through metadata and XMP, tied into XML-structured documents, that we will build meaning to the digital information that is made available.

E-Paper, Electronic Publications, and Richer Content Creation

Our digital displays have become lighter, thinner, smaller, and more flexible. We have moved from large cathode ray tubes to lightweight liquid crystal displays. These are available in cell phones, PDAs, computer screens, and other display formats. We are moving toward an electronic version of paper, the e-paper. For millenniums paper has been the format for conveying information. It is not surprising that our future displays will be paper-like, emulating the feel of paper.

In an e-paper world, digital publishing will supersede the possibilities of printed ink on paper. Ink on paper will become costly and used mainly for very special, limited editions. Newer generations will be brought up reading on portable, flexible digital displays. We already have interactive electronic publications (PDFs) that go beyond text and images. They can contain sound, videos, hyperlinks to other digital content, and the universal three-dimensional format (U3D). The list of possibilities will grow. Documents with richer content can convey much more information than conventional ink-printed documents. They become less linear and much more dynamic and Web-like.

100 Years from Now

DANIEL BURGE
Rochester Institute of Technology

Introduction

When the question is asked at conferences, "Where will the photos taken today be one hundred years from now?," one is really asking two different questions. One question is: "Will we still be able to access and print the image *files* stored on our computers and writable compact discs created with this technology?" The second question is: "Will the *prints* I make today have faded and yellowed away into oblivion?" The answers to these questions are vital when considering the purpose of a collection, which needs to be maintained for the long-term while also allowing for consistent accessibility and usability. If content is not accessible, it would just be an isolated time capsule. So the problem isn't just can someone access images produced *in* a hundred years but *for* a hundred years.

Analyzing the life of a print is actually the easier problem. In many ways that answer has been forming over the last 20 years as preservation technologies for traditional photographic prints have dramatically advanced. As you will read, many of the techniques for saving digital prints are the same as for the traditional photographic prints of the last hundred years.

The first question regarding digital image files is more difficult because opening and displaying an electronic file is much more complicated than just looking at a print. To access the image files, we will need to still have access to the software that can interpret the file's data format, an operating system that can run that software, and a computer that can run the operating system. Every component of the imaging system needs to be maintained to get the picture back from the file.

Technological obsolescence and *material decay* are two primary forces that restrict if not eliminate our access to our images in the future, whether as digital files or physical prints. In addition, there is always the possibility of damage due to mishandling or disasters such as fire and flood, but here we will focus on obsolescence and decay.

Obsolescence is the process of new technologies supplanting current technologies in such a way as to make the current technology useless. For example, the automobile made the horse and buggy obsolete as the primary mode of human transportation. In the same way, advances in the field of computer technology have left a wake of dead technologies. Computer speeds and capacities have grown rapidly. Each new increase in computer processor speed results in a new crop of faster running software applications. New applications have led to larger files. Larger files have led to changes in electronic file storage media. It would not be possible to store even a single digital photo on a 5¼ inch floppy disc from the 1980s. Even new versions of popular software evolve so dramatically that files created from the same product three or four versions past cannot run on new versions. As time marches on, we cannot stand still or the wave of technological development will pass over us and leave us dead in the water with software we cannot run and image files we cannot open.

The second force, material decay, is slower but just as insidious. Some may hope that they can overcome the forces of technological obsolescence by printing out all of their images, but all print types decay. Heat, moisture, pollution, and light breakdown the colorants that make up the image as well as yellow and embrittle the support. Decay also slowly damages electronic file storage media (such as CDs and DVDs), hard drives, etc. But obsolescence will probably render the disc and its data useless before Mother Nature can. So what can we do? Who do we ask for help?

In general, the computer and digital imaging industries have contributed only slightly to solving the problems of long-term accessibility of digital images. Most of the corporate information on image permanence is marketing verbiage implying that permanence is somehow a quality of their particular product or of digital systems in general. However, the current lines of hardware and software will soon be supplanted by new ones and the manufacturers have offered little help to users on how to manage their current files for long-term access. Even the producers of printers, inks, and papers attribute their permanence claims to narrowly defined, non-standardized tests. It is extremely difficult to decipher exactly what the claims are based on and what they really mean for users.

Unfortunately there are no easy answers to this problem; in fact, there are no real answers at all. No individual, company, or institution has been able to develop a practical, fail-safe scheme to ensure the long-term accessibility of digital images. There are currently two separate philosophies that have developed on how to approach the problem, but neither has been formulated into an overall, acceptable strategy.

Essence versus Object

These approaches were well described by Andrew Wilson of the National Archives of Australia in his presentation at IS&T's Archiving 2005. He compared the strategy of saving physical objects (the storage media containing the image data or the actual printed image) with saving the "essence" of the images. So what is this essence, and how do we preserve it? For most of us, printing from the original image file offers no additional value to printing from an electronically copied file. Theoretically any copy of the file, as long as it contains no losses in data, is equivalent to the file first created. Wilson stated that their philosophy was that "preserving the object is meaningless" and that The National Archives of Australia focuses instead on maintaining the essence of the image and the interaction between the data and the technology

that reads it. The essence consists of data, reading software, and an operating system sufficient to generate a visual representation of the image.

Concerns regarding preserving the essence

This philosophy, a strategy of migrating the image data across media formats, as in CD to DVD, does not reduce the value of the final output or display of the image; neither does converting the file from one image file format to another. By consistently migrating the data as new file formats become introduced and popularized and new file storage media replace older slower, lower capacity types, it is possible to maintain the ones and zeros of the images regardless of changes in technology. It does have its drawbacks in that a great amount of effort and resources are needed to consistently migrate the data through each new advancement in technology. This effort is not to be underestimated, as it requires a staff with high-level computer skills in addition to one with traditional image archiving skills. For consumers this strategy may be completely untenable.

The second strategy involves maintaining the original files and then at some future time accessing them through computer "emulators" (software programs created to make a current computer function like an older computer). Of course these emulators will also need enough of the original operating system and the original image reading software to display the image on a monitor and new drivers to print the image to modern printers. Again this approach would require significant technical skills and knowledge of historical computer systems to create the variety of emulators for all of the types and models of computers used up until that point. And they will have to be created before access in needed. If access is needed periodically, then emulators will have to be created as an ongoing effort for each new generation of computers attempting to access the collection. For consumers this approach is even more untenable unless these "emulators" are available commercially, which has not happened even for the previous generations of computers. Nor is it likely to happen as an emulator would have to be created for every new generation of computer. If you are planning on taking the route of just saving the files in their current formats and using an emulator in the future to access them, know that you are relying on a product that does not currently exist. If no one actually creates the emulators 100 years from now, you must create it or you are out of luck.

Another suggestion has been the development and publication of standardized, non-proprietary file formats; reading software; and operating systems. These certainly can be created and attempts have been made, yet these will likely still suffer the pressure of advancing technology, eventually rendering them obsolete as well. The only advantage would be simply to reduce the number of times migrations would have to be made or the number of emulators that would have to be created.

In many ways the maintenance of a digital image collection is the function of an IT department and not an object archive. The commitment to advancing technology in both the computer and data management is no small task in itself. The strategies of the traditional, artifact-based archivist become a minor subset of the digital archivist's duties and not the main activity. When attempting to maintain an electronic storage of digital image files, it is imperative to become actively involved with professional societies (such as the Society of American Archivists or the Digital Library Federation) that discuss these issues. You cannot afford to fall behind in technological updates or advances in preservation strategies.

It is true that for most of us the essence of the image is what is critical for digital photographs. It seems highly unlikely that a simple one size fits all strategy can be developed. It will be up to each individual or institution to devise strategies that best suit its goals and resources, and with that will also come an acceptance of the limits of what they can and cannot do. Of course, in some cases, especially for fine art, the original print will be more valuable than a reprinted version, as the original will have been handled personally by the artist and the print will have been deemed acceptable to the artist at that time. For these, the essence of the image is what the artist created, not what the computer recreated. It would be analogous to comparing an original Ansel Adams print to a print made from one of his negatives at the local drugstore.

Concerns regarding preserving the object

The second approach to saving a collection is to preserve not the essence but the objects themselves. Within the "objects" strategy there are two separate sub-strategies: preserving the original file storage media or preserving hardcopy output. Preserving the original file storage media is probably a weaker approach than attempting to preserve the image's essence. Not only will emulators still be needed to access the files on future computers but the hardware readers to access the media will either have to be preserved or recreated. Attempting to preserve the original reading devices will likely be unsatisfactory as they will also degrade over time due to internal corrosion. If they are used continuously over time they will also fail due to wear and tear and still have to be physically recreated. The media themselves will also be prone to natural aging and be potentially unreadable in the future as they too are sensitive to the forces of heat, moisture, and pollution.

In addition to attempting to save electronic file storage media on your own, there is saving data for hire in the form of digital repositories. These are large data storage facilities whose prime function is to store digital data files similar to the types of physical storage repositories already in use for traditional photographic films and prints as well as paper documents. While some may be associated with specific institutions, others are businesses who draw revenue from renting the electronic storage space. They too are subject to obsolescence problems and must be responsible to notify you if migration to new file formats is necessary. There is also the risk that the repository may go out of business with access to your collection restricted or even lost completely.

This leaves us with the final strategy of attempting to preserve the prints. One advantage of prints is that they are human readable so no reader system needs to be maintained or recreated. The prints can also be in the form originally produced, which may have some historic or artistic value, though it is possible that future printers may produce prints that would have been more pleasing to the originator. On the other hand, printing is expensive and prints take up greater space so a larger area will be needed to house the materials. If the area needs to be temperature and humidity controlled, this will also increase the cost of maintaining the collection.

Suggestions for preserving the essence

It is not possible to suggest in this essay which path is most appropriate for any given collection. The decision whether to attempt to save the data that recreate the image upon display or saving a large collection of already printed images must be decided by each individual or institution alone. The advantages and drawbacks of each strategy have been given. Below are suggestions to keep in mind when attempting to implement your particular strategy. They are not to be taken as a preservation strategy in and of themselves. They are merely aspects of the problem which should be considered.

Keep separate master and working versions of files. The master files should only be used to create new working files as needed or for the process of migration to new media or file formats. It is important to make sure that the master copy contains as much information as possible. It must be large enough and have enough resolution for all potential future applications. If only enough resolution is saved to adequately display the image on a monitor, it will not be accessible later in printed form. Of course there will be a trade-off in that larger files will take up more electronic storage space and take more time to copy if the migration strategy is employed.

There are currently a variety of file formats by which the image data is encoded and software programs that can read these formats. Because of this it will be important to select file formats for master copies that have broad acceptance and do not lose information during transfer. To prevent data loss during usage of images select lossless file types such as TIFF. The popular JPEG format is lossy and degrades in quality upon each usage. If a JPEG version of an image is needed then copies should be created from the master file. There is also the question of RAW files versus corrected files. JPEG and TIFF files are corrected by software in the camera to produce images that more closely match human visual responses. RAW files contain the exact, uncompressed data that the light-sensitive chip in the camera collected upon exposure. This would be a great advantage except that each camera manufacturer has its own proprietary

version of a RAW file. This would make it close to impossible to open years from now if that format fell out of use. There has been an attempt to create an industry standard RAW format by Adobe Systems called DNG (for digital negative). Having an industry standard should be helpful, however, Adobe still owns the format. Having a format published by ISO would be better, but has not happened. For now the best strategy may be to pick either a popular, lossless-corrected format or Adobe's DNG format.

Data also need to be protected in terms of security from viruses, worms, and computer malfunction. It is critical to protect the computer systems which create, house, and read the images from infiltration by criminals or vandals. Keeping up-to-date with the last anti-virus software and preventing unwanted access through the use of firewalls is critical, but may not be 100% effective. For this reason all images should be backed up onto other computer systems and/or written to stable, appropriately stored and handled file storage media. Multiple copies of the media can be created and stored in separate locations to prevent loss due to fire, flood, or accidental damage.

Suggestions for caring for electronic file storage media

While file storage media should not be viewed as an appropriate archiving format, it is still imperative that current use of the data is not lost through negligence in the handling of those materials today. *The Care and Handling of CDs and DVDs—A Guide for Librarians and Archivists* by Fred Byers and published by the National Institute of Standards and Technology suggests the following:

1. Handling discs by their outer edges or the center hole.
2. Using a non-solvent-based felt-tip permanent marker to mark the label side of the disc.
3. Keeping dirt or other foreign matter from the disc.
4. Storing discs upright (book style) in plastic cases specified for CDs and DVDs.
5. Returning discs to storage cases immediately after use.
6. Leaving discs in their packaging (or cases) to minimize the effects of environmental changes.
7. Opening a recordable disc package only when you are ready to record data on that disc.
8. Storing discs in a cool, dry, dark environment in which the air is clean.
9. Removing dirt, foreign material, fingerprints, smudges, and liquids by wiping with a clean cotton fabric in a straight line from the center of the disc toward the outer edge.
10. Using CD/DVD-cleaning detergent, isopropyl alcohol, or methanol to remove stubborn dirt or material.
11. Checking the disc surface before recording.

Temperature and relative humidity recommendations for the storage of optical disc file storage media are given in ISO 18925 Imaging Materials—Optical Disc Media—Storage Practices. In general, optical disc media should be stored at room temperature and within a range of 20 to 50 percent for relative humidity. Cooler than room temperature conditions are encouraged to reduce the rates of deterioration reactions.

In addition to controlling the storage environment, it is important to select and use appropriate enclosures for housing the media. The purpose of the enclosure is to protect the surfaces of the disc from damage due to handling. Jewel cases provide the greatest protection for individual discs, but they are thicker than paper or plastic sleeves so fewer discs can be stored within a given area. Long-term reactivity between enclosure products and the various media have not been adequately studied. Certainly plasticized films, such as polyvinyl chloride (PVC), should not be used, as oily deposits may be transferred to the media over time.

Suggestions for preserving prints

As with electronic image files, it is important to keep separate master and working copies of each print. Make sure that the master copy contains as much information as possible. The print must be large enough and have enough resolution for all potential future applications. Of course there will be a trade-off in that larger prints will take up more physical storage space

than smaller prints. These prints should not be used themselves; copies of these prints should be created as needed so that the original is not at risk for damage.

There are a variety of systems now available to print out digital photographic images. These include inkjet, thermal dye transfer, and electrostatic/photographic as well as traditional photographic papers. Because there is a wide range of quality for these materials both in terms of initial image quality and long-term stability, it is not possible to make specific recommendations. However, it is generally agreed that pigment colorants are longer lasting than dyes. No matter what the original print material, their life expectancies will be increased through the use of proper storage.

Currently there is no ISO standard that provides recommended storage conditions specifically for digital hardcopy outside of traditional silver halide images. It is likely though that since the same forces that drive the decay of traditional photographic images are the same as those for most digital hardcopy, the storage recommendations for the former should apply to the latter. The current ISO standard for the long-term keeping of color reflection prints is ISO 18920 Photography—Processed Reflection Prints—Storage Practices. Unfortunately, the temperature required for the long-term keeping of color prints is below 2°C (35°F), and as such requires special storage facilities. The temperatures suitable for human comfort cannot ensure long life for many of these prints, though future advancements in colorant and support technologies may result in prints that may be kept at room conditions.

In addition to proper storage environments, the use of safe enclosure materials is also necessary to ensure the longevity of digital prints. All enclosures should meet ISO 18902 Imaging Materials—Processed Photographic Films, Plates and Papers—Filing Enclosures and Storage Containers. They should also meet ISO 14523 Photography—Processed Photographic Materials—Photographic Activity Test for Enclosure Materials (soon to be renamed 18916) to ensure that they will not fade or stain the image over time. In addition, Mark Mizen and Christopher Mayhew showed at IS&T's NIP17: International Conference on Digital Printing Technologies in 2001 that when images are stored in albums, plastic page protectors offer additional protection from atmospheric reactions. These will also offer protection from abrasion and liquid spills.

Suggestions for displaying prints

One of the first preservation problems to be found with digital prints was their sensitivity to fade by light, especially those sources high in UV radiation such as fluorescent lights and sunlight. The manufacturers quickly went to work finding ways to make their prints last longer on display. It was such a problem that light stability came to be synonymous with image stability. Manufacturers started quoting print life expectancy based on their material's ability to resist change in the light. Unfortunately, there are many other problems in determining print life expectancy that the light tests did not reveal. The most significant of these was print sensitivity to fading from airborne pollutants such as ozone. In fact, some prints faded faster on exposure to ozone than they did to light. Ozone exists in the atmosphere everywhere. It is also generated in human environments in a variety of ways including electronic air cleaning devices and laser printers. Another problem set of pollutants are the nitrogen oxides. They are also generated in many ways but a big contributor is automobile exhaust.

Because digital prints should not be directly exposed to sunlight or fluorescent light for extended periods of time and airborne pollutants at all, they should be displayed in sealed frames with a UV-protecting glass or plastic in front. It is highly recommended that the print not be placed directly against the glass or plastic glazing, but that a mat spacer be used. This will prevent potential adhering of the print surface to the glass or plastic over time. It may be impossible at times to remove a print that has bonded to glass. The matting and mounting materials used to frame the image should be of the same quality as the materials used for storing prints in the dark.

Additional suggestions for both essence and object

Information about each image including a description of the image's content, its date, its location, the photographer, the owner of the image, etc., are all critical components of the image.

Many traditional photographic prints contained this information in pencil or ink inscriptions on the reverse side or on the enclosure whether an envelope, mat, or album page. Collections of images which have lost all their identifying information become useless when they become detached from original owners who used personal memory to keep track of their images. Adding descriptive information is critical to both images stored as data or printed images. Stored image files can be identified either as a function within their file name (e.g., DEC25 05 Dallas Xmas Jones) or as fields in a database. Large volumes of images with camera original alphanumeric identifiers or incomplete shorthand naming will likely be lost simply as they become unidentifiable within large masses of other image files.

Even if images are stored electronically with logical naming systems and attached descriptive information, the discs themselves need to be labeled, housed, and stored in such a way that the intended disc can be easily retrieved from hundreds or thousands of discs. A drawer full of unlabeled CDs is useless.

No matter whether the file containing data or actual prints is being preserved, redundant copies should be stored at a different location to provide against total loss if one facility experiences a significant disaster such as fire, flood, or earthquake. Another form of redundancy is saving both the image file as well as a hardcopy printout. Of course this requires even greater efforts on the parts of the person or persons responsible for ensuring the long-term access to the image. Also, stored image files or prints should be periodically inspected to ensure that they are still accessible and usable.

Unintended effects of digital image preservation on traditional image preservation

An unintended effect of the rapid change from traditional photography to digital may be the eventual decline in availability of negative printers and film projection systems needed to access photographic negatives, slide films, and motion pictures. If these materials remain in collections, the appropriate playback devices must be maintained for the given formats.

The same is true for magnetically recorded video tape. Ironically, many people transferred film-based home movies to video tape which is a less stable media, and that media is in danger of being replaced again by optical discs. If the original movies were not saved, the optical disc version will need to be created from a video tape with likely reduced image quality.

Summary

Lee Mandell and Sue Kriegsman of Harvard University wisely observed at IS&T's (the Society for Imaging Science and Technology) Archiving 2005 that "Trying to keep up with digital preservation is similar to standing on a sand dune and having the bottom shift out from under you at unpredictable times. Preservation of digital images cannot be based on technology alone, be they stored in computer systems or output from hardcopy printer systems. There still needs to be people valuing the preservation process, so that human effort, time, and financial resources are continually applied. In fact, this is the key. Perusing computer and digital imaging publications in order to find the "right" software, electronic file storage media, or printer systems will not suffice. Nothing short of continuous action upon these issues as a way of life can bring about the much desired result of long-term accessibility to our cherished image collections.

FURTHER READING

A Consumer Guide for the Recovery of Water-damaged Traditional and Digital Prints. Image Permanence Institute, November 2004.

A Consumer Guide to Traditional and Digital Print Stability. Image Permanence Institute, November 2004.

Byers, F. (2003). *Care and Handling of CDs and DVDs—A Guide for Librarians and Archivists.* Gaithersburg, MD: National Institute of Standards and Technology.

ISO 14523 Photography—Processed Photographic Materials—Photographic Activity Test for Enclosure Materials.

ISO 18902 Imaging Materials—Processed Photographic Films, Plates and Papers—Filing Enclosures and Storage Containers.

ISO 18920 Photography—Processed Reflection Prints—Storage Practices.

ISO 18925 Imaging Materials—Optical Disc Media—Storage Practices

Mandell, L. and Kriegsman, S. (2005). Digital Repository Planning and Policy. IS&T's 2005 Archiving Conference. Washington, DC, April 26, 2005, pp. 5–8.

Mizen, M. B. and Mayhew, C. M. (2001). Influence of Enclosure and Mounting Materials on the Stability of Inkjet Images. NIP17: International Conference on Digital Printing Technologies. Fort Lauderdale, FL, October 2001, pp. 231–234.

Wilson, A. (2005). A Performance Model and Process for Preserving Digital Records for Long-Term Access. IS&T's 2005 Archiving Conference. Washington, DC, April 26, 2005, pp. 20–24. ◉

Perception, Evidence, Truth, and Seeing

RICHARD ZAKIA
Rochester Institute of Technology

In 1978 Henri Cartier-Bresson reminded us that Photography has not changed since its origin except in its technical aspects, which for me are not a major concern. (Zakia, 2000, p. xv) This statement, by one of the great artists in photography, is worth pondering particularly with the increasingly sophisticated imaging technology now available. Regardless of the medium used, how high tech it might be, and with what speed images can be captured, manipulated, and transported, it is the human factor that is most important. Pictures, regardless of how they are created and re-created, are intended to be looked at. This brings to the forefront not the technology of imaging, which of course is important, but rather what we might call the "eyenology" (knowledge of the visual process—seeing). What is known about vision and the visual process is overwhelming; what is directly applicable to pictures is not, and this is some of what will be covered in this section.

In the early 1900s, perceptual psychologists at the Berlin Psychological Institute were involved with research in how we see. Out of their research emerged a number of important and practical principles sometimes referred to as the Gestalt laws. They also put forth the concept of a *ganzfeld*, a completely homogeneous visual field in which nothing exists, no objects, no surface texture—just light. When a person is subjected to such a visual field for a prolonged period of time he feels disoriented, may hallucinate, and some experience a temporary loss of vision. The eye must have something on which to fixate for the visual system to function properly. The closest we come to experiencing a homogeneous visual field, other than in a laboratory, includes situations in which a person is completely enveloped by dense fog or a severe snowstorm (a "whiteout"), which causes plane accidents in addition to accidents on the road.

To see, we need something on which to focus. To be able to determine the size of an object in our visual field we need to be able to compare it to a familiar object. **Perception is relative**. The painting, "La chamber d' ecoute (The Listening Room)." by Rene Magritte illustrates this very point. An apple rests in the middle of what appears to be a normal size room but is not. It is miniature, and because of this the apple is seen as gigantic, filling up the entire room. So-called "table top photography" and miniature movie sets such as those used in the film epic *Star Wars* are also examples of how relative our perception is. As long as all the objects on the table or in the movie set are of similar scale, things will appear normal.

Figure–Ground

What we visually attend to at any time is called figure, and it is always against some kind of background. The first step in perception is to distinguish figure from ground. The Danish

psychologist Edgar Rubin demonstrated this in 1915 with two profile faces facing each other (Figure 13). A person normally sees the faces as figure but with a little suggestion he can see the space (ground) between the faces as figure and forming a goblet. (As early as the 1700s French and German artists were *embedding* faces in landscapes. One such is titled "Concealed Profiles of the Rulers of Europe" by Christian Schwan. It is in the Metropolitan Museum of Art, New York.)

A few important observations regarding figure–ground include

FIG. 13 Figure–ground reversal by Danish psychologist Edgar Rubin, 1915. One can see two profile faces or a goblet. Perception will alternate between the two.

1. Figure and ground cannot be seen simultaneously, but can be seen sequentially.
2. Even though the figure and ground are in the same physical plane, the figure often appears nearer to the observer.
3. Figure is seen as having contour; ground is not.

The importance of ground to our perception of figure cannot be overstated. One has only to look at *illusions*, such as the Herring illusion, Wundt illusion, and other such illusions to witness how ground can make lines that are physically straight look bowed.

The measurable physical reality shows that the lines are straight. The visual reality is that the lines are indeed bowed. Remove the ground however, and the lines will look straight.

The importance of ground is further demonstrated in looking at colors. A blue object surrounded by a complementary yellow color as ground will look much more saturated than if the ground is a neutral or green color. The physical color (the colorant) remains the same but the color (our visual experience — perception) does not. Perception is relative.

Common contour

When figure and ground share a *common contour*, a competition or rivalry is set up for possession of the contour (Figure 13). This causes our perception to shift back and forth as we choose to see one or the other as figure. The Dutch artist Maurits Escher was keenly aware of this as one can see in his intriguing work. Of this he wrote

The borderline between two adjacent shapes having double functions, the act of tracing such a line is a complicated business. On either side of it, simultaneously, a recognizability takes shape. (Zakia, 2002, p. 151)

In a playful mood Edgar Rubin in 1921 created a double profile outline of a face of a man and a woman trying to kiss but not being able to since their lips share the same contour and shift back and forth (Figure 14).

Photographic examples of common contour or contour rivalry can be seen in photographs of sand dunes by Edward Weston and in others where a sharp edge exists between a

FIG. 14 Kiss by Edgar Rubin, 1921. The kiss is denied since they both share the same lips (common contour).

dark area in the shadows and a light area in sunlight. (Photographs mentioned and not shown can be seen on the Internet. For example, click on Google, Image, Weston.) Rivalry for the possession of the contour between the dark area and the light area shifts the figure–ground relationship. Our perception of this exchange activates the area, giving it a dynamic dimension. The greater the contrast at the contour, the sharper the edge, the greater the effect. This can be seen in Figure 15, Dunes—Colorado by Dr. Thomas L. McCartney. The contours are common to both the light areas and dark areas setting up a visual rivalry. When the light areas possess the contour, they are seen as figure. When perception shifts to the dark areas as figure, the contour belongs to them. The rivalry is greater at the hard edges than the soft edges.

Another important facet of common contour is the ability to collapse depth. If a camera is positioned so that a distant contour shares a near contour, overlap as a depth cue is eliminated and the experience of depth is lost. Near and far objects are seen as occupying the same plane. This can be seen in Pete Turner's photograph called Push.

The contour of the flat part of the top of a trash can on a beach shares the same contour as the horizon line in the distance. Depth is collapsed where the contours meet but not in other areas of the photograph where parts of the scene near and far overlap. The loss of depth in one part of the photograph but not in other parts sets up a visual ambiguity, which adds interest to the photograph. Figure 16 shows a similar situation in a photograph by Gordon Brown. The top of the beach chair on the left shares the same contour as the horizon line. The top of the chair is seen as being out there where the horizon is while the bottom stands on the sand.

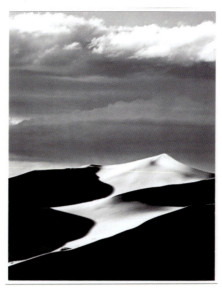

FIG. 15 Dunes-Colorado, Dr. Thomas L. McCartney. The white and dark areas share a common contour for which there is a competition. The area seen as figure will possess the contour.

FIG. 16 Beach Chairs by Gordon Brown. The chair on the left shares a common contour with the horizon, collapsing our perception of depth.

The beach chair on the right overlaps the horizon line, providing a necessary depth cue and feeling of distance.

Embedding

Having two shapes share the same contour is an effective way of *embedding* or concealing images. One only has to pick up a children's magazine and look at the "Hidden Pictures" illustration challenge. Children and even adults take pleasure in finding hidden/embedded images. This can be seen as a form of "hide-and-seek" or even "peek-a-boo," that fascinated us as little children. Both involve a sense of discovery. We play the game whenever we go to a flea market or garage sale or go hunting or fishing. As serious photographers, when we go out to photograph, there is something we hope to find, capture, and share with others. This search and discovery can be thought of as an *archetype*, part of our collective unconscious, a term Carl Jung introduced.

Camouflage

Camouflage can be thought of as a way of confusing the relationship between figure and ground, a way of creating visual noise. In wartime the razzle-dazzle patterns on ships, planes, trucks, and personnel break up the continuity of contours and shapes and therefore the figure–ground relationship. Cubism, as practiced by Picasso, Braque, and others, provided some of the inspiration for camouflage. Artists played an important role in creating such camouflage for the military, by breaking up and confusing figure and ground. When artists became part of the military camouflage units in WWI, an American army officer remarked "Oh God, as if we didn't have enough trouble! They send us artists!"

Gestalt

The Gestalt school of psychology, which originated in Germany in about 1912 by Dr. Max Wertheimer, provides some simple and convincing evidence about how we organize and group individual visual elements so that they are perceived as wholes.

At that time scientists such as Faraday and Helmholtz, who were researching electrical, magnetic, and gravitational phenomena, hypothesized that a type of electrical, magnetic, and gravitational "field" existed, and that physical elements within that field are held together by some type of sympathetic force. The field elements influence one another. They are either attracted or repelled. Their strength is a function of such things as size, position, and nearness.

Wertheimer might have argued that physical fields have their counterpart in visual fields. The main tenet of Gestalt psychology supports this. The way in which an object is perceived is determined by the total context or field in which it exists. Put differently, visual elements within a person's visual field are either attracted to each other (grouped) or repelled (not grouped). The Gestalt psychologists put forth a number of concepts to describe how grouping of visual elements occurs within a context of a field.

The same principles, interestingly enough, were used by Kurt Lewin to study the behavior of people within a particular environment, how they interact with each other in various settings such as school, office, factory, and so on. Photographers doing weddings and group portraits find themselves and their equipment as part of the group dynamics. Gestalt therapy, or Family therapy as it is sometimes called, is yet another example of how Gestalt principles are used. A problem a child may be having at home involves the whole family and how they interact. Similarly, a problem a student may be having in school involves the teacher, classmates, and the environment — the entire field.

Gestalt principles

The Gestalt psychologists were especially interested in figure–ground relationships and in the things that help a person see objects or patterns as "good figure." They suggested a number of principles including proximity, similarity, continuation, and closure.

Proximity (nearness)

The closer two or more visual elements are, the greater the probability that they will be seen as a group or pattern.

In Figure 17 the configuration of dots in A are all equally spaced and can be seen as forming a square. In B and C, by changing the proximity or nearness of some of the dots, we see them as forming a row or column of dots. It is helpful to think of the space between the dots as *intervals*; in this way one can see their importance as they relate to the interval of time in music. Changing the size or time of the interval changes the visual or auditory perception. It is also helpful to think this way when preparing a slide presentation with PowerPoint or editing film or video. The importance of proximity is both spatial and temporal.

FIG. 17 Proximity. Visual elements that are near each other will be seen as belonging together and grouped.

Similarity

Visual elements that are similar (in shape, size, color, movement, meaning, and so on) tend to be seen as related and therefore grouped.

A B C

FIG. 18 Similarity. Visual elements that are similar in appearance or movement will be seen as belonging together and grouped.

In Figure 18 we again see the configuration of dots in A as having the same proximity and are all similar in size and shape. To separate the arrangement so that we have rows and columns as seen in B and C, we need only change the shape or color of some of the dots. The proximity remains the same. We naturally group visual elements that are similar. Gyorgy Kepes, former head of Advanced Visual Studies at MIT, has written "Some elements are seen together because they are close to each other; others are bound together because they are similar in size, direction, shape." (Zakia, 2002, p. 44) A classic example of proximity and similarity working together can be seen in the 1914 photograph Jungbauern Westerwald (Young Farmers) by the great German photographer, August Sander. Three men with the same dark suits, white shirts, and dark hats stand at attention holding canes in their right hands. The two men at the right are seen as a pair because of their nearness or proximity, and because of the interval between them and the third man on the left. In addition, one notices that all three men have similar postures and expressions, but the two on the right hold their canes vertically and their hats are straight, while the man on the left has his hat and cane tilted. He also dangles a cigarette from his mouth. This dissimilarity provides a counterpoint to the similarities in the photograph and adds interest. A similar gestalt arrangement can be seen in Eroded Sandstones, Monument Park, Colorado by William H. Jackson, in Sea Urchins by Anne Brigman, and in Three Nuns by Henri Cartier-Bresson.

Symbolic associations can be seen as a form of similarity thus providing a connection between what is seen in the photograph and what resides in memory. For example, Bruce Davidson's untitled photograph on the cover of his *East 100th Street* book shows a child partially naked with straggly hair and head titled standing limp on a fire escape against a steel bar railing, which takes the form of a cross. Although not consciously intended by Bruce, it serves for many as a reminder of paintings of the crucifixion. Similarity by association can also be seen as a rhetorical form of *simili*. The photograph looks like a crucifixion.

Continuation

Visual elements that require the fewest number of interruptions will be grouped to form continuous straight or curved lines.

The array of dots in Figure 19 is easily grouped and seen as forming an X. This is because of the similarity and proximity of the dots as well as their continuation. One can also easily see a diamond shape. It would be more difficult, however, to see a large W or M (inverted W). This is because continuity would have to be disrupted. It takes more visual effort. A photograph that serves as an excellent example of the importance of continuity is Edward Weston's favorite photograph of his wife Charis, titled Nude 1936. . She sits with one leg tucked under her body and the other upright with her tilted head resting on it. Both arms embrace the legs in an oval shape with hands joined together at one knee. Her face is not visible, just the top of her tilted head, with her hair clearly parted. If one were to trace the contours of her arms and legs they would see a graceful continuation of curved lines.

FIG. 19 Continuation. Visual elements that are more easily seen as being continuous in direction will be grouped.

Closure

Nearly complete familiar lines and shapes are more readily seen as complete (closed shapes) than incomplete.

The array of dots in Figure 20 is more likely to be seen as forming a circle than discrete dots. Again, similarity and proximity are working to assist in the formation of the circle, of closure. In Michelangelo's painting "The Creation of Adam" (Figure 21), the critical space (interval) between the finger of God and Adam invites closure. By forming closure we participate in the painting. If the interval had been wider or shorter, the perception would be different.

Henri Cartier-Bresson's famous photograph "Place de l'Europe, 1932" shows a man leaping over a large pool of water in a flooded street and his reflection in the water. One of the things that makes this photograph memorable is that the man appears to be suspended in air. As he leaps, his forward motion is captured on film the instant before the heel of his outstretched right foot touches its reflection in the water. The decisive moment becomes the decisive distance—the critical interval that invites the viewer to participate in the photograph by completing the jump.

Forming closure on what is being looked at provides satisfaction and balance.

FIG. 20 Closure. Visual elements that can be seen as an incomplete familiar shape will be grouped to form closure and complete the shape.

FIG. 21 "The Creation of Adam" by Michelangelo. Each time we view this painting, we are invited to continue the movement and direction of the hand of God the Creator and form closure—the creation of Adam. The interval between the fingers of God and Adam is critical—the decisive distance.

However, there are times when making it difficult for a viewer to form closure can provide a challenge. Photographs that are ambiguous do just that. They provide a visual riddle that requires extended looking and participation to form a closure.

Pragnanz

The Gestalt principles of organization describe the way we tend to segregate and group visual elements into units or patterns. The overall rationale as to why we do this is explained in part by the law of *pragnanz,* which states that "Psychological organization will always be as good as the prevailing conditions allow." This can be seen in Figure 22 in which cube A is stable as a three-dimensional pattern and B as a two-dimensional pattern. It is difficult to see them otherwise.

Digital seeing

We live in a world of color. The sky is blue; the grass, green; a sunflower, yellow. Blue,

(A) (B)

FIG. 22 Perception is facilitated by good organization and design. Illustration (A) is easily seen as a cube, while (B) is not. (Scientists studying crystal growth under a microscope first observed the tendency of (A) to flip-flop.)

green, and yellow describe only one of the three attributes of color and that is hue (dominant wavelength of light). The other two are saturation (chroma), which describes how strong a particular hue is, and brightness (luminance), which describes the intensity of light.

FIG. 23 Zone System scale from black (zone 0) to white (zone X) in increments of one stop (a factor of 2, a log exposure of 0.3).

When a photograph is made on black and white, only the brightness of the colors is recorded on film or on a charge-coupled device (CCD) light sensor in a digital camera set for black and white capture. The brightness of the colors is recorded and seen as neutral colors, that is, grays. To provide a vocabulary for identifying the scale of neutral gray tones from black to white, Ansel Adams and Fred Archer created a numbering system using Roman numerals (Figure 23). They established what came to be called The Zone System, a method for calibrating all the components that go into making a silver gelatin print—camera, film, development, paper grade, and printing—to consistently arrive at a predictable quality print. One could think of this sequence as the color management of neutral colors.

In using the Zone System, the first and most important stage is visualization. With black and white photography, one must learn to see colors as having only brightness, void of hue and saturation. This takes considerable practice and skill. A Wratten 90 orange filter is sometimes used to assist in the process. Exposure is usually placed at zone I. The film is then developed so that highlight detail falls at zone VII or VIII.

With digital photography and color reversal slide film, the situation is reversed. Exposure is based on the highlights and placed in zone VIII. The shadows fall where they may depending upon the brightness range of the scene. A normal scene has a brightness ratio of 128:1, 7 zones, 7 stops, 2^7.

With black and white film, the range of exposures on the negative that is printable covers 7 to 9 zones, depending on the detail required in the shadow and highlight areas. The same is true for color negative film, but not for color reversal film such as slides and transparencies. These have a printable range of only 4 or 5 zones, as does digital photography, both color and black and white. A CCD or MOS sensor can only record about 4 or 5 zones with detail, which is about the same that an inkjet print will display.

Brightness ranges

The Zone System allowed film photographers to make silver gelatin black and white photographs of what they saw and how they wanted to render them by making adjustments to the brightness range of a subject using development variations. They had to learn to "see photographically" as Edward Weston put it. A short brightness range scene could be expanded by increasing development, a long brightness range compressed by decreasing development. Further adjustments were possible by local "burning" and "dodging" the print and even using bleach to whiten highlights. However, none of this was possible with color film, which contained three integral red, green, and blue sensitive emulsion layers that later, after development, are converted to cyan, magenta, and yellow (c, y, m) dye layers. Any attempt to control the brightness range by adjusting development in one layer would affect the other two integral layers and cause undesirable changes in color and contrast. The same is true for color negative film, but not for color reversal film such as slides and transparencies since the film in the camera was the final image.

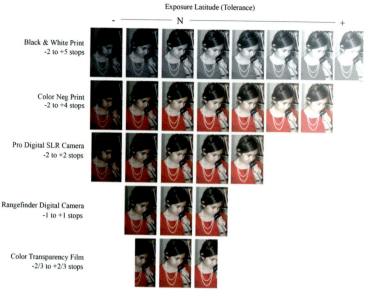

Exposure Latitude (Tolerance)

Black & White Print
-2 to +5 stops

Color Neg Print
-2 to +4 stops

Pro Digital SLR Camera
-2 to +2 stops

Rangefinder Digital Camera
-1 to +1 stops

Color Transparency Film
-2/3 to +2/3 stops

FIG. 24 Exposure latitude for film and digital. Negative films have the greatest latitude and greater for over exposure than under exposure.

Latitude

Exposure latitude refers to the amount of over or under exposure allowable before detail is lost in the image. Negative films, both black and white and color, have the greatest latitude and color slides and transparencies the least. Negative films are more forgiving for overexposure than for underexposure. Pro-Digital SLR cameras allow plus or minus two stops exposure latitude and RF digital cameras, plus or minus one stop (Figure 24). Color film slides have the least exposure latitude; plus 1/3 of a stop, minus 2/3 of a stop. Since negative films have considerably more latitude than digital sensors, they provide an advantage for image capture. The film negative can later be printed or scanned and used as a digital image for manipulation and printing. However, the short dynamic range of a digital camera can be extended by blending two images, one that has been exposed for the highlights and the other for the shadows. This allows one to render the range of tones much like the eyes see them in nature. A photographer can now create color images that are impossible with film photography. Another important fact is that the image can be seen in real time, immediately after it has been taken. This provides a great assist in translating the three-dimensional world to a two-dimensional image. Digital also provides an opportunity to enhance colors to bring out subtle effects not possible with film photography. Minor White would refer to this as "Interpreted Real." In the extreme, one can go from the real to the surreal easily.

George DeWolfe, who for many years used and taught the Zone System and was strictly a black and white photographer, on a personal note, wrote, "I think one of the major perceptual things that changed for me when digital arrived was my ability to make color images that I had traditionally seen and felt in the real world but found impossible with traditional photography." One might speculate that Ansel Adams and Edward Weston, both of whom are not noted for their limited color photography, might have been more successful had they had digital photography available.

Visualization

The zone scale, which had been widely used for film photography, can also be helpful for digital photography. Visualization is independent of the medium used. There is a difference in how

to interpret the zone scale for digital photography, however, since digital provides a more linear recording of light. The zones will record differently on the digital print. Generally, the low zones will register lighter in the print while the higher zones will register darker. For example, what is visualized as a zone VII will print darker and look more like a zone VI. A dark zone II will print more like a brighter zone III. Zone V, the middle gray, remains about the same. This, of course, presents no real problem when using digital since there are so many options available with software such as PhotoShop. "Curves" can be used to correct and adjust any of the zones in the final print. Even lighting and color can be manipulated. As practiced with film photography, one can make local changes using "dodge" and "burn" tools. In a sense, digital photography provides unlimited opportunities for post-visualization. Photographers can now become "painters."

Infrared

Some photographic films and digital sensors can "see" infrared radiation to which the eye cannot. Many objects reflect and transmit infrared radiation differently than light. The chlorophyll in green leaves, for example, is highly reflective of infrared radiation, causing the leaves to appear very dark on infrared negative film and white in the print. In short, when photographing in the infrared, what we see is quite different from what film and digital sensors see. This makes visualization, focus, and exposure difficult and prone to error. Digital photography takes some of the guesswork out of this. Now a photographer can actually see the infrared image on the liquid crystal display (LCD) of an infrared-filtered digital camera, make what changes are deemed necessary, and take another photograph if needed.

Capture and ritual

In comparing the process of creating a photograph on film, especially on a large-format camera with that of digital, an important component that can be lost is the actual process of capturing the image. With film photography, more time is usually spent in carefully studying what is to be recorded and how best to render it, realizing that the nearly unlimited options available with digital are not available with film. Further, large-format cameras, such as view cameras, present the image inverted on a ground glass for viewing. The photographer looks at the inverted image under a black cloth, which blocks out the light—in effect, a little outdoor darkroom. This is much different from looking at a small LCD display on a digital camera in daylight. Quiet time in the dark, alone, studying the scene to be photographed, and making adjustments can be thought of as a form of meditation. In an unpublished manuscript, Ralph Hattersley wrote about printing in a darkroom as an opportunity for meditation, a quiet time that can be therapeutic. Further, the upside-down image on the ground glass tends to engage the right side of the brain, the artist's side, more than the technical, left side of the brain.

Color modality

Color film transparencies look different from color prints, and the image on a monitor looks different from an inkjet print. This should not be surprising. Prints are viewed by reflected light while the image on a film transparency is viewed by *transmitted* light and the image on the monitor by *emitted* light. The modality under which a color image is viewed influences how it is seen. The blue that we see in the sky, which does not belong to any object, and the blue we see in the water of a crystal clear lake are not the same. The modality of one is referred to as aperture color and the other as volume color.

Digital seeing has extended the versatility of photography by allowing immediate visual access to what is being photographed. The LCD display on the camera allows one to view the image before it is taken and after. If necessary, adjustments can be made to correct for exposure, sharpness, lighting, and composition. This is especially helpful when doing close-up photography. Prior to printing an image, it can be displayed on a monitor, studied, and a multitude of adjustments can be made. Digital photography does more than provide immediate visual feedback when capturing and manipulating a photograph. It provides confidence and assurance after the photograph has been taken, especially if the camera has a histogram representation

to check the exposure of the "digital zones." One does not have to anxiously wait till film is processed, hoping that the captured image is what was intended. Further, since nearly unlimited options are available for adjustments, the digital photographer now has, prior to printing, a monitor screen, a "canvas" on which to add or remove color, increase or decrease saturation, adjust sharpness, introduce blur, etc., much like a painter. But unlike a painter who cannot easily remove the color of paint once it is applied to the canvas, the digital photographer can. In a sense, with digital the photographer becomes both a painter and a photographer. Digital seeing provides the same immediate feedback a painter has when creating an image.

Evidence and Truth

One of Marshall McLuhan's one-liners was "A man walked into an antique shop and asked, *What's new?*" When it comes to photographic truth, nothing is new as the history of photography reveals. Composite photography, for example, can be traced back to the 1857 photograph Two Ways of Life by Oscar Rijlander. It was a large 31 × 16 inch photograph printed, not from a single negative, but from some 30 different negatives. Henry Peach Robinson, a fellow painter turned photographer, combined five negatives a year later to create Fading Away. The photographs were allegories and intended to be seen as such. Taken literally, they are fakes.

Spirit photography, the attempt to capture ghosts on film, came into vogue during and after the Civil War. Ghostly images of deceased loved ones would "mysteriously" appear in family photographs. Many people truly believed in such photographs at the time. P. T. Barnum knew they were fake and that people who had lost loved ones in the war were being exploited. Interest in spirit photography and similar phenomena continues today. One only has to go on the Internet, type in "google" and "spirit photography" to be astonished or entertained, depending on his belief.

Seeing is believing

Seeing is believing and believing is seeing. This chiasmus rings true when we stop and think about it. Seeing is believing and the reverse, are not separable. The image incident on our retina is not seen until our brain processes it. What we see, we see to some extent, by choice and by *expectancy*—a condition in which a person is more receptive to seeing what he or she anticipated or wants to see rather than what is. Some people see flying saucers in images, a Loch Ness monster, the Virgin Mary splattered on a wall or on a slice of toast, and so on. Others, do not.

Imagination also plays an important role in seeing as Leonardo da Vinci reminds us in his Treatise on Painting:

You should look at certain walls stained with damp, or stones of uneven color . . . you will be able to see in these the likeness of a divine landscape adorned with mountains, ruins, rocks, woods, great plains, hills and valleys in great variety . . . (Zakia, 2002, p. 209)

We see what we choose to see. In the 1960s an amateur magician, Ted Serios, had convinced a number of people that he was able to make mental images, images of what he was thinking about when he clicked the shutter of a Polaroid camera. He even had a psychiatrist so thoroughly believing this that he wrote a book on the phenomenon, which was later proven to be fake.

Context and cropping

Whenever a photograph is taken, it is always out of the larger context from which it was selected. It is not unlike quoting words out of context; meaning changes with context or lack of context. As such, every photograph looked at can be misread. For example, a photographer on assignment to photograph a large crowd at a protest gathering discovers, not a crowd of 1000 or more as expected, but less than 100. By carefully positioning his camera, he records only the small crowd and speaker and not the empty surround. The result is a misleading

photograph that is completely filled with the protestors and nothing more. The visual implication is that there are more protestors "outside the frame" of the picture—hundreds more. When we look at a picture, we can only see what it shows, nothing more. In effect, the photographer has camera-cropped what he did not want the photograph to show. Cropping is usually done after a photograph has been made, which photo editors do routinely but not necessarily to mislead.

Stretch or shrink
Photographs can be subtly expanded or compressed in a vertical or horizontal direction to create an *anamorphic* image in which a person or object is seen as a bit thinner or wider. If carefully executed and there is no valid reference, the slight change is not distinguishable. At times this is done, for example, to make a female model look thinner in a fashion magazine, or to look wider for an advertisement on losing weight. Stretching is also used in some advertisements for automobiles to give them a slick elongated look. Photo editors sometimes stretch or shrink a photo to fit a layout of a page. What is seen is not necessarily what is.

Photographs as evidence
The ability to doctor photographs by adding, subtracting, multiplying, or substituting things has been with us since the beginning of photography. It has now not only accelerated with digital photography, but has become nearly impossible to detect. Unlike film photography in which one could refer to the original film negative as a physical record, digital cameras not using RAW files leave no tracks behind, so to speak. RAW files are not processed in the camera as are JPEG and TIFF files. They can therefore be considered as the digital equivalent of a film negative and the processing software as equivalent to what goes on in a darkroom to make a print from a negative.

"Photo fakery is everywhere," proclaims the author of *Photo Fakery*, who is a retired CIA expert. In some cases it is impossible to detect. Even a battery of experts can disagree on the truth of a photograph. The Loch Ness monster photo taken and published in 1934 was never proven to be a fake. It remained for one of the perpetrators, on his deathbed in 1994, to reveal that it was faked.

Proving the authenticity of some photographs is painstaking and laborious, requiring much research and analysis. With the advent of digital photography, it has become much more so. Photographic prints now can be a result of a marriage of both film and digital. For example, one could, with the right equipment, write a digital image onto film at a resolution so high that it would look like an "analog" optical image under a high-power microscope. The final print could be a result of capture with a digital camera and digital printing—digital all the way, or it might have had its origins as a film negative or transparency that was subsequently scanned into a computer to create a digital file. In either case, the file could easily have been manipulated before printing. To track down evidence of alterations, one would need access to the source, either the film original or RAW files.

Manipulating a photograph for artistic or dramatic effect is not a problem, unless the photograph is intended to be used as evidence or as documentary. Forensic photography, scientific photography, and medical photography need to be accepted as truthful, although at times, to secure grants or promotions, some fraud is, unfortunately, involved. With photojournalism and documentary photography, there is also an expectation on the part of the viewer that the photographs are indeed factual and not tinted with fiction. And as we have seen in political elections, photographs that are used to promote a candidate should be viewed with the same skepticism as any advertisement.

If critical judgment is to be made regarding the contents of a photograph, then the cliché "buyer beware" becomes "viewer beware." Be critical in assessing the content of a photograph and the legitimacy of its source. The Internet has become notorious for displaying fake and deceptive images and will continue to do so. Fake photographs that get on the Internet spread like a virus and are difficult to stop.

FURTHER READING

Adams, A. (1981). *The Negative.* Boston, MA: Little Brown.

Arnheim, R. (1974). *Art and Visual Perception.* Berkeley, CA: University of California Press.

Brugioni, D. (1999). *Photo Fakery: The History and Techniques of Photographic Deception and Manipulation.* Dulles, VA: Brassey's.

Eisenbud, J. (1967). *The World of Ted Serios.* New York: Wm. Morrow.

Hattersley, R. (2004). Printing as meditation. *Shutterbug.* December, pp. 154, 170, 171.

Kennedy, R. (2005). The ghost in the darkroom. *The New York Times.* September 4.

Rosenblum, N. (1984). *A World History of Photography.* New York: Abbeville Press.

Zakia, R. (2002) *Perception and Imaging.* Boston, MA: Focal Press.

The Photo Marketplace and Contemporary Image Makers

DAILE KAPLAN
Swann Galleries

Not so long ago artists were viewed as bohemians who, unconventional by nature, worked in studios devoid of creature comforts and displayed little interest in promoting their work. The economic reality of selling pieces, though acknowledged, was far removed from an artist's lifestyle. Dealers, on the other hand, were commonly seen as refined gentlemen and women of leisure who discretely "placed" (never sold) artwork. This perception was subsequently passed down from generation to generation. Public auctions were highbrow events in which tony patrons purchased materials from estates accompanied by detailed family histories. Today, such quaint notions associated with the art world are as dated as the silver halide darkroom. Indeed, the making, buying, and selling of art is big business. And, a photographer-artist with dreams of making it recognizes that being commercially savvy is as integral to their success as their work itself.

What exactly constitutes "the market"? The art market is composed of two distinct, but interrelated, components. The gallery system is the primary market. Gallerists, in contemporary parlance, discover new talent and foster mid-career artists by mounting shows. There's nothing quite like the thrill of a well-conceived exhibition in which an artist's latest objects are beautifully installed in a gallery setting, creatively promoted in the press, reproduced in an elegantly produced catalog, and, of course, actively sold. Expositions are the principal vehicles in which private collectors, museum curators, critics, and art advisers not only have an opportunity to see work but learn more about it. As any collector knows, gallery directors are often trained art historians as well as skilled salespeople.

Being represented by the right gallery is often the difference between having your work in the permanent collection of a blue chip museum or a celebrated private collection, and seeing it languish. With the growing popularity of photography the volume of art–photography galleries increases worldwide every year, but so does the number of artists seeking representation. Art galleries typically feature a roster of contemporary and historical figures, though most opt for a non-exclusive association. Finding the appropriate commercial venue is highly competitive and the most challenging task an artist faces. Publications like *Photograph* and *ARTnews* are useful tools for a photographer interested in pursuing a career as a fine artist. It is best to first research the universe of galleries to understand what they specialize in and which photographers they already work with. *Art in America* annually publishes an international gallery and museum guide that provides a panorama of useful information. Alternatively, if seeing your work in a public exhibition is not a top priority, another option is working with a private dealer. Art advisers build (curate) collections for private collectors, and also frequently act on

behalf of corporate clients; for example, hotels, hospitals, and businesses that are buying art for decorative purposes.

The secondary or resale market is synonymous with auctions, a dynamic environment that simultaneously trades on social and commercial interests. Celebrities, collectors, curators, dealers, and agents alike are active players in international venues where works by contemporary artists who employ photographs as well as prints by classical photographers are sold amid spirited bidding. Auction houses specializing in fine art may be found in metropolitan centers throughout the world including New York, Los Angeles, Paris, London, Berlin, Madrid, Stockholm, Rome, Vienna, Sydney, and Tokyo, where public sales are conducted at least twice a year, in the spring and the fall. Historically, most of the material available at auction came from estates. Today, houses also rely on connoisseurs parting with well-respected collections, institutions de-accessioning duplicate pictures, dealers selling inventory, and speculators "flipping" (quickly turning over) works by cutting edge artists.

Galleries are destinations, places to meet artists and fall in love with artwork. Within the past decade, however, a new trend has developed: Collectors are buying at auction. Auction houses conduct previews, which are open to the public, at which time it is possible to sit and examine a treasured object. With the recent stratification of artists buyers increasingly seek out objects by a select group of "art stars." Perhaps a collector wishes to purchase work by an artist–photographer for whom a gallery has a long waiting list. An auction offering work by this figure may be seen as a singular opportunity. However, a typical scenario is that, after the auctioneer announces the lot, frenzied bidding by multiple buyers results in a realized auction price often exceeding the retail value. Auction salesrooms, which were once settings of high decorum, are now volatile market barometers, powerhouses of the new "art world economy." It is impossible to escape the attention paid by the media to stratospheric prices routinely paid for fine photographs as stories about "who outbid whom to pay what" are dramatically recounted in the art and business press. Since artists do not benefit directly from these robust sales figures by, say, garnering royalties, what impact does this new economy have on someone working today?

Photography was invented in 1839 but an international marketplace for fine art photographs became apparent only 30 years ago. Marge Neikrug, Lee Witkin, and Tom Halsted opened the first photography galleries in the late 1960s and early 1970s. Simultaneously the first auctions dedicated to 19th and 20th century photographs were conducted at Parke Bernet (later Sotheby's Parke Bernet), Christie's, and Swann Galleries in Manhattan. Auctions are historically prevalent in England but, from the beginning, New York set the pace for the photograph market and is to this day the center of the marketplace. Photographs, albums, and photographically illustrated books, broadly estimated from $10 to 3000, were sold to the highest bidder. Top prices featured an Ansel Adams photograph of Moonrise over Hernandez for $3000 or an issue of Alfred Stieglitz' elegant magazine *Camera Work*, with multiple photogravure plates, for $200. In 1977, *The New York Times* reported that a pair of Carleton Watkins's albums containing 100 photographs, which were found in a janitor's broom closet, fetched an astounding $100,000 at Swann Galleries. Subsequently, public curiosity grew about a field that, for all intents and purposes, seemed accessible to anyone who operated a camera.

Today banner headlines hailing photography as "the medium of the moment" or "the art form of the century" are typically found in the press. It may be hard to believe that photography was not always such a well-regarded medium. Excoriated and ridiculed in the 1970s, a burgeoning community of photographers, dealers, curators, and collectors were undeterred. They struggled to counteract the critical perception that, since photography relied on a mechanical instrument (the camera), it was not an authentic art form. Curators such as John Szarkowski, Maria Morris Hambourg, and Weston Naef furthered a popular understanding of the medium as a distinctive art form. Exhibitions devoted to Diane Arbus, William Eggleston, Robert Frank, Eugene Atget, and Alfred Stieglitz presented photographic expression as a pictorial language at once accessible and distinguished. Publishers like Aperture, Twin Palms, Abrams, and Bulfinch produced sumptuous monographs, historical surveys, and collectors' guides that went out of print quickly, and are now avidly sought by photographic literature collectors.

A landmark transaction that redefined photography's status as a highly prized collectable occurred in 1984, at which time The Getty Museum, in a carefully orchestrated, highly secret deal, purchased the most important international collections of fine art photography in private hands. The price was a staggering $25 million—an extraordinary "steal" in today's high-powered art market, especially given the high prices collectors regularly pay for Impressionist and Modernist paintings. Consider that Man Ray's Glass Tears—an icon of 20th century photography—was reportedly purchased privately for $1 million more than 5 years ago. Vintage masterworks by Edward Weston and Paul Strand have sold for $500,000, and contemporary pictures by Andreas Gursky, Richard Prince, or Cindy Sherman routinely sell in the mid-six figures. Although contemporary artists represent a strong segment of the market, the highest prices paid at auction are for classical photographs by 19th century photographers. Gustave LeGray's proto-modernist albumen seascape Grande Vague, Sete (1859) realized $871,739, in 2002, while an early architectural daguerreotype by Joseph Philbeit Girault de Prangey, Athenes Temple de Jupiter Olympien pris de l'Est (1842), measuring 7 × 9 inches, realized a remarkable $979,721 in 2003.

The story of how the Getty entered the photography market is a fascinating parable. To this day, for example, museums garner attention for their multimillion dollar acquisitions, blockbuster exhibitions, and sumptuous coffee table books. In truth, however, it is a market. Connoisseurs perceive value and beauty in artworks that are not sanctioned by the canon or, for that matter, the marketplace. Visionary photograph collector Sam Wagstaff, who may be best known for his patronage of a young photographer named Robert Mapplethorpe, spoke eloquently about photography as a uniquely democratic medium, one that made no distinction between a vintage Dorothea Lange Migrant Mother and a great vernacular snapshot of Bonnie and Clyde. This radical approach was the organizing principle of his own collection, which was one of the founding collections purchased by the Getty. The ability to recognize both new talent and innovative trends is vital to a field's intellectual discourse, as well as a vigorous marketplace.

However, without the benefit of a personal introduction to a potential patron or prominent gallerist, how does an artist connect with the trade? Art or photography fairs, which include scores of galleries from around the globe, are extraordinary networking events. The Association of International Photography Art Dealers (AIPAD), which hosts a trade show every February in New York City, is not only an occasion to look at great vintage and modern prints, but also to see the sort of work a gallery presents and, ideally, meet its principal. Additional fairs include Photo San Francisco (late July); Photo Los Angeles (late January); and national trade events such as the Armory Show, in New York, Site Santa Fe, ArtMiami, and the Chicago Art Fair. International fairs include Paris London (May), Paris Photo (November), ArtBasel (June), Arles (July), Perpignon (August), and Paris's FIAC (October).

For photographers who simply do not have the ambition to ply their trade in the rough-and-tumble art world, there are more populist approaches. Benefit auctions (where the proceeds of a sale are directed to a not-for-profit organization) are wonderful opportunities to have your photographs seen by collectors and curators, who are always on the lookout for great new images. A photographer looking for exposure might check out Black & White, a periodical with excellent production values that features full-page ads consisting of a photographer's statement, a representative photograph, and contact information. Those who love doing portraits can create a market niche by focusing on pets or pregnant women or couples or children. For photographers interested in working for a picture agency, there are more and more options. Although Getty and Corbis continue to dominate the field, Photo District News regularly reports about upstart agencies with specialty interests chipping away at these behemoths' market share. And e-businesses, such as, LiveBooks, offer photographers the technology to market their pictures directly to art buyers around the world.

Today the photographic marketplace is in transition. Increasingly segmented opportunities nonetheless abound. Classical photography galleries have not yet addressed the role of digital photography, highlighting instead vintage or modern prints by master practitioners. Contemporary galleries opt for the high concept, and technique is frequently overshadowed

by an artist's reputation. As digital technologies rapidly transform ideas associated with making images and, concomitantly, the definition of photography, the medium continues to thrive, continually reinventing itself to reflect the tenor of the times. Photography, once an "illegitimate" art form, now occupies front and center stage in the market. After a mere 30 years, the best is yet to come. ⊙

The Photographic Studio of the 21st Century

DOUG MANCHEE
Rochester Institute of Technology

Some Introductory Thoughts

A studio may be defined simply as a space a photographer would make photographs. The studio may also be considered a space that has been designed for and equipped with equipment specifically for the objective of making photographs. Studios may be described as the whole space where a photographer works even though some regions of this space may not be directly used for the making of photographs. Because photography followed painting, early studios were modeled after painters' studios. A studio would need to have at least one large window or a skylight to be operational. Having a lot of light was important because of the slow emulsions of the time and the minimal availability of artificial lighting. The quality of the light could be adjusted using large translucent curtains. With the advent of electricity, all of that changed in significant ways with many lighting choices coming onto the market at the time of its invention. Today, contemporary studio lighting is almost always accomplished using artificial light, however, some photographers still make use of window light where appropriate. The famous English portrait photographer Lord Snowdon uses natural light exclusively in his studio.

The Studio in the 21st Century

This essay will discuss some of the basic issues required for designing and equipping a professional photographic studio in the 21st century. Photographers who lease or own a professional photography studios on a full-time basis, however, are becoming increasingly rare; especially in large metropolitan areas. In the 1980s, industrial space was relatively inexpensive and full-service studios were common for most professional photographers. This is no longer the case. Today, most photographers will rent studios on a daily or weekly basis for specific projects. In large metropolitan areas an entire industry has developed to service this trend. A typical rental studio will consist of a building with a number of different size spaces for rent. Other options might include cyclorama walls (to be discussed later), full kitchens, professional hair and makeup capabilities, and natural light-only spaces. Lighting and grip equipment is also available to rent as well as high-end digital capture stations (which come with an operator or "digital technician"). Most photographers will now only rent an office space and an area to store equipment, drastically lowering their operating expenses. In smaller markets with lower real estate costs, photographers continue to lease existing space on a yearly basis. These days it is very rare to see a photographer build a studio from the ground up.

The Impact of Digital Photography on the Professional Photography Studio

Since the beginning of the century the impact of digital technologies in photography cannot be understated. In professional photography, digital is rapidly replacing film as the method of image capture. As mentioned, most rental studios offer the capability of digital capture as well. Another service these studios offer is the archiving of digital files for a set period of time. High-end digital files are very large and storing them can cause problems for photographers who are not set up to do this. All files need to be backed up as well, preferably on another

machine. Many rental facilities now offer this service. Additionally the photographer, or client, may view the files and place orders online. More on digital archiving will be developed later in this essay. Aside from these issues, digital capture has not necessitated a major change in how people think about studio photography. Lower costs and the ability to rent systems allow photographers to use high-end digital systems for almost any project. Most mid-range digital single lens reflex (DSRL) cameras now work with studio strobes as well as all continuous-source lighting systems. For studios utilizing a digital workflow it is necessary to have one, or more, computer stations. Typically, these are on moving carts and contain a CPU, monitor, and a large hard drive for image storage. These stations are used to download files, evaluate images on screen, perform minor retouching, and burn CD or DVD discs. For those photographers designing a studio from the ground up it is important to consider what is necessary to support digital capture, especially electrical requirements. This should be done even if the photographer has no plans to shoot digital.

When Looking for Space

Since the majority of photographers who will be looking to create a studio will be looking at existing buildings and spaces, there are several considerations before deciding on a space. Once a lease is signed, breaking the lease is difficult if the space is not suitable to a specific need. When looking for a space to use as a professional studio, one should consider several things.

Access

Most studios need to be accessible to both passengers and freight. If the studio is on the ground level, a front entry for clients and some deliveries will be necessary. A back entry is desirable to bring in props, equipment, surfaces, and anything else that is large. If the studio is on an upper floor it should be accessible by both a passenger and freight elevator. The ability to bring large objects (or a lot of small ones) is very important in a professional studio.

Ceiling

The ideal studio would have high ceilings. The fewer pipes, electrical metal conduits, and HVAC piping, the easier it will be to adjust the lights and the sets that will be required for projects. Anything that hangs from the ceiling can get in the way. Some ducts and pipes may occur naturally in the studio, such as the fire sprinkler system. As a renter, you will not be able to move these fixtures. When a drop ceiling is present installing a track-lighting system or the use of fixtures for equipment support may be tough to accomplish since this ceiling will take up valuable height.

Flooring

The studio flooring can be made of anything that provides a smooth surface to work on. Wood or tile is nice because either could be used as part of a room in a photo setup. The feel of a facility is heavily influenced by its flooring and much of the studio's design is influenced by its big open floor. It is worth maintaining the floor for both the sake of appearance but also for some not so obvious reasons. A well-maintained floor will stay smooth and flat longer. Water damage may cause buckling and a floor may become uneven. A smooth floor of concrete will help when moving lights, stands, and booms that have wheels requiring smooth surfaces to operate easily. Often products for catalogs will arrive in carts and bumpy floors can cause damage. Concrete can easily be painted with various colors as needed.

Having a level floor is not a big factor, but it is much easier to make things level when the floor itself is level. The floor should not be too flexible, as is often the case in older buildings, because the set may move when someone walks too heavily or there is vibration resulting in blurred images when long exposure times are used. Since liquids are often used, it is best to not use a carpet in the shooting space. Not only will hard floors assist in cleanups, but they will prevent residual damp spots or odors that will make the next setup more difficult.

Dimensions

An efficient photography studio needs to be divided into several separate and distinct areas and be as big as can be afforded. Take the time to evaluate whether the space will accommodate the studio's clientele and allow for an efficient work environment. For a professional studio there should be separate and distinct areas for: shooting, the office, camera storage, prop and surface storage, client/reception area, and a kitchen.

Design

The design of a studio is based on individual tastes, space availability, rental costs, and the type of photography that will be undertaken in the space. If the studio will support catalog work, having a large space to enable the building of many sets makes sense. For a portrait studio, having a medium to small space seems logical to start. Once a space has been determined, a way to proceed is to use graph paper and plan space usage before starting to divide the space up. Each square on the grid paper should represent a unit of distance, e.g., one square equals one foot. Everything that will be in the studio can be drawn to scale on pieces of paper and cut out to allow them to be moved around in a scale drawing. This allows one to visualize relationships and how the space can be laid out.

Building and renovation

Building in the studio space typically means building a few walls to divide the large open space into areas such as a shooting area, dressing area, or storage area. Consideration should be given to building walls that are strong enough to hang backdrops or which allow the attachment of shelving. It is often practical to have walls that will accommodate the hanging of prints, office notes, ongoing work in the finishing area, or newly completed work in the reception area. A great wall covering for this purpose is called Homasote, which can be painted with burlap and glue and then the studio colors. Homasote comes in standard 4×8 foot sheets and allows the temporary hanging of papers with push pins.

Electricity and power requirements

There are never enough outlets in any space used for photography in this era. Computers, lights, cameras, and many other pieces of equipment all require electricity. If there is not enough power or outlets, new wiring will need to be put into the space. This should be done by a licensed electrician and must conform to local building codes. It is never a good idea to be deceitful with this installation. An error with wiring can cause electrical fires and jeopardize the studio's safety.

The electrical power requirements for the studio will depend on the type and amount of lighting that will be used at any one time. Electronic flash equipment is the most common; however, photographers still use tungsten hot lights. Having enough electrical amps in the system is important. When talking about electricity, three terms are used to describe the system: watts, volts, and amperes. A watt defines the fundamental electrical power in a system, a volt is the unit of electrical force, and the ampere is the volume of electrical flow. An analogy for a volt might be found in water pressure. The ampere is the equivalent flow rate and the amount of current flowing at a given pressure defines its power. The power or wattage of a circuit is defined as watts = volts \times amperes.

Electrical wiring can be purchased in different grades or thicknesses depending on the wattage to be carried by the wire. The wire must be of the correct thickness to carry the expected amount of electricity or load to the outlet boxes and to the general lighting. Common household wire would be characterized as 14/2 gauge.

Keeping the building safe is the purpose of a fuse or circuit breakers. Fuses or circuit breakers are located in a box near where the main line comes into the building. The fuse box is the terminal where the electricity is distributed to various outlets and to the lighting used in the studio. Circuit breakers stop the flow of electricity if a load is too great for the system that is pulled through the wires. If a high load is required, there is a danger that the wire's insulation could melt resulting in a fire. A fuse is also a part of many pieces of equipment and is calibrated

to the exact amount of electricity for which the line/equipment is rated. When a higher load is drawn on the circuit, the fuse wire will melt and stop the flow of electricity before a problem occurs.

Circuit breakers accomplish the same thing and consist of a switch that closes, or trips, when too much electricity is drawn. This switch can be reset after the problem is corrected. The circuit breaker has a visible on/off position that makes it easier to determine which circuit has tripped; a fuse requires looking at the metal band to see if it has melted. Of course, to most easily locate the tripped breaker, each circuit in the junction box should be clearly labeled to indicate which set of lights or outlet boxes connect to each breaker. Circuit breakers have a built-in time delay that allows this surge to occur without tripping. The surge is not long enough to melt insulation and start a fire, so the time delay circuit breaker prevents nuisance tripping of the circuit when electrical equipment is first plugged in or turned on.

The power required by most studio flash equipment would be 20 amps. If each outlet in the studio is connected to a 20 amp circuit and each box supports one pack, there should be no problem with having enough amps to run the flash equipment. Having sufficient power for each strobe pack allows the equipment to operate properly and recycle quickly.

Finally, when considering the power requirements for a studio do not forget to consider the computer and heating or cooling requirements of the space. Run an imaging computer system as well as a window air conditioner with the photography studio lighting equipment and the electrical consumption will significantly increase.

Climate control

It will be expected by visitors, clients, guests, and employees that the indoor temperature of a studio will be comfortable. Comfortable might be described as a temperature of 20°C or 68°F. When temperatures significantly deviate from this, various things might happen that would be evidenced by lower productivity in the staff or product changes, e.g., flowers spoiling or models perspiring and damaging their clothes. The equipment that is used to make pictures also generates heat, which contributes to the warm temperatures found in mid-summer in the United States where the average temperature of 85°F is common in August in New York City. The average winter temperature in New York in January is 28°F. Attention should be made to determine the capacity of the system that is located at the studio and its capability to maintain a comfortable environment during these extremes. The heating ventilation air conditioning system (HVAC) should also be capable of simply circulating air as well.

Windows

It is not a problem to have windows in a studio area and the reality is, there may be no choice. Having fresh air and a bright open space leads to a pleasant place to be when not making pictures. When working in a studio though, it will be necessary to block all light transmitted by windows for total control of the lighting. Extraneous light competes with the artificial light on subjects. When doing multiple exposures there must be no ambient light at all. Blackening all window light can be difficult. There are products such as blackout shades for windows that photographers can buy. Rolls of black paper or plastic can be used quite easily and hung over the window frames, but this is a hassle. Many kinds of photographs, especially fashion and furniture, can benefit from window light or with window light as an addition to artificial light. If the space does not have windows and is located in a hot climate, make sure the building has central air conditioning. Photography equipment generates a lot of heat.

Security and insurance

Security, insurance, and safety issues are things to seriously consider. Camera equipment has long intrigued thieves of small portable and expensive items. A studio most of the time will have many pieces of equipment such as laptop computers and digital cameras that must be secure as well as clients' products that are maintained in the studio. Perhaps even more important, the photographer might also be storing irreplaceable negatives, transparencies, and digital archiving equipment in the studio. Even though these materials may not have resale value, they

have great importance to the photographer for future sales. To help with security, the doors into the studio from outside should all be solid core or metal with deadbolt or other industrial "type" locks. A studio should absolutely purchase an insurance policy for potential theft and loss coverage but also for personal liability coverage for accidents incurred while in the studio. A client could fall or experience a personal injury as a consequence of simply being there. In either case, not being personally responsible for such events should be a studio's goal. A sizable loss from either type event could be so large a financial burden that it could close the studio.

Having a security alarm is an absolute. Security systems can be an inexpensive or professionally installed system. Features of alarms might include motion or fire sensors as well window and door switches. A good alarm is in constant communication with a central alarm monitoring facility that notifies the proper authorities when triggered. These systems normally require monthly fees.

Studio storage

A studio will never have enough storage space. Space to store the photography equipment, backgrounds, and props is just the beginning of this problem. Clients will often bring things to the studio that will remain there for many months. The supplies required to build sets such as lumber will seemingly multiply with each job and then there it is, all over the place.

The storing of equipment includes cameras, computer and imaging equipment, and lighting equipment and its related accessories as well as props and backgrounds. Camera and computer equipment must be stored so as to minimize the chance of damage. It will require a good shelving system, which provides a safe and sturdy place for putting things. Keeping cameras in their cases leads to them staying cleaner and well protected from accidental damage from water and dust when not in use.

Backgrounds come in many types and sizes. Standard 108-inch seamless paper must be stored vertically or it will bend and may develop ripples. It should also be kept in its box with a plastic bag to minimize fading and damage from moisture. There is a rack system that can be purchased for this type of storage as well. This system requires very little floor space and keeps the seamless paper easily available on a wall rack. Formica and other surfaces for photo shoots are also common background materials that will need to be stored. Plexiglas also involves special considerations because it is so easily scratched, which can ruin it. Cloth drops can be rolled or folded and stored on shelves as well.

Props are more difficult because they will be a variety of sizes and shapes or even breakable. Even though photographers these days depend more and more on stylists for providing props, there are always some items that are used repeatedly for a particular client or to create a particular look; for example, small pillars for portraits, special chairs, or vases.

Image Archiving

The digital capture environment has its own storage issues. Although a refrigerator-sized system is not necessary, most high-volume studios will need a server system (two or more computers configured together to handle large storage capacity) set up to handle the large files generated and produce a backup file of all images captured digitally.

Many photographers still have a large archive of transparencies and negatives that are stored safely in metal filing cabinets. Filing cabinets that lock should be considered for extra safety and development of a cataloging system. Many photographers store important materials relevant to a shoot, its layouts, overlays, receipts, invoices, etc., together with the resulting photographic materials for a period of time. A very convenient way to store these materials uses a vertical filing or "job" jacket system. Photographic prints can be stored in flat files or print portfolios as well. These boxes are designed to protect the prints from the effects of light fading or environmental influences. Color and inkjet prints do not require archival storage. All boxes will require labeling. Some materials should be stored using acid-free materials. This type of storage would be characterized as archival.

A big problem for older established studios is the storage of transparencies, negatives, and prints from previous years. A database is often the solution for cataloging all the images in storage. This consists of a list of all jobs with a short description of the subject that was shot. A filing code should be established. It can be oriented to the date or to the client and it should be simple. Excellent database software products for this would be Extensis portfolio® or FileMaker Pro®).

It is a good idea to list the client in these databases. Many photographers will include a description of the type of photo shoot it was (product, architecture, portrait), the type of client (agency or direct), and the amount billed as a means of tracking the type of photography most often done. This allows for quick access to all previously photographed jobs and to information that is critical to planning the future of the studio. This job log is crucial to the efficient running of a studio.

Digital imaging archive

While digital image archives do not take up as much room as film archive—given an equivalent number of pictures—they have their own issues. Image backup is probably the most important. It is recommended that at least three copies of each file be kept. Two can be at one site (the studio) and one should be kept off site. Two files should be kept on site because of the potential for file corruption; that is, data in the file deteriorating for some reason, making it unusable. This is unique to digital capture since film rarely deteriorates, at least during the lifetime of the photographer. A copy should be kept off site in the event of theft or a fire. Digital capture has an advantage in this respect since multiple copies of any file can be generated with no quality loss. Files can be kept on large hard drives, magnetic tape, or DVD discs. Sophisticated archiving software now exists allowing the photographer to find files specific to any project.

Cyclorama Wall

Having a large coved wall is a huge advantage for a studio. This wall is called a hard, seamless background or a cyclorama (cyc). A cyc solves several problems for a studio. It is readily available for shooting and can quickly be repainted and maintained rather than buying seamless paper, it cannot be damaged by rolling heavy subject matter across it (computers, cars, etc.), or it will not be torn by models walking or dancing across it. It can also be constructed wider than the commonly available width of seamless paper. Cyclorama walls were more common years ago when studio space was plentiful and cheap. They are very common in rental studios but might not be found in a small studio today. A cyclorama should be located in a dedicated space that is not used for any other purpose.

Studio Safety

One common function of all photography studios is the importance of safety. A photography studio is a complex place, consisting of cords, cables, lighting and camera equipment, light stands, grip equipment, and the objects or people photographed. The studio is also a dark place; when pictures are taken the only light should be on the subject itself, which means the rest of the studio can be very dark. Further, there may be clients and non-professional models present people who are unfamiliar with this type of environment. The last thing a photographer wants to experience in the studio is an accident: damaging expensive equipment, or worse, injuring a client or model. With this in mind there are several things that can be done to make the studio environment safer:

1. Make sure any cords and cables in the way of foot traffic are securely taped to the floor. The tape should run parallel to the cord so all of the cord is covered. If the photographer, when designing the studio, has the ability to place electrical outlets where he desires they should be placed behind the areas where most sets will be constructed. This means that the electrical cables will, for the most part, be out of the way.
2. When photographing models, make sure they have a clear path to the set. Having a model step over and around cables and lighting equipment should be avoided whenever possible.

3. When shooting, try to have some ambient light in the studio so people can find their way around. If strobe lighting is used, this should not create any color temperature inconsistencies in the photographs. If hot lights are used, care must be taken so that the ambient light does not affect the lighting on set.

4. When using a boom arm for a light or light-modulating equipment use a counterweight whenever possible. A better way to ensure that a boom arm does not fall over is to place it directly over one of the legs of the light stand. With this method, the weight of the boom is absorbed by the leg and it is impossible for the stand to fall over. Placing the boom between two legs is not recommended, even if a counterweight is used.

5. Make sure all clamps and grips are securely tightened. This is common sense but photography equipment is heavy and slippage can occur. The worst that can happen is that your equipment will collapse; it is also possible that a light will slip and change positions, altering the lighting on the subject.

6. Communicate with your clients and models. Make them aware of these issues and encourage them to be careful when they are in the studio environment.

Types of Studios

JOSEPH DEMAIO[1]

There are as many types of studios as there are photographers. The requirements of each person's photography will determine the way the studio will be used and how it should be designed. In general, studios can be broken down into four broad types: the professional studio, the artist studio, the amateur studio, and the location studio.

The professional studio

The professional studio, designed to take a wide variety of photographs to fit the specifications of different clients, is more complete than any other type of studio. If you are about to design a professional studio space, try to visit some existing studios. During trade shows in larger cities there are often studio tours in which several of the local studios are open for visitors. The professional photographic organization in your area may also have an occasional tour of local studios. Also, photographers are usually very proud of their studios and will often be amenable to a visit. Seeing how other people solved the design problems of their studios can be invaluable. An efficient professional studio should consist of the following seven areas:

Shooting area

The shooting area should be as free of extraneous objects as possible. It should not be used as a storage area for props, camera, lights, surfaces, or computers. If any of this equipment needs to be in the shooting area it should be stored on moving carts that will allow the greatest flexibility for set construction and lighting. Clients and models will also be in the shooting area so you want to keep that area as open as possible (see the section on studio safety). The larger the shooting area the better, but consider a smaller area if this will allow the storage of non-essential items to be elsewhere.

Reception and display area

The professional studio needs some areas that other types of studios do not require because the professional studio is a place that is visited by clients. The studio entrance should lead to a reception area for the convenience of clients during meetings or a shoot. The reception area usually contains facilities for the display of the photographer's work. This is not only for the entertainment of clients but may also suggest to a client a different type of work that the

[1]Originally published in the *Focal Encyclopedia of Photography, 3rd Edition*.

photographer is capable of doing. This is a subtle way of increasing sales. This area is not only for the display of print work, but also for the display of transparencies and electronic media. It is also nice to have a magazine table or some sort of shelf where photographers can put brochures, magazines, catalogs, etc., that contain samples of their photographs for viewing by clients.

Conference area

There is often a separate room or space with a large table where the requirements of the photo shoot can be planned and discussed with the client. This space should be provided with a telephone for client use during a shoot. Very often clients will want to conduct business or do design work while waiting for a shot to be set up. A room such as this will provide space and privacy for the client. A large flat screen monitor at a high-speed workstation that is connected to the Web is, of course, an absolute.

Kitchen

For those photographers who are going to do food photography, a large kitchen area is necessary. This area is often adjacent to or even within the studio. If located in the studio, it can also be used as part of a set for photographing food preparation. This kitchen should contain an unusually large amount of counter space. This is necessary because food for photography is often prepared in multiples; six turkeys, four apple pies, etc. Also, the food stylist will need room to prepare the dishes and lay out the props in preparation for transferring them to the set. Even if the photographer is not going to specialize in food photography, at least a small kitchen is handy for the preparation of the occasional food shot or for the convenience of clients.

Dressing room

Most studios have a dressing room for models. It should be large enough for the model to feel comfortable or even for the makeup artist to work. Outlets for hairdryers and curling irons are required. A small sink for washing off makeup or for the application of certain kinds of hair or facial treatments is a nice convenience. Since shoots with models often require a large number of garments, a space for hanging them in a way that they can be seen and selected makes things more convenient. Mirrors are a must, of course.

Finishing and shipping area

Since prints usually have some finishing work required, and work is often shipped to clients either by mail or overnight delivery, it is very helpful to have a print finishing and packing area where the materials used for these procedures are stored and readily accessible. A counter with cabinets will hold all packing materials and provide a surface for postage meter, scale, and retouching area. The retouching area can be equipped with a magnifying lamp that makes any retouching procedure much easier.

Workshop

When preparing for shoots or just performing simple maintenance, the photographer is often called upon to do various sorts of building or altering of products and props. A workshop for simple equipment repair or for building sets and preparing props is not only a help but almost a necessity. There should be a sturdy workbench with convenient electrical outlets. The bench might have a vise and behind it shelves or a peg board for hanging tools. This work area is sometimes enclosed or in some way separated from the studio area because of the dust that may be generated by sawing wood or using a file. For those photographers who do a lot of scale model work, the installation of a spray booth for model preparation may be necessary.

The artist studio

An artist's photographic studio will depend on what type of work the artist in interested in doing. If the artist is essentially a photographer who finds subjects in the outside world, then the studio may contain only a desk, storage, darkroom, and an area for looking at finished work and work in progress. Those artists who also work in studio settings, whether for portraits, nudes, dance, etc., will require a studio shooting space with some of the areas described above. Artists often have studios in their homes.

The amateur studio

The requirements of amateur photographers are often modest because of the expenses required to maintain a formal studio. Usually some portion of their living space is set aside for their hobby. This does not mean that they have to do without many of the things that the professional finds necessary. With a little ingenuity and some compromise, the amateur can have an efficient, versatile, and still modest studio.

The location studio

These days more and more commercial photography is done on location at the client's facility since it is difficult to bring operating machinery and computers to a studio. Even art photography has its location studio contingent. This is exemplified by Irving Penn and his famous location studio portraits. Mr. Penn has made a career of moving entire studios complete with large cloth backdrop to such exotic locations as the jungles of New Guinea and the Peruvian city of Cuzco, the ancient Incan capital. For a location shoot, photographers put together what can be called a portable studio. All the necessary equipment (cameras, lighting, backdrops, imaging computers, etc.) is packed in a way that is both convenient to move and to get at on the job. There are specialized packing systems to make location work easier. These usually consist of a canvas bag that holds many accessories for the lighting system. These bags can be unfolded at the job site and hung on light stands so the contents are visible and accessible. A major requirement for a location studio is a strong assistant. ◉

Photographic Virtual Reality

JOHN (CRAIG) FREEMAN
Emerson College

Photographic virtual reality is a type of digital media that allows a user to interact with photographic panoramas, objects, or scenes on a computer display using software called a viewer or player. Sometimes referred to as immersive photography, photographic virtual reality is designed to give the user the sensation of being there.

History

Photographic virtual reality has its roots in the work of the Irish painter Robert Barker, who, in 1787, created a cylindrical painting of Edinburgh. The painting was viewed from the center of a cylindrical surface. Baker patented the invention and coined the term panorama from the Greek word *pan*, meaning all, *horama*, meaning a view, and from *horan*, meaning to see. This intent to immerse the viewer into a scene and the striving to invent a form of experiential representation was continued throughout the 19th and 20th centuries with panoramic and stereo-optic photography. One of the earliest examples of true photographic virtual reality was the Aspen Moviemap project developed in 1978 by a team of researchers from MIT working with Andrew Lippman with funding from DARPA. The research team, which included Peter Clay, Bob Mohl, and Michael Naimark coined the term Moviemap to describe the work they were producing. A gyroscopic stabilizer with 16 mm stop-frame cameras was mounted on top of a car and a fifth wheel with an encoder triggered the cameras every 10 feet. The car was carefully driven down the center of every street in town. The playback system required several early laser disc players, a computer, and a touch screen display. The user could navigate throughout the virtual space.

Although there were many other experiments, it was not until Apple Computer Inc. released the QuickTime VR capabilities for its popular QuickTime Player in 1995 that photographic virtual reality became an established medium. For the first few years, authoring photographic virtual reality was cumbersome and quite technical. Photographers created

work by executing a series of pre-written, modifiable programming scripts in an application called Macintosh Programmers Workshop. In August of 1997 Apple launched the QuickTime VR Authoring Studio application, which greatly automated the process. In the late 1990s iPix began developing software and equipment to support the creation of full 360° horizontal by 180° vertical panoramic imagery. This allowed users to look in all directions including straight up and straight down. Since that time developers have been expanding the possibilities of this emerging form by creating new authoring and viewer software as well as specialized camera equipment and techniques.

Photographic Virtual Realty Panoramas

A photographic virtual reality panorama is a panoramic image that the user can pan left and right, tilt the view up and down, and zoom the view in and out creating the sensation of looking around from a point of view located inside the scene.

Equipment

Generally, the process of generating photographic virtual reality media begins with the creation of source material, which is typically a series of photographic still images, although panoramic imaging devices are available that can create the entire source for a panorama in one image. Source material can be created with a digital camera, a video camera, PhotoCD, or a film camera, where the film is subsequently scanned on a flatbed or film scanner. In some cases photographic virtual reality source materials can be created in a computer graphics software application.

A wide variety of equipment is available for the creation of source material. This can include traditional camera equipment, which has been augmented with specialized tripod heads, ultra-wide fisheye lenses, or parabolic mirrors, as well as, dedicated rotational image capture systems. Most approaches to photographic virtual reality require that multiple images be made of any single scene. It is imperative that all of the images in the sequence match in point of view, exposure, color, and focus. Therefore it is recommended that a tripod with a special panoramic head be used and that all camera controls be operated in manual mode.

Perspective continuity between images is maintained by placing the nodal point of the camera lens directly above the rotation point of the tripod head. The nodal point of the lens is where light rays converge in the barrel of the lens, not the film plane nor the front of the lens element. This assures that the point of view of each image is maintained at the exact point in space as the camera is rotated. Panoramic tripod heads, or camera rigs, are designed with adjustable brackets for this purpose. The bracket will usually also allow the camera to be rotated into portrait orientation for greater vertical coverage. Tripod heads will also often have graduated scale and clutch for accurate rotation of the camera, as well as sprit levels to assure that the rotation plane is level.

The number of shots required for a panorama depends on the field of view of the lens, whether the camera is mounted in portrait or landscape orientation, and the amount of overlap of each image. It is a good idea to overlap the images by at least 50 percent.

Exposure and contrast range can be a serious concern with virtual reality photography as the lighting conditions can vary so much in a single scene. Therefore, it is important that lighting be metered for the entire scene and an average exposure setting set manually and maintained in subsequent shots. If the camera is set to automatic exposure, the exposure will change as the camera is rotated toward lighter or darker areas of the scene. The result will be that the image brightness will vary from shot to shot and will match poorly when combined in the

TABLE 1 Lens and number of images

Lens (mm)	Number of images
6 fisheye	2
14, 15, 18, or 20	12
22, 24, or 27	18
35	20
42	24
50	28

This table indicates the number of images necessary to achieve at least 50 percent overlap using a 35 mm film camera.

stitching process. It is also recommended that automatic white balance not be used for the same reason.

Film cameras were designed to record light so that it could be reproduced on photographic paper. Digital cameras were developed to display images on a computer screen. Both photographic paper and computer screens fall far short of the dynamic range, or ratio between light and dark, which the eye perceives. By taking a series of pictures with different exposure settings the range can be captured and the images can be combined into a single high-dynamic range image called a radiance map.

In most cases it is recommended that the focus be set manually to the hyperfocal distance at smaller apertures to achieve acceptable sharpness for the entire scene.

Software

Once the source material has been collected and digitized if necessary, it must be digitally processed. A variety of software applications exist for processing photographic virtual reality source material, which range from free downloadable applications on the Internet to expensive full-feature packages.

Stitching

The first step in processing the sequence of source material images is to combine them into a single image in a process called stitching. The stitching process prepares the perspective of the image for one of three projection methods and blends the edges of adjacent images to form a single contiguous image. When the right side of a 360° panoramic source image leaves off where the left side begins the image is considered wrapped. This creates a seamless edge when viewed in a player. Although a panorama does not need a full 360° yaw, or horizontal rotation, to be viewed in a player, it would not be considered wrapped. The resulting stitched image is referred to as source image.

Source image

The type of projection method used in a source image depends on the type of source material and what form the final output will take. The three most common projection methods used in photographic virtual reality include cylindrical projection, spherical projection, and cubic projection.

A cylindrical projection image appears with correct perspective when it is mapped onto the inside surface of a cylinder and viewed from the center point of the cylinder. This type of projection is what slit cameras make, and it is the most common projection method used in photographic virtual reality. Cylindrical projection allows for a full 360° yaw, but the vertical tilt, or pitch, is limited to about 110° before perspective distortions will begin to occur.

For pitch angles greater than 110°, a spherical projection method is recommended. A spherical projection image appears with correct perspective when it is mapped onto the inside surface of a sphere and viewed from the center point of the sphere. It can display a full 360° yaw and 180° pitch from nadir to zenith. This kind of an image can only be created if the camera lens has a 180° field of view or greater, or if the source material is collected and stitched in rows as well as columns. Spherical projection can also be referred to as an equirectangular projection. The nadir and zenith points appear stretched into lines at the bottom and top of a flattened spherical projection image so that when it is mapped onto a sphere, these lines converge at the poles of the geometry.

Another solution to full 360° yaw and 180° pitch photographic virtual reality is cubic projection. A spherical panorama can be converted into the six faces of a cube. The cube faces are actually 90° × 90° rectilinear images. Cubic projection is sometimes referred to as cube strip projection or hemicube projection.

Output

Once a source image is complete it must be compressed into an interactive movie file or mapped onto geometry and assigned a user interface so that it can be navigated in a player.

The image is assigned a default pan, which is the horizontal direction that the image will face when it is initially opened in a player. The pan range is determined by the yaw of the source image. In most cases this is 360°, but it can be less if the image is not wrapped and the interface will stop the pan when the edge is reached.

The default tilt is the vertical direction that the image will face when it is initially opened in a player. The tilt range can be set from 0° (no tilt at all) to 180° (complete tilt from nadir to zenith) and is determined by the pitch of the source image.

The default zoom is the magnification of the image when it is initially opened in a player. The zoom range is determined by the resolution of the source image. Low-resolution images will appear unacceptably soft, or pixelated, if the zoom range is not limited.

Photographic Virtual Reality Objects

A photographic virtual reality object is an image of an object that can be rotated, tumbled, and the view can be dollied in and out, creating the sensation of holding the object and examining it. It is created by photographing an object every few degrees as it is rotated, or by rotating the camera around the object's y-axis as it is photographed. The images are then reassembled and compressed into an interactive movie file. Special tabletop rigs are available for capturing object files. Object rigs are designed to keep the object and camera in registration during shooting to assure smooth playback. Tumble can be added by capturing rows of images as the camera or object is pitched on the object's x-axis. This allows the user to turn the object over. In some cases the object can include animation by adding multiple frames to a single view of the object. This technique is referred to as view states. An example of this would be an image of a car, which the user can rotate as well as open and close the doors.

Photographic Virtual Reality Scenes

A photographic virtual reality scene can be made up of multiple panoramic nodes and objects as well as audio and links to other digital media and Internet addresses. Additionally a photographic virtual reality scene can be made from three-dimensional models, which have been rendered in a computer graphic application. By combining these media, a virtual world can be created, which is capable of telling a complex story in a unique and dynamic way. Photographic virtual reality scenes are also referred to as hypermedia. This differs from multimedia, which is generally organized in a linear structure. Hypermedia can be entered, or accessed, from multiple points, navigated in a non-linear, exploratory experience and is often open ended. It has its foundation in the hyperlink, which was invented for the World Wide Web in 1990 by Tim Berners-Lee as a way to organize and access digital documents and other resources. The hyperlink led to the invention of hypertext, which could accommodate true interactive narrative. Hypermedia takes this to the next level by creating a multi-sensory experience. Through these technologies it is now possible to enter and inhabit an image, which is what Robert Barker was trying to achieve over 200 years ago.

FURTHER READING

Berners-Lee, T. and Fischetti, M. (1999). *Weaving the Web: Origins and Future of the World Wide Web*. San Francisco: Harpers.

Cailliau, R., Gillies, J., and Cailliau R. (2000). *How the Web was Born: The Story of the World Wide Web*. Oxford: Oxford University Press.

Debevec, P. E. and Malik, J. (1997). Recovering high dynamic range radiance maps from photographs. In *Proceedings of SIGGRAPH 97, Computer Graphics Proceedings, Annual Conference Series* (Whitted, T., ed.), pp. 369–378. Los Angeles: Addison Wesley.

Oettermann, S. (1997) *The Panorama: History of a Mass Medium*. Boston: MIT Press.

GLOSSARY

Barrel distortion — Distortion in an image from a lens, where straight lines are bent outward from the center of the image.

Cubic projection — A projection method, which represents a spherical panorama as the six faces of a cube.

Cylindrical projection — A projection method, which appears with correct perspective when mapped onto the inside surface of a cylinder.

DARPA — Defense Advanced Research Projects Agency.

Default pan — The horizontal direction that a virtual reality image will face when it is initially opened in a player.

Default tilt — The vertical direction that a virtual reality image will face when it is initially opened in a player.

Default zoom — The magnification of a virtual reality image when it is initially opened in a player.

Dynamic range — The ratio between light and dark.

FOV — Field of view.

HDRI — High dynamic range imaging.

High dynamic range imaging — A set of techniques that allows for a far greater dynamic range of exposures than normal digital imaging techniques. The intention is to accurately represent the wide range of intensity levels found in real scenes, ranging from direct sunlight to the deepest shadows.

Hyperlink — Also referred to as a link, describes a reference in a digital document to another document or other resource. It is derived from the use of citations in literature, but has been adapted to networked computer technology, allowing instant access to referenced document or resource. The World Wide Web is structured on the hyperlink.

Hypermedia — A term used to describe a form of digital media made of images, audio, video, text, and hyperlinks organized and accessed according to non-linear principles. It is generally understood that hypermedia requires computer technology for its creation and its distribution.

Java VR — A multi-platform computer language used to give Web pages more functionality. Java Applet programs like PTViewer or the iPIX Java viewer are used for displaying photographic virtual reality files on a personal computer using the World Wide Web.

Laser disc — The first commercial optical disc data storage medium.

Mapped — When an image file is applied to the surface of a piece of geometry.

Multimedia — The use of a variety of media to convey information. Multimedia is generally understood to be linear in structure and in presentation. Multimedia is often associated with digital media and computer technology. However, a computer is not an essential component of multimedia and its development predates the advent of the computer, as in the case of piano accompaniment at early silent film. The term multimedia is also used in visual arts to describe works created using more than one medium.

Nadir — The lowest point of a spherical photographic virtual reality image.

Nodal point — The point within a lens at which all the light rays converge.

Pan range — The amount that a virtual reality image will rotate on the y-axis when it is viewed in a player from 0° to 360°.

Pitch — The up-to-down rotation of a panoramic tripod head or the rotation of a virtual reality image around the x-axis.

Pixel — The smallest unit of a digital image file that can be assigned its own color and value.

Pixelated — An effect caused by displaying a digital image at such a large size that individual pixels appear square to the eye.

Player — A piece of software, which is designed to present digital media files. A player is sometimes referred to as a viewer.

QTVR — QuickTime virtual reality.

QuickTime VR — QuickTime is a high-performance multimedia technology developed by Apple Computer Inc. for displaying digital media files. QuickTime VR is a functionality of QuickTime that allows the display and navigation of photographic virtual reality files. It can operate as a stand-alone application or on the World Wide Web.

Radiance map — A high-dynamic range image.

Rectilinear — The type of image created by a standard camera lens where straight lines appear straight. Rectilinear lenses have a FOV less than 180° and do not create barrel distortion.

Remap — To convert an image from one type of projection to another.

Resolution — The dimension of a digital image in pixels. The resolution determines the file size and level of detail of an image.

Scanning or slit camera — A type of camera that exposes a narrow vertical slice of an image as it rotates around the vertical axis.

Source image — A single panoramic image created by stitching together a sequence of source material images.

Source material — An image or sequence of images created for processing into a virtual reality panorama.

Spherical projection — A projection method that appears with correct perspective when mapped to the inside surface of a sphere.

Stitching — The process of combining several discreet images into a contiguous panoramic image.

Tilt range — The amount that a virtual reality image will rotate up and down on the x-axis when it is viewed in a player from 0° to 180°.

Uniform resource locator — A standardized address naming convention for locating and accessing resources on the World Wide Web. Also known as simply a URL.

URL — Uniform resource locator.

User interface — The functional and sensorial attributes of software that is relevant to its operation.

Viewer — A piece of software designed to present digital media files. A viewer is sometimes referred to as a player.

Virtual reality — An interactive computer-simulated environment.

VR — Virtual reality.

VRML — Virtual Reality Modeling Language.

View states — When a photographic virtual reality object includes multiple frames of animation in a single view of the object.

World Wide Web — An information network in which the items are located and accessed on the Internet.

Wrapped — When the right side of a 360° panoramic source image leaves off where the left side begins creating a seamless edge when viewed in a player.

Yaw — The side-to-side rotation of a panoramic tripod head or rotation of a virtual reality image around the y-axis.

Zenith — The very top, or apex, of a spherical photographic virtual reality image.

Zoom range — The amount that a virtual reality image will magnify when it is viewed in a player.

Potlatch, Auction, and the In-between: Digital Art and Digital Audiences

A. D. COLEMAN
Independent Photography Critic, Historian, and Curator

Two models of digital art-making and dissemination dominate the current discourse on this subject: *potlatch*—the open-handed giveaway of one's bounty, as practiced by the Kwakiutl Indians of the Pacific Northwest—and *auction*: sale of one's work to the highest bidder. As an alternative, let us explore a fertile middle ground, which I'm calling here "the in-between." Among the issues involved are the politics of access, the challenges of unstandardized

technology, and the imminent shift in systems for the distribution, presentation, and financial support of digital art.

As we move into the 21st century, only a small fraction of the world's population enjoys the privilege of computer use and Internet communication. Except in certain museum and public-display contexts, on the levels of both production and distribution the making of digital art and the engagement with it as an audience member presently involve access to a computer and, in many cases, to the World Wide Web. Even in first-world countries, this represents disparities—of economics, of education level, of class, and of race, among other inequities.[1]

From a political and pedagogical standpoint, therefore, some of our attention and energy must concentrate on heightening awareness of who's tacitly excluded from this discourse, so that we and they can join in steadily expanding the audience and dissolving those borders.

We also need to keep in mind that every technological advance in the digital field, however exciting it may prove for the artists who adopt it, leaves some segment of the existing audience behind. The already vast and ever-growing diversity of computer hardware, software playback media, project design and display programs, and Internet data-transmission and display systems effectively guarantees that some significant percentage of the computer-equipped and computer-literate and Web-ready audience for any work of digitally transmitted art will find itself unable to open, view, download, or otherwise access that work on perfectly good and reasonably up-to-date computers adequately connected—if necessary for that project—to the Internet. This problem will only grow worse over the next decade, I venture to predict. It certainly won't be solved by the advent of so-called "Web services," whereby software will be stored online and accessed via subscription by users; who knows what compatibility will exist between the artwork one creates and the software-subscription decisions of any prospective viewer thereof?

Add to this, by the way, the fact that as this or that generation of hardware and software obsolesces and disappears, digital artwork created with and for one or another variant thereof all too frequently obsolesces with it, unless and until it's repurposed and reconfigured for the newer technology.

So . . . want an art-and-science project? Apply your insights and imaginations to the creation of Digiomnivore, a form of artificial intelligence 'bot capable of ingesting any form of digital media and playing it back according to its programmed purpose. Maybe it should take organic form, as a genetically engineered digestive-regurgitative-excretive biosystem—something not necessarily as unlikely as you might think, given recent biotech advances that enable the bar-coding of molecules, the creation of nanobots,[2] and the introduction of miniaturized electronic circuitry into microorganisms. Or maybe, since we ourselves seem poised to become the first generation of cyborgs, you can devise this as an implant, a media-input slot in some inconspicuous, otherwise unused area of the body.

Whatever form it takes, until its invention artists and audiences alike remain fated to struggle with the real but generally undiscussed problem of systems proliferation without standardization—incoherent distribution. This bewildering multiplication of encoding, storage, distribution, and retrieval systems confronts the bottleneck of comparatively unevolved display technology. At present, the audience encounter with purely digital art—art that takes no analog form—happens on the VDT or computer monitor, a device that's changed very little over the past twenty years. Designed for single-user viewing, the VDT functions as the end-point of digital-art distribution, the physical site at which that art meets its audience. Its limitations determine the impact of that art, and need to be factored in by the artists working with these technologies. New forms of VDT—including a paint-on, emulsion-based liquid and a fabric-like

[1] One can only regret that the late French sociologist Pierre Bourdieu never turned his attention to the subject of computer usage and the Internet. Perhaps one of his followers will bring to those subjects the strategies of analysis that Bourdieu applied to the ways in which issues of class shaped other discourses, as in his work with Alain Darbel and Dominique Schnapper, *The Love of Art. European Art Museums and their Public* (Stanford, CA: Stanford University Press, 1990).

[2] "'Nanobots' may be future of medicine," Associated Press; datelined Washington, June 29, 2000.

version—seem obvious alternatives, but the invention and manufacture of more varied forms of digital-art display may well be artist-driven.

During a PBS interview on the Charlie Rose Show[3] the great composer, arranger, and producer Quincy Jones spoke eloquently about his studies in Paris after World War II with the legendary music teacher Nadia Boulanger. As a jazz musician, working with the assumption of improvisation and the freedom it implies, he was struck forcibly by her insistence on the value— the creative value—of structure and boundaries as stimuli in the making of art. And Jones came to agree with her: whether the constraint was the 3-minute duration of the standard 10-inch 78 rpm record or the 12-bar structure of traditional blues form, these boundaries served the artist who used them well. The more restrictions you have, the freer you become," Jones said, or words to that effect. In that regard we can recall what John Keats, one of its most devoted servants, said about the strictures of sonnet form: that he discovered therein "not chains but wings.

I can't imagine any digital artist speaking that way about the VDT, perhaps because as a container for creativity it doesn't offer anywhere near the challenge that sonnet form or 12-bar blues does. Up till today, looking at digital art largely means squinting at stuff on the equivalent of small- to medium-sized television sets. Imagine, for comparison's sake, if photography for the last century and a half had found itself viable only in the form of the daguerreotype, and only in the standard 19th-century sizes for that medium's plates. Surely that would eventually—if not quickly—have reduced photography's audience. The same holds true, I'd contend, for digital art. We can anticipate a major surge in the audience and market for work in this form once it's liberated from the pixellated prison of the now-standard computer monitor or screen.

Let us turn next to the issue of the bugginess of just about all the software that anyone uses in doing any digital art project. In late 2001 Bill Gates made headlines in the trade publications by pledging Microsoft to the production of less defective software. I can't imagine any other industry in the world in which it would be newsworthy—on a cover-story level—for a leading manufacturer to declare that his company's product should be "trustworthy" and "reliable."[4] In what other realm would Gates's announced determination to vend goods that merely work dependably merit media attention, praise for speaking "the language of leadership," and the adjective "ambitious"?

In any other industry, untrustworthy and unreliable goods get called what they are: lemons, junk, shoddy and inferior merchandise. Somehow, in computer software, we tolerate a level of defect and a frequency of failure that would have us up in arms if we encountered it in our telephone systems, our cars, our CDs and stereos—and especially in our typewriters and cameras and trombones and toe shoes and stage lights and amplifiers and all the other tools we employ to produce art.

For decades now, the software industry has forced consumers—including digital artists and photographers—into paying for the privilege of serving as its beta testers. They've even got their own software piracy police force out there right now, in hot pursuit of anyone with the temerity to refuse to pay for the error-ridden programs Gates and others belatedly acknowledge they've been foisting off on us for all these years. They have yet to apologize for this—or for the incomprehensibility of their documentation, the appalling quality of their tech support, or their ridiculous no-return-once-it's-opened policies.

As for the "rigorous industry standards" one trade magazine refers to—just exactly what are those? No software I've ever installed comes up to even the minimum requirements of the "Software Bill of Rights" proposed at www.amrresearch.com. I'll believe Gates's promise—and the assumption that this signals some tectonic shift—when I see results. And I'm not holding my breath.

[3] "The Charlie Rose Show," November 22, 2001.
[4] For example, see the special issue of *Information Week* for January 21, 2002 (issue 872), devoted to "The Sorry State of Software Quality." Note therein particularly Stephanie Stahl's Editor's Note, "Poor-Quality Software Needs Zero Tolerance" (p. 8); George V. Hulme's cover story, "Software's Challenge" (pp. 22-24); and Bob Evans's
"A New Era for Software" (p. 72).

What this industry needs isn't high-minded internal memos on code quality from Bill Gates. It's some whopping settlements in some major class-action suits against them for false advertising and deceptive business practices, and victories for the plaintiffs in some substantial individual suits for damages. Hit 'em where it hurts: make it unprofitable for them all to put their bug-riddled, conflict-prone, endlessly patched, frequently crashing programs on the market.

Bringing back the pillory for the worst offenders wouldn't hurt, either. Gates himself is a prime candidate for the stocks; given Microsoft's market share, no company has put more bad code on the market. And for all of Gates's vaunted business savvy, it's not even good business—customer relations entirely aside—for them to have done so. In his book *Software Engineering: A Practitioner's Approach*,[5] author Roger Pressman shows that for every dollar spent to resolve a problem during product design, $10 would be spent on the same problem during development, and that would multiply to $100 or more if the problem had to be solved after release. Meanwhile, statistically speaking, one out of every ten lines of programming code is incorrectly written at birth. And the most efficient systems in place for quality control right now reduce that to only one faulty code line in every hundred.

This represents an aspect of the situation of digital-art production that goes so widely unmentioned that it appears to be the form's dirty little secret, though it's in no way the fault of any digital artist. From its origins until today the field of digital art has confronted a problem without much if any precedent in the history of art-making. Digital artists work under a tremendous handicap—to wit, a continuous, exhausting, psychologically debilitating struggle with defective, ineptly designed tools in whose conception and development those artists had little or no voice. Just as you can't understand the dynamics of the New York art world from 1970 through the present without factoring in the skyrocketing cost of real estate in that city during that period, so you can't really grasp the context in which digital art gets made without an awareness of this inherent instability in the technical end of the production system.

The amount of time, energy, money, and frustration expended by digital artists on grappling with this severely impaired toolkit constitutes an important but neglected aspect of the sociology (and psychology) of digital-art making from its origins till the present day. I foresee no rapid resolution to this situation. And this refers only to those artists who've actually committed themselves to working digitally, and not to those many others who might well have pursued serious efforts in this medium and contributed substantially to it but became discouraged by these faulty products and turned their attention elsewhere.

Moving to another subject: Digital art-making offers artists everywhere—again, that is, those with access to the technologies—the opportunity to make artworks without making objects. This constitutes the true dematerialization of art. But how will such work—which will take the generic form of what we now call "files"—reach its audiences? It will come to them either encoded and embedded in some physical software medium (computer diskette, CD-ROM, DVD, or variant thereof) or housed at a server and made available over the Web. Neither method particularly suits—or, for that matter, requires—the distribution and sales systems for art that have dominated the past two centuries: museums, commercial galleries, non-profit spaces, private dealers, auction houses, book publishers and booksellers, magazines and their editors and writers. Digital art-making, in conjunction with technologies of delivery already in place and soon to come, enables a direct artist-to-audience communication, and an equally direct feedback loop.

These methods of digital distribution will force digital artists to rethink their fundamental assumptions about the financial support systems for their work. In a direct producer-to-consumer relationship, what model should one follow? And, when one has opted for the creation and distribution of intangible work in the form of "files," however transmitted, what strategies of pricing and what payment structures work best? Purchase? Rental? Subscription and/or membership may come to the fore as new approaches to patronage and audience support and as new ways for artists to subsidize their work.

[5] Roger Pressman, *Software Engineering: A Practitioner's Approach* (New York: McGraw-Hill, fifth edition, 2001).

Let us consider a model. Imagine, if you will, a website for Digital Artist X (DAX), parts of which are free and open to all but other parts of which require a password, which changes regularly and is available on a subscription basis. For $25 per year for an individual subscription, or $250 per year for an institutional one (allowing access for all members of a school's media-arts department, for example), visitors get the following:

* Monthly posting of completed work, work in progress, and other examples of what DAX currently has on the front burner.
* Access to an archive of past work by DAX, and of course all the relevant boilerplate— DAX's CV and biography, critical commentary on DAX's work, etc.
* Notes, journal extracts, quotations from whatever DAX's reading that she feels pertains to her work.
* A chat room where DAX and invited guests—critics, curators, other artists, other teachers—discuss issues relevant to DAX's work.
* A bulletin board where subscribers can post their comments about all that and interact with each other.
* Periodic, pre-scheduled live studio visits, via streaming audio and video, in which subscribers actually get to see DAX at work, clips from these to be archived at the site.
* Periodic, pre-scheduled live chats with DAX, in which DAX engages in online dialogue with subscribers.
* By-appointment-only online critiques by DAX of student work.

If DAX found a thousand individual subscribers worldwide, or a hundred institutional subscribers, DAX's site would earn $25,000 per year. I know a number of digital artists—and even analog photographers—who could put such revenues to good use. Yet I know of no experiment with such a model by an artist, so it stands untested. This distribution model may not work, but assuredly there are others that will, and it's up to artists to discover them.[6]

This brings us, inevitably, to the issue of intellectual property, which lies at the heart of any discussion of the distribution of art. I acknowledge the oh-so-Sixties trendiness of asserting that "the Net should be free," and the more recent fashionability of proposing, as does the Electronic Freedom Foundation's John Perry Barlow,[7] that "information wants to be free," and I certainly consider art a type of information. But the 'Net is simply a vehicle for the dissemination of information, with no inherent objection to compensation for that act; and information, including art-as-information, no more "wants to be free" than does cat food. The translated locution really means that those who take this position would like to see the free distribution of art-as-information.

So would I. But, this side of paradise, that can take place only if art's producers happen either to come from the wealthy classes (and are therefore able to give their work away) or else if they're subsidized by private patrons, the corporate state, the academic sector, or the government—all of which, of course, filter (that is, censor, both tacitly and overtly) everything they underwrite. Artists in the States envy the level of government support available as a matter of course to—for example—artists from the Netherlands, Canada, and the Nordic countries. Curiously, however, and perhaps not coincidentally, as a rule they can't name a single Nordic, Dutch, or Canadian visual artist they consider a major contributor to the current field of ideas. Conversely, Nordic, Dutch, and Canadian artists envy the corporate support of the arts we've achieved in the States, usually without recognizing how it's defanged whatever authentically oppositional, anti-corporate impulses our artists once felt.

[6] A project of my own, the Photography Criticism CyberArchive (photocriticism.com), represents my own experiment with this model. A password-protected, subscription-based repository, it includes hundreds of my essays and hundreds of texts by dozens of other writers past and present on photography and related matters.

[7] Notably, Barlow has yet to put his money where his mouth is by placing his own income-producing lyrics to Grateful Dead songs into the public domain.

At the risk of sounding untrendy, I must say that as a maker of intellectual property of various kinds (including poetry, fiction, and visual art, as well as ratiocinative prose), I believe in the necessity of laws protecting intellectual property and copyright, and believe they will endure well into the digital age. It's no accident that the basis of intellectual copyright law was written into the U. S. Constitution in the late 1700s, and not as an afterthought or amendment but right up front—Article I, Section 8, right in there with Congress's empowerment to coin money and declare war. The survival of makers of intellectual property—including digital art—depends on protecting their ability to control and make a living from the production and distribution of their work. The digital environment offers them remarkable opportunities to do so, in a context that makes possible the elimination of middlemen and gatekeepers who, historically, have interfered in the artist-audience relationship at least as often as they've facilitated it.

But that same digital environment also offers various means of hijacking the labor of others, and has engendered a culture of entitlement whose members feel free to take what they want. So any pedagogy of digital art distribution needs to include an inquiry into the concept of intellectual property and the various alternative forms of financial support for artists, along with familiarization of both students and faculty with copyright law—both national and international—and subsidiary-rights licensing, and even encryption technology.

When museums ask artists to transfer copyright and all other rights to them along with the works themselves, as they've begun to do here in the States, then artists (and their teachers) need to join the battle initiated by such organizations as the National Writers Union in the U.S., in such lawsuits as the landmark *Tasini vs. Times* case. No single action will more directly affect your control over the distribution of your work than surrendering all rights to it.

Finally, it seems evident that as the technologies of data transmission and information display change, the very environment of digital-art distribution will shift with it. From the wireless Internet-in-your-pocket option to broadband Internet-everywhere innovations, we can expect to carry digital data with us, show images on our clothing, turn our walls and furnishings into monitors, walk through and interact with digitally generated and holographically credible 3-D spaces—perhaps even have digital receptors implanted in our bodies.

The advent of media arts/time-based arts programs in colleges, universities, and art schools signals an unprecedented merger between what we once considered hard science—computer theory, programming, and such skills—with both media studies and the fine and applied arts. This hybridizing hothouse promises to be among the most fecund sources of innovation in 21st-century communication. In that context, production and distribution find themselves inextricably intertwined; it's almost impossible to consider one without the other.

In the title of this paper I juxtaposed *potlatch* and *auction*. Digital distribution of digital art facilitates each of these systems, as most artists' websites bear witness to at one end and eBay's art section demonstrates at the other. Nothing truly innovative there—just old wine in new bottles.

But the next several decades, I anticipate, will see a lot of experimentation in what I've called *the in-between*, with digital artists and their digital audiences collaborating in testing unprecedented, and potentially healthier, ways of getting artwork to its optimum user base while making it possible for artists to survive and even thrive on the fruits of their labors. That's the challenge, and I for one can't wait to engage it as both a maker of intellectual property and a member of the audience for art.

The Pressure to Stay Current

BARRY HAYNES
Photographic Author

Beginning in 1975 with the first computer science class that I enrolled in at the University of California, San Diego—where in 1978 I received a BA in Computer Science—I have been

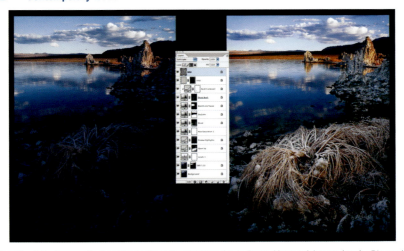

FIG. 25 A before and after Photoshop illustration from Barry Haynes' latest book, *Photoshop Artistry for Photographers Using Photoshop CS2 and Beyond*.

involved in this cycle of keeping up with technology. Since 1988 that technology has been focused on photography and its interaction with the software Adobe Photoshop and computers. It has been my experience that technology can take over one's life and get in the way of creativity. It is important to learn how to manage the need for technology but not let this need dominate the motivations to use it. This essay will share my story and experiences on this treadmill called keeping current. In this 30-year journey I have developed some personal rules to manage the abundance of technology in this field without it managing me. This essay will also feature a short history of how quickly digital photography has quickly moved into the ultimate solution for shooting and printing that is currently used today.

My Journey with Photography and Technology

I've been working with photography and technology most of my life. My first camera was an Instamatic 104, which I took to England on a trip when I was 14. The Instamatic camera used 35 mm film but the film was preloaded into a plastic cartridge that was simply dropped into the camera and then you started shooting. The image format was square, versus the traditional 1×1.5 aspect ratio of 35 mm. I got some good pictures on that trip and this started an interest in photography that has become stronger and more pronounced during my life.

A Navy photographer

After two hard working quarters in 1972 as a freshman at University of California at San Diego's Revelle College, I found the beach more interesting than school where I was studying pre-med. Originally I went to Revelle because it was a beautiful place and far away from San Jose. After 6 weeks I realized that I was at the last possible time to drop all my classes and not flunk out. I was not ready for school so I went to the Navy recruiter's office and I got a commitment in writing on my enlistment contract that I was to be a Navy photographer.

After boot camp, where I was one of only two out of 80 in my company who had any college experience, I went to the navy photography school at the Pensacola Naval Air Station in Pensacola, Florida. This was a very large building filled with hundreds of little darkrooms each having faucets with flowing developer, stop-bath, and fixer. You did not drink out of those taps but it was great for a photographer. I got to use every kind of camera of that time including Leica 35 mm cameras, Mamiya twin lens 120, 4×5, and even a 16 mm Aeroflex movie camera with sound track on the film. The photography training there was very good, even if it was not

artistically inclined. I lucked out and got to stay and took every course they offered including photojournalism and motion picture. I learned the technology of traditional film photography of that time, 1974. After spending the rest of my Navy time on the shooting crew at the Fleet Training Center back in San Diego, I decided to go back to school at University of California, San Diego (UCSD).

BA in computer science and UCSD Pascal

The prior pre-med competition experience had convinced me I no longer wanted to be a biology major and that I actually really liked photography. I almost took a photo job at an ad agency in Los Angeles but I said, I've got to finish college first now or maybe I never will. During those first two quarters in college before the Navy, my friend, Roger Sumner, had scared me away from computers because he was at the computer center for what seemed like 24 hours a day, his eyes were usually red from lack of sleep, and he spent most of his time reading through piles of computer printout listings of massive Algol programs that ran the main Burroughs 6700 computer at UCSD's computer center.

I took an initial computer class to learn how to program in a computer programming language called Pascal. The following quarter I was helping to teach the class and had decided that Computer Science was going to be my major. Thus began a 13-year hiatus from photography and a deep immersion into technology.

I learned all about computers: how they work, how to program them, how to write compilers and assemblers to translate from human-like languages into the numbers that computers understand, and how to teach and help others understand. As I learned about computers, I also taught others the entire time I was there. You may think you understand something but when you have to teach it to someone else, that is when you really learn it! I worked on the UCSD Pascal project where we created a portable computer programming system and ported it to other new "micro" computers. Most of these new computers were the micro-computers that were just becoming popular in the late 1970s. The Apple II, based on the 6502 chip, was one of the first. I ported the UCSD system to the Intel 8086, a hot new chip that several years later became the base for the IBM PC. When you port a system like this, you get a chip on a board in a box with an instruction manual sharing the instructions of the computer chip and a description of how they work. This is basically the numbers you have to feed into that computer to make it add, subtract, etc. I had to write the program, which included an assembler that would translate the human-understood computer language into numbers that the computer would understand. I then had to write the assembly language instructions to run the UCSD system on that particular computer. I had to get the entire UCSD system up and running on this new computer. This is much harder than pushing the button to bootstrap, or start, you computer. You are writing all the computer instructions that the new computer has to go through to actually run itself. Obviously, I was into this technology at that time and I learned a lot about how computers work. Ken Bowles, who started and ran the UCSD Pascal project, was honored by UCSD in the fall of 2004 as one of the most innovative professors and creating a computer system that became well known and used throughout the computer industry. What I learned on this project gave me the confidence and knowledge to work anywhere in this new field.

Ten years at Apple Computer

In 1979, I became tired of school and wanted to get a job in the motion picture industry. I interviewed for these jobs and while I was waiting for their answers I went to San Jose to visit my family. While I was there I went to have lunch with my college friend who worked at a small company called Apple Computer. It was a long lunch and by the end of the day they had offered me a job.

I worked at Apple from January of 1980 until I took a leave of absence to work on my personal photography in August of 1989. During almost 10 years at Apple I did Apple II Pascal, based on UCSD Pascal; worked on Apple III Pascal; created the Lisa Pascal Development

System; and also built Mac Smalltalk, an object-oriented programming system for the Macintosh. I was heavily into software development environments; the tools that allow other programmers to create software.

Seeing Photoshop got me back into photography

This all changed one day in 1988, I believe, when I was walking down the hall at Apple and saw a bunch of people crowded around a cubicle. It was Russell Brown from Adobe showing off a new program called Photoshop about a year before it ever shipped. At the end of his demo I asked him if I could get a copy. He reached into his shirt pocket and handed me my first copy of Photoshop on a diskette.

Soon after that I left the field of software development environments and was developing the technical end of a research corporate alignment, the "Medianet Project," between Apple Computer and Nynex, the phone company in Manhattan. I got to spend a lot of time in New York and learn all about the publishing industry and how it dealt with images. Even back in the late 1980s, broadband fiber high-speed networks were available in New York City and people in the publishing industry were very concerned about how to transport large color digital files around on these networks.

Back in the late 1980s, the advertising industry used million dollar Scitex computer systems to manipulate color photographs. They would pay a "Scitex Shop" $300 an hour to use these special computers to do things that Photoshop could easily do on an iMac today. I was this guy from Apple visiting the multimillion dollar Scitex shops in New York and telling them "you'll be able to do all that on a Mac soon." They all thought I was nuts, but most of them went out of business just a couple of years later when what I had told them came true. Most of the typesetters had lost their jobs a year or two before that when Lisa then Macintosh and other PCs were suddenly able to use CompuGraphic software to set type, which had previously been an art form done by hand. I had helped the CompuGraphic team port their typesetting software to the Lisa.

The Medianet project was fun and I worked on it until I decided to leave Apple in late 1989 to pursue my own photographic interests. I learned a lot about digital photography during those last two years at Apple and certainly decided that it was now to become my main focus. I became very good a Photoshop, but trying to actually make color digital prints at that time was still quite frustrating. The desktop computers in the late 1980s were fast enough to do design and layout, but working with a 3 megabyte Photoshop file back then was probably slower than working with a 600 megabyte file today.

Away from technology, back to the craft of photography

My time at Apple was a great experience, I was there when everyone wanted to work at Apple. It was the place to be and there were lots of great people there. Lots of big egos too though! When I started there were fewer than 500 employees including manufacturing and when I left the company had grown to over 10,000. Apple's technology was always better than Microsoft. UCSD Pascal was better technology than Microsoft and the UCSD system actually competed with Bill Gates to be the initial software on the IBM PC. The best technology does not always win the political battles though. Individuals and different teams at Apple were working against each other instead of working together to beat the, at that time unexciting, competition of Microsoft. Poor marketing decisions, bad relationships with dealers and distributors, non-committal to corporate alignments, and in-battles between engineers, were the things that gave Microsoft a leg up when Apple really had the better technology. A lot of great technology ended up in the round file. Most of the technology we all take for granted today was included in ideas and discussions we had during meetings for the Medianet project—back in 1988. A "My Yahoo"-like thing on the Internet, Java-like transportable objects, downloadable movies, virtual tours, DVDs, and many other ideas were floating around back then. My Medianet boss, Mike Liebhold, is the one that convinced Apple to have a CD player built into every system. What a great idea! It sometimes takes a long time for ideas to become actual products that people use on a daily basis.

I was really ready to get back to the craftsmanship required in photography where the tools were not changing all the time and a person could focus on things like making a really great print. Working at Apple there was a new operating system version every week or two. You could usually play with the latest technical toys by just calling the company up and saying you worked at Apple and wanted to try it. I had a budget in our group of $100,000 a year to buy new digital photography toys. This was when the original Nikon 35 mm scanner cost $10,000; the first Canon "Still Video" digital camera was $10,000; and the Dupont Forecast, the first dye-sub color printer, cost $60,000. I wanted something that was stable, that actually worked, and that I personally could afford.

I took a one-year leave from Apple in late 1989 and finished the darkroom I had built into my house. I purchased a Jobo processor so I could process my own color and black and white film and also make my own Cibachrome prints. I had a nice Bessler enlarger with a color head and started shooting film with my new 4 × 5 camera. I took a Cibachrome masking class from Charles Cramer of the Ansel Adams darkroom behind the Best Studio up in Yosemite. Charlie was making dye transfer prints at the time and I was quite impressed with these. They were far better than anything a computer printer could do. I thought about learning the dye transfer process from Charlie.

I still have my finger in digital too

I got invited to a National Photographer's Association (NPPA) event at Martha's Vineyard in 1989 where I met Russell Brown of Adobe, Shelly Katz of *Time* magazine, and George Wedding of the *Sacramento Bee*, among others. Everyone who attended wanted to learn this new digital technology and we had some early digital cameras and Kodak dye sub-printers, which were really quite good.

Because of my experiences and contacts from the Medianet project and the Martha's vineyard event, Apple Computer and the Seybold Publishing Conference hired me for two years, 1990 and 1991, to conduct a live demonstration at the Seybold publishing conference sharing everything from scanning to final pre-press output using desktop computers and peripherals as contrasted to those million dollar Sytex systems. I produced a full-color brochure using the Mac and sold copies of it to Nikon and other companies to use as promos at tradeshows. Sometimes I would get phone calls from people in the Midwest who had my brochures and suggested "I'm sure you did that on a Scitex machine," but I produced them on the Mac with a Nikon scanner and Linotype image setter.

I taught my first Photoshop workshop for the *Sacramento Bee* in 1990. Not many people were teaching Photoshop back then. I then went on to teach at the Kodak Center for Creative Imaging in Camden, Maine. This was the first place in the country to have a great set-up for teaching digital workshops. At that time, it seemed that Kodak was positioned to be a leader in this new digital revolution. Apparently they were having their own internal political wars between the new digital folks and the old guard film and paper group. From what I heard, the film and paper group won out at that time and many great digital printer and other products and ideas went down the toilet. The Center for Creative Imaging was cut from the Kodak budget and soon went out of business. Years later Kodak had to pay for this lack of vision about digital technology with massive layoffs and loss of market share. Now, of course, film and film cameras are going away fast. I hope to still be able to get 120 format and 4 × 5 Velvia, but I do not use 35 mm film cameras anymore and digital certainly beats them all. I use a Pentax 6 × 7 from time to time, but these days it is hard to find a good place to properly process the film.

I met my wife, Wendy Crumpler while giving a Photoshop talk at the Daystar booth at the Macworld conference in 1993. Wendy initially hired me to teach Photoshop to her commercial clients in New York City where she lived and worked. I was in Santa Cruz, California, and a long-distance romance started. We wrote our first Photoshop Artistry book while also having our first child together in 1995. Our son Max was born two weeks after the book was published. He is 12 years old now and we're just finishing the 8th edition of our book.

Since the early 1990s I have taught Photoshop and digital printmaking workshops at the Seybold Publishing Conference, Palm Beach Photographic Workshops, University of

California Santa Cruz, Mac Summit Conference, Santa Fe Photographic Workshops, Anderson Ranch, International Center of Photography, Fotofusion, and many other places. Wendy and I have also been teaching workshops in our studio for the last 7 years. Teaching workshops or providing a place to teach workshops is a separate technology issue because you have to buy new computers, scanners, printers, and other equipment every year or two as image data continue to get bigger and Photoshop requires more RAM.

Finding a Digital Printer for Photographers

It was approximately 1988 when Photoshop was first on the scene and desktop computers started to be used for digital photography. One could create beautiful images on the computer screen, but it was not until approximately 1993 when affordable photographic quality desktop digital printers became available. The first somewhat affordable digital printer that actually made "big enough" photographic quality prints was the SuperMac ProofPositive Dye Sublimation printer. SuperMac called me to evaluate a unit in 1993. I jumped for joy to have this printer because I could now finally do beautiful prints from all my digital landscape images. There was a $20,000 price with this printer and it made 12 × 17 inch prints. This is the same size as the Epson 2200, which cost $700 and had much better quality. I also got a special deal on the ProofPositive and later purchased the unit for half price at $10,000. The trouble with these prints though was that when you put them up on the wall in a frame, the colors turned magenta after about 3 years. All dye sub-prints were of limited color permanence.

Color permanence was a problem with digital printers until the Epson 2000, 7500, and 9500 came out about 5 years ago. They had permanent color, marketed at 200 years, but it was hard to calibrate them and get the colors you actually wanted. Those colors also had a metamerism problem. Metamerism is a condition where the colors change when viewed with different types of lights. The prints would look great with 5000 Kelvin print proofing lights, but when you took them out in the sun these same prints were green.

In 2003 Epson came out with the 2200, 7600, and 9600 with Ultrachrome inks and this solved most of the problems for making color prints. Photographic quality was very sharp with a good dynamic range and the metamerism problem had been mostly solved for color prints. It was still hard to make black and white prints with absolutely no metamerism unless you used third party print drivers, such as the ImagePrint product from ColorByte. Imageprint makes great black and white prints on Ultrachrome printers but it costs more than $500. Some papers, especially glossy, could also have a bronzing problem with Ultrachrome prints. Sometimes you could see a reflection in solid black areas when looking at the prints from an angle.

In 2005, Epson came out with the Ultrachrome K3 2400, 4800, 7800, and 9800, which have a larger dynamic range than regular Ultrachrome and an even better ink set that makes wonderful color and black and white prints using the Epson profiles and drivers without metamerism or bronzing.

There are other color printers. HP has several good printers as well that some photographers use. The inks for the Ultrachrome and Ultrachrome K3 ink sets have a color permanence of 80 years or more on most papers, even longer for black and white. This seems to be much better than the old C print or Ilfochrome traditional photography color prints that were marketed with a color permanency between 12 and 25 years. Darkroom black and white prints have been king for quality and permanence, but now I believe the new Ultrachrome K3 inks will give them a run for their money in longevity.

Digital Cameras for Photographers

I mentioned the Canon still video digital camera that I bought for $10,000 on Apple's budget. It photographed using a 640 × 480 pixel array that was video quality. I can get the same thing from my 10-year-old video camera. This was not a camera that came anywhere close to 35 mm film in quality. At the time, I was not going to buy a digital camera until it could stop motion, shoot 3 to 4 frames per second, and the quality was close to what I could get by scanning a piece of 35 mm film at 4000 dpi.

Getting a great digital file by scanning film with a desktop scanner is something I have been able to do for about the last 10 years. I have tried lots of digital cameras over the years. There have been many commercial digital cameras costing $20,000 or more, although some of them could not stop motion. For my situation though, as a landscape photographer, why pay that much money when you can shoot film for cheaper and get better quality? For many commercial shooters, they could justify the $20,000 5 years ago so they would not have to pay for film or wait and pay for processing anymore.

I wanted a digital camera of at least 35 mm quality that would stop motion and shoot 3 to 4 frames per second and be able to use my existing Canon lenses. The Canon IIDx certainly fit the bill, but it was $8000 when it first came out. Had I been a commercial photographer, I could have saved that much in the cost of film and processing, not to mention those clients who are chomping at the bit to have a digital file to take home at the end of the shoot! The 6 megapixel Canon D60, at $4000, and 10D, at $2000, were certainly equivalent in quality to the Digital Rebel, but they did cost considerably more when they were released. When the Canon Digital Rebel came along with the same quality as the D60 and 10D but at a cost of $1000, then it was time for me to buy!

I've shot over 11,000 images with my Digital Rebel and I can make high-quality prints up to 22 inches in size. For some images, I can go even larger. If I had been shooting film over the last few years, I never would have shot that many images and I would have missed some great shots. With digital photography, I just shoot it and do not worry about it. I have more fun shooting and I get to see the pictures right away. Editing and correcting the images is much faster, even though I shoot more images. I have all the images instantly available to show prospective clients. With film I only would have had the time to scan a few of them. I bet many readers of this essay who shot film still have thousands of images on film that were "going to be sorted and scanned one of these days." Most of the digital stuff I shoot now gets sorted and filed on the same day. I LOVE IT!!! Now I am eyeing the Canon 5D, which has the same size sensor as a 35 mm, is 12 megapixels, and costs only $3000. I've tried one with the 24-105 zoom and I'll be getting it as soon as I get $3000 I can spare. Until something better comes along by that time, which it will of course.

Speaking of better, I was recently talking to well-known landscape photographer Charles Cramer and he is getting a $30,000 digital back which may replace the 4×5 film he has been shooting for 30 years. Since he spends $8000 a year for film and processing, this actually makes financial sense too. Check out his article about this in the essays section of www. LuminousLandscape.com. If Charlie is going digital, that tells me something.

The march of all the other digital toys, too

The brief history I have given you sharing the evolution of digital printers and cameras also exists for desktop film scanners, flatbed scanners, Macs, PCs, CRT monitors, LCD monitors, all the versions of Photoshop (I have used versions .087, 1, 1.1, 2, 2.5, 3, 4, 5, 5.5, 6, 7, CS, and CS2 so far), and all those third party Photoshop plug-in filters and virus protection software.

Then there is the history of backup storage devices which began with punch cards (yes, I used punch cards), reel-to-reel magnetic tape drives, optical storage disks (extinct), DAT tape drives (extinct), CDs, and now DVDs. What will be next, holographic storage devices? The power strips and surge protectors and the newest thing, camera memory cards are constantly changing. Both my digital cameras have the compact flash format, which I like. For the last 9 years or so there have been the monitor calibrators; scanner, printer, and film profile-making software; spectrophotometers, etc. These are things that can take up a lot of your time and can also take a big slice out of your pocketbook.

Let us not forget to mention digital projectors. I have been giving lectures with a computer hooked up to a projector since 1988 and probably even before that when I worked at Apple. I love my Epson Powerlight 745c, which weighs very little and can project 1024×768 real pixels and fill up a large room with my computer's screen. Millions of colors are projected accurately and I use it all the time when giving talks and teaching workshops. You may be thinking: Why is he writing about the obvious? It is very important to know that many years of

teaching Photoshop color correction using a 640 × 480 projector—where the projected color and contrast could not even begin to approximate the colors on my computer screen—gives me flashbacks to an unhappier era. I would have to say over and over again: "If you could actually see the colors on the projection screen then. . . ." My son likes it too for projecting DVDs and we have learned that if you project them from a 1024 × 768 computer like my old G4, versus a VHS DVD player, you get essentially HDTV quality. Do not get a big screen TV, buy an Epson projector instead and use it for your business presentations and also for movie night.

It is interesting to recall the different types of computer memory chips that I purchased and installed over the years. I always enjoyed installing my own memory chips and have done that on the original Intel 8086 board (64 K maybe), the Apple II (I had the one and only special 80 K one so I could re-compile the Pascal computer), Apple III (128 K), Lisa (1 megabyte, wow!), Original 128 K Mac (I had 4 megs in mine for Mac Smalltalk), Mac II (32 megs, I believe), Mac CI, Mac Quadra 900 (the most expensive Mac I ever bought: 32 megs cost $1000 and I had 128 megs), Mac Power PC 201?, Mac Power PC 8600, Mac aqua G3 tower (seldom worked properly), PowerMac G3 (I still use it with 750 megs), iMac (we have 4 at 256 to 750 megs), EMac (we have 4 at 750 megs to 1.25 Gigs), Mac Duel Processor G4 (my previous computer, 1 Gig, we use it to watch DVD movies), Mac Duel Processor G5 (my current computer which is great, 2.25 Gigs). I do also own one PC but it runs NT or Windows 98 and has the original AMD Athlon processor, which I tested Photoshop on for my friend at AMD. I received this machine in lieu of a payment for evaluation so technically I have never actually purchased a PC! I guess my next Mac will have an Intel processor and the family is due for a new portable. Maybe Apple will send me one after reading about all the Apple computers I have bought and used over the years.

Simplifying your march with digital toys

Part of the reason I have told you this long story is so you will understand and appreciate the words of wisdom I am about to share. The advice I will give is coming from someone who has been deeply involved in technology for the last 30 years and who now wants to focus on personal photography.

I know many photographers tend to be gadgeteers. Photographers are people who have spent lots of time looking at the latest cameras and films to analyze their inherent qualities. With digital photography there are a lot more gadgets to keep up with and if you feel that you always have to know the latest of everything, you will find that this can take up most of your time. If you need to buy the latest of everything, it can take up most of your money too.

You do not have to be independently wealthy or have unlimited amounts of time to spend to be able to produce beautiful prints with today's digital cameras and printers. If you are just entering this field, you have chosen the correct time. Digital cameras have evolved to the point where I can say for 99 percent of the population, "don't bother with film." If you want to do really large landscape pictures and cannot afford $5000 to $30,000 for the best digital cameras, then maybe shoot 120 or 4 × 5 film. If you start shooting film now, you will have to buy a scanner and have to find a quality place to get the film processed. You may need a scanner anyhow to scan film that you have shot in the past but otherwise, I'm now ready to say skip it. Film is going out and digital cameras are really great these days.

Limit the size of your digital gear bag

The software applications I use most are Adobe Photoshop, Bridge, and Netscape Navigator for e-mail and the Web. Because I write books, create training videos, and have a Web site, I also use Adobe GoLive, Acrobat, Premiere, and InDesign. Most of these Adobe applications come in one bundle, reasonably priced, called Adobe Creative Suite. TextEdit, which I use for letters, is free with the Mac. I do not use Microsoft Word or any Microsoft products, it is simpler that way because you never know if Microsoft will be feuding with Apple and something you rely on will suddenly not work on the Mac. I also use Color Vision Optical to calibrate my monitor and Snapz Pro X to make screen grabs for books and articles. I do not use any third party Plug-ins because with my Photoshop Artistry book and workflow techniques you can

actually do most things a photographer would need to do just by using Photoshop. I no longer make scanner or printer profiles because the canned profiles that come with Epson printers and even third party papers these days are just fine. If my monitor does not exactly match my print, I can fix that with either Optical or Photoshop.

I have previously tried third party Photoshop plug-ins, had lots of profile making software and hardware, used various scanners (which I still use occasionally), tried USB hubs, still used Microsoft Word, and had Filemaker, Excel, Illustrator, etc., just in case I needed it. The problem is that when you have all this stuff you need to drag it around with you and update it all the time. This takes extra time and costs money too.

For example, a software company had kindly let me borrow a spectrophotometer, which had a serial cable hookup along with $3000 worth of software to make profiles. Now this was a $2500 device! A year later, I upgraded my computer and wanted to also upgrade the software so I could talk about it in a new version of *Photoshop Artistry*. I called the company and they sent me a new $2500 device, now with a USB cable instead of a serial cable, and a new set of software worth $3000. I installed all the software, got the new spectrophotometer hooked up, and nothing would work because the USB dongle (a copy protection device) was incompatible with the new software. After calling this company several times to get a new dongle and not getting one, I just had better things to do and I have not used this stuff since. Imagine how frustrated I would have been if I would have paid for all that paraphernalia! Note: Every company I've known that has used a dongle for copy protection has eventually gone out of business!

Don't believe the marketing flyer—try it yourself

I have been buying digital equipment for 30 years and I seldom believe the marketing hype. You can read the marketing materials for the specs about a particular device, but to really decide if you want it, test it yourself or get advice from someone you trust who has used it. One manufacturer's 6 megapixel camera will not perform the same as another company's product, and so one camera may have more digital noise, may not be as sharp as another, or may capture the color in a way that you do not like. If you find a manufacturer you can trust, get to know a local store that carries their stuff or ask a local rep from the company. They will be able to tell you 90 percent of what you need to know. When a new product comes out that you want to buy, contact the local store or representative and see if you can borrow one for a day or week before you buy it. If you are a good customer, especially with photography equipment, this can usually be arranged. For example, I've been shooting Canon cameras all my life and I have also been using Epson printers for the last 10 years. During that time, I have grown to rely on their products and trust the people I know at these companies. The same is true for Apple and Adobe. It would take a really great product to get me to switch to Nikon cameras, HP printers, or a PC workstation. I do know they have good products, but switching from what you know takes time and money to adjust. By the way, over the years I have known many photographers who have switched from PCs to Macs but very few have gone the other way. Lately, I have also come across quite a few Nikon lifers who are now buying Canon digital cameras, but in my travels I have not seen much activity going in the other direction. Folks with a lot of Nikon lenses should also consider the Fuji digital cameras, which are compatible with Nikon lenses.

Find friends who read and/or do their own tests

There is so much information out there these days that you could spend 24 hours a day reading information just on Photoshop Web sites. There are some good sites online though. Just go to www.Google.com and type in the kind of information you are looking for; for example, "digital camera reviews," "Adobe Photoshop downloadable training videos," Epson 2400 printer reviews. The most useful sites on the Web change frequently so, instead of my listing them, I suggest that you Google the things you are interested in and then decide for yourself who is just spewing marketing hype and who has useful information. I just spent 30 minutes doing a search because I got distracted by some of the stuff

FIG. 26 Ship Rock Fire Sunset. Barry Haynes, 2006.

I found testing the above phrases using Google. Be careful, the Internet can suck up your time. Occasionally I subscribe to magazines but they are also a time sinkhole. Find a friend who reads all the photo magazines or better yet who performs their own tests. I have lots of photographer friends. Some, like Charles Cramer and Bill Atkinson, are people I have known for many years and realized that they share a lot of my interests and they also spend more time in some areas of photography than I do. I just read one of Charlie's articles on Luminous Landscape (a great site by the way). There is lots of great information and also amazing images at www.charlescramer.com and www.billatkinson.com. Charlie and Bill also teach workshops, which you can find out about on their sites.

My friends in Corvallis, Oregon, Dave McIntire and Thomas Bach, are also photographers. I got to know them via the local Corvallis Photo Arts Guild. Dave makes amazing landscape prints and I have learned a lot about photography from him. Thomas Bach performed substantial research on inks and printer issues at HP but now he makes art prints for himself, painters, and illustrators who want exact copies of their one-of-a-kind art so they can sell the reproductions. Thomas is a wealth of knowledge about printers, how to clean clogged inkjets, papers, etc. (www.photobach.com). Bruce Ashley, a commercial photography friend in Santa Cruz (www.bruceashleyphotography.com), used to do most of Apple's product photography and we became friends when I worked at Apple and we were both interested in this "new" digital photography. Bruce always knows about the latest cameras and monitors and many other things and I always appreciate his advice. Maria Ferrari is a commercial photographer in New York (www.mariaferrari.com) whose work I really admire and she knows a lot about commercial photographers as well as their Photoshop needs and priorities. She also teaches Photoshop workshops in New York. Carl Marcus is a great landscape photographer and friend in Telluride, Colorado, who also likes to hike and photograph. I appreciate his opinions about cameras, printers, papers, etc. I call these friends to get their opinions and I trust what they have to say. I get ideas from them and then I often also try new products out myself. If I bounce something off these people and they do not agree with what I am saying or thinking,

then I know I better look at it more closely. It is good to find your own group of photography friends; you can all learn from each other.

When I moved to Corvallis, Oregon, 8 years ago, most people in the Photography Guild there were just using film. I was the digital guy. Now many of them are digital experts themselves. Find smart friends who can afford expensive toys and then let them buy first. One of my friends has a Canon II Ds Mark II, a Canon 20D, and the newer Canon 8 megapixel Digital Rebel. No way that I could afford to get all three. I think he got the 20D first then decided he wanted bigger files so he bought the IIDs Mark II, and finally he decided that both of those cameras were too heavy for his extended backpacking trips so he bought and uses the 8 meg Digital Rebel for that. It is a really light camera but since I already have the regular Rebel, I am shopping for the 5D next. What my friend told me about his uses of these cameras was very helpful information. Many of my workshop students have all the latest and often most expensive camera and computer equipment but they take workshops from us to learn how to use them and make really great digital prints. We try out their toys and often help them figure out how to use them. Since we don't have to buy them either, it is great fun.

Get the most from the equipment you have

You do not always need the new version of everything. If you are taking pictures and making beautiful prints, be happy and create your art. If you need to do it faster or better or with higher quality then look into getting something new. With online update checking, computer software is always out there seeing if there is a new version of something. I set up my computer so it NEVER automatically installs anything. If your computer automatically installs something, this may break something else. You want to know when something changes and you want to know what changed so if something no longer works properly, it is possible to figure out what went wrong. As I mentioned earlier, when I was at Apple, we had a new operating system available to us almost every week. The person in the next office was always upgrading to the next version. He also always had all the extra software, control panels, desktop toys, Photoshop plug-ins, etc., that he could find. His computer was always crashing or something was not working properly. I kept on getting things done while he had the "hood open" on his computer trying to figure out what was wrong.

Let other people do the testing

When I do update things, I tend to assume I will have to update several things, learn new stuff, and deal with conflicts. When a new version of the Mac OS comes out, or a new computer like the new Macs with Intel Processors, I let other people bang their heads against the wall. People who are the first to try that new Mac OS or that new Intel Processor are often the ones who discover that some of the software they use and rely on does not work anymore. They have to lose productive time discovering this and then they have to spend time and money getting new versions. The worse situation is updating to a new OS then finding out that there is not a new version of the software you need that works on that OS. Usually after a new OS or computer has been out for a year or so, most of these problems get solved and other people spend their time figuring them out.

Buy the older version at a discount

When a new computer or software comes out, you can usually get the better configuration of the previous model for a lot less than it ever was before and also a lot cheaper than the new version. I am using a duel 1.8 GHz Mac G5, which is great for the workflow I have. Photoshop might be 20% faster sharpening a file if I had the 2.5 GHz model or had 4 Gigs of memory instead of 2.25, but for my workflow this would only save me 5 minutes a day. I would rather spend that extra cash on more hard disk space or the Canon 5D that I want. If I were sharpening images every 5 minutes 8 hours a day, then that faster machine would be worth it.

The pressure to be up-to-date

Because we make part of our living from our *Photoshop Artistry* books, we have to be using the latest version of Photoshop. We are now using Photoshop CS2 and it is one of the best Photoshop updates ever. I love all the new features, but I could still make wonderful prints using Photoshop CS or even Photoshop 7. There would be certain features I would not have in those older versions, but my creativity would still be very close to the same. The CS2 version does allow me to work with digital camera files much more efficiently so I upgraded my camera to the digital world and it also helped to upgrade Photoshop. Updating for a good reason is great but American society, marketing, and keeping up with the Joneses puts pressure on us to always have the latest of everything and this is not necessary. Take an extra photography vacation instead. Are you learning about the new versions of Photoshop? Play with it. Try things out, make prints, try this, try that. If you have a hunch, try it. Go through the menu bar and look for new features. Use the online help system or the help menu to look things up. The only other Photoshop book I have ever read thoroughly, besides my own, is the Photoshop manual for very early versions of Photoshop (say, version 2). I learned 90 percent of what I know about Photoshop from trying things out. When I need to learn something new, I will check the online help system and that will usually explain 60 percent of what I need to know. It will tell me what a tool does and what the options are (some of them at least). Then I learned the rest, how best to actually use the tools, by trying things and experimenting. Do not always believe the manual either or even my book or anyone else's book. You may discover a better way. I do have several other Photoshop books, but I usually use them as a reference to see what other authors do with particular features. They often do things in different ways or have different opinions than I do. We all learn from each other. I try one way, I try another, and I often come up with something different from either. You need to learn how to do this too. Trying something with a backed-up digital file has zero risk. When you get a totally new piece of software, you sometimes have to break down and read all or most of the manual or some book about that software. After using computers for so long, most software is similar to something else I have used before and I am able to feel my way around and figure it out. Many years ago, when I first started at Apple and in college, I used to always read the entire manual for things. You can learn a lot of useful things that way but to really understand them and have the information useful for the future, it is better to actually use those things and try them out under different circumstances. This is what we have our workshop students do. They try our color correction workflow and techniques on their own images. Making a great print with your own image is always more satisfying and a better learning experience. Have fun in this, now digital, photography world! 🌀

Science as Art

MICHAEL R. PERES
Rochester Institute of Technology
DAVID MALIN
Anglo-Australian Observatory; RMIT University

Since its invention, photography has been recognized as both an art and a science, linked by the technology through which its images are captured and then preserved. It is natural that aspects of these three components, in varying degrees, would be evident in photographic images. The extent to which art, science, or technology dominates the photographic expression is in the hands and the imaginative eye and mind of the practitioner. The importance of the motives in photography is as relevant in the digital age as it was for Daguerre and Fox Talbot, both of whom made some of the first photographs of scientific subjects.

Once its potential was realized, the intent of scientific photography has always been to make images without the photographer's personal biases being unduly evident. However, true objectivity is not possible, since someone has to press the shutter, light the subject, and frame the scene. In addition, the myriad of considerations necessary to convert a three-dimensional view into a two-dimensional image are almost all influenced by the photographer or imposed by the technology. So while the intent may be complete objectivity, subjective influences inevitably intrude.

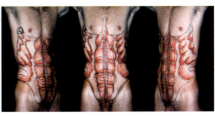

FIG. 27 It is a slight departure from scientific methods to photograph and present in ways that are not scientific. Dr. David Teplica is both a practicing plastic and reconstructive surgeon as well as a photographic artist. (Photograph by David Teplica, M.D., M. F. A.)

Most scientific photography is done with visible light and traditional cameras, but it may also be used to record invisible objects with dimensions of atomic or cosmic proportions, exploiting almost any region of the electromagnetic spectrum and in ways that are unconventional or highly specialized—holography and electron microscopy come to mind here. Scientific imaging also embraces the representation of scientific data that have no visual counterpart, such as a radiograph, or that is purely numerical, such as a fractal. Many of the subjects are recorded specifically because they have not been observed before, or cannot be observed directly, or simply because an image is the most convenient way to capture a rich stream of data, as in an outward-looking astronomical telescope or downward gazing earth-orbiting satellite. Consequently, a frame of reference is often absent from many science pictures, and when presented without scale, title, or context, they may appear as abstract images to the uninformed viewer.

It is clear that scientific photography offers a vast opportunity for anyone with a creative eye, although many of its practitioners would not consider themselves artists. Indeed many would not admit to being photographers in any conventional sense either. Nonetheless, it is hardly surprising that images made for science can be aesthetically pleasing or even inspirational, since they often reflect aspects of the world of nature, of science, and of technology that are not easily observed. Sometimes this world is inaccessible, unseen, or non-visible, yet can produce images that are mysterious, revealing, provocative, or inspirational to the science community and beyond.

Much of this was foreseen by the French astronomer Arago, who introduced Daguerre's revolutionary invention to the French government in July, 1839, with the intention of making the details public in return for a generous life pension for Daguerre. The full text is in Eder's *History of Photography*. It was clear that Arago saw the new process as useful in archeology, astronomy and lunar photography, photometry, microscopy, meteorology, physiology, and medicine, while noting ". . . its usefulness in the arts." Thus from the beginning, the value of photography in the sciences was recognized.

The objective of preserving scientific data through permanent images was a key motivation before photography itself was invented. The idea of recording the outlines of leaves and insect wings using light alone was suggested 1802 by the photographic pioneer Thomas Wedgwood. This became a practical reality with Fox Talbot's calotype salt-paper prints and through John Herschel's cyanotype (blue-print) process, invented in 1842. A year later this led to the first book to be illustrated with photographs, Anna Atkins' *British Algae: Cyanotype Impressions*.

Atkins' book contained over 400 shadowgraphs and appeared a year before Fox Talbot's much better known *Pencil of Nature*. In the preface to her book Atkins wrote, "The difficulty of making accurate drawings of objects as minute as many of the Algae and Confervae has induced me to avail myself of Sir John Herschel's beautiful process of Cyanotype, to obtain impressions of the plants themselves, which I have much pleasure in offering to my botanical friends." Despite its prosaic title and unusual subject matter, it contains images of science that are delicate and often quite beautiful, revealing the variety, transparency, and detail of natural forms in a way that no drawing can.

Atkins' skillful work showed that photographs had the potential to replace the pencil drawings often used for botanical specimens and to provide a new and visually compelling means of expression. It had also convinced some people, uninterested in algae, science, or even photography itself, that the forms and textures captured by this new process could be intriguing or even beautiful. It is in these ways, through inspiration, insight, and expression, that images of science may also occasionally, by chance or design, be works of art. It is a rather small departure from this to deliberately make scientific images that are intended to be aesthetically pleasing but that almost incidentally include scientific subjects and use scientific equipment, ideas, or techniques.

There were other early practitioners of science photography whose work was groundbreaking in both its photographic results as well as its aesthetic qualities. In her chapter on "The Search for Pattern" in *Beauty of Another Order*, Ann Thomas writes, "Mid-nineteenth century art critic Francis Wey (1812–1982) while puzzling over whether photography was an art of science, decided ". . . it was a kind of hyphen between the two." In fact art-science was the term nineteenth century astronomer Thomas W. Burr used to describe the recording of magnetic and meteorological data in 1865."

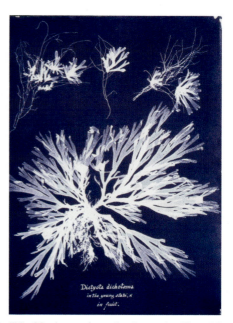

FIG. 28 Image from the first scientific publication illustrated with photographs of British algae produced by Anna Atkins as cyanotype impressions. This plate from her book is of *Dictyota dichotoma* in the young state and in fruit. (Image courtesy of the New York Public Library, New York.)

There were many pioneers dedicated to using photography as a means of scientific enlightenment, and initially most were British or European, though the work of New Yorker, John William Draper caught the eye of another pioneer, the distinguished astronomer, Sir John Herschel. Commenting on Draper's Experimental Spectrum, a daguerreotype made in 1842, he refers to ". . . the beauty of the specimen itself as a joint work of art and nature. . ." Later, and exploiting an entirely different property of photography, Thomas Eakins, Eadweard Muybridge, Étienne-Jules Marey, and Harold Edgerton at various times showed how it can be used to stop motion with arresting images. Later still we find photography firmly allied to the microscope to explore the hidden beauty of the very small or to the astronomical telescope to reveal unseen cosmic landscapes.

Many of these early practitioners were scientists who turned to photography to add to their understanding. More unusual was the photographer who turned to science for inspiration. The exemplar of this approach might be found in the pioneering woman photographer, Berenice Abbott, who made her reputation with her monumental Federal Art Project documentation *Changing New York* (1935–1939). Berenice Abbott proposed a new role for herself as science photographer, but she found little encouragement for her interest. In later life she turned her considerable talents to capturing scientific ideas in images, and wrote that photography was ". . . the medium pre-eminently qualified to unite art with science. Photography was born in the years which ushered in the scientific age, an offspring of both science and art" (see Figure 29).

When we look at scientific images taken 150 or more years ago, many now seem to be minor works of art, partly because of their rarity, but also because many of those who embraced photography in its early days had some artistic training or temperament. Many of

the early processes also had a delicacy of tone or color that lends a grace and style rarely seen today, however, few of the early science pictures that we now see as artistic, neither sought nor received the attention that we accord them today. They were exchanged between friends or colleagues, shown at the meetings of the learned societies of the day, and sometimes exhibited as examples of the art of photography. The world's first photographic exhibition was held in Birmingham, England, in 1839. It consisted of 56 photographs by Fox Talbot, of which half were pictures of grasses, seeds, ferns, and other botanical specimens. Many of these "photogenic drawings" have not survived, but by description they are clearly images of science.

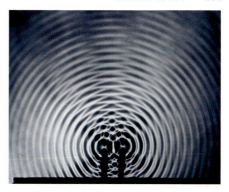

FIG. 29 A scientific image made for science purposes that is also pleasing to the eye, by Berenice Abbott. (Image courtesy of the Museum of Contemporary Photography, Columbia College, Chicago, Illinois.)

Not all practitioners had Fox Talbot's eye for composition and as photography became more specialized and complex, pictures for scientific purposes were often made without aesthetic considerations. However, as photography became more widely available in the 1880s, largely through the efforts of George Eastman, and more widely published through magazines such as the *National Geographic*, specialists in geography and geology, botany and anthropology, to name but a few, soon found their images were more desirable for publication if they were also good to look at. Thus scientific photography overlapped with photojournalism, and as photojournalism reached its zenith in the 1960s, interest in scientific images as visually interesting artifacts similarly increased.

FIG. 30 A scientific image revealing an interesting and difficult-to-see aspect of nature, presented as an abstract image. The wings of the lacewing are imaged using a desktop scanner. (Photograph ©David Malin, 2006.)

As Ann Thomas writes in *Beauty of Another Order*, "scientific photography is a subject long overdue scholarly attention and several publications and exhibitions have paved the way for more comprehensive treatment." Among them she lists are *Once Visible* at The Museum of Modern Art, New York, in 1967; *Beyond Vision* at the Science Museum, London, in 1984; and *Images d'un Autre Monde* at the Centre National de Photographie, Paris, in 1991 as well as several other important exhibitions worldwide.

Another notable activity designed to promote an aspect of scientific photography as art is the Nikon Small World photomicrography competition, which was started in 1974. The entries are exhibited widely throughout North America. The Japanese Society of Scientific Photography has also had an annual exhibition since 1979 and a similar but more recent series of *Visions of Science* competitions and associated exhibitions are held annually in the UK. "Image-aware" institutions such as the Rochester Institute of Technology also support scientific imaging and their *Images of Science* exhibition has traveled widely.

Nowhere has the inspirational nature of the scientific image penetrated further into the public consciousness than in astronomy. Since the early 1980s, true-color photographs of distant stars and galaxies from ground-based telescopes became commonplace. Now more than a decade later, the stream of stunning images and groundbreaking science from the Hubble Space Telescope have transformed our view of the universe both scientifically and aesthetically.

In addition, several generations of probes and satellites have visited the outer solar system. Not surprisingly, the most photogenic of the planets, the ringed world Saturn, provides the most remarkable and haunting images from the joint USA-European Cassini spacecraft. The beauty of these pictures is no accident; space agencies long ago realized fine images and frontline science were both perfectly compatible and complementary.

At the other end of the scale, optical and electron microscopes are also capable of producing striking images, sometimes in the cause of science and sometimes for art's sake. The scanning electron microscope is especially adept at this since its magnification can be so high yet create images of great depth.

Figure 31 is an image taken by Felice Frankel, a well-known "scientific artist" at high magnification and author whose work has been widely published and exhibited worldwide. In the image, a drop of ferrofluid (magnetite suspended in oil) is on a slide on top of a yellow slip of paper, and magnets under the paper are pulling the magnetite particles into place.

Another contemporary example of photographers working on the frontiers of art and science are Oliver Meckes and Nicole Ottawa whose work is compelling, powerful, and fascinating. Their photographs portray their subjects with scientific accuracy and visual elegance. Figure 32 shows a section through the leaf of a lavender plant. The rounded structure (pale tan, lower center) is an oil gland that produces lavender's aroma. The color in this image was digitally added later since scanning electron microscopes are only capable of producing monochrome images.

A more conventional scientific photographer whose work transcends mere scientific illustration is Professor Andrew Davidhazy of the Rochester Institute of Technology. For more than 40 years, Professor Davidhazy has

FIG. 32 Among the dense hairs on the leaf of a Lavender plant nestles a yellow capsule of the plant's essential oil. Image courtesy of Oliver Meckes and Nicole Ottawa, Eye of Science.

FIG. 33 This photograph, titled Double Screw, reveals how a series of still images taken of a subject will be imagined when the sample is rotated past moving imaging slit rather than a traditional shutter. (Image courtesy of Professor Andrew Davidhazy, School of Photographic Arts and Sciences, Rochester Institute of Technology, Rochester, New York.)

FIG. 31 Photograph by Felice Frankel, *Envisioning Science: The Design and Craft of the Science Image*. Cambridge, MA: MIT Press.

developed or refined unusual scientific imaging techniques, many of which manage to com-
bine the concepts of time and motion into one picture, often with surprisingly beautiful
results as seen in Figure 33.

More than 170 years after the first science pictures were created, there is still an ambiguity
associated with this type of photography. Just as the intent of the photographer decides what
category of image will be made, so it is the mindset of the beholder that decides if it is art.

FURTHER READING

Ede, S. (2000). *Strange and Charmed: Science and Contemporary Visual Arts*. London:
Calouste Gulbenkian Foundation.

Eder, J. M. (1978). *History of Photography*. (E. Epstean, translator). New York: Dover
Publications. (Originally published by Columbia University Press in 1945.)

Frankel, F. M. (2002). *Envisioning Science: The Design and Craft of the Science Image*.
Cambridge, MA: MIT Press.

Frankel, F. M. and Whitsides, G. M. (1997). *On the Surface of Things*. San Francisco: Chronicle
Books.

Kemp, M. (2000). *Structural Intuitions: The 'Nature' Book of Art and Science*. Oxford, UK:
Oxford University Press.

Thomas, A. (ed.) (1997). *Beauty of Another Order: Photography in Science*. London and New
Haven, Yale University Press, in association with the National Gallery of Canada.

Valens, E. G. (1969). *The Attractive Universe: Gravity and the Shape of Space*. Cleveland, OH:
World Publishing Co.

ADDITIONAL INFORMATION

British Photographic Exhibitions, 1839–1865
http://www.peib.org.uk/
Science, Art, and Technology (The Art Institute of Chicago)
http://www.artic.edu/aic/students/sciarttech/2f1.html
Art–Science Collaborations, Inc.
http://www.asci.org/artikel2.html
Oliver Meckes and Nicole Ottawa, *Eye of Science*
http://www.eyeofscience.com/
Images from Science, Cary Graphic Arts Press, 2002
http://images.rit.edu
http://www.ncbi.nlm.nih.gov/entrez/query.fcgi?cmd=Retrieve&db=PubMed&list_uids=
14805684&dopt=Abstract
http://japan-inter.net/ssp/e/index4_e.html
http://www.britishcouncil.org.ua/w3/photos/default.asp?e=120505
Visions of Science
http://www.visions-of-science.co.uk/

Index